A
Feminist
Critique

Also by Cassandra L. Langer

New Feminist Criticism

Feminist Art Criticism

A Feminist Critique

*How feminism has changed
American society, culture,
and how we live
from the 1940s to the present*

Cassandra L. Langer

ASJA Press
San Jose New York Lincoln Shanghai

A Feminist Critique
How Feminism has Changed American Society,
Culture and How We Live from the 1940's to the Present

ASJA Press
an imprint of iUniverse.com, Inc.

For information address:
iUniverse.com, Inc.
5220 S 16th, Ste. 200
Lincoln, NE 68512
www.iuniverse.com

Originally published by HarperCollins

ISBN: 0-595-16518-4

Printed in the United States of America

To those who live passionately—Irene, Alberta, Bob, and Kelpie—the lights of my life. And to my mother and father who had faith in me.

We need to be reminded these days about what women have been and can be, it's a question of their place in society. Their really deep and fundamental place in society.

Dorothea Lange, ca. 1964

Contents

Acknowledgments

This book could not have been written without the steady support of my partner Irene Javors and the generosity of Deborah Hillman, who read and commented on the manuscript. I especially want to thank my editor, Cass Canfield, Jr., who encouraged me to write this book and offered helpful advice and criticism, and his assistant Karen Schapiro for their invaluable contributions. I owe an enormous debt to my feminist foremothers and fathers, to the men and women who were my teachers, and to the writers who preceded me and forged a path in the wilderness. Amy Richards, Gloria Steinem's able assistant, and Steinem herself were most generous in sharing ideas with me. Most of all, I want to thank my friends and colleagues in the women's movement who are too numerous to name. My heartfelt thanks go to my cat family—Tashi Gable Goodfellow and Tinker Sinclair—for sharing their intuitive wisdom and Tao of living, and for providing support to keep me going.

Introduction: "The Times They Are A-Changin'"

I began this book long ago in 1963 when Bob Dylan's song "The Times They Are A-Changin'" inspired me as a painter, writer, and poet. After more than twenty-five years of working as an art historian-critic and teacher focusing on women and art, it was clear to me that current controversies revolving around feminism constituted a genuine problem—a problem that has led to garbled theories and partial accounts concerning its development. Dylan's song advises writers and critics to keep their eyes open and not to speak "too soon" because "the wheel's still in spin." By focusing on the spinning wheel of feminism and trying to keep my eye on the world that it has created, I have tried to make sense of the incredible tapestry of life that feminism is in the process of weaving.

Feminism has politicized the conditions of human life in general. In looking at various issues through a variety of lenses—art, music, films, and popular culture—one becomes aware that value is conferred upon things by those who are in a position to make policy in their spheres of influence. Sexism colors our society's view of women. By comparing and contrasting readings and interpretations, I take a closer look at sexual politics, identity and autonomy, racism, coming of age, ageism, woman hating, violence and violation, and homo-prejudice in the context of modern and contemporary life in American society. Covering the broadest spectrum of women's lives, past and present, I have probed the communication media's disturbing perspectives on women as a group.

For sections of this book that deal with the earliest decades of the movement to liberate women, I have relied on archives, jour-

nals, and other published materials to reconstruct the history of feminism in the United States. But for chapters for which I could locate women to tell me about their experiences, I was anxious to round out the picture of how women actually live their lives. Through contacts in various states and countries and by "surfing the net," I have connected with a wide diversity of women aged fifteen to ninety-six: women who are Caucasian, Asian, African American, Native American, and Latina; who span the socioeconomic spectrum from one who is a mail carrier on a rural route in South Carolina to another who is a prestigious artist in New York City; women who are married and autonomous, lesbian, single, celibate, and who have established their own lives.

By examining the theme of violence that courses through people's lives and musing about women and their place in the world, readers will learn how the American feminist movement originated, what impact it has had on the lives of women and men, why certain ideas and images have changed, and what this change has done to shape our notions of feminine and masculine over the past half century. Readers will see how various contributions (both women's and men's) have truly enriched the history of our culture, despite some of the compelling and unresolved questions about sexism that still plague us in the workplace and in our lifestyles.

In writing this book, I conceived of the framework as an allegorical chessboard on which players make moves from position to position in time and space. But in trying to draw attention to the inequality in male-female relations and the considerable cultural resistance that has grown up around it, I came to realize that feminism is a story whose beginning is lost in the past and whose present and future are still being written on the winds of change. By citing the views of various foremothers of feminism, I also understood that although most Americans say they are strongly in favor of equality between the sexes, in general most men have a vested interest in either denying their privileged position or in legitimating it as natural, moral, or right. This situation is bad for business and bad for us as a society. I was pleasantly surprised to find that despite this undeniable fact, feminism does not always view men as abusers at best, rapists at worst, and always predatory. So, although the general course of

this book is based on contradictions inherent in these gender disputes, I have also made an effort to show how various waves of feminism have flowed and ebbed around them.

By trying to reframe the dimensions of "difference" among various groups of women and men, I have tried to represent the full spectrum of feminism's possibilities in generating future potentialities. Even so, I must confess that I found it difficult to write a nonpolemical book about a polemic.

Twenty years ago, the poet Adrienne Rich wrote in a piece entitled "The Kingdom of the Fathers" from her book *Of Woman Born* (1976):

> Patriarchy is the power of the fathers: a familial-social, ideological and political system in which men . . . determine what part women shall play or not play . . . I live under the power of the fathers, and I have access only to so much privilege or influence as the patriarchy is willing to accede to me, and only for so long as I will pay the price of male approval.

These sobering words are as prophetic now as they were when Rich first set them on paper. Clearly, there are traditions of thought that are feminist in nature and that grow out of women's experience. The notion that the personal is political is as evident in Rich's language and consciousness as it is in the words of Betty Friedan, Gloria Steinem, Robin Morgan, and a host of others. Rich was responding, as many feminists today still do, to the belief that the socially constructed experience of women is a consequence of being born female in a universe dominated by male values that don't allow women to develop their full potential.

Philosopher Sandra Harding argues that since women's experience has not generated the problems that most male theoretical frameworks address, these intellectual structures, for instance, Marxism, are deficient in making women's lives visible. This lopsided view hurts us as a society. By attempting to do something about standards of measure not of their own making, feminists have touched upon the boundless possibilities opened up by discovering their own creativity and using it to equalize today's chaotic society.

Virginia Woolf explored the politics of gender in her book

Orlando, in which she ingeniously pushed the boundaries of personality. Other foremothers, such as Olive Schreiner, described the double exploitation of women in private and public spheres, and French author Simone de Beauvoir posited a second sex in which the male was a positive norm and woman was a negative "other." They were succeeded by a host of Americans, including Betty Friedan, Kate Millett, Gloria Steinem, Susan Brownmiller, and Susan Faludi, who build feminist campaigns based on their consciousness of gender roles, inequalities, and women's radical possibilities for transforming society as we now know it.

Making sense of the whole tapestry of feminism and drawing one's own conclusions is difficult in the face of so much confusion about its meaning. The sheer number and diversity of feminist undertakings are what makes the subject so difficult. Feminism at its best is an inclusive and humanistic striving to free people's creativity. It attempts to give one an understanding of what community can really mean and how we as loving people can best achieve our mutual goals. Feminism is about human rights—human rights are feminist rights.

As I write, in the fall of 1995, a ferocious political battle once again rages over women's rights. Senators are threatening to roll back gains on abortion, affirmative action, and violence against women, and angry editorials dot the pages of the nation's newspapers. To get some idea of how women of various generations and social classes currently regard feminism, I sent out a brief survey of ten questions and surfed the net for feedback. One respondent, Cesi Kellinger, who identifies herself as a feminist and specialist in books on women and art, said:

> Look, I am 72 years old and thus not a very good source for your project. But like Pavlov's dogs I seem to respond to certain words: books is one, feminism is another. As to what I think—young women are in general not in the feminist corner where one upholds the equal sharing of power because at twenty you care little for that sort of thing. Give them ten, fifteen years and *some* of them will join the ranks, enough I believe to continue bringing pressure on the political process. Have we made progress? There are many days when I despair, but then I look up at the wall where in a golden frame there is a bill from the New York State Assembly declaring that from this day on any money a woman brings into a marriage will remain *her* own. The date: March 2, 1837.[1]

Her point goes right to the heart of the matter. "When women have won their battle," she argues, "the world will then be okay."[2] I don't know if winning the battle is certain, but I do know that the old models people have banked on in the past don't seem to be working anymore.

Feminism, for all its faults, must be credited with having tried to right the old wrongs and set our society on a new and better path. The women's movement has succeeded in posing the question: How do we create a more equitable society for women? Through dialogue with each other, future generations of women and men will continue to labor to realize the dream of equal opportunity for us all.[3] Whatever changes feminism brings to society, people can count on one thing: "The Times Are A-Changin'."

Notes

1. Letter to the author, October 6, 1994.
2. Ibid.
3. The revolution is spreading. Anyone who is interested in starting a conversation, stimulating debate, and/or applying cutting-edge business thinking to a variety of topics, contact me at Cassandra Langer (Kelpie 1.@aol.com).

A
Feminist
Critique

1

What Is Feminism?

Today we are still grappling with Sigmund Freud's question, "What do women want?" This is a fascinating, poorly understood, time-consuming, and often disheartening topic to explore.[1] It's hard to make sense of the ever-shifting points of view and developments within a social movement, as well as the many academic controversies found in the popular presentations of it. The interests of feminism are varied, and the balancing of rights against responsibilities still challenges us. The feminist critique is a way of asking questions and searching for answers based on women's experience. Although not all women want the same things, feminism has had an unparalleled influence on American life and culture.

As a revolutionary movement, feminism has a long history. It first formed in this country in the earliest days of the colonies in New England. Since that time, women have been told that they should happily give up their own work for their husbands and/or children. Scores of women from every class have been forced to bear children in a society that provides prisons for some offspring and the death penalty for others, who become criminals because our society is not willing to allocate resources for their education and useful employment. Women have traditionally been oppressed because of their ability to reproduce and the division of the private and public spheres by gender.

The central goal of feminism is to reorganize the world on the basis of equality between the sexes in all human relations. To advance their cause, feminists have focused on a variety of problems, including patriarchy, gender modeling, individual freedom, social justice, equal educational opportunity, equal pay for equal work, sexual harassment, and human rights. Unfortunately, woman's power in shaping governmental policy to her own needs has been severely limited by the politics of gender. The revolutionary fathers did not heed Abigail Adams's advice to her husband, John (who was sitting as a delegate to the Continental Congress in Philadelphia in 1777), when she wrote:

> In the new code of laws which I suppose will be necessary for you to make, I desire you would remember the ladies and be more generous and favorable to them than your ancestors. Do not put such unlimited power into the hands of the husbands. Remember, all men would be tyrants if they could. If particular care and attention is not paid to the ladies, we are determined to foment a rebellion, and will not hold ourselves bound by any laws in which we have no voice or representation.[2]

Among the mothers of the American Revolution, Abigail Adams is particularly prominent. Her strength of character and her patriotism stood the severest test, and she realized that she could not simply surrender to the legislative process created by her husband and the Sons of Liberty. Unfortunately, she could not enforce her womanly sentiments, so they went unheeded.

Higher education for women became a primary goal of the reform movement. In the United States change came at a snail's pace. Only as women emerged from the home as public speakers and abolitionists could they effect any meaningful change in their conditions. Only by breaking the bondage of the home and the handicap of silence imposed on them by patriarchy, did women began to transcend their condition. The term *patriarchy* means a system of male authority that oppresses women through its social, political, and economic institutions. In all the historical forms that patriarchal society takes, whether feudal, capitalist, or socialist, a sex-gender system and a system of economic discrimination operate simultaneously. Patriarchy results from men's greater access to, and control of, the resources and rewards of the social system. Furthermore, specifically male val-

ues are expressed through a system of sanctions that reward the upholders and punish the transgressors.[3] In the socioeconomic sphere, women are disadvantaged by a system that favors men through legal rights, religion, education, business, and access to sex.

This imbalance led analytic feminists to coin the word *sexism*, a social situation in which men exert a dominant role over women and express in a variety of ways, both private and institutional, the notion that women are inferior to men. The terms *patriarchy* and *sexism* reflect women's rising awareness of the oppression women suffer under this system.[4] The British writer Virginia Woolf showed that she understood the circumstances that gave rise to these terms (long before the 1970s) when she argued that a woman needs financial independence and "a room of her own" to become herself. Woolf's 1929 essay "A Room of One's Own" is applicable today.[5] For the vast majority of women workers, finding a way to obtain better wages and working conditions is still a priority. Although the number of women who were "gainfully employed" increased rapidly during the nineteenth century, they were unable to control their own wages, legally manage their own property, or sign legal papers. The American writer Lydia Maria Child was outraged when she was not allowed to sign her own will; her husband, David, had to do it for her.

For these and other reasons, most feminists agree that poverty is not gender neutral. During the nineteenth century, inequities were worse for working-class women who could be forced to hand over all their earnings to an irresponsible husband, even if they were left with nothing for their own survival or the maintenance of their children. If a woman tried to divorce such a husband, he was legally entitled to sole guardianship of the children. In this system, a woman had no right to her own children, and male lawmakers customarily gave custody of the babies even to an alcoholic father. Women were subordinate to men on the basis of discriminatory legislation, as well as men's exclusive ability to participate in public life.

Many men, as well as women, rebelled against this unjust system, considering the marriage laws unfair and iniquitous because they gave men control over the rights of women.

Between 1839 and 1850, most states passed some kind of legislation recognizing the right of married women to own property. Women continued to struggle against the perception that they were unfit to participate in government because of their physical circumstances. Since the founding of our nation, the politics of reproduction has dominated social and economic relations between the sexes. Because of gender manipulations, it becomes very difficult to see and understand the realities of women's experience and how it affected them.

So the struggle for women's rights continued to be a difficult one. The fight for enfranchisement of women in the United States covers the period from 1847 to 1920. Academic feminists generally divide it into two parts: "first wave," referring to the mobilization of the suffrage movement in the United States and England between 1890 and 1920 (although an organized "feminist movement" for women's suffrage already had existed for forty years),[6] and "second wave," referring to the formation of women's liberation groups in the United States, Britain, and Germany in the late 1960s.

The mid-twentieth-century feminist critique is a way of looking at the conditions of women that developed over time and that goes beyond equal pay for equal work. The feminist critique is a system that, despite its failings, attempts to humanize power relations in a way that is beneficial to us all. Betty Friedan asserted that in the movement's next stage—"the restructuring of all our institutions on a basis of real equality for women and men"— "the dynamics involved . . . are both economic and sexual; the energies whereby we live and love and work and eat, which have been subverted by power in the past, can be truly liberated here, in the service of life for us all."[7]

Organized feminism, however, began with the Seneca Falls Convention of 1848, an event that articulated what some American women wanted in the mid-nineteenth century.[8] On July 19 and 20 of that year, five women decided to call a Women's Rights Convention at Seneca Falls, New York, to discuss the social, civil, and religious rights of women. During this period, Elizabeth Cady Stanton and Lucretia Mott reviewed the Declaration of Independence in light of their own experiences and those of other women. Their Declaration of Principles,

which fueled generations of women in their bid for equality, declared: "The history of mankind is a history of repeated injuries and usurpations on the part of man toward woman, having in direct object the establishment of an absolute tyranny over her. To prove this, let facts be submitted to a candid world."[9]

In a manner similar to the current presentation of facts offered by the contemporary women's movement, these foremothers and others introduced a range of issues that implicated men and showed how their self-serving acts affected woman's status in society. These reforming women had no illusions about the gender system and knew that their views would be distorted. The declaration asserted, "In entering upon the great work before us, we anticipate no small amount of misconception, misrepresentation, and ridicule; but we shall use every instrumentality within our power to effect our object."[10]

The struggle was on. Margaret Fuller's brave book, *Woman in the Nineteenth Century*, put it bluntly:

> We would have every arbitrary barrier thrown down. We would have every path laid open to Woman as freely as Man . . . then and then only will mankind be ripe for this, when inward and outward freedom for Women as much as for Man shall be acknowledged as a *right*, not yielded as a concession. As the friend of the Negro assumes that one man cannot by right hold another in bondage, so would the friend of Woman assume that Man cannot by right lay even well-meant restrictions on Woman.[11]

Indeed, women have been answering Freud's question for a long time. The main problem is that they still are not being heard.

The Civil War of 1861 helped bring women into national politics. After the victory, the intersection of the women's liberation movement and the emancipation of the slaves underscored the issue of enlarging the electorate. Since the blacks were now free citizens, they were entitled to the suffrage rights of citizens. Women saw this development as one that might bring them the vote as well. They were totally unprepared for the opposition of the Republican politicians and the desertion of their cause by the abolitionists, who had been their staunch allies. Appalled at the appearance of the word *male* in the proposed Fourteenth Amendment to the Constitution, Elizabeth Cady Stanton, Susan B. Anthony, and Lucy Stone, leaders of the liberation movement,

raised the issue of whether women were actually citizens of the United States. The advocacy of "manhood" suffrage, as Stanton warned, "creates an antagonism between black men and all women that will culminate in fearful outrages on womanhood."[12] Men, including large numbers of white men, were concerned with ensuring the vote for black men, but they were little interested in how such a measure would affect women.

From a historical vantage point, Stanton's misgivings seem prophetic. Racism and the condition of women have continued to be explosive national issues since the Civil War. These twin injustices ignited the revolution of the 1960s and sparked the heated debates surrounding the Anita Hill and Clarence Thomas Senate hearings of the 1990s.[13]

The growing chasm between men and women, regardless of race, was thrown into sharp relief by the Fourteenth Amendment, which was passed in July 1868. Although Senator Cowan of Pennsylvania offered to strike the word *male* from the legislation, and Senator Williams of Oregon argued that the interests of men and women were one, their views were ignored. Williams understood that putting women in an adversarial, rather than a complementary, position in relation to men would eventually create a state of war and "make every home a hell on earth."

On the other side of the divide, Senator Frelinghuysen of New Jersey argued that women had a "holier mission" in the home, which was to assuage the passions of men as "they come in from the battles of life." When all was said and done, the hand that rocked the cradle still had no say in the process.

The beginning of the twentieth century saw American women still fighting for the right to vote. Inequities continued in education, marriage, property rights, legal rights, religion, and the realm of divorce. The years between 1910 and 1915 were a period of confusion and growth, during which a growing number of female workers were providing fresh arguments for women's suffrage. The foundation of the Women's Party in 1916 brought new energy into the political sphere. Twelve states had finally given women the vote, so that women now constituted a new force in the presidential election.

By this time, it was clear to all parties that the group that

opposed national suffrage for women would lose women's support in twelve states that controlled nearly a hundred electoral votes. Even though the female vote did not sway the election of 1916, women were able to win presidential support and reorganize their party. By 1918, after years of dogged effort, the suffrage amendment passed by a vote of 274 to 136, exactly the two-thirds majority required to accomplish it. After fifty-three years of progressive effort, women finally had won the right to vote. This was the wedge women would need in the coming years to force their way past what Carrie Chapman Catt warned suffragists would be "locked doors."

Women's greatest challenge, however, was not to gain the vote, but to change patriarchal values. Their efforts were based on two assumptions: (1) that a man claiming to be sensitive to what women want must first recognize, as Fuller pointed out, that "Man cannot by right lay even well-meant restrictions on Woman" and (2) that men who are humanists can be persuaded to give up their unfair advantages voluntarily. These assumptions bring forth an underlying assumption that feminism is both a movement that strives for equal rights for women and an ideology of social transformation whose aim is to create a better world for women beyond simple social equity. In fact, feminism urges such men to question the whole idea that an unfair advantage is really an "advantage."

A QUESTION OF SOCIAL REFORM

There are many different views and factions within feminism. The movement encompasses major differences of opinion about how its goals can best be achieved and how they should be defined. This situation is not unusual, since in all the major movements in the history of ideas and social reform, the participants have had such differences. What unites all feminists, what they all have in common that makes them "feminists," is the belief that they must question and challenge sexual stereotypes and that opportunity should not be denied to either men or women on the grounds of gender. Friedan, who is often called the mother of contemporary feminism, defined it as a conviction "that women are people in the fullest sense of the word, who

must be free to move in society with all the privileges and oppor-
tunities and responsibilities that are their human and American
right."[14] This is a major aspect of "classical feminism." Its mission
is to achieve full quality for women of every race, religion, eth-
nic group, age, and sexual orientation.

In the course of its struggle to achieve equality for women, the
current feminist movement has coined many new terms that
have had an intensely unsettling effect on contemporary society
and culture. Knowing that leading researchers in any field have
their own biases helps one to understand the controversies within
today's women's liberation movement that are reflected in how
various people have chosen to define the problems women
presently face. Many of these explanations are hotly contested.
What follows is a basic guide to the terminology that is crucial to
understanding any discussion of the feminist revolution.

Feminism as a term has generally been misapplied to the
strand of modern feminist thought that presumes female superi-
ority and celebrates femininity; it is a brand of female essential-
ism that is usually associated with cultural feminism and that
Monique Wittig labeled the ideology of "Woman is wonderful."[15]

Cultural feminism is sometimes erroneously called "radical
feminism," yet it is basically a nonpolitical attitude that concen-
trates on the development of a separate female counterculture, or
"womanculture." The term was first used by socialist feminists
around 1972 as a critical way of referring to nonpolitical radical
feminists. Cultural feminists are usually not concerned with
mass reforms or public changes, preferring to concentrate on
individual solutions and the creation of alternatives to the main-
stream of society. Far from denying the importance of biological
differences between the sexes, cultural feminists tend to glorify
the differences, to imply that they are unchangeable, and to
accept the idea that women are by nature less violent, more
cooperative, and more caring than are men.[16] American cultural
feminists, however, stress the notion that "woman" is constructed
by society.[17]

Female supremacism is based on the belief in the existence of a
female principle, or uniquely feminine essence, that is the source
of all good and of true morality. This belief holds that a feminist
revolution would bring about not equality but the reversal of the

present power structure, resulting in women's dominance over men.[18]

Gynarchy refers to government by women, or women-centered government. It is a concept similar to matriarchy. (The writer Charlotte Perkins used the term *gynaocracy*.)

In fact, there are so many terms for various feminist stances that an individual feminist may fit a large number of labels. Many third-wave feminists who have read Catharine MacKinnon and Andrea Dworkin's theories are rejecting them and favoring "postfeminists," women such as Camille Paglia, Naomi Wolf, Nadine Strossen, and René Denfeld, who, according to Susan Faludi, author of *Backlash*, identify themselves as feminists but do not follow classic feminism's party line.

Every word has a denotative and a connotative meaning; the denotative meaning is the dictionary definition, and the connotative meaning is the one in common usage. In the connotative sense, *postfeminism* implies that everything has been accomplished, and in the denotative sense, it implies that there is no more feminist movement according to the media. Clearly, the ambivalence of the term is enough to confuse anyone, but it expresses considerable resistance to investigating sexual differences and testing them against certain realities. Postfeminism is characterized by negative criticism, but it appears to be lacking in new possibilities and to be deficient in creating a reality that works for women. Its greatest contribution has been to show what may need to be reevaluated in the movement to liberate women. In a real sense, the division between classic feminism and postfeminism cannot be bridged easily because the feminist movement has been cut short by the coming of neoconservatism and multinational capitalism in the 1980s. The best that can be said in defining *postfeminism* is that it clashes with classical feminism's need to move toward positive change. Faludi called it a media-defined phenomenon that is a counterassault on feminism, full of "hip" cynicism and antifeminist messages dressed up in feminist clothes.[19]

Many feminists dislike such language, believing that it implies a hierarchy and the sort of control peculiar to male-dominated organizations. The battle lines that are forming over "feminism" are disturbing because the feminist goal of reforming patriarchy

does not necessarily include replacing male dominance with female dominance, as is sometimes imagined by antifeminists, although there are some feminists who would like to see just that happen.[20]

It's hard to imagine a word that elicits a more wide-ranging set of beliefs than does *feminism*. People are often bewildered by it. It evokes both positive and negative images and makes people either happy or furious. Feminism challenges us to examine our assumptions about difference, gender, sexuality, power, and social roles, and this can be a frightening, as well as a difficult, process.

Having defined a few of the terms that are particular to this debate, let me start the discussion by elaborating on the question, "What is feminism?" The historian Linda Gordon suggested that "feminism is a critique of male supremacy offered in light of a will to change it, which in turn assumes a conviction that it is changeable."[21] It is a philosophy based on the fact that American women still live in a male-dominated culture and society. The fundamental problem is how to change the values, attitudes, and priorities of our citizens. These shades of difference are what make feminism so engaging. Today's feminists are women who are as eager men are to test themselves in the arena of life. To understand why women embrace feminism requires examining some of our most basic assumptions.

A major premise of feminist theory is that sexual politics supports patriarchy in its politicization of personal life.[22] In such a system, the majority of men view women first and foremost as child bearers. So the female body and how it is represented is continually and inevitably caught up in any discussion of women's liberation. Most men imagine that women's chief concerns, because of their reproductive biology, center on home and family. Thus, a patriarchal system locks women into roles that are based on their bodies' capacity to reproduce. Most men think of the home as the physical space in which women do their work: housekeeping, cooking, serving, taking care of the children, and other tasks associated with the domestic sphere. It is in this frame of reference that feminist theorists work.

The "myth of motherhood" and the cult of the nineteenth-century "true woman" persist. They categorize all women as

mothers and caregivers even when they do not wish to perform these roles, or as Mary Wollstonecraft put it, "All women are to be levelled, by meekness and docility, into one character of yielding softness and gentle compliance." Under patriarchy, differences between men's and women's "true" natures have been based on a conviction that women have softer emotions than do men and that their job is to marry, produce children, and strengthen family life. According to this implied contract, as long as a woman sticks to the program, she is entitled to certain compensations and privileges. Thus, traditional marriage ensures a wedded woman's use of her husband's name and his protection and financial support.

More than twenty-five years after the rebirth of the drive for women's rights, the world is still assimilating (often distorting and vulgarizing, but nevertheless raising) the revolutionary ideas that Wollstonecraft first expressed in England in her 1792 book, *Vindication of the Rights of Woman*. "Women are," Wollstonecraft cautioned, "as much degraded by mistaken notions of female excellence, as they are by notions of their supposed inferiority." That is what makes the question "What is feminism?" so tough to answer.

Although the 1950s were seen as a golden age of marriage and domesticity by many, Friedan's groundbreaking study of "The Happy Housewife Heroine," in *The Feminine Mystique* (1963), exposed the frustration of the unhappy, educated, middle-class, mostly white housewives between what they were supposed to feel and what they actually felt. Each one believed that "the problem that has no name" was hers alone—such was women's isolation from each other. At home, these women tried to make themselves beautiful, cultured, and respectable, but they were never really away from their children; they went marketing with their children, changed their children's diapers, talked about their children, and played mahjong or bridge.

"Raising three small children in suburbia," artist and writer Phyllis Rosser explained, "was the most depressing work I've ever done." Surrounded by baby bottles, cereal boxes, and dirty dishes, married women found that child rearing consumed most of their day. This was the "American Dream" that Rosser and millions of other intelligent American women were living, and

for many it was a nightmare. Friedan's comparison of house-wives' lives to conditions in Nazi concentration camps may seem extreme to many women (although many women viewed their mothers' lives this way), but during the 1960s, it struck a resounding chord for a generation of middle-class white women whose self-respect had been systematically destroyed by their inferior status as unpaid home workers and consumers.

The "mystique of feminine fulfillment" that Friedan chronicled emerged after World War II, when suburban housewives like my mother became the "dream image" of women all over the world. Behind it, as Friedan demonstrated, was anger and mental anguish—even insanity, brought about by the fact that they had no public careers. The loss of identity that came from being relegated to and isolated in the home created the psychic distress that many of these women experienced—"the problem with no name." It contributed to the depression and rage that many middle-class women of that generation felt because their contributions to society were belittled and child rearing was not considered intellectually challenging. Friedan rejected the biological determinism of Freudian theory. Her view of women as a weaker social group led her to argue for a massive self-help program to help women reenter the labor market.

Inspired by Friedan's book, women began to form consciousness-raising groups. In the absence of psychological experts, women's own thoughts and feelings about marriage, motherhood, and their bodies began to emerge. They discovered that women were treated like children. In essence, they felt they had no identity of their own, which led them to sail boldly into the unknown in search of themselves.

A handful of women began writing about women and psychology. Miriam Greenspan's *A New Approach to Women and Therapy*, Harriet Goldhor Lerner's *The Dance of Deception: Pretending and Truth-Telling in Women's Lives*, Phyllis Chesler's *Women and Madness*, and Jean Baker Miller's *Toward a New Psychology of Women* addressed a host of psychological issues affecting women. These writers viewed women as a socially subordinated group and examined their problems within a sociopolitical framework.

From the late 1960s to the mid-1980s, feminism was a clear

force for progress and against alienation. Feminism's effects on gender issues, business, government, the military, education, religion, families, and dating and sexuality—in short, all aspects of life—was felt throughout the society and culture. But Friedan's book established a framework that was hostile to the traditional nuclear family and conventional female roles, and it seemed to exclude the homemaker from feminism's brave new world. The idea of staying home, raising a family, and doing housework was so negatively portrayed that it left no place for many women who wanted to do so.

During this stage, Kate Millett's *Sexual Politics* became a best-seller, and it was by far the most demanding feminist book of the 1970s. The author charged that throughout history, the interaction between men and women was one of domination and subordination. On the basis of this premise, Millett isolated "patriarchy," a pattern of male domination based on gender, as the chief institution of women's oppression.[23] From this vantage point, it was reasonable to see the nuclear family as a "feudal institution that reduces women to chattel status." In such a system, there is no possibility of an honest disagreement among equals. In Millett's view, patriarchy authorizes the relative dominance of male domains over female ones. This dominance disadvantages women and puts them at the mercy of those who control the resources. In fact, women themselves are resources, like water or pastureland, to be traded among men. If a woman belongs to a man, she is like a slave; for example, a father may marry a daughter off against her will to further his own ambitions. The woman has no rights, and her offspring are her husband's property to do with as he likes. Millett's appraisal simply reiterated the judgments of nineteenth-century feminists, who saw a connection between the sexual division of labor in the home and in the workplace and women's oppression in modern industrial society.

According to Millett's reasoning, marriage is a financial arrangement—an exchange of goods and services in which men benefit and women lose. In this pooling of resources and sharing of responsibilities, one party, the man, retains everything he came into the marriage with, whereas in many cases, the woman brings a dowry with her, contributes free domestic and child care

services, and serves her husband and his career. If she has an education and aspirations of her own, they are sacrificed to the needs of her husband and family. To be fair, late-nineteenth-century feminists contributed to Millett's difficulties because they tended to consider women morally superior to men. They believed that motherhood was the fundamental defining experience of womanhood and that no women was complete without it.

Coming out of the first stage of the contemporary women's movement, Millett believed that her main concern was to find an explanatory theory for the subordination of women to men. In the United States, an alliance of conservative women and clergymen insists that woman's role is to be a homemaker and caretaker. Modernism and sexism view gender in terms of occupational specialties: Man is the hardworking provider who has liberated his woman from the burdens of production. Contrary to this model, Millett and many socialist feminists of the period believed that most women would be better off if they did not have to choose between their offspring and meaningful work. They argued for professional care of the young because it would allow women to choose between family and career (many women choose both). In short, they were attempting to change the prevailing idea that the domestic sphere was the sole appropriate domain of women.

Extending her explanation of patriarchal sexism to representations of women in literature, Millett applied her theory to "great" books by famous male authors, including D. H. Lawrence, Henry Miller, Norman Mailer, and Jean Genet. She exposed how male writers in the United States and internationally recast men and women's body parts to form a social reality that promoted sexism. She made "sexual politics" and the tyranny of gender roles her central focus, demonstrating that women are routinely objectified and dehumanized by male writers.

Millett unmasked the roles that power and domination played in these authors' descriptions of imagined sexual activities. In one of the most systematic indictments of patriarchy ever written, she examined and criticized social relationships between the sexes. Focusing on the audience's experience as a witness, or voyeur, she unmasked the sexism underlying these texts. Taking Henry Miller's phrase from his novel *Sexus*, "I slid to my knees

and buried my head in her muff," Millett showed readers how Val places his girlfriend Ida under his domination and how he lies to get what he wants. Moreover, Val's mastery is assured because of his extraordinary genital organ; he uses his penis to reduce Ida to nothingness. Who she is and what she wants have no meaning to him. In the book, Miller's hero sadistically enjoys dominating Ida and withholding sexual gratification from her.

For Millett, Norman Mailer is an "American schizophrenic whose creative genius is homicidal, and whose inspiration is murder." In his novel *The Deer Park*, Mailer has his character Elena assert that women "weren't born to be free, they were born to have babies." Mailer's macho heroes use their magic weapons—penises—to lay females out. In his writing, according to Millett, sex is combat; engagement, an attack; and domination, the ultimate goal. Mutual pleasure is never Mailer's objective, and love never seems to enter his mind.

In such works, females are brought to heel and beaten, and the sadistic overtones that Millett discerned in her pathbreaking work on sexual politics are still evident in today's gangsta rap and in our justice system, which often treats women's fears of stalkers, rapists and domestic violence as trivial.

Answering the question, "What is feminism?" necessitates raising two other questions: (1) How can women and men treat each other better? and (2) What factors contribute to the difficulties they experience in relating to one another? At bottom, women want a world in which people of both sexes can communicate their feelings and perspectives in a way that allows them all to be heard as equals.

The 1960s and 1970s saw the emergence of many spokespersons for feminism, which led to the establishment of courses that introduced women into history. It was not surprising that with a discipline as new, as unusual, and as speculative as contemporary women's studies, dissension soon emerged. I think dissension arose for two reasons. First, some of the major feminist thinkers, such as Friedan, Millett, and Gloria Steinem, were inflexible about their initial theories—Steinem's notion of women's moral superiority, for example. Many people were put off, especially, by these women's views on the nature of men and women and on women's oppression in marriage, home, and bed.

Second, and, in the long run, more important, was the natural growth and continuing outreach of the liberation movement itself. Changes in occupations, day care centers, dual earning capacity, and family leave have all contributed to a more egalitarian and less conventional contemporary lifestyle in the United States.

Despite these factional disputes about the actual conditions of women's lives, despite the hardships that the antifeminist backlash of the 1980s, with its attempts to scare women back into the home, imposed on those struggling for women's liberation, feminism has impelled all types of people to construct and reconstruct their respective roles in this society and culture. The current unrest and mood of apprehension that seems to pervade the women's movement arose from the fact that many people don't really understand the double bind that women are in. Moreover, women generally fail to see their own position within the private and public domains. Caught between their own lives and political ideologies, they are only beginning to gain some insight into how policy decisions are directed at them. The ongoing debates about welfare, for example, demonstrate how laws manage women and children. "Each time we talk about things that can be experienced only in privacy or intimacy," explained political scientist Hannah Arendt, "we bring them out into a sphere where they will assume a kind of reality, which, their intensity notwithstanding, they never could have had before."[24]

Nowhere is this situation more evident than in attempts to deal with women's experience in the world. Foes of feminism argue that contrary to what Friedan said, what happens in the home has an impact on society and the public sphere. Their relatively recent attempts to police the womb in order to protect the life of the unborn have collapsed the private into the public. The medical control of birth has given new meaning to the expression "the personal is the political." But what does this phrase really mean? As author Mary Gordon explained, "We have to examine the definition of the personal. . . . The personal and the private have long been the hiding place of scandals. As long as the personal is defined by men, and until men listen to what women consider the personal, neither side knows what the other is talking about."[25] So it is imperative to examine individual

women's experiences to provide a framework of meaning: to understand women's experiences from the standpoint of how we actually live our lives, rather than through theoretical investigations. It is crucial to ask how we arrived at where we are now. This is far more important than knowing the political cataclysms that occurred along the way. Only by striving to transcend the unproductive polarization that has grown out of questions of private and public, identity and value, masculine and feminine, can we move beyond the play of politics and get closer to the true meaning of the movement to liberate women. To shed some light on this question requires a review of our social, political, and cultural history, involving religion, education, our bodies, work, and relationships with each other. Feminism, regardless of how you define it, has become a lightning rod for the causes that will transform our society and culture.

LEARNING FROM EXPERIENCE

At the moment of birth, sexual differences in anatomy proclaim "it's a girl" or "it's a boy." So begins the journey toward maturity for each girl or boy. Yet, as the French writer Simone de Beauvoir wrote in her pathbreaking book *The Second Sex*:

> One is not born, but rather becomes, a woman. No biological, psychological, or economic fate determines the picture that the human female presents in society; it is civilization as a whole that produced this creature, intermediate between male and eunuch, which is described as feminine. Only the intervention of someone else can establish an individual as an Other.[26]

From the cradle, an artificial distinction between the sexes is created and fostered. Boys are taught self-reliance and self-control; girls are taught to lay their natural talents away like a holiday tablecloth. Our society educates males and females differently. Feminism argues that the repression of natural abilities in both men and women has contributed to many of our current social ills.

In fact, psychoanalysts agree that the image we project in society often has little to do with the inner person. People use clothes—designs, materials, colors, textures—as a means of com-

munication in which they proclaim their sex, their social status, their wealth, and their taste. The gap between experience and meaning among generations of women and men balloons with the social and cultural movement known as modernism—that is, with a dress code that identifies us by gender as masculine and feminine and then attaches character qualities to these manufactured identities that have nothing to do with our talents and desires. Gender describes a conceptual system in which you are what you wear and assume an identity that you were not born with.

When Virginia Woolf sought "a room of her own" in which to consider what she felt about her life, and how her experiences had been distorted by structures of understanding that had nothing to do with her truth as a woman, she was forced to deal with how she felt about the central issues of sexism and patriarchy. Maybe that's why she wrote her famous cross-gender novel *Orlando.*

When she sat down at her desk, what was she confronting, and how did she come to formulate her marvelous thesis that sexual identity is fluid? In creating her character, I imagine Woolf initially explored the question, "Where did I first acquire my notions of gender?" She then might have asked, "What was I taught?" "How did I learn it?" and "Who instructed me?"

The novel opens with the narrator, who is based on Vita Sackville West, Woolf's grand passion. In the story, Vita starts life as a male named Orlando, which totally changes her attitude and possibilities. In writing this text, Woolf was well aware that Vita had lost her beloved ancestral home, Knoll, to a male relation because she was born female. As a result of English laws of property succession among her class, Vita could make no legal claim to the home she loved. So Woolf's novel is both a witty attempt to restore Vita's legacy and a sportful look at her own romantic union.

Orlando provides a stage onto which Woolf can project the differences between masculine and feminine identities. First, Woolf describes the dominating position of the narrating male subject in the context of aristocratic society. However, from the time that the Vita/Orlando character appears on the scene to the moment of his dramatic transformation midway through the story, the

reader has a mild sense of dislocation. In the course of the novel, Orlando travels far and sees a great deal, but when he wakes up to find himself a woman, he is totally amazed and seized with confusion. Hesitating he—now she—reflects on traditional beliefs about male and female and tries to adjust to her new gender and what it means. Everything he has been taught must be questioned, and he must now learn to act in a manner opposite from what he has done all his life.

Orlando immediately loses his confidence and, feeling exceedingly uncomfortable, begins learning how to behave like a woman. In one hilarious scene, Woolf describes Orlando's difficulties with his dress and manners. Orlando experiences women's restrictions with wonder, fear, and loneliness. Later, pondering his new identity, Orlando carefully reflects on the advantages and disadvantages of life for both sexes. Inexperienced and rash, she falls passionately in love with a dashing adventurer. By highlighting the female Orlando's inability to take action in the world and her experience as a kind of commodity, and by comparing it with Orlando's less encumbered life as a man, Woolf underscores the contrasts between the male and female genders. As Orlando's lover goes charging off into the great unknown, Woolf shows how men grant themselves freedom while denying it to women who must remain at home like caged birds.

There is a tremendous irony in this story. Woolf shows that women of enterprise and initiative are not content to confine themselves solely to marriage, home, and family. For Woolf, the prevailing concept of "woman" is inadequate and doesn't encompass her experience. She recognizes that "patriarchy" is the reason why women find themselves marginal to Western male interests.

A 1946 poll revealed that 25 percent of women would have preferred to be men, while only 3.3 percent of men wanted to be women. By 1950, nearly 60 percent of all women aged eighteen to twenty-four were married, as opposed to only 42 percent in 1940.[27] Although women had entered the workplace, they held low positions and were underpaid, rarely promoted, and discouraged from competing for male jobs. Between 1963 and the present, ideas stemming from the movement to liberate women

have permeated psychology, sociology, anthropology, literature, art, and politics, and gained measurable influence over educational theory. Many people now recognize that inequality limits women's participation in public life and perpetuates the social emphasis on male values.

Feminism, for all its faults, has given birth to one of the few compelling visions of our era. It is a vision that attempts to deal compassionately not only with women's inequality, but with the pressing problems in the world.

The struggle for knowledge, for training, and for opportunity was first articulated by American women because of their discontent with women's status. This discontent gave birth to a reform movement on behalf of women. It was women's general belief that they were treated as mere chattel, having no rights whatsoever, existing merely to serve a father, husband, brother, or some other man. Such a picture contains partial truths. The stories of feminist networks, individual courageous acts, and collective pioneering exploits offer touchstones on the long road to answering Freud's question, "What do women want?"

Notes

1. For instance, Gloria Steinem's books make the best-seller list; Susan Faludi's blockbuster *Backlash* exposed an undeclared war against American women; Naomi Wolf's *Fire with Fire* urged women to seize the day; and in *Who Stole Feminism?*, Christina Hoff Sommers accused feminist extremists of promoting a dangerous new agenda.

2. *Familiar Letters of John Adams and His Wife Abigail Adams During the Revolution* (New York, 1876), 286–87, letter dated March 31, 1776.

3. Maggie Humm, ed., *Modern Feminisms: Political Literary Cultural* (New York: Columbia University Press, 1992), 408.

4. Marilyn French, *The War Against Women* (New York: Summit Books, 1992).

5. Virginia Woolf, *A Room of One's Own* (New York: Harcourt Brace and Company, 1929).

6. Eleanor Flexner, *Century of Struggle: The Woman's Rights Movement in the United States* (New York: Atheneum, 1970), 206.

7. Betty Friedan, *The Second Stage* (New York: Summit Books, 1981), 168.

8. For an excellent overview of these women and the events that shaped the women's rights movement, see Flexner, *Century of Struggle.*

9. Ibid., 75.

10. Ibid.

11. Ibid., 67.

12. Ibid., 144.

13. Anna Quindlen, "Apologies to Anita" in the *New York Times*, Op-Ed page 5 November 1994, sec. 23. See Jane Mayer and Jill Abramson, *Strange Justice* (New York: Houghton Mifflin, 1994) regarding the many confusions about this historic case of sexual harassment and sexual politics.

14. Betty Friedan, *It Changed My Life: Writings on the Women's Movement* (New York: Random House, 1976), 127.

15. Unless otherwise indicated these definitions are taken from Lisa Tuttle, *Encyclopedia of Feminism* (London: Longman, 1986), 105.

16. Ibid., 73. It should be noted that under the powerful influences of postmodernist theory during the 1980s, this term underwent a dramatic change in meaning and application and became the opposite of what it meant in the 1970s.

17. Teresa de Lauretis, *Technologies of Gender* (Bloomington: Indiana University Press, 1987).

18. Tuttle, 104.

19. Faludi, *Backlash* (New York: Crown, 1991), xix, 172.

20. Ibid., 134. I am grateful to Elvira Casal for referring me to this source.

21. Linda Gordon, "What's New in Women's History," in *Feminist Studies/Critical Studies*, ed. Teresa de Lauretis (Bloomington: Indiana University Press, 1986), 29.

22. Ibid., 408.

23. Ibid., 26. Gender is the most important theoretical contribution of the second wave of feminism. According to Linda Gordon, the idea of gender difference is a code word that has now taken on two meanings. The primary meaning is that women have a different voice; a different muse; a different psychology; and a different experience of love, work, family, and goal. In her essay, "Writing History: Language, Class, and Gender" (in *Feminist Studies*, ed. Gordon), Carroll Smith-Rosenberg describes gender in terms of a conceptual system that imposes a fictive order upon the complexities of economic and social development. According to Smith-Rosenberg, it is a code of behavior by which people are expected to structure their lives and allows them to create their definition of the normative and the "normal" (33).

24. Hannah Arendt, *The Human Condition* (Chicago: University of Chicago Press, 1958), 50.

25. See "Mary Gordon and Robert Stone Talk About Sexual Harassment," in *Pen Newsletter*, Issue 85 (Fall 1994): 27.

26. Simone de Beauvoir, *The Second Sex* (New York: Knopf, 1953), 49.

27. William H. Chafe, *The Paradox of Change: American Women in the 20th Century* (New York: Oxford University Press, 1991), 176.

2

The Players and Their Positions

The history of modern feminism is closely intertwined with histories of democratizing social reform. It is for this reason that I have chosen to concentrate my efforts on a select group of feminists who are representative of these currents. Several of these are women, whom Susan Faludi, author of the best-selling book *Backlash*, describes as "Pod feminists," planted by the right.[1] Faludi's disparaging term applies to those who pass themselves off as authentic feminists and who, certain media hosts like to imagine, are authentic feminists, when in actuality these women (such as Camille Paglia, whose position on man/boy sexual freedom justifies sexual acts between boys and older men) rarely support anything vaguely resembling a classical feminist creed. Throughout this study, I refer to women who hold these views as third-wave women's liberationists.

Thus far, I have shown that feminism is a mosaic in which many parts fit together to form a continuous whole. The quest for freedom for the modern feminist is a struggle to understand the inherent instability of the present and to cope with the frozen organizational structures inherited from the past. But this is a period of struggle in which one must never lose sight of the fact that feminists are pushed and pulled by different forces as they

constantly ask what gives meaning to women's lives and how the world appears to different groups. Only by looking at feminism's *origins, history, primary issues, major figures, conflicts,* and *contributions* to the way people currently live and work with each other can one begin to dispel some of the myths and misconceptions that surround it. By examining this emotionally charged arena, readers will see how various points of view have produced links between such unlikely bedfellows as the Religious Right, radical feminists, and postfeminists. Indeed, understanding the issues surrounding women's oppression in the United States requires knowing who the participants in this debate are, what they are concerned about, and where they stand.

"THE NEW FRONTIER"

In recent years, the New Right movement has entered with a striking zeal into local and national politics that affect women. Primary among those groups who oppose feminism is Operation Rescue, based in Binghamton, New York. Founded in 1986 by New York used-car salesman Randall Terry, Operation Rescue has received national media attention for its efforts to shut down abortion clinics. Terry brought street-fighting tactics—a kind of urban guerrilla warfare—to the antiabortion movement. Not content to lobby Congress or petition the Supreme Court in a lawful manner, Operation Rescue activists physically barricade clinic entrances, vandalize property, and intimidate women who are attempting to enter the clinics and the medical professionals who staff them. Following the March 1993 murder of Dr. David Gunn in Florida, Terry, claiming that murder can never be advocated, nonetheless expressed relief that at least Dr. Gunn would no longer be able to kill unborn babies.

Another area that now concerns Terry is homosexuality and what he sees as special rights for gays and lesbians. Subsequent to President Clinton's pledge to lift the Department of Defense ban on gays and lesbians in the military, Terry added opposition to eliminating the ban to the Operation Rescue agenda.

Pat Robertson's Christian Coalition is probably the most influential national Christian Right group in the United States. Founded in October 1989, it boasts more than 400,000 members,

organized in countylevel chapters in all fifty states. In 1995, the coalition began to wield real political power through its tireless efforts to take control of the Republican Party from the grassroots level up and by supporting and electing "stealth candidates" to local school boards, county commissions, and other offices. These candidates are generally people who run under false pretenses and reveal themselves as fundamentalists only after they have been elected to office. The Christian Coalition's local chapters produce voter guides outlining which candidates support the "pro-family" agenda. These guides are distributed through church networks to Christian voters.

In 1992 the Oregon Citizens' Alliance became the official Oregon affiliate of the Christian Coalition, earning a $20,000 donation in support of Measure 9, which attempted to deprive gay and lesbian citizens of their civil rights. In 1993 the coalition took part in a battle over the "Children of the Rainbow" curriculum in New York City schools and coordinated a county-by-county campaign in Tennessee county commissions to issue statements opposed to the inclusion of lesbians and gays under the federal Civil Rights Act, among many other activities.[2]

"The Religious Right should not be described only in terms of fundamentalist and evangelical Protestants," cautioned Frances Kissling, president of Catholics for a Free Choice. "The last quarter century has seen the development of a strong conservative Catholic movement that is increasingly linked with the Christian Religious Right. The Right wants its vision of private and public morality to become public policy. Whether the issue is abortion, lesbian and gay rights, or sexuality and AIDS education, the Right believes the law should reflect their narrow view," Kissling stated.[3] Helen M. Alvare, of the National Conference of Catholic Bishops, argued that in their "abortion obsession," feminist leaders take no account of the rights of the fetus.

Catholic Campaign for America is a "Who's Who" of Catholic Republicanism. The Catholic League for Religious and Civil Rights actually works to restrict basic constitutional rights, including freedom of speech, freedom of the press, and the right to privacy, claiming that such restrictions are necessary to defend the rights of orthodox Catholics. The Free Congress Foundation, headed by Catholic archconservative Paul Weyrich, operates

"National Empowerment Television," a cable and satellite television channel transmitting extremely conservative programming twenty-four hours a day.

Terry, Robertson, and Weyrich appear to be like many individuals who have no critical distance. Here in the United States, Robertson is waging a sacred crusade to have Christians "seize the control points of society away from the forces of anti-Christian secularism."[4] He and his followers think that "the feminist agenda is not about equal rights for women. It is a socialist, anti-family political movement that encourages women to leave their husbands, kill their children, practice witchcraft and become lesbians."[5] And polemical postfeminist authors like René Denfeld help to foster this antifeminism.

Phyllis Schlafly's Eagle Forum is based in Alton, Illinois. Although much smaller than other Christian Right women's organizations, Concerned Women for America's "Eagle Forum" has gained respect from leaders of the Religious Right. Ralph Reed, executive director of the Christian Coalition, has described Schlafly as the woman who is the most responsible for the defeat of the Equal Rights Amendment.[6] Schlafly's high media visibility has allowed Eagle Forum's denigration of "feminism" to reach a mainstream audience. In 1990 Schlafly founded the "Republican National Coalition for Life," and she has maneuvered Eagle Forum into a position of great responsibility within the delegates' coalition committee, drafting national Republican party platforms and policies with regard to abortion and homosexuality. Under the smoke screen of Christian love, Schlafly is promoting a politics of hate that could have violent consequences for her homosexual son and other gays and lesbians.

Out-and-out opponents of feminism, unlike nonfeminists and even antifeminists who take a milder view in their criticism of the women's movement, believe the movement is dangerous to society, church, and family. They characterize feminists as irresponsible, selfish, destructive to husbands and children, degenerate, and un-American. And one may grant that early factions like Bread and Roses, Witch, Redstockings, and SCUM used abusive language, hated men, and alienated many people with their shock tactics. Yet this kind of antagonism can be found in any social movement, and it does not necessarily define its major goals.

Everything the New Right movement has to say on the subject of feminism is the opposite of what I believe classical feminism stands for. Clearly, contemporary feminism manifested itself in fresh and liberating ways through a variety of concerns that directly touched women's lives. The strongest argument for what novelist Cynthia Ozick called "classical feminism," in her essay "Hannah and Elkanah: Torah as the Matrix for Feminism," is that it frees women to be ourselves and to use our talents to create the best possible society.[7] It puts us in touch with what Betty Friedan called the "personhood" of women. Listening to the ways in which various conservatives and liberals refer to feminism shows how language can be used as a political instrument and means of power. The fractious speeches that Patrick Buchanan, Robertson, and Schlafly make are meant to alarm and manipulate people. These three and their friends tend to scapegoat anyone who opposes their viewpoints. This behavior contradicts the message of Christian love and respect they claim to be upholding.

LIBERALS, MINORITIES, AND MODERATES

In sharp contrast to the New Right movement, liberals and those in the civil rights movement generally see the battle for women's rights as part of the total struggle for human rights. However, that the lives of women have not been a civil rights issue for them has created a lot of ill will between liberals and feminists and caused much confusion about the goals of women's liberation, particularly in minority communities. To understand the antagonism between liberal factions, particularly the left and feminists who feel betrayed by many who make these claims as "liberals," one has to look back at the sexual politics that helped to expand the first stage of the contemporary women's liberation movement.

Marilyn Webb was twenty-six and one of the leaders of the student revolution of the 1960s. While giving a speech denouncing a system that views people as "objects and property," she heard shouts: "Take her off the stage and fuck her!" "Take her down a dark alley!"[8] Such blatantly sexist comments really hit a nerve. Something important happened during that speech.

Women in the progressive movement, like abolitionist women before them, instantly realized that their brothers in freedom were just like their fathers before them. They suddenly understood that if women's issues were to be put on the front burner of the radical stove, they would have to do it themselves, and this made them very angry.

It is not surprising that feminists of the 1970s were inspired by their own interests and that their breadth of thought was limited by the times. And white feminists of this period had yet to confront their own unexamined racism. This system of bigotry, focused on African Americans, Jews, gays and lesbians, and others who were constructed as outsiders, is often referred to as the white supremacist system. It represents a continuing pattern in the United States that accounts for much of the hate that divides us as a society today.

Even among liberal groups, the advance of African American women has been slow and still meets with astonishing resistance. As the movement toward the liberation of women grows, African American women find themselves, if they are at all sympathetic to the issue of feminism, in a serious dilemma. Many feel that racial justice is more important to them than is sexism. So although some African American women are sympathetic to feminism, many feel that they are more oppressed as a race than as women. Those who do share feminist ideals often use Alice Walker's term *womanism* when talking about sexual equality.[9] Feminism has been associated with white women in the minds of many African American women, so these women are uncomfortable with the term even though they generally support the women's liberation movement and have become more contentious since the 1991 Anita Hill/Clarence Thomas Senate Judiciary Committee hearings into the nomination of Thomas to the Supreme Court.

In short, for liberal and radical men and for some minority women, as well as for the civil rights movement, the lives of women are not a civil rights issue. The confusion pervading the debates over racism and sexism has caused a lot of anger about the goals of women's liberation, particularly among minority communities.

Growing out of women's general discontent and rage over

their lack of rights, radical organizations, such as Redstockings, Bread and Roses, and Witch, were not taken seriously by the public, so Friedan and other middle-of-the-road feminists discussed the formation of an organization that could deal with women's lives effectively. Thus, the National Organization for Women (NOW) was founded in 1966 to launch a new movement in the United States for a truly equal partnership between men and women. NOW originated in Washington, D.C., as a proactive association to ensure that all members of society are given equal opportunities in life. Like many feminist organizations, it focuses on more than one issue, and it defines feminism as "the radical notion that women are people." Furthering the concerns of its members, numbering over a quarter of a million, it is the largest multi-issue feminist organization in the United States. Its members work toward eliminating all forms of discrimination and violence against women. Classical feminism had it roots in NOW.

Young NOW feminists, for instance, launched a spring 1994 offensive against violence and marched in Washington, D.C. This is a generation that faces increasing violence and harassment on the streets, in the schools, on television, in movies, and in their homes. Emphasizing that people have the right to be free from violence, to control their own bodies, to have equal opportunities, and to be a positive force for change in their own lives, these individuals have the courage of their convictions. They concentrate on women's health and reproductive rights, including high-quality health care, safe and legal abortions, effective birth control, and health education for women, regardless of their ability to pay. NOW, according to Friedan, fights to "break through the silken curtain of prejudice and discrimination against women in government, industry, the professions, the churches, the political parties, the judiciary, the labor unions, in education, medicine, law, religion and every other field of opportunity in American society."[10]

Members of NOW identify violence against women as the primary weapon against women's equality, and they recognize a connection between global and personal violence. People who belong to the organization are dedicated to resolving conflicts nonviolently at all levels of human interaction. One of NOW's

chief goals is to eliminate racism, since the organization believes that racism inflicts a double burden of race and sex discrimination on women of color. In this regard, it is committed to identifying and overcoming racism's barriers to equality and justice. The group doesn't avoid controversial issues and is committed to opposing discrimination based on sexual orientation, asserting the right of all persons to live with dignity and security. These are Americans who believe that bringing about full economic equality for women will ensure that women participate fully in our society. They are also convinced that this is a way to end the feminization of poverty, a circumstance in which poor women are condemned for conditions over which they have little or no control.

Another area that NOW focuses on is body image. In challenging the oppression of fat people in our thinness-obsessed culture, the organization works to empower all women (and men) so they will take a more positive and accepting view of their bodies. Also high on NOW's agenda are homemaker's rights. NOW supports legislation and programs geared toward economic equality in all domestic partnerships. By recognizing the economic value of services performed for family and society, it hopes to pressure the government and private employers to compensate home workers for the labor they give. Along with economic parity, the organization is dedicated to ensuring economic protection for older women. It is working hard to replace discriminatory systems and to ensure that older women have dignity and security.[11]

Recognizing that women vary greatly, Women's Freedom Network (WFN), founded in 1993, is seeking alternatives to what it defines as "extremist, ideological feminism" and "anti-feminist traditionalism." The women of WFN celebrate the achievements women have already made and view women's issues in light of a philosophy that defines members of both sexes as individuals, rather than as representatives of their gender. WFN doesn't set different standards of excellence, morality, or justice for men and women. Rather, it believes that the rhetoric of victimization trivializes real abuse, demeans women, and promotes antagonism instead of real partnership between the sexes. WFN holds "that there can be no equal rights without equal responsibilities, and

that women are competent and capable of assuming responsibility for their lives." In fact, WFN rejects what it calls the "creeping paternalism that under a feminist guise portrays women as victims who are not responsible for their behavior." Committed to what it perceives as "genuine diversity," WFN hopes to empower individual women, rather than the state and its bureaucracies.

Essentially neoconservative in nature, WFN's literature explains that coverage of gender issues is dominated by what the organization calls a limited and often skewed set of interests. WFN proposes to redress this imbalance by providing different perspectives on comparable worth, affirmative action, sexual harassment, family violence, welfare reform, and other gender-related issues. Comparable worth means that women would get paid the same wages for doing the same jobs that men do.

Affirmative action, which has become a hot topic, dates from the program introduced by President Lyndon Johnson in 1964 prohibiting discrimination in employment. It requires contractors to establish measurable goals and timetables for integration to achieve equal opportunity, regardless of race, color, religion, sex, or national origin.

WFN's concern with family violence is directed at domestic issues, such as incest, wife battering, child abuse, rape, and forced pregnancies. And, welfare reform generally relates to governmental programs that aid single mothers and dependent children. Other gender issues include such concerns as prostitution; pornography; surrogate mothers; medical technology; organ harvesting; in-vitro fertilization; eating disorders; civil rights for gays and lesbians, transsexuals, and bisexuals; and menopause. The organization hopes to focus attention on these problems through op-ed articles, public speaking, liaisons with college campuses, and placing speakers on television and radio shows.[12] WFN's glib literature suggests that much of what the organization plans to do will be targeted toward the media, politicians, and academics, rather than on an openly activist front.

As these examples illustrate, there are many women's organizations: *The Directory of National Women's Organizations* contains descriptions of 477 diverse groups devoted to women's issues. [13] No one can deny that the past thirty years have been a time of

unprecedented consciousness-raising by feminists, regardless of their orientation. According to a Gallup poll conducted in 1990, the majority of American women agree that feminism has altered their lives for the better.

THE THIRD WAVE

Nadine Strossen, president of the American Civil Liberties Union and a professor of law at New York Law School, is a feminist who opposes any gender-based stereotyping that denies an individual full autonomy, equality of opportunity, privacy, and self-determination. She believes that gender stereotyping can operate against men as well as women."[14] "Liberal equity feminists," such as Strossen, Elizabeth Fox-Genovese (who founded the Institute for Women's Studies at Emory University), and Christina Hoff Sommers (author of *Who Stole Feminism?*), understand gender as a culturally shaped dichotomy, assigning particular groups of attributes and behaviors according to biological sex. They also tend to oppose governmental intervention in the marketplace and in people's lives.

To those who are familiar with her earlier work, it is amazing that Fox-Genovese now faults the feminist movement for favoring the interests of credentialed women such as herself at the expense of disadvantaged women. Her new sensitivity is encouraging to other feminists who have known this fact all along but somewhat suspect because Fox-Genovese isn't organizing this group of women so they can be upwardly mobile and become credentialed like her and other WFN members.

Moreover, many women and men simply don't relate to the term *feminist* because it has become identified with what Strossen derogatorily tagged the "MacDworkinite" position (so-called victim feminism or radical feminism). "Polarization," as critic Robert Hughes suggested in his popular book *Culture of Complaint*, "is addictive." It is true that Catharine MacKinnon and Andrea Dworkin have pursued their attack on pornography both through psychoanalytic theories of gender identity and by drafting laws defining pornography as a violation of women's civil rights. But what grates on people is their view of pornography as "sexual terrorism and subordination of women."

MacKinnon and Dworkin see the production of pornography as an issue of politics, rather than morals, because of how the industry actually uses women and children. Although they have allied themselves with the Religious Right in their efforts to curtail what they see as a war against women, they differ from their fundamentalist confederates in their belief that pornography institutionalizes the sexuality of male supremacy, which fuses the eroticization of dominance and submission with the social construction of male and female. We need to appreciate that these are birds of a very different feather.

Far from being crazy, as those who oppose them intimate, Feminists Fighting Pornography (FFP), Women Against Violence Against Women (WAVAW), Women Against Violence in Pornography and Media (WAVPAM), and a number of other feminist organizations are wholly devoted to fighting pornography because they believe it harms women. These groups maintain that the safety and well-being of over half the human race is of greater value than the freedom to create degrading images of women that, at the least, according to Marilyn French, "legitimate and, at worst, promote sadistic violence against them."[15] MacKinnon and Dworkin believe that their opponents are treating "freedom of expression" as more important than a force that harms women.

Janice Raymond argued that "choice is not the same as self-determination. Choice can be conformity if women have little ability to determine the conditions of consent. Pimps roam bus stations to entrap young girls (young boys also get entrapped in this process) who have left incestuous homes thinking nothing worse could happen." Understanding women's complicity, Raymond states, helps women to discern the different ways in which women come to accept what men want us to accept.[16]

Here are two views, pro and con, regarding the rights of citizens. Both of these positions concerning women are justified and apparently irresolvable. These factions part company on a constitutional point concerning the quest for individual freedom. Strossen's book *Defending Pornography* deals with free speech, sex, and the fight for women's rights. In this presentation of wildly divergent interpretations regarding freedom of expression, the split is now so polarized that it appears to be irresolv-

able. The question that remains unanswered involves how to find a middle ground. Contrary to the "widespread misconception that feminists generally support censorship of pornography," Strossen noted that not all feminists are antipornography. In fact, there is a growing market for pornography aimed at women consumers, heterosexuals, bisexuals, and lesbians.

Ellen Willis's 1979 essay "Feminism, Moralism, and Pornography" was one of the earliest public critiques of the growing antipornography movement.[17] For obvious political and cultural reasons, she explained, nearly all pornography is sexist in that it is a product of a male imagination and aimed at a male market."[18] At the time she made this observation, it was true; however, in the past decade some women, so-called do-me feminists (a recently coined term that alludes to women who relish their sexual freedom) who know what they like in bed and how to ask for it, don't care about being politically correct, and several of them like the new feminist pornography.

Many feminists in the arts, for instance, argue that what really needs to be examined is the clear distinction between pornography and art. It appears that as a community, feminists cannot get themselves together enough to come to some consensus on the connection, if any, between pornography in magazines, books, films, and so forth and how people choose to conduct themselves in real life. Arguments over pornography and sexuality help to fuel debates about art and so-called trash. One of the first arrivals on this scene, Paglia's book *Sexual Personae*, hit the charts like the Rolling Stones' "Jumping Jack Flash." In it, Paglia raised hackles by asserting that "if civilization had been left in female hands, we would still be living in grass huts." Yet, her pronouncement that "at the moment of its birth the feminist movement descended into dogma" gets to the nitty-gritty of what is currently troubling feminism.

Paglia shocks audiences with her out-of-control train of thought and charges through cultural history like the proverbial bull in a china shop. Her compulsive studies of a variety of costumes, lifestyles, types of makeup, and sexual perversions have raised a multitude of ethical and social considerations. Paglia admits that the Beatles were important and that Elvis Presley was even more so, but states that she is a "dyed-in-the-wool,

true-blue Madonna fan." This statement outrages strict feminists who consider Madonna a sexist. The views of these strict feminists represent the *reductio ad insanitatem* of the politically correct in the women's liberation movement. Many people in the women's movement dismiss Paglia as a "faux feminist" and have turned their anger over differences in sexual ideology against her. But those who fathom how their own strength as women underscores Paglia's analysis of popular culture will understand the erotic issues she is confronting, whether they agree with her or not.

That feminism blames rape on pornography, Paglia maintains, ignores what to her are just the facts of nature. According to her theory of psychobiology, feminists shouldn't be saddling boys with all those absurd guilts because it is natural for them to mingle sex and violence. Paglia believes that feminism has "put young women in danger by hiding the truth about sex from them."

Paglia uses certain feminist factions as straw dogs, opposing their beliefs with hers and then offering in their place her reductive view of relations between the sexes. She has never really come to grips with the problem of why a certain segment of the population behaves in such a brutal and sadistic manner or why specific individuals allow themselves to become victims of these people. Her biology-is-destiny-based "logic" regarding the "natural" match between the sexes as "hot" sex is as simplistic as Christina Hoff Sommers's conclusions about the romanticism of the infamous staircase scene in *Gone With the Wind* that I will discuss later. Asserting that "gay men know how to deal with this [sexual freedom]" is absurd, since they are getting beaten up, raped, and killed, too. But despite her makeshift analysis, Paglia raises several points that deserve consideration, including the strength that women really have in and of themselves, women's right to sexual pleasure, and women's spirituality.

Sommers claimed that Paglia has been given a bum rap because she dares to attack "gender feminists." But the real reason for Paglia's quick rise in popular culture, asserted Michael Bronski, author of *Culture Clash: The Making of the Gay Sensibility*, "is that essentially she is a neoconservative."[19] An "out" lesbian, Paglia is hardly a "neoconservative," and she currently identifies

herself as a "pagan liberal." If one subscribes to the idea that liberty is the mother of virtue, then Paglia is valiant in refusing to be brainwashed by either conservatism or politically correct notions of feminism, and for that alone she deserves to be respected.

Furthermore, many people agree with her that "women must take personal responsibility for the path they choose" and that there must be a reordering of priorities in America. From my perspective, Paglia seems to be a libertarian whose writings on sex, art, and American culture periodically hit the nail on the head. But she is just one of many players on the board.

These are mean-spirited debates that split feminists into what MacKinnon and her allies label "'liberal, so-called' feminists," who are being manipulated by "'pimps' or 'pornographers,'" and what Strossen calls "MacDworkinites" and "pornophobics." In her review of Strossen's book, Abbe Smith wondered "if we really have to choose between freedom of expression and sexual equality, between civil liberties and civil rights?"[20]

And she isn't the only one considering this problem. On countless talk shows, a young, attractive, and glamorous woman with unshakable poise addresses the audience. Her name is Naomi Wolf. Her first book, *The Beauty Myth*, an indictment of the cosmetics and fashion industries' stranglehold on women's self-esteem, went through five printings. Wolf is a bridging figure with one foot on each side of the divide. Not since Gloria Steinem first hit the media has so much attention been paid to feminism. In Wolf the media have found a Machiavellian spokesperson ready to deliver an acceptable form of feminism to the population at large. Her latest book, *Fire with Fire: The New Female Power and How It Will Change the Twenty-first Century*, has been hailed as a model for bringing feminism out from the cutting edge and into every marketplace in the country.

Wolf's basic premise is that since the Anita Hill incident, American women have mobilized around many of the personal and political issues that are crucial to their lives now. If we continue to do so effectively, she says, the future is ours. If we don't, we may not get another chance any time soon. Like Paglia, Wolf is a tantalizing mix of theater and self-promotion, and she has some intriguing ideas. Talking about female sexuality and aggression, Wolf commented, "The male body is home to me, my rocket,

my whirlpool." Her seemingly bold assertions risk alienating feminists like Steinem because she criticizes what she sees as a victim-centric sensibility and impossibly rigid standards of what is and isn't feminist—for instance, the belief that feminists don't wear makeup—that she thinks have kept many women away from the movement.

Fire with Fire has stimulated heated debates within the feminist movement. Wolf like Paglia blames those who allow themselves to be victims and condemns women who "identify with powerlessness" at the expense of taking responsibility for the power they do possess. But a close examination reveals Wolf's brand of feminism to be a thinly veiled rehashing of thoughts and discussions that have already taken place. She adds a new spin to the controversy with words like "democratic capitalism," and "power feminism."

Power feminism, she says,

examines closely the forces arrayed against a woman so that she can exert her power more effectively . . . encourages a woman to claim her individual voice rather than merging her voice in a collective identity . . . is unapologetically sexual; understands that good pleasures make good politics . . . knows that poverty is not glamorous; wants women to acquire money, both for their own dreams, independence, and security, and for social change [and] hates sexism without hating men.[21]

Unfortunately, Wolf's framework for social change seems to gloss over the realities of most women's lives, such as the lack of education and job opportunities, childbearing, and divorce.

Another writer on the new woman's fast track is Katie Roiphe, who is angry about rape politics on American college campuses. When she got to Harvard in the fall of 1986, Roiphe discovered that the feminism on campus was not the 1970s feminism she grew up with. Feminism suddenly meant being "angry about men looking at you in the street" and writing about "the colonialist appropriation of the female discourse."[22] Rebelling against the "feminist thought police," she argued that women's sexual freedom was being curtailed by puritanical feminists. Roiphe maintained, as do most postfeminists, that statistics were being manipulated to scare college women with a nonexistent "epi-

demic" of rape. "Stranger rape," she asserted, "is rare and true, date rape almost never happens."

Her outrageous charges have made her a celebrity. From her vantage point, the politically correct image advanced on campus "of a 50s ideal" was one her mother and other feminists of that era fought so hard to get away from. The university women she encountered on campus and in classes were perpetually offended by sexual innuendoes. Roiphe found their "wide-eyed innocence" fanatical and unreal.

"Your body is a battleground," reads Barbara Kruger's mixed-media artwork. Susan Brownmiller, in her pathfinding book *Against Our Will: Men, Women and Rape* (1975), called rape "a deliberate, hostile, violent act of degradation and possession on the part of a would-be conqueror, designed to intimidate and inspire fear." Because of pressure from classic feminists, rape has come to be regarded as a crime of sexual assault rather than of sexual passion.

Most of us think the punishment should fit the crime, but the problem is that not all of us agree on the degrees of rape. There's "stranger rape," which many rape victims think of as being analogous to "mugging." But there is also "acquaintance rape," which some women consider a form of extortion, and "date rape," for which the victim has presumably given the perpetrator some sexual encouragement. And some people don't believe that husbands can rape their wives or that it is a serious criminal offense to do so.

The truth is that 75 percent of female college freshmen state that they have experienced serious sexual aggression, often with violence. But their remarks raise questions about what they term rape and how they perceive sexual aggression. These assaults, regardless of how one defines them, generally occurred in the senior year of high school or the freshman year of college. Recent headlines have highlighted the harsh reality that sexual assault on college campuses is a major problem, yet few cases are reported. Feminists are asking, Why do so few women report that they have been assaulted? Why are so many cases mishandled by campus authorities, causing additional trauma to the victims? Are universities afraid of civil suits and unwanted media attention? Are these cases real or figments of overstimulated female imaginations, as Roiphe suggests?

In reviewing ways in which sexism operates at universities, particularly in regard to tensions growing out of talk about rape, Roiphe said that women exaggerate. Her book *The Morning After: Sex, Fear, and Feminism on Campus* ridicules the horrendous treatment that sister students have reported experiencing at the hands of their male peers and puts down men who are sensitive to women's concerns. Like Paglia, Roiphe thinks that claims of date rape are spurious. Her dissatisfaction with Harvard's new "politically correct feminism," however, results in her critique of feminism rather than of sexism. She maintains that "rigid orthodoxy" and "a new bedroom politics" rule the campuses. "Precisely the danger in this kind of feminism is that it creates a dwindling space for men. It makes men into objectifiers—sleazy brutish creatures interested only in sex."[23] Those who oppose Roiphe's position ask whether there is something wrong with expecting men to act as though there are two people in bed and two sexes in the classroom and workplace. She has no answers. Similar to other third wavers, including Paglia, Wolf, and Sommers, Roiphe disconnects from the "cut-and-dried feminism" she opposes. Her enmity toward what she labels the "politically correct" feminism she encountered on campus confirms her belief that "some feminisms are better than others."

Statistics indicate that more than half the 55 million married women in the United States will be victims of domestic violence sometime in their lives. But everybody knows there are three kinds of lies: lies, damned lies, and statistics. Playing with numbers is an old political game, and people with various economic and social aims constantly misuse statistics. Hard to believe? It depends on who you ask and on which answer fits a particular political view, Sommers asserted in her *Who Stole Feminism?*

What concerns orthodox academics like Sommers and other neotraditionalists is that statistics are being manipulated. Sommers insists that women have entrusted power to those she labels "gender feminists"—as opposed to "traditional feminists" (or just plain women)—and that it is dangerous to do so. Her book claims to reveal how untruths pull the wool over our eyes. She wants those she calls "traditional feminists" to fight back—whether by "statisticulating" for themselves or daring to talk back to a statistic or simply calling the bluff of a graph. She then

advances a characterization of "gender feminists" that allows her to say, "Let's return to standards!"

Such a view has validity, but it may prevent people from detecting the more subtle and dangerous motivations behind such an argument. According to Paul Lauter, the core curricula, reading lists, textbooks, and anthologies that are used in colleges and universities are not set in stone. Sommers and Robert Hughes appear to think they are. The current crisis in the humanities that Paglia has exploded over on television and in her recent publications is about integration, not intellectual standards. In fact, it is about the absurdity that says courses in Western civilization equal Christian civilization. One can love reading the Bible, Greek plays, Shakespeare, Hawthorne, Melville, Henry James, and Ernest Hemingway. But one can also be immensely challenged by poring over works by Frederick Douglass and Zora Neale Hurston's *Their Eyes Were Watching God* and by viewing art shows, such as "Women Artists 1550 to 1950," "Bridges/Boundaries: African Americans and American Jews," and "Black Male."

A major problem appears to be the way universities have ghettoized certain human experiences such as women's studies and black studies. The unwillingness of universities to integrate these suppressed experiences into the general curriculum is what has created the fragmented situation we have today. Unfortunately, in the hands of a few dogmatic feminist academics, "women's studies" programs have created stereotypes of men that are as wrong-headed as the media's image of women's libbers as a group of deranged bra burners.[24]

Unquestionably, the best new scholarship is inclusive, not exclusive. It facilitates an examination of how differences enrich our lives. This type of exploration is dangerous to out-and-out opponents of feminism because it makes students think critically—it makes them think for themselves—which, after all, is the mission of higher education. Many of my students believe that Madonna enables women to see that the meanings of feminine sexuality can be in their control and that the constant puns in her lyrics also invite this creativity in relation to the text.

In fact, what a multicultural and interdisciplinary approach does is expand our critical horizons. The works of writers such

as Louise Erdrich, Gloria Anzaldua, Barbara Smith, Frederic Jameson, John Boswell, Audre Lorde, and Adrienne Rich, and artists like Harmony Hammond, Adrian Piper, Faith Ringgold, Ana Mendiata, Robert Mapplethorpe, and scores of other creators have provided the public with a body of knowledge that has opened up learning on every frontier and enriched us immensely as human beings.

In the United States, since the emergence of the civil rights and the feminist movements, great strides have been made in transforming the way students are educated. Women's studies programs, despite their real problems, have integrated women's experiences into the culture as a whole and provided exciting new intellectual theories and methodologies. *Ms.* magazine reported there are over 600 women's studies programs at U.S. colleges. There are no fixed borders in intellectual inquiry, nor should there be.

What Sommers and others who hold a rigid view of scholarship never come to grips with is their own submission to, and collaboration with, their oppressors. Supporting ideas fostered by narrow-minded academics like the late Allan Bloom or subscribing to the limited views proposed by Dinesh D'Souza's *Illiberal Education*, Sommers claims that her demands for excellence spring from love rather than a closed mind.

Those Sommers identifies as "gender feminists" proceed from an assumption that the foundation of human development is wholeness. To them, the kind of fragmentation that Sommers proposes is unbearable. Her denial of equitable education only causes students to fall deeper and deeper into the abyss of ignorance that currently afflicts American education. This sort of conditioning results in the eternal reproach of those who yield to the will of another, "You haven't done enough for me," and fosters what Robert Hughes called "the culture of complaint."

Under Sommers's old educational model followers will constantly expect more and more from the system and never learn to take responsibility for their own actions. The educational system she upholds habitually turns out individuals who behave like automatons and who are not self-reliant. Such students do not grow and develop into effective people. When they don't get what they believe they should have, they blame someone else or

the system. This is victim mentality. Giving up the victim game, as Wolf implies, would mean giving up the self-destructive games many of us have been taught to play in the family and taking responsibility for our own actions and the impact they have on others. That's what having character is.

Sommers's radical splitting off from women she deems "bad" reveals her disappointment and frustration with feminism. By disassociating herself from what she calls "extremist ideological feminists"—and "anti-feminist traditionalism"—and falling back into a philosophy that "defines women and men as individuals and not in terms of gender," Sommers hopes to gain power by maintaining the status quo. Her term "gender feminists" is wrong because it demonizes people like Steinem and Lauter who are struggling to get a fair hearing for diversity in scholarship and life. Obviously, there are considerable differences among those who call themselves feminists and women who don't classify themselves this way.

René Denfeld, author of *The New Victorians*, accuses today's feminists of promoting a "Victorian vision" of womanhood. Born in 1966, this young writer maintains that she speaks for the "majority of women," who she claims, unlike feminists, want to win but don't want a battle of the sexes to last "forever." What we don't need, she declared in her book, "is what feminism stands for today."[25] A "big feature" of the "date rape oeuvre," Denfeld explained, "is the man as predatory; woman as helpless victim view." According to her, this is the "New Victorianism," and the reason that women of her generation are abandoning the women's movement.[26]

Lesbians are the red herring in Denfeld's book, despite her biased beliefs that it is appropriate to focus people's attention on lesbian battering and the fact that lesbians share many of the same problems that everyone else does.[27] Moreover, Denfeld admits that it is important to recognize that the leading lesbian feminists (whom she doesn't name) do not speak for all lesbian women.

Denfeld next proclaimed that "stamping out sexually oriented expression is considered a top priority for many of today's feminists." What she calls "feminist-sexual-purity crusades" appall her. This has become an issue for NOW, Denfeld states, but she

fails to acknowledge the contentious debates going on among NOW members and other groups regarding the "inherent" evils of pornography.

Collapsing feminism's focus on spirituality into one joined to moral purity, Denfeld's view of the "new paganism" is that it promotes "matriarchal religious beliefs" and infatuation with goddess worship, witchcraft, and magic. She believes that strict feminism is based on a "utopian vision" that holds that women are morally, ethically, and spiritually different from men—and, by extension, superior to them. Denfeld claims:

> Many of the causes endorsed by feminists today—the anitporn campaign, the promotion of lesbianism as a political action, sweeping new definitions of rape, and goddess worship—are noteworthy for avoiding or only peripherally addressing the subject of economic and political equality. Instead of combating inequality in public realms, which would require working with the "patriarchal" system, current feminists blame societal mores, sexual literature, pop culture, and religion for women's problems and offer little more than the promise of transformation to solve them. We want a women's movement that promises to do something concrete to help improve our lives. We want a movement that *listens to us* and then works on the issues we care about.[28]

It is difficult to establish who Denfeld is actually talking about when she says "we." One strongly suspects that she does not speak for the majority of women of her generation in the United States or elsewhere. In fact, as she herself affirms, the majority of feminists—indeed women—believe that women need a women's movement that will achieve complete equality between the sexes.

In her view, criticizing male behavior is a personal attack. In such a climate, it is difficult even to discuss sexism. Yes, it is wrong to accuse individual men of being rapists and oppressors without knowing anything about them or their politics, as Charlie Chaplin's film *Limelight* suggests. But it isn't wrong to say that women's history shows that an institutional system based on male power has abused women throughout the ages of Western culture. When Denfeld misrepresents "today's *Ms.*" as a separatist, male-hating, and lesbian publication, she is intentionally deceiving readers. Contrary to what she says, the work of

male writers appears in the magazine, articles acknowledging the fact that women have relationships with men are frequently published, and essays suggesting how to work out sexism in relationships are often featured.

One suspects that Steinem's observation, "having someone who looks like us but thinks like them is worse than having no one," is an accurate evaluation of the views represented by Denfeld. Her claim that there is no recognition of decent guys by feminists is an out-and-out untruth. Actually, today many couples belong to NOW and participate actively in feminist causes. Obviously, men who are feminists recognize that other men may resent the message that they are unworthy of the trust of their female peers but understand that until they prove themselves worthy, there is no reason for a sensible woman to think otherwise.

In *Daughters of Feminism*, Rose L. Glickman vividly shows the inadequacy of the media's facile oversimplifications about women of so-called Generation X.[29] Beginning with how young women regard the word *feminist*, Glickman provides ample evidence to balance Denfeld's sweeping and often misleading generalizations. A case in point is a response to the question, "Would you call yourself a feminist?"[30] The answer: "I really don't know what it means."

Actually, Denfeld doesn't speak for the vast majority of young women who do embrace feminism and aren't afraid to call themselves feminists—advocates of women's rights who wholeheartedly support the goals of NOW and are redefining feminism for their generation. An estimated 60 percent of the participants in NOW's 1992 March for Women's Lives consisted of young women aged eighteen to twenty-three. And there are other statistics from Denfeld's text that support the fact that many young women are solidly behind the goals of the women's movement.[31]

Sadly, in trying to find the source of femiphobia in the United States today, one has only to turn to Denfeld's book to understand how confused and uninformed women who hold her views are and why they are withdrawing from feminism and condemning some of its strongest leaders. Her unexamined and deeply rooted fear of lesbians and her inability to hold men responsible for the unequal society they have helped to create and maintain offer no

challenge to the classical feminism she wishes to displace.

One of the best expressions of the difficulties involved and the complexity of the overall problem may be found in Martha Nussbaum's review, "Feminists and Philosophy," in *New York Review of Books*, in which she discusses the strengths and weaknesses of this new type of scholarship.[32] In systems such as Paglia's, Denfeld's, and Sommers's, unlike the ones Nussbaum represents, people who disagree with their values are labeled criminals, so others who agree with their viewpoints can prefer charges against them. Sommers, for instance, expects people to believe that liberals, not the powerful groups that initiate wars, destroy neighborhoods, and make laws to excuse themselves, are the source of women's unhappiness.

Postfeminists like Sommers, Paglia, Denfeld, and Wolf seldom evaluate ideologies that sustain our male-centered power-based culture and that seem to guarantee that unhappiness will be a constant feature of many women's lives. Viewing Western knowledge as a cure-all for what ails this society, these women refuse to deal with the patriarchy's exercise of power over human beings who are dependent on it. It's easier to attack people and programs that probe the causes of oppression and seek answers to the problems that plague us as a society. Postfeminists such as those I've mentioned balk at holding patriarchal society accountable for the social conditions it has created. Their message to women and men is that they do not have to change themselves. By stressing an ideal of masculine power, Sommers, like Paglia and even Wolf, abrogates women's potential for autonomy and society's potential for change.

People have misread the movement for women's liberation because of the way the mass media have represented it. Commentators avoid asking hard questions about the structure of work, marriage, childbearing, and society. Moreover, by choosing only certain "experts" to comment on data or discuss issues (for example, William Bennett on welfare), they limit the discussion to the level of a four-alarm fire. Because of this manipulative brand of media journalism, people in the United States have the absurd idea that feminism is a monolithic movement bent on destroying the American way of life (as if there could be one way that satisfied all individuals).

Antifeminist rhetoric on the Right is an epidemic, but the new young Republicans aren't willing to condemn feminism entirely. William Kristol, a Republican strategist, maintains, "I'm not willing to abandon all the progress for equal rights for women and I never said we should. But where we go from here is a big question. The fact that feminism has had certain good consequences doesn't absolve one of the responsibility for pointing out that it's had certain bad consequences."[33]

Among neoconservative professional women, the agenda is less clear. Danielle Crittenden, the editor of *Women's Quarterly*, a Washington-based periodical for and by conservative-minded women, represents the new Republican "counter counterculture" (a group of sophisticated young conservatives who are the new nonfundamentalist wave of their party). Her quarterly has published feature articles like "Violence Against Taxpayers: Why the New $1.5 Billion Violence Against Women Act Won't Protect Women from Violent Crime, but Will Subject Them to an Assault of 'Abuse Experts,'" by Betsy Hart, a columnist for Scripps Howard News Service.[34]

Although I have chosen to limit my introductory discussion of "players" to a small number of postmodern figures, I discuss many more participants throughout this book. Clearly, the practice of feminism is like an intricate chess game with an endless array of possibilities, one in which the king can only be checkmated.

THE FIELD

Under the umbrella of feminism, you will find first-wave, second-wave, third-wave, socialist-Marxist, lesbian, liberal, psychoanalytic, Religious Right, neoconservative, ecological, multicultural, postfeminist, and do-me feminists. It's easy to get swamped in this sea of cresting waves while struggling to keep your head above water. To stay afloat, keep in mind three basic concepts. First, one common theme that flows through all these choppy waters is that women are victims of institutionalized male supremacy and need special protection. Second, those who are labeled "gender" or "victim" feminists, including such classic feminists as Friedan and Steinem, insist that women require

special care and sensitivity in their jobs, in public spaces, at home, in schools, and in the military. Third, several feminists have promoted sexual liberalism, and third-wave postfeminists, such as Paglia, have joined with academics like Strossen and groups of sexual liberals to oppose what they label the "radical feminist" antipornography campaign. Paglia is part of a new wave of writers and thinkers, including Roiphe, Wolf, Sommers, and Denfeld, who are in a class of their own!

Paglia and others in this third wave of the women's liberation movement join together in thinking that the victim theme is exaggerated and applied to a wide range of behaviors that are "ugly" and "unlawful," but not really all that harmful to women. They maintain that sexual harassment and pornography, for instance, are areas in which protections for women are colliding with individual liberties.

Assuredly, feminists themselves contribute to the difficulty in understanding the feminist movement because of the added pressure that feminist leaders feel in presenting their points of view. Most worry that if they are not consistently strong and clear about their opinions and experiences, they will be misrepresented by the media. Their emphatic statements are often misread by young women, who wholeheartedly want to build a new society but reject the idea that they must be "politically correct" or follow a prescribed format of behavior to reach that goal. In fact, many of these young women aren't even sure what being a feminist means.

Notes

1. Susan Faludi, "I'm Not A Feminist but I Play One on TV," in *Ms.* (March–April 1995):31–38. In this article, she discusses the self-identified postfeminists of the 1990s.

2. Information provided by the Fight the Right Action Kit of the National Gay and Lesbian Task Force via CompuServe online forum, 1994.

3. "Catholics for a Free Choice," CompuServe journalism online forum, 1994, *CompuServe*—Online.

4. *Roanoke Times and World News*, 5 January 1991.

5. "Equal Rights Initiative in Iowa," *Washington Post*, 23 August 1992, A15.

6. The Equal Rights Amendment (ERA) simply reads as follows:

 Section 1. Equality of Rights under the law shall not be defined or abridged by the United States or any state on account of sex.

 Section 2. Congress shall have the power to enforce, by appropriate legislation, the provisions of this article.

 Section 3. This amendment shall take effect two years after the date of ratification.

 Written in 1921 by suffragist Alice Paul, the ERA has been introduced in Congress every session since 1923. It passed Congress in 1972, but failed to be ratified by the necessary thirty-eight states by the July 1982 deadline (it was ratified by thirty-five states). Supporters claimed the ERA was needed because the equal-protection clause of the Fourteenth Amendment does not provide adequate protection against sex discrimination. Opponents claimed that the ERA would provide no benefits and might hurt women.

7. Cynthia Ozick, "Hannah and Elkanah: Torah as the Matrix for Feminism," in *Out of the Garden: Women Writers on the Bible*, eds. Christian Buchmann and Celina Spiegel (New York: Fawcett Columbine, 1994), 88–93.

8. Todd Gitlin, *The Sixties: Years of Hope, Days of Rage* (New York: Bantam, 1987), 363.

9. Sexual harassment, which alludes to the unfair pressure an employer puts on an employee for sex, has become a central concern of feminism. Such unfair power relations make it uncomfortable for persons in subordinate positions to do their jobs.

10. Betty Friedan, "NOW Statement of Purpose," in *It Changed My Life* (New York: Random House, 1976), 88–91.

11. William S. Affleck [CIS 74021,751], CompuServe online, 10 July 1994. Some NOW contacts online are Affleck, of Washington State, and Bill Willis [CIS 72567,2640) of the National Board of NOW (and New Jersey NOW). Affleck cited a few of the changes that Seattle NOW has already helped to achieve: the Comparable Worth Law in Washington State, one of the nation's first marital rape laws, the Establishment of Domestic Partnership Law in Seattle and King County, the Establishment of Battered Women Defense in Washington, the largest percentage of women legislators in the nation, and the state's ratification of the ERA. The address of Seattle NOW is 4649 Sunnyside Avenue North, No. 222, Seattle, WA 98193; phone 206-632–8547.

12. All information was taken from a letter to the author and a brochure from Rita J. Simon, president of WFN, 15 September 1994. The address of Women's Freedom Network is Suite 179, 4410 Massachusetts Avenue, N.W., Washington, DC 20016; phone 202–885–2965.

13. Available from the National Council for Research on Women, 530 Broadway at Spring Street, 10th Floor, New York, NY 10012; phone 212–274–0730. The council also has information on work-in-progress, opportunities for research and study, and mailing lists.

14. Cathy Young, "Interview with Nadine Strossen," in *Women's Freedom Network Newsletter* 1, no. 3 (Summer 1994): 1.

15. Marilyn French, *The War Against Women* (New York: Summit, 1992), 168.

16. Janice G. Raymond, *Women as Wombs: Reproductive Technologies and the Battle over Women's Freedom* (San Francisco: Harper San Francisco, 1993), 103.

17. Ellen Willis, "Feminism, Moralism, and Pornography," in *Powers of Desire: The Politics of Sexuality*, eds. Ann Snitow, Christine Stansell, and Sharon Thompson (New York: Monthly Review Press, 1983); Arlene Raven, "Star Studded: Porn Stars Perform" and "Not a Pretty Picture: Can Violent Art Heal?" in *Crossing Over: Feminism and Art of Social Concern* (Ann Arbor, Mich.: UMI Research Press, 1988).

18. Willis, 462.

19. Quoted in John Gallagher, "Attack of the 50-Foot Lesbian," in *The Advocate* 666: 43.

20. *New York Time Book Review,* 21 January 1995, 13.

21. "Who's Afraid of Naomi Wolf?" in *Off Our Back* 24 (December 1994): 1, 8–11.

22. Katie Roiphe, *The Morning After: Sex, Fear, and Feminism on Campus* (Boston: Little, Brown, 1993), 5.

23. See "Goddess, Riot Girl, Philosopher-Queen, Lipstick Lesbian, Warrior, Tattooed Love Child, Sack Artist, Leader of Men," in *Esquire* (February 1994): 51.

24. For two contrasting views, see Frances A. Maher and Mary Kay Thompson Tetreault, *The Feminist Classroom* (New York: Basic Books, 1994); and Daphne Patai and Noretta Koertge, *Professing Feminism: Cautionary Tales from Inside the Strange World of Women's Studies* (New York: Basic Books, 1994).

25. René Denfeld, *The New Victorians: A Young Woman's Challenge to the Old Feminist Order* (New York: Warner Books, 1995), 211.

26. Ibid., 11.

27. Ibid., 47.

28. Ibid., 210–11.

29. Rose L. Glickman, *Daughters of Feminists* (New York: St. Martin's Press, 1993). This book is an excellent representation of the confusion, struggle, and redefinition of feminism now taking place among younger women. Unlike Denfeld's simplistic vision of feminism, Glickman's account attempts to deal with the movement in all its complexity.

30. Ibid., 5.

31. Denfeld, *The New Victorians*, 248.

32. Martha Nussbaum, "Feminists and Philosophy," in the *New York Review of Books*, (20 October 1994, 59–63.

33. James Atlas, "The Counter Counterculture," in the *New York Times Magazine*, 12 February 1995, sec. 6, 38.

34. Ibid., 34.

3

The Origins of Sexism

All sexist concepts derived ultimately from classical antiquity, the Hebrews, and the early Christians. If one turns from these sources to American society, one finds that despite its heterogeneity and the fact that it includes people of many cultural and religious backgrounds, it has largely been influenced by a Greco-Judeo-Christian tradition. It is this context that provides a vision and framework for creating and maintaining an American society of ordered liberty.

The Industrial Revolution transformed Western societies in the 1800s. The United States followed suit. In the nineteenth century its factories thrived, its railroads crisscrossed the nation, and its cities expanded. During the Civil War a relative handful of entrepreneurs profited from this revolution, and others gained broader opportunities, but vast armies of the disadvantaged, including the poor, wage slaves, immigrants, African Americans, women, and children, were worse off than before. Machines, money, and men dominated the nation. At the turn of the century, this dangerous and complex situation led to the formation of labor unions and organizations that fought for the rights of the disenfranchised. In the transition from an agricultural to an industrial society, the rural poor had become the urban poor.

Across the radical and socioeconomic spectrum, women were awakening to injustice and taking action. Sexism was what

women wanted rooted out of the nation. Live Pryor wrote on behalf of her "Down Trodden Colored Sisters of Virginia," of the white men "who rule us with a rod of iron, and show themselves on every occasion the same Crule Task Master, as ever, have introduced on the Statute books right to wipp woman."[1] Linking personal and political rights, women stretched the model of individual rights to the limits, demanding self-ownership and self-development and, above all, the right to sexual and reproductive self-determination. Elizabeth Cady Stanton said that the political equality of women would entirely revolutionize the family. "When woman is man's equal the marriage relation cannot stand on the basis it is today. . . . This same law of equality that has revolutionized the state and the church is now knocking at the door of our homes." She believed it would lead to a "purer, higher, holier" condition of marriage and family.[2]

During this period, conservatives cried out that women were going to destroy the family. This fear led Angelina Grimké to produce *Letters on the Equality of the Sexes and the Condition of Woman*, in which she dissected the familiar doctrine that the Bible decreed that women were inferior, grounding her argument for equality in a contrary interpretation of the Scriptures. She also attacked marriage laws and women's lack of legal rights; called for equal education and equal pay; and asked women to forgo fashion, partying, and favors from men. She compared white women's chains to those of slaves, particularly enslaved women. Her discussion of equal "human rights" for women and men did not separate those rights from duties and responsibilities: "All rights spring out of the moral nature: they are both the root and offspring of responsibilities."[3]

Currently, for moral and psychological reasons, the New Right evangelicals openly oppose women's demands for liberation and steadfastly maintain the vicious cycle of sex segregation that relegates women to second-class citizenship—the "cult of the true woman," philosophy that the Grimké sisters and Stanton campaigned so hard to abolish. People who were raised with these fundamentalist beliefs think that the Old and New Testaments are infallible guides to personal salvation and that they contain the prescriptions for just laws and the good society.

On the one hand, today's secular humanists and feminists,

much like their progenitors, question whose religion and whose morality are to be cited. They point out that in a "Godly" country, Christian doctrines, as practiced by certain fundamentalists, are intruding on the lives of families and children and on women's rights, gay and lesbian rights, the curricula of public schools and universities, public libraries, political life, and secular culture, to say nothing of the lives of millions of people who do not follow Christian faiths.

On the other hand, nationally syndicated columnist and television commentator Patrick J. Buchanan, in his book *Right from the Beginning* (1988), articulates the ultraconservative agenda for America. He declares that the influences of secularism are responsible for the country's deterioration. Feminism, safer sex, abortion, pornography, gay and lesbian rights, welfare, secular culture, and AIDS are his targets. The American values Buchanan attacks are centrist, secular, intellectual, spiritual, and cosmopolitan. He argues, "Someone's values are going to prevail. Why not ours? Whose country is it, anyway?" Fundamentalists of this ilk find it extremely difficult to separate the two realms of value—religious and secular—because of the unity of their faith and morals. Members of the New Right, who acknowledge only one brand of allegedly Christian values, want to pass laws that disenfranchise or abuse other Americans who don't agree with them.[4] Their stance has forced people who appreciate constitutional values, including feminists, to take a stand and fight to maintain their basic civil rights.

All this serves to show that a great deal of confusion surrounds traditional religious and constitutional beliefs. Trying to divine the deeper meaning of Western religious lore brings one into direct contact with a profound gender and sex technology that developed the masculine spiritual principle while suppressing an appreciation of the feminine and identifying it with degraded instinctual nature. Struggling for some sense of clarity in this fog, academic feminists have challenged the sexism of the theory that women were closer to nature than men.

In 1972, in an effort to retrace the steps by which society has placed a lower value on women, anthropologist Sherry Ortner posed a fundamental question, "Is female to male as nature is to culture?"[5] By taking another look at the way women are identi-

fied with nature, she hoped to learn how systems that discriminate on the basis of gender are generated and sustained. Her conclusions—that the deployment of "nature" by society to devalue women would only change with massive reforms in reproductive and child-rearing practices, combined with men's and women's dual participation in the work force and politics—helped change the way many scholars (and activists) thought about the so-called laws of nature and women's bodies.[6]

For centuries, sexual difference has been encoded in metaphors based on nature. Among the ancient Greeks, Hesiod proclaimed that the first entity after Chaos was Gaia (earth), who gave birth parthenogenetically to her husband, Ouranos (heaven). The earth, like the human female body, gives birth to all that humans need. Ancient Greek thought colonized the earth (and a woman's body) as a field to be plowed and fertilized so it would bear fruit.

Taking their cues from the cultures that surrounded them, the early framers of the Old Testament collected legends, fragments of law, historical works, and imaginative literary compositions, which were altered by various transcribers over time, and began with the story of Genesis. In written and visual depictions, Eve is the seductive devil's agent who corrupts Adam and causes the fall of man. These formulations represent beliefs that have shaped history. The notion of inherent differences between the sexes is something we've all been carefully taught, as Angelina Grimké observed. We've accepted metaphors of a woman's body as nature—as a field to be cleared, sown, and harvested. So our civilization's gender inequities are deeply rooted in our legends and myths.

"Nature, Mr. Allnut, is what we're put in this world to rise above." Lurking behind that memorable line from the film The African Queen is the all-too-familiar story of people's relationship to nature. During the growth of Christianity, the early father's produced new scholastic commentaries that reshaped common spiritual beliefs. Christian polemics against paganism denied the reality of the body—of the material world—in favor of a higher male order—heaven. The separation of heaven from earth set up the dualities between the sacred and profane that still plague our civilization.

To understand the notion that women are closer to nature than are men, one must turn to the Greek philosopher Aristotle. Aristotle set the standard when he advanced the idea that women are women because they lack certain qualities and are afflicted with a "natural" defectiveness. He said, "The female is as it were a deformed male; and the menstrual discharge is semen, though in an impure condition; i.e., it lacks one constituent, and only one, the principle of soul."[7]

After the overthrow of pagan culture, this idea persisted. Christian symbolism united woman, serpent, and tree. This symbolism may have derived, in part, from the myth of Medusa. Classics professor Page duBois interpreted it as relating to the "association of the female body with earth. The earth is full of stones, which are seen by the Greeks as her bones, as seeds of human beings; the earth is also the place of burial. To be turned to stone by the gaze of the mother is to return to the earth."[8]

But the growth of this legend—dust to dust and ashes to ashes—cannot be fully understood without scrutinizing the story of Genesis. By first examining Eve, as seen in Western patriarchal religion—as the mother of us all, as the scapegoat of both the Old and the New Testaments—and then examining how the feminine has been symbolized in psychology, philosophy, and the visual arts, one can better grasp how Eve came into being and what she means.

The mythical, explained Jungian psychoanalyst James Hillman, is "the speculum of the psychological, its reflection [is] beyond the personal."[9] In Greek mythology Athena, who embodies wisdom and courage, was born directly from the head of her father, Zeus; thus, she was not born of woman. For most academics, the discourse of opposition begins, according to the French psychoanalyst Jacques Lacan, with the displacing of mother knowledge for father language, which the myth of Athena, the biblical Eden, and the creation of the Virgin Mary symbolize.

Scholars have suggested that there was a prevailing matriarchal and matrilineal system that was overcome by one that was patriarchal and patrilineal. Whether there was actually a matriarchal, as distinct from a matrilineal, culture is open to debate, though myths and art provide a rich image of such a culture.

What one finds is that this conception was handed down through cultural tradition. In earlier mythic legends from the ancient world, the tree in the garden represents resurrection and immortality. It belongs to the old goddesses and is guarded by a dragonlike creature. As mothers and women, these goddesses were more powerful than their male consorts, gods. Approximately 6,000 years ago, the old goddesses were overthrown by patriarchal invaders who were threatened by the old pagan religions. These ancient matriarchal forces were seen to reside in the material body, the earth, and everything that sprang from her. So the origins of sexuality are positioned in a religious discourse in which not only Jews but Christian Gnostics believed that the merely human (therefore female) must be transformed into the divine (the living spirit that is male) to ascend to the paradise of heaven. This fantasy is about animal nature and human culture.

This historical battleground is mirrored in the Genesis legend. The story of the Fall is supported by historical events that relate to the displacement of a pagan goddess—worshiping principle by a monotheistic masculine deity. The Levite Bible's creation tale dramatizes the narrative of Adam and Eve in Eden, constructing a set of meanings that separate the world into both a divine and a natural state, as well as a gendered one—masculine and feminine.

The ancient Hebrews dethroned paganism, in the form of Eve and the serpent of wisdom, to usher in their new cultural order. Thus, they created the seduction scene in which Eve is charmed by the snake into plucking the fruit from God's forbidden tree of knowledge. In this scene, Eve embodies the principle of disobedience and rebellion. She consults with the serpent, who is sometimes referred to as the "instructor," who urges her to eat from the tree. Eve, in turn, persuades Adam, who is there to maintain order and the rights of the father, to eat the fruit. Adam listens to her, succumbs, and then joins her in disobeying God's commands.

Male writers tend to ignore the fact that Adam, too, is an active force who exercises control over the future. They blame the Fall on animal nature (Eve). When God asks Adam what happened, Adam blames Eve. With the awakening of their ability to

think for themselves, the now fully knowing and sexualized couple are forced to leave the garden by an angel with a flaming sword. They relinquish their childlike innocence for the so-called wickedness and suffering of the adult-oriented material world.

After the expulsion, Yahweh condemns Eve (woman-body) to submit to Adam (man-mind). Eve, the scriptures explain, is the insignificant part of man, his rib. She was created out of him and therefore is inferior to him. Adam gave birth to her. But feminists caution readers to keep in mind that Eve, like Athena, is man's creation—what he wants her to be, not what she herself is. In short, in the Hebrew telling of the tale, matrilineal power is displaced and patriarchal man is given domination over his literary creation, woman.[10] This understanding of pleasure and submission is at the heart of the story.

Scholars have pointed out that the story of Adam and Eve is similar to the Greek myth in which the ancient goddesses are displaced by the new gods. Moreover, they have also made a connection between patrilineal descent and the fact that some Greek philosophers believed that only the man created new life, while the woman merely nourished it in her body (therefore, the newborn was only of the father's lineage).

The Old Testament legend is a reflection of antifemale projections that were later adopted into the literature of Christianity. Over the centuries, the Christian church consolidated its economic and political gains and used the New Testament to silence and control women, as Grimké noted in her manifesto. The church's hostility to women served to disenfranchise them from their own individuality, sexuality, and spirituality. St. Thomas Aquinas (d. 1274), like Aristotle, declared woman to be an "imperfect man." As passive and inferior beings, women were viewed as the property of men. "The devaluation of woman," Simone de Beauvoir explained, "represents a necessary state in the history of humanity, for it is not upon her positive value but upon man's weakness that her prestige is founded. In woman are incarnated the disturbing mysteries of nature, and man only escapes her hold on him when he frees himself from nature."[11]

James Hillman offered yet another mythological reason for male dominance. It is that male consciousness is superior to female consciousness because Eve was extracted, during Adam's

deep sleep, from his unconscious. Thus, the sleep of Adam, a fall-en state of man, produced Eve, who is Adam's physical, that which degrades him. According to this reasoning, the male becomes the precondition for the female. This is how gender becomes the specific area of disconnection. Hillman noted that as long as the physical represents the female, it will go on receiving antifeminist projections.[12]

In the feminist theory of patriarchy, the "war of the sexes" rep-resents the conflict and competition between two different modes of creativity: the genital, or feminine, which is concerned with reproduction, and the intellectual, or masculine, which is involved with the creation of ideas.[13] To keep women in their place, men have set a high value on ideas and have privileged creative acts over childbirth, seeing intellect as directly linked to the divine (immortality). The female act of reproduction is deval-ued and despised because the bearing of children only grounds women more deeply into the material realm, which is equated with mortality and death. In theory, the triumph of "culture" leads to mind-body polarity, eros-thanatos (the opposition between love and death), and the current nature-versus-culture debate.

It is from these early sources that sexism arose. The Hebrew creation myth saw any rebellion by women—any attempt to empower themselves or gain back their self-esteem—as a threat, a transgression. Thus, even man's fall from God's grace signals the woman's failure to conform to male ideology. Ironically, it is Eve's disobedience, her willingness to take a risk, that distinguishes her from Adam and sets her apart as the teacher of humankind.[14]

What is striking about these narratives, from a feminist van-tage point, is that the creation of Eve is a fantasy projected onto women of the male desire to go wild and lose his dogmatic belief in self-control by giving in to his bodily and emotional needs. What is the most threatening to man is that whoever provides this pleasure also has the power to dominate him. As a conse-quence, the female body becomes transformed by man's imagi-nation into the sign of both pleasure and suffering. Eve is the bait that represents physical temptation. Her very existence is a reminder of carnal desires—of weakness. So the female body is recast by Christians into evidence of original sin.

Religion focused attention on the female body. The Christian worldview was extended further by St. Paul, who put the rational masculine power of the Logos (the word) and the intuitive, feminine power of Sophia (wisdom) into the person of Christ (the anointed). St. Paul exhorted his listeners: "It is good for a man not to touch a woman" (Corinthians 7:1). Paul collapsed nature and women, creating an equation that contributes to our current difficulties. Since patriarchy sees nature and women as closer to the uncivilized, they become the twin denigrations that support the universality of female subordination. According to author John A. Phillips, the Jewish philosopher Philo developed his belief on the basis of the story of Adam and Eve and theorized that man symbolizes mind and woman, the senses.[15]

Gender identity is conditioned by culture, but hierarchical gender relations are part and parcel of this conditioning. Macrobius wrote, "The world is man writ large and man is the world writ small."[16] Concentrating on controlling women's bodies, the church fathers treated females as if they embodied the morality of the entire human race. The victory of culture over nature made even the way women give birth unsuitable to Christianity.

Christian legislation established such rituals as "churching," which denied postparturient women admittance into any church for a forty-day period following the birth of a boy, on the theory that giving birth made them spiritually impure. After the quarantine expired, a woman could be churched with a ritual designed to remove the impurity of motherhood. If the poor woman was unfortunate enough to have a girl, she was isolated for eighty days because the patriarchal priesthood considered girls twice as impure as boys. At the end of that time, the mother had to make a sin offering to the priest, in atonement for her "crime." Such antifemale ideas were greatly enhanced by the church's doctrine of original sin transmitted to all generations via the flesh of women.[17]

Points of doctrine were cloaked in narrative. Stories were used in sermons to drive home a point. Masculine essentialism, inserted into religious traditions, produced the virgin birth of Jesus. Borrowing from the ancient Greeks, the church fathers created the Virgin Mary, who is the only one of her sex who is free of

original sin.[18] The creation of the Virgin Birth mythology may have been because "the study of Our Lady," as Henry Adams wrote, "leads directly back to Eve, and lays bare the whole subject of sex."[19] Virginity was the opposite of sexuality; sex and sin are at the root of all evil.[20] Through the Virgin Birth, Mary escaped the debt of Adam and Eve. Moreover, the coexistence of opposing concepts regarding interpretation is responsible for the extreme complexity of early Christianity.

To certain sects of Gnostic Christians, Eve was favored as the "Mother of all living things" and the "Serpent Mother."[21] This was a positive image compared with the more traditional Jewish and conservative Christian views. In a Gnostic poem entitled "Thunder—Perfect Mind," for example, one hears the empowered feminine confirming:

> I am the first and the last. I am the honored one
> and the scorned one. I am the whore and the holy one.
> I am the wife and the virgin. I am (the mother) and
> the daughter. . . . I am she whose wedding is great,
> and I have not taken a husband . . . I am knowledge,
> and ignorance . . . I am shameless; I am ashamed.
> I am strength, and I am fear . . . I am foolish,
> and I am wise . . . I am godless, and I am one
> whose God is great."[22]

At the heart of this Gnostic poem is the powerful multiplicity of the feminine—of nature. The poem appears to be an explanation of natural processes. Surviving verses like this one may partially explain the myth of Virgin Birth that harks back to ancient goddess societies and attempts to heal the split in feminine nature created by the voice of the church. In view of the virgin–whore partition, it is indeed ironic that *virgin* originally meant "one in herself" (self-contained). According to feminist philosopher Ester Mary Harding, it refers to a woman's psychic wholeness.[23]

The relevance of this idea is demonstrated in Geoffrey Ashe's book *The Virgin: Mary's Cult and the Emergence of the Goddess* because "the religious history of mankind shows a recurring tendency to worship a mother-goddess."[24] Thus, outside orthodox Judaism and conservative Christianity, the divine feminine embodies Sophia (wisdom), Eve (sexuality), and Mary (spirit),

all of whom are simultaneously sacred and profane.[25] The alternating currents between the material and the spiritual, whether integrating or separating, reestablish a wholeness of consciousness that nourished early Christianity.

In sharp contrast, the Roman Catholic cult of Mary pictures the rehabilitation of Eve and the old mother-goddesses as an acceptable object of devotion in Christianity because she is now chaste. But even this role model creates problems for today's Catholic women because the Holy Mother is never a minister herself, never a powerful church figure. Instead, she is always a tethered handmaid, a conduit through which the compassion of Christ is conveyed. In any case, at the time the Virgin Mary was being glorified, real women were being persecuted as witches all over Europe. Whole villages of women were wiped out, leaving male-only towns.

The Genesis plot raises theoretical questions, such as these: "What is unrepresented in the female as embodied in Eve by male writers? What was Eve's real motive for the initial transgression?" In this male narrative, one is given no clue as to what Eve wants or why she wants to break free of the couple's pact with God because it is not her story that is told. Eve is a puppet and never writes her own lines; rather, it is Adam's story that one hears.

The spiritual, as nineteenth-century abolitionists Sarah Grimké and her sister Angelina maintained, is inextricably bound to the notion of a Creator. Women's discontent with their position in religion and society is not new. Twentieth-century feminists, like the Grimke sisters, wanted to go beyond such negative male-dominated images to conceptualize more positive visions of women as a sex class. During the tumultuous 1970s and into the 1980s, feminist theorists, such as Mary Daly, created a spiritual renaissance.[26] They justified their claims to equality by showing how women had been violated by sexism, by the biases of the Greco-Judeo-Christian convention of associating women with discounted nature.

IDOLIZATION AND DERISION

Now I can return to de Beauvoir's pivotal question, "What does it take to make a woman?" "A man," theorist Teresa de Lauretis

answered in her book *Technologies of Gender*. De Lauretis argued that the essence of gender is its construction. In other words, how our society has manufactured images of sexual difference shapes our attitudes about what is appropriate masculine and feminine behavior. All Western culture, de Lauretis believes, is the engraving of this history and of that accumulation on our consciousness. This is why the idea of gender as sexual difference is crucial to feminist theory.

Nowhere has the sexualization of the female body been so vividly seen as in the visual arts because the nude body, from classical time on, has been the standard measure of aesthetic beauty and mastery in artistic instruction. In the creation myth, female beauty is enveloped by the overriding shadow of Adam's temptation. The uncontrolled female body becomes an embodiment of evil—the disruptive tool of the devil. In this narrative, nature is portrayed as uncontrollable and the serpent is synonymous with malice.[27] To meet the threat of female evil, the church fathers created a series of aesthetic conventions for interpreting biblical accounts. The works of various artists, beautiful in themselves, supplemented the evidence of the Bible. Duccio di Buoninsegna, Giotto, Fra Angelico, and Masaccio, despite their individual styles, were all required to follow the dictates of the church in commissioned altarpieces featuring gold backgrounds, in frescoes painted in approved colors, and in matters of taste.[28]

Feminists object to such images because of the ways in which they encode discrimination on the basis of sex, and considerable effort has been devoted to finding a solution to this problem. This is why feminist-influenced artists, art historians, and film critics look at how the individual spectator is addressed by the work of art—the way she or he identifies with it. Most theorists believe that the way people see meaning is connected to their gender, culture, religious upbringing, sexual orientation, race, age, and class.[29]

There is no doubt that the female form in art and film is frequently a projection of the male's complementary opposite—Adam's rib. Women are commodities for men's use, so, as de Lauretis noted, even when it is located in the woman's body, sexuality is a property of the male. Since the displacement of the goddesses, female sexuality has been defined in relation to the

male. It is this man-made, male-controlled message that many films and other works by feminists try to correct.

On the one hand, woman has been made into man's opposite; she is man's archetypal fantasy, and her body is the projection screen for his imagination. Thus, she becomes not only the difference, by virtue of her identity as other than a man, but the sign in language and theory of what the Lacan called "otherness."

On the other hand, "otherness" is not something one claims in white mainstream culture unless one is involved in constructing a platform for social change. The marginalization of black gangsta rappers, for instance, functions in a similar way to the "otherness" of race, culture, sexual persuasion, or geographic location. Misreadings are a matter of misunderstanding and not pushing one's comprehension to the limits. Therefore, what Lacan labeled "otherness" needs to be seen in relation to identity and to patriarchalism because, as bell hooks pointed out, white men control our judicial, legislative, and financial systems.[30]

In her argument, de Lauretis treats language as an evolutionary process of constructing "mother tongue" and "father speech." The meaning of language, as I demonstrated earlier, is grasped through a religious, sexist discourse that displaces man's desire for sexual pleasure on to the female body. Taking the notion of gender apart shows that Adam's fall had more to do with his own behavior than with Eve's. It was Adam who gave in to pleasure and who broke his contract with God. In Scripture, the female body, like metaphor in poetry, is used as an instrument through which men communicate with each other.

Two inferences can be drawn from the study of Western religious accounts. First, man must subdue his feminine side and second, he must repress his lust and desire to have fun. In the early period and the Middle Ages, because there was so much illiteracy, Christian artists who represented the creation myth were required to call attention to these twin themes through their illustrations. Regarding the iconography, there can be little doubt that the transformation of the snake, who was originally inspired by the pagan dragon who guarded the tree of life into a symbol of evil, was promoted by religious reformers who wanted to establish a new order.

According to the Bible, woman's guilt for what she has sup-

posedly done in the beginning of time makes her obediently submit to man: "and thy desire shall be to thy husband, and he shall rule over thee" (Genesis 3:19, 16). Adam and Eve were expelled from the Garden of Eden, and since the time of the Fall, all people have had to labor in misery. This circumstance is viewed as the woman's fault. But it is also the sin of passion that stains us. Adam's inability to resist temptation condemned all humankind. St. Paul declared: "Wherefore, as by one man sin entered into the world, and death by sin; and so death passed upon all men, for that all have sinned" (Romans 5:12). Despite his transgression, since Adam is male he got to "rule over" Eve.

Philosophical revisionists of the seventeenth and eighteenth centuries, however, broke with previous generations in this regard. They speculated that Eve was a female Prometheus—a courageous benefactor who stole the greatest gift the deities were withholding: knowledge! For Johann Gottfried Herder and Immanuel Kant, the "fortunate fall" represented a transition in human history that they regarded as a gain, not a loss. They thought of it as an act of singular courage in which humanity distinguished itself from animals by choosing reason over instinct. So how did patriarchalism honor Eve's courage? She was reduced to a subordination even more extreme than the one she had challenged: She was to work out her salvation within the boundaries of domesticity. As a consequence, within family and church, woman is eternally dependent on man.

From this study, one can conclude that God-fearing Western organizations have used the creation myth to exclude women from participating as leaders in most religious institutions on the basis of a degrading narrative they invented. Eve's story, as told by the rabbinical scholars in the fifth or fourth century before Christ, is, according to John Phillips, also an attempt to displace the old goddesses. Feminists of the 1970s rejected the Genesis story because in it, Eve and women in general are synonymous with evil and the sexualized body. The acceptance of the story of the Fall meant that in most Western religion and culture no reconciliation was possible between women and theology. Thus, feminists concluded that this perspective left women spiritually and psychologically raped.[31]

SPIRITUAL LIBERATION

In light of all this, it is clear that many Americans are having a hard time finding some organizing principle in the world—some concept for living that makes sense to them. Their difficulty in doing so may be why so many Americans today are reexamining their spiritual values.[32] This reexamination is demonstrated by the books people buy; by radio and television programming; and by the tremendous appeal of contemporary paganism, Native American spirituality, and Eastern religions.[33] According to a survey conducted by Clark Wade Roof, a researcher at the University of California, baby boomers are on the cutting edge of all this spiritual seeking. They share a subjective and deeply personal approach to religion, and 77 percent of them believe that more needs to be done to advance equal opportunities for women.[34]

A powerful conversation on spirituality is emerging from the women's movement. In 1993 Clarissa Pinkola Este's book *Women Who Runs with the Wolves* was on the *New York Times* best-seller list. From a Jungian perspective, it addresses what the author views as the natural spiritual nature of woman. In practice, women's search for signs of spiritual life in the universe attempts to reconcile Western religion's nature and culturel split.

"The goddess has been rescued," cultural theorist Gloria Orenstein asserted, "by a contemporary feminist-matristic art."[35] As depicted by feminist artists, "She" has reemerged in all her forms as a powerful, integrated spiritual being similar to the Gnostic poet's "Perfect Mind." The deity is a mixture of elements—primordially feminine and engendering male—stressing the interconnection between creation and destruction. In their quest for a strong goddess who is not only compassionate, wise, empowering, and healing, but capable of enlightening both men and women, sometimes through "a nightmare of bizarre happenings," devotees are encountering aspects of divine nature that challenge orthodox Hebrew and Christian portrayals by reuniting nature and culture, masculine and feminine.[36]

It follows that contemporary feminists have created a rich spiritual tradition that is closer in conception to the Gnostic belief in rapidly changing energies that inform individuals and

the cosmos. But they part company with the Gnostics and have a different attitude toward nature and culture.

Feminist spirituality embraces yin and yang, the classic Chinese emblem of conjoined male (yang) and female (yin) powers. This dualism is interpreted as cyclic alternation of all sorts of dualities: light and dark, summer and winter, good and evil, youth and age, heaven and earth, birth and death. The symbol reminds one that every half of a dualistic pair contains something of its opposite within its heart. It encompasses the shadow side of the divine and expresses the metaphysical features of what is called the feminine (and masculine) in us all. Feminist spirituality develops as an act of fusion.

Women's longing for a mythology of their own found an outlet in revisionist views of prehistoric matriarchies. In contemporary art and film one finds the most striking illustrations. Ana Mendieta, who came to the United States from Cuba in 1961, immersed herself in blood, violence, and fertility. Her transfigurative rituals were meant to dissolve the boundaries between spirit and matter. Her "Silueta" series was an image based on her own silhouetted figure, which she blasted into the earth with gun powder or set on fire in the sky. Her poetic use of her own body is obsessively tied to Cuba and her Latin heritage.[37]

Betye Saar's collages and boxes, such as "Nine Mojo Secrets" (1971), an assemblage of fiber, beads, and seeds, with the eye of the universe at the top and a picture of an African ritual in the center, evoke images of female power and symbolize the African American experience. In her "The Liberation of Aunt Jemima" (1972), Aunt Jemima carries a rifle and pistol against a background of pancake-flour boxes.

Other feminist artists like Mary Beth Edelson use ritual, myth, and symbol to revive the concept of the Great Goddess. Tapping into ancient sources to inspire a fresh sense of female empowerment in the present, Edelson is attempting to restore the universal balance she feels is absent from patriarchalism. Combining Jungian psychology, feminism, dreams, fantasies, and time-lapse photography, she draws paths of light in the air. She seeks out isolated caves and ruins to make her connection to them palpable. She uses stone and fire, light and dark, to create a communal vocabulary. So there are various visions of the religious process

and spiritual expressions that sometimes converge at a number of points in contemporary feminist practices.

Feminists maintain that it takes only a small glimpse of the truth to free oneself. One example of breaking down old stereotypes is Chris Newbys's black-and-white film *Anchoress*. The film, set in fourteenth-century Britain, tells the story of a young woman obsessed with a wooden statue of the Virgin who ends up a cloistered prophet. The film was inspired by two letters on the wall of the village church in Shere, written in 1320. They referred to the "enclosure" of a local girl, Christine Chapenter, "for fulfillment of a better life." From these letters, Judith Stanley Smith and Christine Watkins created a powerful feminist morality tale. By working with the central paradox of being enclosed in order to be set free, the film illustrates how, like the Virgin, Christine is revered but denied the power to act.

By going back to the nature-versus-culture debate, Newby uses the medieval landscape as a metaphor of women's physical and sacred reality. *Anchoress* shows a rural priest's abuse of a young girl's fascination with a statue of the Virgin, using it as a lure to enclose her in a church wall for life. As an anchoress, the girl is a doorway to Christ. In a fashion similar to that served by the Virgin Mary, she mediates between her community and the male-dominated church. In one scene she embroiders the Virgin's cape in red because she experiences it that way in her visions. Time after time, the young cleric tries to impose his vision of the Virgin in blue on her, only to have her reject it. Eventually, Christine escapes; explores her own unbridled spirituality; and, finally, defying the authority of the church, plunges through a cathedral trapdoor into an underground cave, where she is transformed into light.

Through this feminist film, the audience is shown the power of slaves. By freely stylizing the medieval period, the film presents a timely look at a timeless encounter between an individual's spiritual vision and the weight of collective patriarchal authority. By revisioning woman as the center of the narrative and giving her access to her own body, *Anchoress* refutes the metaphysics of male domination and transcends the sexist system that was established by the Greco-Judeo-Christian patriarchy.

Sexism and its relationship to key elements of Western religious tradition are under revision by feminists. In some cases, feminists are trying to refute negative images of women that have developed over centuries. In others, they are exploring cosmic aspects of nature. And, in still others, they are creating rituals and works of art that express an alternative mythology.

Using women's experiences of menstruation, sexual intercourse, pregnancy, birth, lactation, and menopause, feminists have created a more open story of human relationships with nature that are nonhierarchical and more community based. This emerging spirituality has produced some common images that have surfaced in the works of women from different countries, in different media and styles, and from different phases of women's lives.

Marxist-feminist art critics like Rozsika Parker and Griselda Pollock, however, reject any association of women with nature as a product of sexist thinking. Whereas ecofeminist Susan Griffin sees nature as our sister, poet Marge Piercy chooses to see nature as our mother. "I belong to battle as the heron to the reeds/till I give my body back," Piercy wrote.[38] Reaching beyond patriarchal wisdom, feminists have explored the relationship between women and nature—language and reality—to raise some intriguing questions. In trying to resolve the problem of mind over matter, they have produced a rich body of work for us to study and have contributed greatly to our overall understanding of humankind's place in nature and creativity.

Notes

1. James MacGregor Burns and Stewart Burns, *A People's Charter* (New York: Vintage Books, 1993), 154.

2. Ibid., 155.

3. Ibid., 139.

4. One wonders if these political religionists are really Christians or simply using other people's faith to gain power for themselves in the secular world. Christ's "love" seems to have disappeared for these practitioners. Hate is not a Christian value. Many other Christians, including Bill Moyers, wonder what kind of Christianity, if any, they really stand for.

5. Sherry B. Ortner, "Is Female to Male as Nature to Culture," in *Woman, Culture, and Society*, ed. Michelle Zimbalist Rosaldo and Louise Lamphere (Stanford, Calif.: Stanford University Press, 1974), 67–87.

6. See commentary on Ortner's article by R. Tong (1989), reprinted in *Modern Feminisms: Political, Literary, Cultural*, ed. Maggie Humm (New York: Columbia University Press, 1992), 252.

7. Page duBois, *Sowing the Body: Psychoanalysis and Ancient Representations of Women* (Chicago: University of Chicago Press, 1988), 184.

8. Ibid., 89.

9. James Hillman, "On Psychological Femininity," in *The Myth of Analysis* (New York: Harper & Row, 1972), 267.

10. Whether one thinks David Rosenberg and Harold Bloom's *The Book of J* (New York: Grove Weidenfeld, 1990) is fiction or revisionist scholarship, the fact remains that it has complicated an already complex history of the formation of spiritual consciousness. The simple truth is that since its publication, many traditionalists, feminists, and postmodernists have been challenged to rethink their theories of and practices concerning religion and spirituality.

11. de Beauvoir, *The Second Sex* (New York: Knopf, 1953), 75.

12. Hillman, "On Psychological Femininity," 215. In psychoanalysis, the great divide is between the abysmal side of bodily man that is buried in the "physis, and the dark embrace of female matter that is the alchemical equation of the psyche."

13. In a conversation with me, urban anthropologist Deborah Hillman pointed out that in everyday life, the conflicts between women and men are much more subtle and concrete and have to do with different approaches to many aspects of being, doing, and relating.

14. Rosenberg and Bloom, *The Book of J.*

15. John A. Phillips, *Eve: The History of an Idea* (San Francisco: Harper & Row, 1984), 50.

16. Macrobius, *Commentary on "The Dream of Scipio,"* vol. 2, trans. W. H. Stahl (New York: Harcourt, Brace, Jovanovich, 1952), 12.

17. Barbara G. Walker, *The Woman's Dictionary of Symbols and Sacred Objects* (San Francisco: Harper & Row, 1988), 172–73.

18. DuBois, *Sowing the Body*, 103. Apollo points to Athena, born from the head of her father Zeus, "not nursed in the darkness of the womb." Her real parent is the masculine.

19. Henry Adams, *Mont St. Michel and Chartres* (London, 1913), 198.

20. Marina Warner, *Alone of All Her Sex: The Myth and the Cult of the Virgin Mary* (New York: Vintage Books, 1983).

21. Ibid., 165.

22. Elaine Pagels, *The Gnostic Gospels* (New York: Random House, 1979), 66; and James M. Robinson, ed., *The Nag Hammadi Library* (San Francisco: Harper & Row, 1988).

23. Ester Mary Harding. *Women's Mysteries* (New York: Putnam, 1972).

24. Geoffrey Ashe, *The Virgin* (New York: Arkana, 1988), 7.

25. Ibid., 22–28. As Ashe pointed out, even in Jewish scripture, the female principle returns as wisdom, a mediator between Israel and its remote God. See also Michele Roberts, *The Wild Girl* (London: Methuen, 1984), a fictionalized Gospel according to Mary Magdalene.

26. Mary Daly, *Beyond God the Father* (Boston: Beacon Press, 1973).

27. This is somewhat ironic, given the phallic symbolism that permeates so much modern psychology and postmodern theory.

28. Umberto Eco, *Art and Beauty in the Middle Ages*, trans. Hugh Bredin (New Haven, Conn.: Yale University Press, 1986).

29. Cassandra Langer, "Transgressing le Droit du Seigneur," *New Feminist Criticism: Art-Identity-Action*, eds. Joanna Frueh, Cassandra Langer, and Arlene Raven (New York: HarperCollins, 1994), 306–26.

30. bell hooks, "Gangsta Culture—Sexism and Misogyny," in *Outlaw Culture: Resisting Representations* (New York: Routledge, 1994), 122–23. Actually, much of the book addresses this problem.

31. As if to prove this idea, in 1995 the pope reconfirmed the Catholic Church's position by frustrating women's attempts to become priests.

32. Garry Willis, *Under God: Religion and American Politics* (New York: Simon and Schuster, 1990). Offers an inclusive reading of American religion and politics.

33. Carolyn J. Harrison, "The Contemporary Spiritual Seeker: Implications for Counselors," in *Journal of Humanistic Education and Development* 33 (December 1994): 58-64.

34. Ibid., 58–59.

35. Gloria Orenstein, "The Reemergence of the Archetype of the Great Goddess in Art by Contemporary Women," in *Feminist Art Criticism: An Anthology*, ed. Ariene Raven, Cassandra Langer, and Joanna Frueh, 71–86.

36. Irene Javors, "Goddess in the Metropolis: Reflections on the Sacred in an Urban Setting," in *Reweaving the World: The Emergence of Ecofeminism*, ed. Irene Diamond and Gloria Feman Orenstein (San Francisco: Sierra Club Books, 1990), 211–14. This is the subject of Javors's forthcoming book.

37. For more on the relationship between contemporary art and feminist spirituality, see Lucy Lippard, *Overlay* (New York: Pantheon Books, 1983).

38. Estella Lauter, *Women as Mythmakers* (Bloomington: Indiana University Press, 1984), 177.

4

Media—Friend or Foe?

Cultural fictions are embedded in women's psyches as deeply as the roots of an ancient oak penetrate the ground. Negative representations of women have been developed over the centuries. From Michelangelo's portrayal of a female-faced serpent on the ceiling of the Sistine Chapel to contemporary images of deadly women, there has been a historical bond among men based on misogynist ideas about women. No wonder people are in conflict over the roles women should play in everyday life. Robert M. Entman's book *Democracy Without Citizens* examines the relationship of the mass media to the dominant ideologies of American life. In it, Entman asserted, "The free press cannot be free" because it is inevitably dependent on economic and other conditions.[1]

The same can be said of other entertainment and supplementary mass media. Films, for instance, condition much of what we Americans think about how men and women should act. But artistic images give us genuine insight into how certain misunderstandings have shaped our perceptions of independent women.

Images of women as they are depicted on the screen are often a projection of the producer's mind, not an expression of female reality. In an effort to clarify the historical and social formation of the feminine under patriarchy, feminists have had to address a

variety of complex and interrelated issues. Their scholarship has shown us that by the end of the 1940s, and well into the 1960s, women with ambitions of their own or who desired a life of worldly achievement over a life of domesticity were considered pathological by psychoanalysis and kept in their place by religion and other institutions that urged a return to the "eternal feminine."

The most obvious feature of this postwar campaign to rehabilitate women for men was a barrage of mass media advertising presenting the housewife-mother ideal role model, which was used to influence how women thought of themselves. It takes a sophisticated audience to recognize that representations of male and female reinforce traditional ideals and abound, not only in the literature and the Bible, but in films and television programs. Debates have raged for years on the effects of the mass media in shaping perceptions, and one would have to be remarkably naive to think that the media do not. The media, from which many people get their information, are controlled by powerful special-interest groups. They have a tremendous stake in attracting and holding the largest possible audience. So how scrupulous are the major newspaper publishers, television producers, and filmmakers? How accurate are their stories? An injurious report may sell newspapers, magazines, books, and radio and television shows, and it may fill the local movie houses, but it may also conceal the truth.

The media's reliance on elite groups and individuals for information inevitably slants what we see. News reports, despite their avowed standards of objectivity, often fail to give equal weight to various opinions. This approach is particularly evident in the television program *Nightline*, where sound bites substitute for analysis. For example, President Reagan's popularity seemed to have blinded the press to the evidence that his policies, which account, in large part, for the present financial difficulties the country is in. Reports fail to mention, of course, that twenty-eight cents of every dollar that Americans now pay in federal taxes go to pay just the interest on the debt that was accumulated during only twelve years of Reaganomics.[2] In fact, the federal budget would have been balanced in 1995 if not for interest payments on the debt accumulated by the heroes of the Right:

Ronald Reagan and George Bush. Yet many journalists seem to have chosen to ignore this reality in reporting on the national debt.

Similar biased evaluations are evident in the coverage of women's liberation. As Entman explained, "The primary business purpose of news organizations is to package audiences' attention for sale to advertisers, who foot most of the bill (they provide 75 percent of the revenue for daily newspapers and nearly 100 percent for television)." Feminism is not a popular subject, but it is controversial, and most biases of the producers of television programs grow out of the need to manufacture programs that will attract and retain mass audiences. So when the television program *Sixty Minutes* does an overview of the women's movement, it tends to leave out historical facts that its producers consider offensive or makes those who speak about them appear ridiculous.

Abortion, sexual harassment, wife battering, prostitution, pornography, and date rape are all "hot" headlines in the information marketplace. Although there is a vast difference between fact and misrepresentation, one important question is "Why are mass audiences so easily influenced by what they see?" There are two possible reasons for this circumstance, one technical-financial and the other educational. First, experienced directors know how to use techniques, such as close-ups of objects or individuals, to grab our attention. Edited flashbacks are a kind of visual and mental act of remembering. Cutting allows the interests of the inner world of the mind to shape the objective outer world, thus influencing spectators to notice what directors want them to see. Artistry aside, one should never forget that behind entertainment's facade of fantasy is an interlocking maze of complicated business structures with investors who are looking for profits, and that the quest for profits often determines what gets produced and, ultimately, what we see and don't see. Second, the media often turn their spotlights on events because of popular pressure. By personalizing and sensationalizing the news and hot issues, they pack the house: witness the O. J Simpson epic. Politicians create images of themselves, and television sells us on them. It is only after the election, when politicians act "out of character" that we discover who they really are. By deliberately

slanting coverage to promote one view over another, media journalists and documentary filmmakers inject their own biases or someone else's into what we see. Viewers often think that the media system holds a mirror up to reality, but, in actuality, it constructs versions of reality.

FEMINISM AND HOLLYWOOD FILMS

The engine that drove the great cinema of the past was money. It was media capitalism that created the Hollywood studio system, which reached its zenith in the 1930s and early 1940s. This was the golden age of Metro-Goldwyn-Mayer, Warner Bros. Pictures, Paramount, and Twentieth Century–Fox.[3] In this period, Fox Movietone was the largest producer of newsreels, followed by Hearst's Metrotone News. As this industry grew, more and more studios were formed, with each studio having its own standards for format and production. The main objective was to produce films for mass consumption. Stars were contracted and featured in a variety of typecast roles made for mass consumption. The art of making money lay close to America's moviemaking enterprise, and it still does.

In the United States the effects of movies as a socializing agent played an important part in perpetuating or modifying certain feminine types and role models. Marjorie Rosen's book *Popcorn Venus* (1973) is one of the best accounts ever written about women and the movies. It reveals how a medium that began by asking awkward questions about the sexes ended up progressively arresting attempts to deal responsibly with women's issues. Rosen concluded that the studio system's increasing involvement with commercial practices led it to reject any significant threat to the matrimonial imperative. Undoubtedly, the movie moguls themselves helped to support the existing double standard by disapproving of women who challenged marital bonds. Yet they inevitably made money from such bold women by punishing them, in the films they produced, for being illicit, immoral, or aggressive.

At the time of the Great Depression of the 1930s, Hollywood's box office stars found themselves in a variety of jobs, ranging from aviator to dancer. They dressed well, ate well, and showed

few signs of wear and tear during these hard times. It was an era of changing self-definitions for men and women. The German actress Marlene Dietrich created a sensation at parties simply by dressing in a yachting cap, blue blazer, and white bell bottoms when every other woman at them was dressed in an evening gown. Though she wore her pants loose like a man's, she didn't look like a man. She prompted a lot of men and women to question their own sexuality because they were attracted to her. What was it that Dietrich had? What quality was it that sold at the box office? Seen in the light of fashion, her style—her assertion of personal freedom—could be interpreted as a visual display of fluid sexuality.

This fluidity of sexuality is fascinating to Americans, whose views about sex are rigidly puritanical. Most people in this country assume that there is a given connection between biological maleness or femaleness and the choice of an opposite-sex partner for intimate sexual relations.[4] Although film critic Christine Holmlund suggested that a lesbian continuum in women's films existed in the early- to mid-1980s,[5] the merging of female friendship and lesbian sexuality occurred much earlier and is rooted in Hollywood film conventions. During the studio system's golden age, women, as portrayed in movies, novels, and true-romance magazines, were allowed to undress in each other's presence, sleep in the same bed, hold hands with each other, and confide intimacies to one another. Rarely, however, were they portrayed as abandoning men in favor of women, and almost never without dire consequences, as in the film adaptation of *The Children's Hour*, in which the lesbian character is obliged to kill herself.

Hollywood capitalized on people's uncertainties about sexual identity and sexual gratification by exhibiting them in motion pictures. Take, for instance, *Christopher Strong*, a box office flop that featured the Bryn Mawr graduate Katharine Hepburn. Hepburn's angular beauty was popularized by ads that read "Off-screen she wears blue denim overalls and hob-nailed boots," which must have intrigued bisexual and homosexual viewers. Is this gay window advertising, the commodification of a lesbian sexuality, or the highlighting of women's resistance to being made up by men? One simply can't be sure when trying to assess the role of shifting sexualities in a money-making movie industry.

Director Dorothy Arzner was a lesbian whose own desire may have subconsciously shaped her representation of the character played by Hepburn. As film scholar Judith Mayne explained: "One of the important features of Arzner's career is the way lesbianism affects her films in diffuse ways. There are no lesbian plots, no lesbian characters in her films; but there is a constant and deliberate attention to how women dress and act and perform, as much for each other as for the male figures in their lives."[6] It is these contradictions between so-called heterosexual and homosexual modes of behavior that continue to intrigue most spectators. Hepburn evoked strong bisexual feelings. Her detractors found her harsh voiced, but her new, different, and independent spirit captivated audiences on and off the screen.

What these elusive and suggestive sexualities reveal is the mixed messages that came out of Hollywood during this period. Dietrich made her American debut in *Morocco* (1930), an atmospheric romance about an entertainer who must choose between wealthy artist Adolphe Menjou and Foreign Legionnaire Gary Cooper. The public flocked to see Dietrich in pants. In *Morocco*, she dresses in a white tuxedo, sings a song, and ends her number by kissing a woman on the lips and throwing a rose to the man of her choice, Gary Cooper. Her bisexuality clearly fascinated her audiences—both men and women—perhaps because her sexual behavior was far more aggressive and masculine than was Cooper's; Cooper was vulnerable and passive by comparison. Representations of this sort seem to sanction less rigid gender roles.

One of the most remarkable features of the Hollywood system was its creation of masculinity. A year after *Morocco*, the studio released *Public Enemy*, starring James Cagney as a gangster on the rise who heartlessly smashes half a grapefruit into his moll's face and gets away with it. This brutality confirmed that in Hollywood, as in much of America, during movies' "golden age," beating up women to keep them in line was OK. Dietrich may have cracked the whip and appeared stronger than her male lovers, but, in the end, as Rosen pointed out, in most of her films, her independence is forfeited, and she goes off into the desert obediently following several paces behind her man.

Just as images of women in films perpetuate myths of femi-

ninity, cinematic treatments of masculinity help to reinforce myths of manhood. "Men's relation to feminism," critic Stephen Heath noted, "is an impossible one." It may be impossible because a lot of men find their male identity and relate to other men by putting women down. For example, it is easier for adolescent boys to refer to women as "bitches" and "whores" than to deal with the falseness of the bodybuilder model of masculinity. These verbal displays follow established conventions of manliness among many groups of teenagers, regardless of race or class. But this is a dangerous practice because it reinforces the neo-Darwinian idea that the "natural" man is brutal—that men can't help being aggressive and treating women as sexual prey because this behavior is programmed in their genes. Bragging and posturing often lead immature boys to prove their virility by sexually harassing girls or, in the worst cases, raping them. This brand of masculinity reduces a man to his sexuality in the same way that femininity reduces a woman to a sex object.

Prohibition-era films made flamboyant use of alcohol, drugs, raunchy jokes, themes of child abuse, and ethnic slurs. Before the censorship imposed by the Hays code, women were impertinent. Heroes called them "sister," and "broads" could say, "What's it to you buster?" and then proceed to seduce anyone who they fancied. Hollywood women may not have won the battle of the sexes, but their portrayals of modern women were lively and reflective of the "new women" as authentic individuals. In these films, African Americans, homosexuals, Jews, and other minorities are acknowledged to exist, which film critic Janet Maslin points out "was not often the case in postcode days."[7]

In the 1940s Hollywood adapted James M. Cain's *Mildred Pierce* for the screen. Scriptwriters Randy MacDougall and Catherine Turney transformed the book into an engrossing film noir in which Mildred was played by Joan Crawford. An altogether modern woman, Crawford went after the role with grim determination and had the drive to get what she wanted. She convinced Jerry Wald to cast her, instead of her rival, Barbara Stanwyck, in the part. As it turned out, Crawford was perfect for the role because of her life experience as a waitress, a shopgirl, and the winner of a Charleston dance contest.

"Don't tell what Mildred Pierce did!" was the film's advertis-

ing slogan. In the movie Crawford plays a waitress-turned-restaurateur who, the movie poster suggests, kills for her cherished but vicious daughter, Veda. Novelist Whitney Otto observed that Pasadena, California, was "the place where Mildred's faithless husband and ungrateful daughter spent their time among the snob set, conspiring against her as she toiled away in her Glendale pie shop."[8] This is a story about a married working girl from the wrong side of the tracks who claws her way to the top and becomes the successful owner of a chain of restaurants. The film is marred by its simplistic presentation of Mildred's character. We know almost nothing of what drives her. Ann Blyth's extraordinary performance as Veda, a self-hating talented pianist and singer, makes the competition between the two women rage with emotions.

It is interesting that the framing device of the murder of Mildred's second husband, Monty Beragon, is not in Cain's novel. Yet it is one of the most dramatic moments in the film. Mildred, betrayed by her husband and tormented by her jealous daughter, is about to be punished by the law for the murder of her unfaithful and abusive mate. In the end, patriarchal truth (in the person of the detective) wins out, and the detective reveals the killer to be her daughter, Veda. Unwittingly, Mildred has destroyed everything she has worked for and loved, and ends up competing with her adored daughter for male attention.

Like Eve, Mildred tried to be autonomous and like Eve, she was punished for it. She is condemned because of her driving ambition, because she isn't a nurturing wife and mother. Blame is projected onto her because her wish to rear her daughter with warmth and tenderness is sacrificed to her career. This is what she must be punished for by losing the only thing she cares about because she cannot provide the sustained emotional involvement needed by both her first husband, Bert, and their child. In the forties, this underscored the message that a mother's place is in the home and taking care of family, not competing with men for jobs.

American films, literature, and art often portray working women as unattractive, unhappy, and domineering. What does *Mildred Pierce* say about women with ambitions of their own, who feel trapped in marriages that no longer work for them?

According to some right-wing fundamentalists and neo-Darwinians, they are biological freaks who aren't maternal because they don't change diapers, sew buttons on grown men's overcoats, and confine their ambitions to baking cookies and pies for their families. Both husbands in the film blame Mildred, and so does her daughter, who identifies with their point of view. It is obvious to everyone that Mildred's ambitious yearnings have led her to the sorry state she finds herself in. She has only herself to blame, and the lesson for women is "don't be yourself." Women are told that motherhood is their real career and that it means limiting themselves to child tending and housekeeping.

In 1945 Crawford won the Academy Award for Best Actress for her performance. The blatant contrast between what it took for a woman to succeed in Hollywood and what the films themselves presented shows us how the studio system really regarded independent women. The "new woman" films that Hollywood created worked to defeat the independence of the female protagonists. In truth, women made little real progress in the 1920s, and by the 1940s, aspiring career women were still limited to positions that were especially set aside for them according to traditional American ideas about home and family.

LEARNING FROM TELEVISION

In a country that professes to adore mothers, where moms are hailed with a national holiday and celebrated in song, and where young men allegedly use their mothers as the standard by which to choose their wives, why are autonomous women so hated?

The twentieth-century debate over woman's place and the meaning of her experience in the home as a wife and mother was first articulated by novelist Philip Wylie in 1942, when he characterized mom as a kind of vampire. The debate intensified several years later, in 1947, with the publication of *Modern Woman: The Lost Sex* by Ferdinand Lundberg and Marynia Farnham. Lundberg and Farnham believed that part of the "woman problem" resulted from the decline of the home as a social institution. Women, they declared, were off track, and their neurotic reaction to male dominance had cast them adrift in a sea of contradiction.

The "true woman," in contrast to the feminist aberration, was, in her role as a wife and mother, a sterling example of self-acceptance and self-fulfillment. The independent woman was a "contradiction in terms."

Representations of suburban life on television played an enormous role in promoting traditional family values because advertisers viewed the housewife as the ideal shopper. Television came of age during the 1950s, and as a home-based form of entertainment, it became the perfect vehicle for selling the suburban lifestyle. To a national audience, it presented images of good housekeeping, the newest appliances, and the latest model cars. Programs and advertisements offered consumer items and behavioral models that were designed to be sold to all members of the family.

In the 1950s the role of the American housewife in the nuclear family was glorified by television programs like *The Adventures of Ozzie and Harriet, Leave It to Beaver, The Donna Reed Show,* and *Father Knows Best.* These shows focused sympathetically on the struggle of commuting husbands to maintain their wives and children in pastoral splendor. In these programs, the mother was the ideal homemaking wife, dressed in a flowery shirtwaist, apron, and high heels. Supper was always on the table on time, and the mother's sole concerns were to provide a spic-and-span home for her husband and children, and teaching her children "proper" behavior. On television "true women" always put their families before themselves to the extent that career and other interests were precluded. Later, more realistic shows presented macho chauvinists in situations that influenced viewers on a variety of attitudes toward Jews, African Americans, and feminists. In an episode of *All in the Family,* the character Archie Bunker comments, "If your spics and your spades want their rightful share of the American dream, let them go out there and hustle for it, just like I done. . . . I didn't have no million people marchin' and protestin' to get me my job." This bigoted outburst was offset by his wife Edith's humorous response, "No, his uncle got it for him." Archie's views represented his inability to comprehend the new lifestyles of his daughter and son-in-law.[9]

Neither male nor female is attractive in this series since it was meant to satirize prejudice. Edith is always making a spectacle

out of herself. Her overly rouged cheeks, shrill laughter, and shoddy clothing make her a kind of a clown—a lovable female grotesque. Her world is always topsy-turvy. True to the conventions of the comedy of marital combat, despite his limitations and beer belly, Archie remains the center of attention. It took writer and director Norman Lear three years to convince the nervous networks that America was ready for *All in the Family*. To the surprise of the major advertisers, the show got a substantial share of ratings, and their worst fears were not realized. The show made it possible to produce situation comedies like *Maude* and *The Jeffersons*, which took a hard look at real family problems.

In just half a century, television has become a global power that has a profound impact on everything we do and think. There are now more than 750 million television sets in almost 160 countries, watched by more than 2.5 billion people. There is no escape from the way television affects our daily existence. Advertisers spend about $21 billion a year on television; a thirty-second commercial on *The Cosby Show* cost $440,000 in 1987, and *Fortune* magazine reported that the show generated around $75 million in revenues for NBC per year.[10] Television has helped to win elections and shape opinions. It's big business.

Television breeds many controversies. For example, does it promote violence? Are nude talk shows on cable and the soft porn shown on some soap operas eating away at the core of American morality? What about the lyrics and sexual innuendoes in MTV rock videos? What about the fundamentalist evangelists, filling the air with consternation, outrage, and pleas for more money to fight against feminist causes? Television, like films, has become an essential part of our lives. It has widened our horizons as viewers but at the same time has exposed us to some of the most incredible nonsense.

Many advertisers avoid controversial programs and stipulate that their products must not be advertised in any program that mentions abortion, homosexuality, and gun control or that disparages religion. To ensure that advertising revenues are maintained or increased, producers must conform to what major corporations want. This situation causes self-censorship and shapes the content of much of what we see and hear.

Thus, the hidden premise of sex discrimination is revealed through the inherent sexism in traditional modes of representing motherhood in both films and television programs. In posing the question "What is feminism?" I am asking readers to use their basic intuition, experience, and intelligence to make an independent evaluation of the subject because it is so entangled in the meshes of sexual difference. Doing so takes courage, and it involves a willingness to grow and change. It means questioning entrenched prejudices, obdurate opinions, and ways of thinking you may have been committed to for a long time.

This brief summary of the media is intended to show that the more you learn about the subjects of both feminism and the media, the more equipped you are to understand and make judgments about them. As you have seen, it has become increasingly more difficult to articulate what feminism is as the gaps between women have widened. Certain factions have attempted to end prematurely some of the debates that still need to be developed by women to conduct fruitful talks about the issues, including our different positions.

The groundwork that was been laid for women today by the original women's reform movements is invaluable. Many of the voices from those movements still speak to us from old film clips, feature movies, radio and television interviews, and the pages of books. By reading between the lines, one can often see the patterns of discrimination manifest in this documentation. The story of feminism—its history, success stories, comic disasters, current problems and trends, and possible future—is a story told by the men and women who are making it happen. What women want has changed over time and from generation to generation.

Notes

1. Robert M. Entman, *Democracy Without Citizens: Media and the Decay of American Politics* (New York: Oxford University Press, 1989).

2. Frances Fox Piven and Richard A. Cloward, *Regulating the Poor: The Functions of Public Welfare* (New York: Vintage Books, 1971).

3. In addition, RKO Radio Pictures, Columbia Pictures, Universal Pictures, United Artists, Selznick-International, and Walt Disney were active during this period.

4. Jeffrey Weeks, *Sexuality* (New York: Routledge, 1989), 13.

5. Christine Holmlund, "When Is a Lesbian Not a Lesbian?: The Lesbian Continuum and the Mainstream Femme Film," in *Camera Obscura* nos. 25–26 (January–May 1991): 145–78.

6. Judith Mayne, *Directed by Dorothy Arzner* (Bloomington: Indiana University Press, 1994), 63.

7. Janet Maslin, "When Hollywood Could Be Naughty," in the *New York Times*, 4 February 1994, C–1, C–16, C–17. It should be noted that for more than half a century, Hollywood has had enormous power and influence in shaping the way Americans see the world. Take, for instance, D. W. Griffith's classic film *Birth of a Nation*. Based on a racist novel, *The Clansman,* by Thomas Dixon, it was a significant milestone in American cinema history, with its glorification of the hooded vigilante horsemen who made up the Ku Klux Klan and rescued helpless white women and children from savages. This film is a product of a culture that appeals to an exclusive market: white racist Christians. It has had a uniquely privileged place in the teaching of film history because of its technique if not necessarily its content, and only recently have revisionists been able to present it in the context of its time.

 It is indeed ironic that Oscar Micheaux's *Within Our Gates,* a rare example of a surviving feature film directed by an African American, is designated a "race movie"—a film made specifically for a black audience. This startling film, which has not been seen for more than seventy-five years, contradicts all the ideas presented in Griffith's *Birth of a Nation.* Featuring a mixed-race cast, it confronts racism head-on through a story of a young African American woman who seeks a northern white patron for a southern school for African American children. It shows scenes of lynching and an attempted white-on-black rape that may have been a response to Griffith's film. In a similar fashion, Julie Dash's film *Daughters of the Dust* was made from an black aesthetic and portrays an African American woman's reality.

Each of these films produces a variety of responses and is a compo-
nent of "spectacle or image society." Griffith's creation is a powerful self-
portrait and shows how racist the industry could be.

8. Whitney Otto, *Now You See Her* (New York: Villard Books, 1994), 124.

9. Ibid.; Entman, *Democracy Without Citizens*, 200.

10. Entman, *Democracy Without Citizens*, 140.

5

The Facts of Life

The transition from World War II—the era of Rosie the Riveter and national day care centers—to the thirteen-year period that Betty Friedan characterized as the time of the "feminine mystique," was a "dark age" for many educated white middle-class housewives who knew that raising a family was not a lifetime job. Working-class women, however, didn't have the luxury of choice: they had to work.

For women of this century, the most influential event, besides gaining the right to vote, was the December 7, 1941, sneak attack on Pearl Harbor by Japan. It dramatically altered American life and permanently shattered the social fabric of women's lives by shifting their roles decisively. Suddenly women were part of the war effort, helping to make guns and tanks and fueling the fight for democracy.

By 1943, more than 4 million women were employed in munitions work alone. Fifteen million more joined the work force, doing such formerly masculine jobs as coal mining, operating mechanical hoists, greasing machines, and firing and cleaning antiaircraft guns. Ladies' rooms were installed in factories, and child care facilities were provided. Women were now 36 percent of the labor force, and to the dismay of their male supervisors, they worked faster than men, had fewer industrial accidents, and did less damage to tools and materials.[1] Wartime opportuni-

ties may have broadened the life chances of some women significantly, but they did little to alter the fundamental structure of inequality from which women suffered.

Women who took advantage of the war effort to follow their dreams were abruptly brought back to reality when the men returned home. In the postwar era they were displaced from industry. In June 1945, 95 percent of the female war workers planned to stay in their jobs. But with 11 million veterans coming home to old jobs that had been reserved for them, it was essential to displace the women. Within two years, more than 3 million women had resigned or been fired from their positions. But turning the clock back proved harder than expected. Many women who were normally barred from effective competition were earning good wages and had discovered that they liked their independence and having their own money to spend.

Hollywood responded to men's anxieties over the situation by producing film after film that attempted to rehabilitate women for home and family. Women were told to give up their jobs and their independence and devote themselves to the domestic needs of the returning war heroes. William Wyler's *The Best Years of Our Lives* (1946) depicted the lives of three complex women only in terms of the "veteran problem" and the impact of their liberated lifestyles on their soldier mates.

In the film, Homer (Howard Russell), a sensitive ex-sailor whose lost hands have been replaced by metal hooks, is having difficulty adjusting to civilian life. First, he can't deal with the fact that his fiancée, Wilma (Cathy O'Donnell), is squeamish about his disability. Then he suffers because he knows he will never get his hands back. For audiences, Russell symbolizes the disfiguring conditions resulting from the war. His disabilities evoke feelings of pity and fear.

Ex-bombardier Fred Derry (Dana Andrews) returns home to find that his wife, Marie (Virginia Mayo), has become a nightclub singer and is cheating on him. He takes the only job he can get as a lowly soda jerk in a drugstore. Former infantry sargent Al Stephenson (Fredric March) comes home to find a changed world. When he went off to war he was a respected banker, husband, and father. When he returned he was an unemployed former infantry sargent. While he was away, his wife, Milly (Myrna

Loy), managed to raise her children and get a glimpse of being an independent woman. Upon her husband's return, she had to regress back to the role of the self-sacrificing wife who puts aside her newly experienced autonomy to buoy her husband's flagging self-esteem—she even tucks him into bed.

The overt text of the film involves sacrifice in war. If you are a man, you make sacrifices for your country by giving up life, limb, and property. If you are a woman, you sacrifice your feminine role by becoming employable and independent. The subtext of the film reveals an interesting paradox: when a man returns home from war, his sacrifice entitles him to take back the job he once had, as well as reassert his masculine perogative vis-à-vis women. Therefore, during demobilization, women were encouraged to leave their war-assigned jobs and go back to being girlfriends, wives, and mothers. By doing so, more men replaced women on the job. After the cataclysm of World War II, this was a very reassuring formula for reestablishing security. Al never considers the difficulty Milly may be having adjusting to his return.[2]

In one scene, Fred rushes to Homer's defense and punches a stupid superpatriot through a glass display case. He is not so much defending Homer as venting his anger at being stuck in a degrading job. We know that another source of his feelings of impotence and failure is his high-living wife who looks down on him. Eventually, the couple separate and Fred becomes interested in his buddy Al's daughter Peggy (Teresa Wright).

The drama of physical and spiritual rehabilitation in which the nation was engaged is played out through Russell's character. Wilma, however, is a conventionally "good woman"—loyal, chaste, and principled—unlike Marie, who is selfish and insensitive because she wants to pursue her own dreams. Homer's fears force Wilma to give him an ultimatum, and he finally removes his hooks in front of her, exposing his handless forearms that leave him "as helpless as a baby." To his immense relief, he finds that Wilma is supportive, and they embrace. Previously, Homer had felt too ashamed and demasculinized to hold her.[3]

The Hollywood postwar film genre simultaneously criticizes and reinforces existing cultural ideas and stereotypes. On the most immediate level it tells women that their place is in the home,

taking care of their husband and families. On another level, it intimates that not all women are satisfied with being wives and mothers. Ultimately, the pictorial snare that is meant to convince the audience that reestablishing the home is the resolution to the "veteran problem" backfires because of their knowledge that Fred's wife, Marie, is an agent of change and progress who is not content to repress herself and return to an earlier symbolic order of masculinity and femininity.

Recognizing the importance of this paradox in the context of what it means to be a woman, Penny Marshall's revisionist film *A League of Their Own* (1992), starring Geena Davis, Tom Hanks, and Madonna, tells the war story from a white woman's vantage point. The movie relates the tale of the All-American Girls' Professional Baseball League, founded in 1943, when it appeared that men's baseball would be a casualty of the war. The league was crucial to the financial survival of the major baseball franchises. The film opens with a Chicago candy-bar magnate who sends his agents scouting the countryside for women who can play ball. In rural Oregon, the scout finds two sisters, Dottie and Kit (Davis and Lori Petty), and brings them back to Chicago to try out with a lot of other hopefuls, including those played by Rosie O'Donnell and Megan Cavanaugh.

A onetime baseball great whose drinking has ruined his career is recruited to coach the team. It takes Jimmy Dugan (Hanks) a few weeks to dry out and get interested in his players. By the end of the season, the Rockford, Illinois, team is in the World Series against Racine, Wisconsin. *A League of Their Own* shows that after years of supporting the image of the docile little woman who sat at home, American society suddenly needed women who were competent and could be trained to do hard, skilled work.

The story is told from the perspective of Dottie Hinson, the Geena Davis character, who is now older and taking a trip to Cooperstown for ceremonies honoring the women's league. In a flashback, we learn that Dottie never took women's baseball seriously, even though she was the best player of her time. In her own mind, her life was simply on hold until her husband came back from the war. Dugan, the coach, tells her she "lights up" when she plays baseball. But this cuts no ice with Dottie.[4]

Marshall's film reveals the ambiguity of women's position in

society. It shows the tug-of-war women experienced between old and new roles, traditional and pioneering values. In a bittersweet and engaging movie, Marshall tells the stories of the players, their coach, the game, and the way this chapter of woman's liberation fits into American history and redefined what women of this generation wanted.

During the 1940s and well into the 1950s, the "feminine mystique" created the popular myth that a woman's highest calling was to be a housewife and mother. Women, particularly white middle-class wives, tried to live up to this image by making themselves attractive to men, taking care of their husbands, and assuming responsibility for raising children even when they had to work. The patriarchal belief system reinforced what writer Virginia Woolf characterized in 1931 as "the Angel in the house" syndrome. Even today, the long "shadow of her wings" still weighs heavily on many women, who assume that being feminine means taking on these responsibilities.

Despite the "Angel's" spellbinding image, the proportion of working women doubled between 1940 and 1950, and, for the first time, the majority of working women were married. It was economics, however, rather than ambition, that drove American women into the work force.[5] By 1955 the average wife worked until her first child was born and went back to work when the last of her children had started school.[6] It is not surprising that these working mothers were relegated to low-paying jobs and were discriminated against in the workplace.

RECLAIMING BODIES AND SOULS

"The female body," author Susan Rubin Suleiman stated, holds a central place in the Western cultural imagination.[7] The fact is that women are self-conscious about their bodies and confused by how men write about, paint, and discuss female bodies. So the question of women's bodies and women's sexuality is a highly loaded one. In this chapter I reflect on additional considerations that may explain some of the reasons for the disorientation women experience in relation to body and soul. The sad truth is that our culture has produced many false and sentimentalized images of women. One immediately thinks of biblical stories,

fairy tales, religious and secular art, and the Hollywood stars. These conceptions create conflicts within women between who they are as individuals and what society wants them to be that they may carry into their own practices.

Witness the lives of women of color, who have been described only by a space within whiteness—for example, Olympia's maid in Manet's *Olympia* or Butterfly McQueen in *Gone with the Wind*. They are always in a white story, not in a story of their own or in which they are the narrator, as in *Waiting to Exhale*. Few white feminists have studied black, Latino American, or Asian American culture and social organization in the United States. As a consequence, much of the analytical framework developed by the feminist movement in this country during the 1970s applied largely to women who were white and middle class. Ironically, the emerging feminist movement drew many of its metaphors, such as the idea that women and blacks get their identity and status from white men, from the black civil rights movement.[8] Nevertheless, the continuing struggle for human rights and feminism's recasting of women's traditional roles have been central forces in redefining what women of various classes and races want now in restoring women's lost identities. A striking example is Charlayne Hunter-Gault's fascinating first-person account *In My Place*, a moving story of what it means to be a woman of African descent in America.[9] In this book, she presents abundant evidence of the importance of her heritage in creating a perceptual framework that shaped her work as an exceptional reporter.

And many other creative challenges have moved women along in our journey to greater consciousness of diversity. For example, Ntozake Shange's play *For Colored Girls Who Have Considered Suicide/When the Rainbow Is Enuf*; Terry McMillan's novel *Waiting to Exhale*, which gives us insights into how various black women feel about their lives; and anthologies like *This Bridge Called My Back* and *Making Face, Making Soul*, which encourage a lively dialogue among various groups of women and men of all races and creeds, have all contributed to teaching white feminists tremendous lessons about the struggle of diverse individuals to connect with each other in a productive way.

Occasionally Hollywood films, such as Elia Kazan's *Pinky*

(1949), starring Jeanne Crain, Ethel Waters, Ethel Barrymore, and Nina Mae McKinny, when read from a feminist perspective, make some strong points about the struggle against both racism and sexism. *Pinky* is the story of a young black nurse, who has been "passing for white" in the North, and her return visit to her hometown in the South. Ethel Waters plays the Mammy figure, a stereotype of a kind of female eunuch, and Jeanne Crain, a white actress, plays her granddaughter Patricia Johnston (Pinky). Ethel Barrymore, one of the great ladies of the theater, plays the white matriarchal plantation owner, Miss Em.

Kazan's representation of women as a group reflects the "normal" status of women in the South during the late 1940s and early 1950s. Right from the start, he establishes a gaze that constantly centers on Pinky. Spectators follow Pinky, who appears to be white and is carrying a battered suitcase, into a ramshackle town. The dirt roads that she walks along define the contours of the various differences that will soon shake the very foundations of the society she has returned to. William Lundigan plays Tom, Pinky's white doctor boyfriend. But the film's real focus is on the three strong female characters. The worldview of love and marriage as the longed-for ideal in the film captures the audience's imagination in the first few frames and misleads spectators into thinking that marriage will be the happy ending for Pinky.

Kazan's strong contrasts of light and dark create a sense of disorientation and disequilibrium that mirror Pinky's feelings about coming back to the South. The institutions of family, class, and race, represented by Mammy and Miss Em, prop up the intolerable contradictions of southern society—black and white. The representations of the older women establish the repressive and hierarchical relationships between the races and sexes. But as the film gradually discloses, Mrs. Johnston and Miss Em have created their own special relationship, built on mutual respect and a genuine understanding and affection for one another. Kazan shows that their friendship is disruptive to the repressive containment of southern society, but what is more important, he shows us how the unique relationship sets Pinky on her journey toward liberation.

Although some blacks consider *Pinky* a racist film because it features a white woman in a black role, Kazan's film attempts to

show how it feels to be black, as well as white, and what it's like to move forward for civil rights and for oneself as a woman. Despite the fact that Kazan chose not to deal with the issue of miscegenation, *Pinky* may be seen as a "womanist" film. What comes to mind in analyzing it from a feminist vantage point is Gloria Anzaldua's term *interfacing*, which means "sewing a piece of material between two pieces of fabric to provide support and stability to collar, cuff, yoke." Interfacing, as I am doing in this interpretation of *Pinky*, requires the provision of a space where people of all races, classes, and ethnicities can come together and share their experiences by respecting their differences. The film, for all its flaws, leaves audiences with an image of women's liberation and black empowerment that is difficult to equal.

A PERILOUS PASSAGE

Feminists' efforts to pioneer a new understanding of what women want raises questions about what it means to be a woman. The logical place to begin exploring this issue is with girls and gender bias. Nothing could be less natural than the patriarchy's construction of the feminine, as Simone de Beauvoir observed. Unlike the inherent biological condition of "maleness" and "femaleness," the gendered terms *masculine* and *feminine* designate historically contingent interpretations of the meanings of gender as a social and psychic construction tied to material conditions.[10] From birth onward, sexual stereotyping tells girls to be "sugar and spice and everything nice." A new report by Girls, Inc., of New York, an educational research corporation, entitled *Past the Pink and Blue Predicament: Freeing the Next Generation from Sex Stereotypes*, stated that girls are actually similar in personality to boys before they reach puberty.[11]

It is during adolescence that girls' self-esteem and curiosity about the world are severely eroded. The physical changes that occur in girls during adolescence are dramatic and obvious. Girls begin their menstrual cycle and experience their first bleeding, which marks their passage into womanhood and the capacity for reproduction. Girls of all colors and classes share this experience, which can be frightening for those who are ill prepared to assume their new status.

In her book *The Women's Room*, Marilyn French uses the character Mira to describe the precise moment that brings women closer together and marks the end of their childhood:

> At the end of her fourteenth year, Mira began to menstruate and was finally let in on the secret of sanitary napkins. Soon afterward, she began to experience the strange fluidities in her body, and her mind, she was convinced, had begun to rot. She could feel the increasing corruption, but couldn't seem to do anything to counter it. The first sign was that when she lay in bed at night, trying to move ahead of her disposal of both God and Perfect Order to something more usable, she could not concentrate.[12]

Menstruation separates girls from boys and turns girls into sexual beings. Going through puberty makes girls feel self-conscious and unsure of themselves. They worry about pimples, body hair, how their breasts are growing, and how they smell. Girls begin to think about boys and to talk about sex with their friends, and they are at a great risk of unwanted pregnancies, getting involved with drugs, or dropping out of school. Under patriarchy, these rites of passage from girlhood into womanhood require us as a society to teach young women to postpone pregnancy, which means that they must begin to deal with their sexual desires and those of men, as well as with their fantasies about the allure of teenage motherhood. So the language of victimization is built into the sex education that girls receive and that represents females as the actual and potential victims of male desire.[13]

Gloria Steinem and other "protectionist" feminists (those who stress how women are disadvantaged by the patriarchal society) argue that girls lose their confidence when they enter adolescence. They contend, first, that male aggression throughout childhood reinforces the girls' status as female. Girls are teased, tickled, touched when they don't want to be, and violated in ways over which they have no control, since their verbal expressions are treated as meaningless. The wolf-pack mentality of teenage boys, who act in a group to make fun of girls and violate them, is epidemic. Swimming pools have become unsafe, and high schools have become testing grounds for sexual aggression. Among adolescent boys, it's become a sport to rob girls of their confidence and self-esteem. Carried to its extreme, this dreadful sexism reinforces the belief that women are subordinate to men.

Sadly, this belief, in turn, leads some men to think they have the right to abuse women.

The true nature of this prejudice is made clear by such incidents as "raping for points." In her article "Crying Rape!" Lynn Wenzel cited the 1993 case of the Lakewood, California, High School "Spur Posse" gang to illustrate the ever-present connection between jock mentality and sexual violence.[14] Named after the San Antonio Spurs basketball team, the "Spur Posse" raped girls as young as ten for points. These were "nice, white middle-class boys," who believed that girls should "lock themselves up in a cage if [they] find the world dangerous."[15] Clearly, the boys intended to use their superior numbers and strength to enforce their own will.

Where are boys getting these ideas from? There are several schools of thought on this question. Feminists argue that these ideas come from patriarchalism, with its fantastically ferocious images of masculinity. Neo-Darwinians claim that such male aggression is biologically determined. Feminists believe that sexual violence is a means of controlling women's bodies, then using them as objects of gratification regardless of how it hurts. And Lakewood High is not the only instance. Many readers will be familiar with accounts of the Glen Ridge rape case, for example, in which several New Jersey high school football heroes sadistically raped and degraded a mentally retarded girl using a broom stick and baseball bat.

Defending rape reinforces the message that it's all right for red-blooded American boys to violate girls in our society. The question we should be asking is, "How can such violent behavior be justified and explained away?" To Susan Brownmiller, one of feminism's most articulate voices, the fear of rape has cemented patriarchy itself, serving, "from prehistoric times to the present, [as] a conscious process of intimidation by which all men keep all women in a state of fear."[16]

Girls do need to be protected, as Gloria Steinem and others have said, especially when men simply either stand by and let abusive things happen or participate in such actions themselves by performing or protecting such behavior. And Camille Paglia is also right to insist that "we must eliminate social injustice where we can." How to do so remains an unsolved social prob-

lem. The question remains: If we, as mature individuals, are not willing to express an opinion on fundamental human rights, then have we, in effect, failed as human beings?

One thing that really sticks out now is the growing number of groups and individuals of both sexes who reject what they see as an outdated identification with the victim-survivor. Classical feminists really find this development disturbing because a community that cannot take responsibility for the actions of its citizens and shifts the blame to those who are victimized by them is in deep trouble. Take, for example, the case of Jane Roe, who Susan Cheever, in a review of the autobiography of Norma McCorvey (the real Roe in *Roe v. Wade*), asserted "is not a symbol we would have chosen."[17] What does this statement actually mean? Almost everything in McCorvey's story could have happened to many young women in a country where the rights of women and children are not vigorously defended. McCorvey was an unwanted child, a failed mother, a reform school graduate, a worker at dead-end jobs, and a lesbian. Although she isn't a feminist Joan of Arc, she is a survivor who, despite her lack of privilege and her journey through poverty and violence, gives us a real picture of how women are violated simply because they are women.

Women whom Susan Faludi labels "Pod feminists" belong to a third wave who call themselves feminists but don't share the concerns of classical feminists. Many of these individuals, like Cheever, insist that women have to stop seeing themselves as victims, and they believe that this is the only way that women can command authority. But most of us would agree that it is difficult to do so when you don't start from a basis of self-confidence and a sense of your ability to act effectively in the world. Such differences of opinion are significant because they reflect more deeply rooted national sentiments concerning the implied contract that exists between the individual and the state.

The controversial nature of these differing views has sped the development of new feminist factions. These popular-culture feminists want to avoid an outbreak of hostilities between the sexes and economic classes. What they don't seem to realize is that feminists have been struggling for equality since the

founding of the Union. The reactions of third-wave, neoconservative, and counterculture feminists run the gamut of American fears. One can trace them back to the debates of previous generations regarding "woman's place." Domestic tranquillity and future relations between the woman of the 1990s and her man are at the heart of this renewed dispute. Taking a stand on behalf of women like McCovey requires engaging in open warfare with the victimization of girls and women in a patriarchal society that discounts their violation and then blames them for it.

"The sexist, misogynist, patriarchal ways of thinking and behaving that are glorified in gangsta rap," explains bell hooks, "are a reflection of the prevailing values in our society, values created and sustained by white supremacist capitalist patriarchy."[18] Many books and movies represent women as vain and shallow, bitchy, or just a little ridiculous—helpless fairyland princesses waiting to be rescued by the white knights or handsome princes who defeat or kill the bad queen. Without authentic protection from the real abuses of patriarchy, most females are subjected to the desires of abusive males. "It's men who are responsible for battery," stated Robert L. Allen and Paul Kivel of the Oakland Men's Project, "and for stopping male violence."[19]

During adolescence, this gender socialization can reach crisis proportions, and parents who try to intervene find themselves squarely up against the system of sexual-identity imprinting I referred to earlier in this chapter. This initial social conditioning is hard to break and frequently leads to disturbing problems for girls and boys who have grown up in this setup. Evidently, such powerful encoding contributes to the sense of helplessness that many girls express. Third-wave women, such as Paglia, Naomi Wolf, and Katie Roiphe, who blame the "victim" for the predicament she finds herself in, don't seem to take this fact into consideration. By the same token, "difference feminists" (those who believe there are inherent differences between males and females) are not facing up to many women's self-destructive and bizarre acting out, which contributes to their status as casualties of the sex wars.

FEMALE DESIRE AND IDENTITY

The establishment of her own identity is crucial to a girl as she strives to assert her independence. She forms close friendships and spends her free time doing things like shopping for clothes, applying makeup, and giggling with her friends about a variety of subjects, especially boys. At this stage, "an adolescent will attack her mother for just about anything," psychotherapist Carol J. Eagle noted.[20] Psychotherapist Irene Javors suggested that patriarchy requires "symbolic matricide" for adolescents of both sexes to move on in their lives and claim their own identities.[21]

The work of Jean Baker Miller and Carol Gilligan at the Stone Center of Wellesley College and the Harvard Project for Women is essential to discussions of the observed mental and behavioral differences between boys and men and girls and women. Both Miller and Gilligan have found new ways of looking at women's growth. An examination of separation theories of development tends to confirm that they perpetuate our culture's devaluation of women, since all psychological progress is seen to occur within the context of growth away from the mother. Miller and Gilligan concluded that this type of matriphobia leads to "mother blaming" and rejection of what feminist philosopher Marilyn Chapin Massey called the "feminine soul" in our modern society.

Unfortunately, feminism's struggle against patriarchy takes place almost entirely within patriarchy. In her latest book, *Terrible Honesty*, Ann Douglas proposed that the very formation of modern culture is based in matricide.[22] She believes that disempowering the mother is a touchstone of modern society. The theory of the mother-daughter plot in all its variations, however, goes back to ancient times. One has only to turn to Sophocles's "Oedipus" story or those of Iphigenia, Electra, and Clytemnestra or of Demeter and Persephone to reframe traditional familial structures from a feminist vantage point. In the Electra story, the daughter sides with her father against her mother, despite the fact that the father has had her sister killed to launch his ships. Separation and loss are inevitable in patriarchy within the context of motherhood and daughterhood. Theoretically, this bond must be broken if women are to bond with men.

"The first discourse, sexuality as violence," explained feminist social psychologist Michelle Fine,

> is clearly the most conservative and equates adolescent hetero-sexuality with violence. At the 1986 American Dreams Symposium on education, Phyllis Schlafly commented, "Those courses on sex, abuse, incest, AIDS, they are all designed to terrorize our children. We should fight their existence, and stop putting terror in the hearts and minds of our youngsters." One aspect of this position, shared by women as politically distinct as Schlafly and the radical feminist lawyer Catharine MacKinnon, is the view that hetero-sexuality is essentially violent and coercive.[23]

Clearly, the theme of sexuality as violence dominates feminists' discussions and illustrates the ambivalence many women feel in dealing with the topic of female sexual victimization. Perhaps the taboo against openly discussing female desire contributes to this problem. As Fine pointed out, sex education curricula authorize (1) the suppression of a discourse of female sexual desire, (2) the promotion of a discourse on female sexual victimization, and (3) the explicit privileging of married heterosexuality over other practices of sexuality.[24]

Girls depend on others for their self-definition and affirma-tion, and as a result of their early conditioning, they generally conform to other people's demands, rather than develop their own autonomy. Under patriarchy, they have learned to relate to the world in terms of femininity and masculinity. "Pretty women seem to appeal to us as more dependent and childlike," admit-ted William Dean Howells. The cult of femininity and men's focus on the female body has created a society that overvalues beauty and encourages girls to downplay their intelligence. Men have taught women to regard themselves as sex objects; as a result, many women's pride is centered on their physical appear-ance, on not their accomplishments and character.

THE PATRIARCHAL IMPERATIVE

As I have shown, the defining motif has been the sex-gender sys-tem, with its emphasis on feminine and masculine behavior. It is so because Freud's ideas, based on formulations arrived at from his clinical study of psychoneuroses at the turn of the century,

became the model that defined the acceptable forms of sexuality in our society and culture before feminism. This model included gendered modes of conduct that were a fixed "norm," so that any other modes of conduct, such as those of gay men, lesbians, and transsexuals, were deemed unnatural. Freudian psychoanalytic theory constructed a negative model of engenderment that is intimately tied to sexual politics. Psychoanalytic feminism has done much to call Freud's assumptions into question, which has led to a series of questions about motherhood and female identity in relation to the sex and gender system.[25] Feminist scholar Marianne Hirsch theorized that Freud's notions of the "pre-oedipal closeness to the mother, oedipal separation and attachment to the father, the subsequent transfer of that attachment to another male love object and the wish for a child" are often combined with many forms of resistance against this course of development and a continued "female identification."[26]

Reading Freud, as many feminists in the 1970s did, revealed that his entire theory of the human psyche was conditioned by his concept of penis envy. Rather than illuminate a reality common to both sexes, for example, childbirth and mothering and the "reality of connection," as Gilligan argued, Freud located male sexuality in a single bodily organ and explained women's sexuality in terms of the lack of that organ. Most feminists agree that the sexism of Freud's theory assumes male superiority and female subordination.

Early feminists were among the first to have the courage to take a wider view of gender politics and ideology. They started with the bedrock of patriarchal masculinity by rethinking the female body in relation to female sexuality. Mary Daly's book *Pure Lust* suggested that women's difference from man is so distinct that the male-defined Western concept of the human species does not apply to her. Among French feminists, a similar concept emerged. Luce Irigaray found that male definitions repress differences and reduce the woman to the universal one—man. The separation theories of Daly and Irigaray, however, remain striking and problematic because they seem to echo those of nineteenth-century philosophers like Jean Isoulet, who believed that women were spiritually superior to men.[27]

During the 1950s, most teenagers in high school didn't stop to

question whether Freud's theories made any sense. The black-and-white sex education films they were shown in segregated classes only served to reinforce cultural stereotypes of masculine and feminine behavior. Adolescents who dared to question the status quo were dismissed as wiseacres, crackpots, or worse yet, perverts. Determinist theories have lingered on, and even today, Paglia is infatuated with concepts of mastery and sexual differ-ence. Over time, Darwin's theory was misunderstood to be a social theory when it really referred to genes, and this misper-ception led to no end of speculations about biology as destiny in the 1980s and today.

Difference feminists, who include Gilligan and linguist Deborah Tannen, see men and women as functionally a "differ-ent species." The question of biological determinism is hotly debated by Paglia, Andrea Dworkin, and Robert Wright. The theme of sociobiology and sexual behavior is the main focus of Carol Tavris's book *The Mis-measure of Woman*, and it has been expanded by Anne Fausto-Sterling, author of *Myths of Gender*.

These are issues that few feminists agree on. Gilligan's book *In a Different Voice*, which some hailed as the "feminist book of the 1980s," supported the view that women's moral and ethical development is significantly different from men's.[28] Gilligan found that a third of the women she tested spoke about their moral reasoning in a way that was different from the culturally validated male models of "truth" and "justice." On the basis of her sample of well-educated white middle-class subjects, she concluded that women seem to have an ethical value system that takes into account the particulars of people's lives, as well as responsibility for others, rather than loyalty to an abstract prin-ciple, which appears to be the hallmark of the male model. Unfortunately, feminist research of this sort has been distorted by certain neoconservative factions, who then use their brand of it to proclaim that feminism encourages female supremacy.

Actually, both women and men have written provocative and controversial narratives regarding the nature of sexual and polit-ical relationships. According to French, men are obsessed with female reproduction. "The attitude that women alone produce children pervades all societies and all levels of mentality, from the simplest to the most sophisticated," she pointed out.[29] But there

are cultures in which men are believed to be the primary contributors to reproduction; it is their bodily "substance" that produces children in the bodies of females. Currently, it's impossible to escape neo-Darwinism. Psychobiologist Robert Wright, author of *The Moral Animal*, contended that "human males are by nature oppressive, possessive, flesh-obsessed pigs."[30] As Wright's and Paglia's works demonstrate, the notion of trying to prove men's inherent aggressiveness is not new. "The ideas of Victorian scientists," stated writer Leora Tannenbaum, "are regaining popularity in the 1990s."[31] The theory that evolution has made men and women fundamentally different has been kicking around since the 1850s. But striving to justify aggressive behavior among human males hardly substantiates that males are "naturally" dominant over females. "It is absurd to expect studies of animal behavior to provide profound insights into the complexities of human decision-making," Tannenbaum asserted.[32]

bell hooks took up this subject in her essay "Seduced by Violence No More," in which she discussed the difficulty that black men and women have rethinking masculinity and opposing patriarchy:[33]

> Black males, utterly disenfranchised in almost every arena of life in the United States, often find that the assertion of sexist domination is their only expressive access to the patriarchal power they are told all men should possess as their gendered birthright. Hence it should not surprise or shock that many black men support and celebrate "rape culture."[34]

hooks pointed out that the media do not pay much attention to "progressive, black male voices in rap or cinema [who] rap against rape."

hooks further stated that "black females must not allow ourselves to be duped into supporting shit that hurts us under the guise of standing by our men. If black men are betraying us through acts of male violence, we save ourselves and the race by resisting."[35] This is difficult advice for many black women to follow because they often view self-protection as taking something away from young men and want to secure their affection. One teenage girl remarked, "If I ask him to use a condom, he won't feel like a man."[36]

Resisting this line of self-destructive thinking is difficult for all women, regardless of race, particularly when even so radical a figure as Andrea Dworkin seems to subscribe to the "biology is destiny" theory in asserting that male-female sexual intercourse involves inherent subjugation. To neo-Darwinians, regardless of which side they are on, men are genetically more aggressive than women. According to their logic, women use other equally inherent behaviors, such as flirting and blushing, to show sexual interest. But this sexual stereotyping doesn't explain why some women, who are said to be monogamous by nature, aren't. Nor does it account for sex workers—prostitutes—who enjoy their jobs and pursue their clients with enthusiasm. And there's a lot that exists in between the two images I have used as examples.

Actually, Wright's focus on the "madonna versus whore," dichotomy in his book reminds one of the beliefs of the early church fathers. His theory of genetic determination seems to be as full of holes as theirs was and as flawed as those of the essentialist feminist separatists who want to create a separate women's culture based on a belief in the uniqueness of the female. Neither Wright nor the difference feminists can explain heterosexual women who favor rough sex over snuggling up to a warm gentle man, gay and lesbian sado-masochistic sexuality, transsexuals, hot sex during pregnancy, and women who are sexually aggressive and dominant.

On the other hand, Allen and Kivel, the founders of the Oakland Men's Project, believe that heterosexual men participate in an "unspoken contract" and are socialized to act like men. They maintain that a growing number of men are critical of sexism, but are afraid to voice their concerns because they worry about being beaten up by other, less mature men.

The feminist rebellion against social conventions, together with women's increased sexual freedom, appears to have somewhat altered the basic roles between men and women. But in a country with a history of trying to accommodate both slavery and freedom, it is not surprising that shifts in manners and morals have not changed the sexual division of labor in which women assume most of the responsibility for home and children while men go out into the world to earn a livelihood. Wright and the sociobiologists suggest that this sexual division of labor is

due to "natural law," but Allen and Kivel's idea of patriarchy's "unspoken contract" contradicts this theory, as does bell hooks's position.

Feminist scholar Sheila Rowbotham stated that interpretations of the biological differences of men and women that were produced during the nineteenth century in the West are still used in capitalist society to control women. Author Hilary Rose contended that Marx did not see that "the production of people is . . . qualitatively different from the production of things."[37] In her book *Now You See Her*, novelist Whitney Otto argued that the real reason men are threatened by women's independence and intellectual interests is that women may refuse to take care of men or may do without them altogether.

The song "Wild Women Don't Have the Blues," by blues singer Ida Cox, voiced this idea in the black community long before Otto, a white woman, wrote her novel:

I've got a disposition and a way of my own,
When my man starts to kicking I let him find a new home,
I get full of good liquor, walk the street all night,
Go home and put my man out if he don't act right.
Wild women don't worry,
Wild women don't have the blues.[38]

In her book *The Mermaid and the Minotaur* (1976), Dorothy Dinnerstein argued that current family arrangements lead to boys' absolute dependence on their mothers, forcing them as adults to seek control of women. Dinnerstein's solution to this problem is to end the sexual division of reproductive labor. But Dinnerstein paid scant attention to the fact that girls are also entirely dependent on their mothers and failed to provide a sufficient explanation of how this dependence affects them.

Nancy Chodorow's book *The Reproduction of Mothering* (1978) discussed how the sexual division of labor encourages women to mother and the impact of mothering on the psychological development of girls and boys. Girls learn to develop relational capacities by internalizing their roles as caregivers, "reproducing" their mothers, while boys learn to reject the female aspects of themselves, such as nurturing and compassion, to adopt a masculine gender identity.

Sex-role ideology and socialization accounted for the roles children grew up with in the late 1950s and throughout the 1960s, as they do today. By the mid-1960s, the role models to which girls and boys were expected to conform by parents, religious institutions, schools, and teachers seemed, for the most part, to be ridiculous and outdated. The prim black-and-white movies that teenagers of the 1950s had watched in segregated classes always featured an authoritarian white male voice-over that explained how Jane and Tom should act on a date. This behavior included the no-petting sequence—nice girls didn't. But most nice girls did let boys touch their breasts because they liked the feeling.

Because girls did not make themselves the true subject of their inquiries, what underlies our present preoccupation with women's role in society is a generalized mistrust of what is feminine in us—"sugar and spice and everything nice, that's what little girls are made of," even if it isn't so. "Femininity," Brownmiller noted, "is a romantic sentiment, a nostalgic tradition of imposed limitation. . . . Biological femaleness is not enough."[39]

Brownmiller went on to say that femininity pleases men because it makes them appear more masculine by contrast. What unites many women and some men is the struggle against colonization by the dominant patriarchal culture, which thinks that the essential and fundamental sin of woman is to refuse the femininity it has defined for her. Women who want to keep their men have to worry about the size of their breasts and the shape of their buttocks, whether they have great legs, and if they have good hair and skin. Those who want husbands have to follow Clare Booth Luce's advice and turn their bodies into "mantraps."

Put in its simplest form, the predicament for liberated women has been and continues to be: How can I find meaning in a world that won't let me be myself? To grasp the nature of the problem and how it functions in a patriarchal belief system, it is important to understand that the balance of power between the two sexes is inherently uneven. Men control the armies, courts, bureaucracies, educational and religious establishments, channels of communication, and dominant sectors of the economy.

In her book *The Grounding of Feminism*, historian Nancy Cott

described how "domestic political society and culture" continued to orient women toward husband and family and caused many of them to be ambivalent about having both families and careers. Cott's astute study demonstrated that the rich diversity of women's experiences, like the River Nile, brings its wealth from a thousand sources. What feminism attempts to do is restructure the attitudes of both women and men about the proper place of women in society. Clearly, Elizabeth Cady Stanton's theory of women as a class with a collective right to individuality free of sex-role constraints is alive and thriving almost a century later in the vocabulary of the modern women's liberation movement, despite the beauty myth.

There is little doubt that patriarchal society overvalues its paradoxically shifting notion of female beauty. Given a choice between beauty and brains, most women would still choose beauty. Because of this preference, men have accused women of being narcissists. Narcissus is the mythical man who was so enraptured of his image reflected on the surface of a pool of water that he tried to embrace himself. It is man's glorification of the female body and the millions of images the mass media have produced that account for women's obsession with physical beauty. Women have been conditioned to be narcissists. They have learned that they will be loved and admired by the culture if they look like the patriarchal ideal. But this belief starts to break down when a woman grows up and is forced to accept her natural limitations.

PREGNANCY AND MOTHERHOOD

In the United States, motherhood is a mixed blessing for many women and a subject of much debate. Getting pregnant in a culture that claims to revere mothers should be a cause for celebration, and the nation has set aside a day honoring mothers. Nevertheless, Madonna's "Papa Don't Preach," with its archingly defiant line, "I've made up my mind: I'm keeping my baby," outraged Planned Parenthood of New York City because it suggested that the singer was telling girls that getting pregnant is cool, having the baby is the right thing to do, and don't listen to anybody who tells you otherwise. This reveals an inherent

conflict in our society regarding pregnancy. No wonder children are confused.

On another level, the Vatican and the fundamentalists with whom it shares a common ground, should have rejoiced. Here was a pop superstar supporting their pro-life position. Who cares about the fact that most teenage mothers with babies are on a path to permanent poverty because they can't support their babies or that the religious fundamentalists insist these girls have these babies but don't want them on welfare.

All this is confusing to adolescent girls whose sexuality is budding but whose ability to make adult choices hasn't matured. As it happens, Madonna's pro-choice lyric isn't necessarily an antiabortion statement. A teenage subculture, however, views Madonna's lyric "I'm keeping my baby," as a reinforcement of its perception that's its "cool" to be a mother. Forty percent of four-teen-year-old girls will become pregnant before they turn twenty.[40] To many adolescent girls, having a child announces that she is a real woman and is fulfilling her destiny. Unfortunately, they often do not have the psychological or social resources to fulfill the role of motherhood adequately, which leads to a host of problems I address in later chapters.

MENOPAUSE

Human females from adolescence on are driven by nature to be in touch with their bodies. As a woman enters her forties to fifties, she becomes aware of complex changes taking place in her body—an irregular period or an occasional hot flash. The term *climacteric* is used to refer to the phase a woman goes through in the transition from the reproductive to the nonreproductive stage of life. During this time, women's menstrual cycles may become erratic, and women go through a series of physical, emotional, and hormonal changes that may be disconcerting. *Menopause* refers to the final cessation of menses within the climacteric phase. It has been subject to distortions and misconceptions and is, as writer Ursula K. Le Guin maintained, "one of the very few topics to which cling some shreds and remnants of taboo." Even today, mention of the term evokes embarrassed laughter, particularly among men. In the United States, women

over age sixty-five are the fastest-growing segment of the population, according to Robert N. Butler, director of the National Institute on Aging.[41]

Most young girls can't wait to grow up. Getting older is a vital part of women's experience, but few of us think of it as a step along the path of the "change of life." Furthermore, although menopause is one of the most important stages in a woman's life, it received little attention until recently. For a number of reasons, a host of negative meanings are attached to the term. First, for many women menopause is a marker of growing older, and aging seems to evoke the fear of death in most of us. Second, the woman in middle- or old age has been presented by the media, if she is allowed to be visible at all, as the vicious mother-in-law, the spinster, the old-maid school marm, the maiden aunt, or the libidinous middle-aged woman (such as Mrs. Robinson, in the film *The Graduate*). Furthermore, literature, painting, sculpture, photography, and film present many negative stereotypes of the older woman. The crone, hag, harridan, fishwife, shrew, virago, frump, mad woman, and dotty old lady are all associated with women past the age of menopause.

Gynephobia (the fear of women) accounts for the biased and inaccurate information about menopause that has accumulated over the centuries. Men's irrational fear of women provided the underlying impulse to view menopausal women as ill or insane. The medicalization and "pathologization" of menopause during the nineteenth century seems to have been rooted in ancient beliefs. The replacement of midwives by professional physicians led to "cures," such as ovariotomy and hysterectomy, for "female troubles," rather than the natural herbal remedies generally used by these learned women.

David Reuben, author of the best-seller *Everything You Always Wanted to Know About Sex But Were Afraid to Ask*, confirmed all these clichés when he wrote, "When a woman sees her womanly attributes disappearing before her eyes, she is bound to get a little depressed and irritable. . . . Having outlived their ovaries, they may have outlived their usefulness as human beings—the remaining years may be just marking time until they follow their glands into oblivion."[42] The demeaning nature of Reuben's conclusions are all the more revealing when one realizes that the

average age for menopause is fifty-one! Reuben's dreary observations come out of a stockpile of sexist premises, arguments, and clichés that have commonly been applied to women's bodies by the patriarchy.

Menopause, for instance, was believed to render a woman vulnerable to depression and increase her chances of serious illness, especially cancer. Thomas Mann's novella *The Black Swan*, which was first published in the United States in 1954, offered stark gynecological descriptions rooted in these ideas. It tells the story of a woman's sexuality, self-deception, sickness, and death. With clinical detachment, Mann describes Rosalie Van Tummler's carnal desire; fear of aging; and, finally, the onset of uterine cancer. He maintains the stereotype of the post-menopausal woman, embodying the sorrow, pain, and even terror she experiences at the loss of her capacity for reproduction.

An impressive film that treats the theme of aging is *Mrs. Skeffington,* starring Bette Davis and Claude Rains. It is about a fading beauty who makes herself ridiculous as she fights growing older. Her fears drive her to mistreat her faithful husband and become a laughingstock among the younger set she tries to run with. In an outlandish scene, her wig slips, and her whole act collapses as she is revealed for the balding old woman she really is. Even she finally beholds herself as she actually is—ridiculous.

Davis played the role to perfection because she grasped the fact that becoming an older woman in America is, as writer Susan Sontag suggested, viewed as a process of becoming obscene. Davis's treatment of Mrs. Skeffington lends the character a poignancy that transcends the woman's pathetic attempts to stay forever young. Mrs. Skeffington's ever-faithful husband rescues her, and even though he is going blind, he reassures his wife that she is still "beautiful." The film's special blend of poetic grace and quiet realism shows a woman who is out of touch with the times and herself, and who embodies many women's fears of growing old.

Until recently television has viewed aging as a disability for women, but not for men. Take, for example, Christine Craft, who was fired from a Kansas City station a few years ago for being what the male studio bosses said was "too old, too ugly, and not

deferential to men." And, she is only one example that reflects telemedia's medieval misogyny in relation to age discrimination. One can hardly imagine the same criteria being applied to David Brinkley or Walter Cronkite. Craft, to her credit, courageously made something worthwhile out of her humiliation by writing a book describing her experience. Then this feisty woman enrolled in the McGeorge School of Law in Sacramento and began a new career doing fill-in radio in San Francisco. Other women, like Lois Hart, who wore her hair in a ponytail, have been forced to adopt a more "grown-up" style because of pressure from their stations.

Marciarose Shestack, who was the first anchorwoman in the United States, was told by a news manager that "a woman will anchor here over my dead body." The fact is that things have changed a lot since the 1970s, when Jessica Savitch was celebrated as the "first anchorwoman in the South." Despite the gains, most anchorwomen, or, at least, those who work in network news, have a running battle with management over how they dress, act, and wear their hair. "For every two minutes of glamour," wrote Savitch, "there are eight hours of hard work."[43] Regarding how women looked, she asserted, "The minute viewers write or call in about your looks, it means they were not listening to what you were saying."[44] Objectively, a reporter's appearance shouldn't be a consideration, provided that it doesn't distract from the business of communication. Barbara Walters, for instance, takes her own retinue of aides along on the road because she wants to "concentrate on the substance of the story, not the cosmetics."[45] The main objective is to do the job properly. The implications of such discriminatory policies could not be more profound. The specter of renewed sexism, coupled with ageism, puts everything feminists thought they had achieved at risk once again, despite gains by reporters such as Diane Sawyer and Lesley Stahl.

Most of the depictions of female aging I have described are horrendous. They focus on the desirability of older men and the uselessness of older women. But because of women's activism, today's films present more complex images of older women. *Fried Green Tomatoes, On Golden Pond, The Whales of August, Driving Miss Daisy,* and *How to Make an American Quilt* all show

more positive and accurate pictures of elderly women who love life and live it to the fullest. In real life, one immediately thinks of such inspiring role models as singer Rosemary Clooney; chief executive officer Linda Wachner, who heads Warnaco Group and Authentic Fitness; cosmetics queens Mary Kay Ash and Estee Lauder; and the late choreographer Agnes de Mille.

Feminist art historians point out that "when women artists deal with aging, they counter both the real world's and the art world's ageism, which is especially demeaning to women, who still must prove their worth in the terms of a beauty based on standards of youth."[46] This is why staging a spectacle like "Whisper, the Waves, the Wind," is a political act. This performance piece, orchestrated by artist Suzanne Lacy, took place in May 1984. In it, 154 older women, of all races and backgrounds, who ranged in age from 62 to 99, walked in dignified lines toward cliffs overlooking a picturesque California beach. They gathered around small white-covered tables before an audience of one thousand and told them about their experiences of growing older in America. By participating in this event, these women created a different vision of the world in which older people are cherished for their beauty and wisdom. They seemed to be saying, "My body has gotten older, so what? I have much to give, to be, and to learn from each stage of my life." Lacy's work stands in direct contradiction to Reuben's negative depiction of older women.

In the next fourteen years, 60 million women in the United States will experience the "change of life." This profound shift in their lives will influence the quality of their aging. Currently, menopause is "hot." Ms. magazine noted that since 1993, this country has been experiencing a "menoboom"—with articles, advice books, and television programs bombarding us with often-conflicting information. The truth is that during my lifetime, menopause has gone from invisibility to striking visibility. In 1994, Fortune magazine published an article in its prestigious Executive Life section entitled "Menopause and the Working Boomer."[47] Today, because of the influence of feminism, more men and women appear to be challenging old paradigms and reaching for more authentic collaborative routes to empowerment and intimacy. Companies like AT & T, Easton Corporation,

and MetLife have formally addressed the impact that menopause can have on their employees. Despite these changes, as Herlene Marshall, aged forty-nine, owner and president of the Boutique recording label, Bainbridge Entertainment, pointed out, "Most of my friends at major corporations are loathe to discuss menopause openly at work. They think it will be bad for them politically."[48]

Old myths die hard. Unfortunately, the current debate on menopause still creates an adversarial relationship between physicians and pharmaceutical manufacturers, on the one hand, and nonmedical researchers, feminists, and consumers, on the other hand. But as midlife women grow in numbers, self-assurance, and independence, they are taking more responsibility for learning about their bodies and for telling other people their views and, hence, are reclaiming their souls. They're learning how menopause affects their physical, mental, emotional, spiritual, and psychological health, and they're examining the pros and cons of hormone replacement therapy and discovering natural alternatives. Outside the workplace, the movement to break the silence has picked up steam. The Red Hot Mamas, a 1,500-member menopause support group that started in Ridgefield, Connecticut, now has chapters in other towns and states. This group is teaching us about the passage from girlhood through womanhood to old age. Because of their devotion, more people are beginning to lose their misconception about older women and are starting to believe that we all need sensible information about menopause. One woman stated that "if men had problems like this you can be sure they would be a top priority for medical science."[49]

Her charge goes to the heart of the problem. The Office of Technology Assessment reported that the medical community has essentially neglected menopause until recently, as it has many other women's health issues. Robert Barbieri, a professor of obstetrics and gynecology at Harvard Medical School, admitted, "Many people who finished training before 1980 did not have much exposure to menopause."[50] Today a woman has many options, of which medical treatment is just one. But deciding on treatment is still a real nightmare. If a woman thinks of menopause as a medical event, and our health care system

encourages her to do so, she has to think twice about taking the drug estrogen. Estrogen replenishes the body's declining supply of the hormone while reducing or eliminating the uncomfortable signs of menopause. It also may reduce the risk of heart attacks by 50 percent. But scientists have also found that the drug may escalate the risk of uterine cancer and gall bladder disease. The controversy involves other issues as well. And some women have turned to more "natural" approaches to menopause, including those suggested by Susan S. Weed in her book *Menopausal Years,* which encourages the use of natural herbs to nourish the entire hormonal system.[51]

Feminism has changed American women and taught us that the body does not limit the soul. Most of all, feminists are calling for us to integrate a broader public into the process of growing older. They are saying that we need to reframe our dialogue in a way that can build communication and understanding. If we want to energize our visions, rather than dwell on what's not working, we need to change our approach to problem solving as it relates to both men and women and the mortality we all share.

A good model of the sort of change some feminists want is Barbra Streisand, who at fifty-two is still making headlines. A singer, actress, and director, Streisand knows what sexism is because like all women, she has had firsthand experience with it. Few directors in Hollywood work harder than she does to get the details right. She is a woman who studied the Talmud for three years just to make *Yentl,* a stunning critique of patriarchy. Since then, she's made successful films, such as *The Prince of Tides,* despite "a handful of 'boys-clubbers' who were not supportive of her and made her job 'extra difficult.'"[52]

One of Streisand's biggest problems is that she has not been taken seriously as a director. Perhaps this is why she produced a television movie, starring Glenn Close, based on Colonel Margarethe Cammermeyer, the Bronze Star Vietnam veteran who was banished from the National Guard for acknowledging her lesbianism and then reinstated after a brutal court battle. Streisand is a teacher and considers such subjects relevant for society as a whole. She is hardly an example of the cold, reclusive, bleak, and infertile image of the older woman who is

merely waiting to die that Reuben and other sexists have pre-
sented. Hepburn, Jessica Tandy, Friedan, Steinem, and Streisand
are only a few notable examples of women who have proved
how inappropriate our images of menopausal women have been
and still are.

Notes

1. William H. Chafe, *The Paradox of Change* (New York: Oxford University Press, 1991), 40–75.

2. For an insightful discussion of the problems of veterans, see David A. Gerber, "Heroes and Misfits: The Troubled Social Reintegration of Disabled Veterans in 'The Best Years of Our Lives,'" in *American Quarterly* 46 (December 1994): 545–74.

3. Marjorie Rosen, *Popcorn Venus: Women, Movies and the American Dream* (New York: Avon, 1974).

4. Roger Ebert's review of film available on CompuServe—online entertainment.

5. William H. Chafe, *The Unfinished Journey: America Since World War II* (New York: Oxford University Press, 1986).

6. Susan Faludi, *Backlash* (New York: Crown, 1991), 54.

7. "Introduction," in *The Female Body in Western Culture*, ed. Susan Rubin Suleiman (Cambridge, Mass.: Harvard University Press, 1985), 2.

8. Catharine Stimpson, *Thy Neighbor's Wife, Thy Neighbor*, ed. Vivian Gornick and Barbara K. Moran (New York: New American Library, 1971), 622–57.

9. Charlayne Hunter-Gault, *In My Place* (New York: Vintage Books, 1992).

10. For a better understanding of how gender stereotyping and/or sexism works, see Marilyn Chapin Massey, *Feminine Soul: The Fate of an Ideal* (Boston: Beacon Press, 1985), 9–29; Nancy Chodorow, *The Reproduction of Mothering: Psychoanalysis and the Sociology of Gender* (Berkeley: University of California Press, 1978).

11. Literature from Girls, Inc., 30 East 33rd Street, New York, NY 10157–0203.

12. Marilyn French, *The Women's Room* (New York: Summit Books, 1977), 14–15.

13. Michelle Fine, "Sexuality, Schooling and Adolescent Females: The Missing Discourse of Desire," in *Disruptive Voices: The Possibilities of Feminist Research* (Ann Arbor: University of Michigan Press, 1992), 31–59.

14. Lynn Wenzel, "Crying Rape!" in *New Directions for Women* 22 (May–June 1993): 4–7.

15. Ibid., 3.

16. Susan Brownmiller, *Against Our Will: Men, Women and Rape* (New York: Simon & Schuster, 1975), 15.

17. Susan Cheever, review of Norma McCorvey, *I Am Roe* (New York:

HarperCollins, 1994), in the *New York Times Book Review*, 3 July 1994.

18. bell hooks, "Gangsta Culture—Sexism and Misogyny," in *Outlaw Culture: Resisting Representations* (New York: Routledge, 1994), 116.

19. *Ms.* magazine 6 (1995): 8. Information is available from Robert L. Allen and Paul Kivel, Oakland Men's Project, 440 Grand Avenue, Suite 320, Oakland, CA 94160.

20. Carol J. Eagle and Carol Colman, *All That She Can Be* (New York: Simon & Schuster, 1993), 61.

21. Irene Javors is a psychotherapist, life-skills coach, and executive trainer who runs the Rainbow Advantage, a learning resources and self-development center in New York City. She has worked extensively with problems of creativity, feminism, and spirituality.

22. Ann Douglas, *Terrible Honesty: Mongrel Manhattan in the 1920s* (New York: Farrar Straus Giroux, 1993). Other feminists, such as Brownmiller and Dworkin, have also pointed out that fairy tales like "Snow White" and short stories like Count Leo Tolstoy's "The Kreutizer Sonata" indicate a lethal misogyny. The wicked queen and the murdered wife are just two examples of this free-floating hate.

23. Fine, "Sexuality, Schooling and Adolescent Females," 33.

24. Ibid., 32.

25. Marianne Hirsch, *The Mother/Daughter Plot: Narrative, Psychoanalysis, Feminism* (Bloomington: Indiana University Press, 1989).

26. Ibid., 102.

27. Massy, *Feminine Soul*, 9.

28. Her study has been criticized because it focused only on white middle-class women and men. Nonetheless, it is a valuable measure of how these men and women see themselves and views their intentions.

29. French, *The Women's Room*, 25.

30. Robert Wright "Feminists, Meet Mr. Darwin," in *The New Republic* 211 (28 November 1994), 42.

31. Leora Tannenbaum, "Gene Fools," in *In These Times* 19 (6 February 1995): 14–17.

32. Ibid., 15.

33. bell hooks, "Seduced by Violence No More," in *Outlaw Culture: Resisting Representations* (New York: Routledge, 1994), 109–13.

34. Ibid., 110–11.

35. Ibid., 123.

36. Quoted in Fine, "Sexuality, Schooling and Adolescent Females," 40.

37. Hilary Rose, "Hand, Brain, and Heart: A Feminist Epistemology for the Natural Sciences," in *Signs* 9 (Autumn 1983): 83.

38. Quoted in Daphne Duval Harrison, *Black Pearls: Blues Queens of the 1920s* (New Brunswick, N.J.: Rutgers University Press, 1993), 111.

39. Susan Brownmiller, *Femininity* (New York: Simon & Schuster, 1984), 14–15.

40. Fine, p. 48.

41. For reference to the Butler study and further information on how the visual arts have expressed concern about this issue, see Arlene Raven, "Commemoration," in *Crossing Over: Feminism and Art of Social Concern* (Ann Arbor, Mich.: UMI Research Press, 1988), 199–208; and Joanna Frueh and Arlene Raven, guest eds., "Feminist Art Criticism," special issue of *Art Journal* 50 (Summer 1991).

42. David Reuben, *Everything You Always Wanted to Know about Sex but Were Afraid to Ask* (New York: McKay, 1969), 365.

43. Jessica Savitch, *Anchorwoman* (New York: Putnam, 1982), 162.

44. Ibid., 73.

45. Ibid., 131.

46. Joanna Frueh and Arlene Raven, "Editors' Statement," in "Feminist Art Criticism," special issue of *Art Journal* 50 (Summer 1991): 10.

47. Faye Rice, "Menopause and the Working Boomer," in *Fortune*, 130 (14 November 1994): 203–12.

48. Quoted in ibid., 204.

49. Quoted in ibid.

50. Quoted in ibid., 208.

51. Susan S. Weed, *Menopausal Years* (Woodstock, N.Y.: Ash Tree Publishing, 1992). Weed's book must be read carefully because she tends to contradict herself regarding various herbs.

52. Michael Shnayerson, "Barbra Streisand: The Way She Is," in *Vanity Fair*, (November 1994): 192.

6

Sexist Role-Playing

Growing up in the 1950s, when Betty Crocker's *Picture Cook Book* led the nonfiction best-seller list, gave women a feeling of security in an insecure time. From the vantage point of today's feminism, it was a peculiar time that reflected the contemporary women's focus on homemaking, children, self-improvement, and religion. Books with instructions on how to make love, become pregnant, raise children, and be creative topped the best-seller lists. Women were shaped by men's ideas about them—male desires, fears, and images.

For women of this era, ambivalence about their role in society was a growing concern. The culture compelled women to show off their bodies while it criticized them if they became "femme fatales" or "brains." "Good" women couldn't be barflies, nightclub singers, mistresses, or ruthless gold diggers. There were good reasons why women of the 1950s were filled with a sense of futility, despair, and rage that were directly related to the unmistakable socioeconomic patterns of political and financial power evident then.

It was an era of unprecedented growth, as well as paranoia, for the nation. The economic boom of 1945 to 1973 rolled on with only an occasional recession. Inflation was negligible, natural resources were plentiful, and all segments of the population were improving their positions. More babies were born between

1948 and 1953 than in the previous thirty years. Couples married earlier, started having children earlier, and were in an affluent state of mind despite their worries about the Cold War. America was the land of opportunity and of plenty, and finally, the American dream appeared to be coming true.[1]

Nonetheless, Americans entered the 1950s obsessed with a sense of fear and anxiety. These years also marked the rise of a newly influential group of right-wing politicians. Senator Joseph McCarthy rose to national fame by making reckless charges that the State Department was riddled with Communists. Fearing the enemy within, he and other witch hunters scapegoated the intellectual establishment, and those they felt were soft on communism became their special targets. McCarthy terrorized outspoken Americans in all walks of life. Artists, writers, film producers, lawyers, homosexuals, and even college students weren't safe. The faintest suspicion of communism was enough to destroy you. McCarthy's falsely constructed idol of American liberty demanded new sacrifices to fuel its fires. He and his Senate committee made it their nationwide agenda to get rid of the "commies" and homosexuals in the military. Grave violations of Americans' civil liberties and the Bill of Rights took place under the guise of protecting national security. These repressions led to an outpouring of frustration, rage, depression, and confusion on the silver screen.

The suspicion, fear, and need to suppress oneself that dominated the 1950s accounts for the rise of movies featuring rebels without causes and sheds some light on the prominence of the male figure as a central focus of excitement, particularly Montgomery Clift, Marlon Brando, and James Dean.

A Place in the Sun (1951), an adaptation of Theodore Dreiser's *An American Tragedy*, introduced the good/bad boy fan clubs that grew up all over an America dominated by the silent, conforming man in the gray flannel suit. Audiences sympathized with George Eastman (Montgomery Clift) for knocking up and then accidentally knocking off frumpy Alice Tripp (Shelley Winters) because the girl he was doing it for, Angela Vickers (Elizabeth Taylor) was "worth it." When the film was first shown, few people in the audience seemed to identify with Alice Tripp. A poor working-class girl with stars in her eyes, she idolizes George, gives in to him, and pays the price.

This fatalistic film plays out like a Greek tragedy. Scene after scene reinforces this impression: the cry of the loon over the lake that Alice drowns in, close-ups of the actors' faces distorted by emotion and conveying a sense of helplessness in circumstances over which the players have no control. George is novelist Theodore Dreiser's "Everyman." For Dreiser, people are endlessly struggling to survive in an uncaring world in which accidents of birth and environment leave little room for free choice or action. Central to the film is Dreiser's idea that to be masterful in America is to have material goods and status.

Clift's character George finds the glittering promises of wealth forever out of reach. He is poor, uneducated, immature, and weak. The faith that sustained his religious-minded parents is empty for him. George is ashamed of his parents, and as soon as he is old enough to make his own way, gets a job as a bellboy. He is seen working in places where luxury alone is valued and from which he is excluded. Who can blame him for wanting such riches?

After participating in a hit-and-run accident, George flees to Chicago, where he finds work at the Union League Club. There he meets his wealthy uncle, who offers him work in his business. We watch George gravitate helplessly toward his fate as his hard work and his uncle's patronage earn him a position of supervisor. Audiences identify with him because he is like so many people who are altered by the situations in which they find themselves. George is depicted as progressively abandoning the values he grew up with: kindness, caring, and honesty. The film, unlike Dreiser's novel, portrays George as an aspiring one-dimensional man, a victim of his own ambition. Most of the audience, particularly the male viewers of the time, were persuaded by Stevens's intelligent directing to identify with George Eastman's desire to succeed at any cost.

Montgomery Clift's sensitive portrayal of the hardworking, troubled, sexy young antihero set a standard. Talented and good-looking, he became a teenage heartthrob—a kind of male pinup. Stylistically, however, Clift was only the beginning of a long line of American movie renegades. What attracted women to this new style?

Masculine appeal is something women tend to disagree on, but if one takes attraction at face value, male stars give us some

insights into emerging American masculinity during this period. Stanley Kowalski's torn, sweaty T-shirt so emphasizes the hero's body and his sexual force in *A Streetcar Named Desire* (1951) that it fostered a macho school of acting and aroused a generation of male teenagers to imitate this arrogant maleness. Stanley embodies rampant sexuality and a kind of simple-minded crudeness associated with the working class. This fetishization of the primal male was a lasting and significant change that expressed modern civilization's fascination and fear of the marginal man— the outsider on the fringes of polite society.

None of these mutations could have occurred without the active approval and encouragement of people who believed in the centrality of traditional gender roles to the existing social order. The source of this notion of masculinity may be traced to *Streetcar* and identified in its image of the male body as a lean, mean, virile machine.

In the film adaptation of Tennessee Williams's play, a pathetic Blanche Dubois, perceptively portrayed by Vivien Leigh, is made to appear cold, unproductive, and predatory while the brutal and brawny Stanley, played by Marlon Brando, is presented as a manly man. Stanley is a stud with sex appeal and little else. Blanche's sex-starved sister, Stella, and a large part of the audience—male and female—seem unable to resist Stanley's charisma supposedly because it is so elemental.

Williams, a gay white southern playwright, told *Life* magazine that Leigh had brought everything to the part he had intended and much that he had never dreamed of. The psychoanalyst C. G. Jung theorized that every man has a repressed female self, "the anima," and every woman has a repressed male self, "the animus." Williams's sympathy for the fragile Blanche, who was the anima (feminine) aspect of himself, went largely unnoticed by the majority of youth-oriented audiences. In this period, fans willingly flocked to see figures like Brando represented and then habitually identified with him, rather than with images of older women as vulnerable and complex as the one Leigh portrayed. Paradoxically, what seemed to captivate young female audiences was not Stanley's masculinity, but his male vulnerability. Most girls and women of the 1950s seemed uninterested in the problems of women at midlife.

In *On the Waterfront* (1954), the social problem of union corruption is turned into the story of Terry Malloy, an outlaw hero unwilling to help the crime commission's investigation of union-related murders. In this urban western, Terry's ethereal girlfriend (Eva Marie Saint), the sister of a murdered man, urges him to do the right thing by reporting the evil Johnny Friendly to the crime commission. It is impossible not to be touched by her performance, but audiences of the era failed to see this fragile, quiet woman as a heroine. Ultimately, Terry has to fight it out with Friendly and beat him in a fistfight. He is a triumphant working-class hero, a "contender" with exposed flesh and bulging biceps, who beats his way to respectability.

"What are you rebelling against?" a naive girl asks Brando in *The Wild One*. "Whadda ya got?" was his celebrated answer. In this film, Brando plays a motorcycle-riding juvenile delinquent who tries to appear every bit as bad as the town fathers think he is. There is something naive and appealing about his feigned toughness. Teenagers could identify with his combination of swaggering bravado and rebelliousness, and the "teen angel" who sees how misunderstood he really is. The girl, Cathy, appears to be the only one who knows what the young rebel really means.

All the growing-up movies of the 1950s are filled with innocent girls or sacrificial female lambs who express their own defiance through their relationships with good/bad boys, rather than through their own rebellion against oppressive social values. Pulling away and distancing emotionally from mother produces tough guys, but the real message is that any vulnerability or any kind of softness makes you "feminine" in this culture, and that's a negative in a woman-hating social system. This gender stereotyping and sexism contributes to the matriphobia—the mother blaming that goes on in our society and is so confusing to growing girls. It perpetuates our culture's devaluation of women and the feminine for both girls and boys.

It is not surprising that the patriarchal belief system opposes female ways of being in the world. Its view of the universe is based on gynephobia. Many men picture the feminine in themselves as something that ought to be gotten rid of or repressed. An active illustration of this gynephobia may be seen in the film

Tea and Sympathy, in which a sensitive young man, Tom Lee (John Kerr), contemptuously nicknamed "Sister Boy," is tormented by a sophomoric athletic coach-housemaster (Leif Erickson), who married Laura (Deborah Kerr) to prove his manhood, and the college boys who emulate him.

This is the classic story of a young man who marches to a different drummer and is punished for it. Tom Lee's classmates call him "Sister Boy" because, like Jim Stark in *Rebel Without a Cause,* he rejects their pack mentality. Tom likes Bach and prefers the company of his housemaster's wife, Laura, whom he is clearly in love with, but his tormentors don't see his infatuation with her. They label him a sissy because they find him sitting on the beach with a group of faculty wives, sewing a button on a shirt. The real problem is that of a boy who is driven to suicide when he is falsely accused of homosexuality by men whose sporting activities, as Vito Russo explained, "provide the most homoerotic action on the scene."[2] Laura finally saves Tom by sleeping with him.

The role of Laura was a difficult one for Deborah Kerr to play because of the Production Code. Kerr wrote Vincente Minnelli (the director) that "the Breen Office is very difficult about the homosexual angle, which is, I understand, their objection. Adultery is OK, impotence is OK, but perversion is their bête noire."[3] The actress was wrong: adultery was not OK, and the Catholic Legion of Decency was influential in the way the seduction scene in the woods was filmed, which the playwright Robert Anderson said "looked more like the second coming of Christ than the first coming of Tom Lee."[4] The morally correct epilogue that was added to the film to make it acceptable taught people that an older woman's instruction and initiation of a young man into sex might be a positive thing, but at the same time, such behavior could not be condoned by a respectable woman. Ten years later at a college reunion, Tom is given a letter in which Laura writes that she was forced to leave her husband in disgrace because of what she did and tells him she blames herself because what she did was wrong. It's hard to know what to think of the mindless demand for conformity made by the Catholic Church and the Breen Office because, as a result of Minnelli's sensitive direction and the artful performances by both Deborah

Kerr and John Kerr, the film actually thwarted their objectives. When interpreted from an outsider perspective on women and homosexuals, the altered *Tea and Sympathy* discloses a hatred of sexually active older women and a contempt for homosexuality.

Ironically, macho stars like William Holden had to shave the hair off their chests to conform to the classical Greek ideal of masculine beauty required by Hollywood in the 1950s in such films as *Picnic*. Yet, the apparent taboo against portraying empathic relations between the sexes was occasionally broken by ambiguous films like *Tea and Sympathy*, whose central focus is on the difficulties of becoming an adequate man in a patriarchal society and the impossibility that someone might actually be homosexual in real life.

In the end, in most films of the era male sexual identity is just as constructed as the female. Two cases in point are Clift's intensely introverted, innocent, and naive George Eastman, who ends up in a hopeless condition being led off to the electric chair, and Brando's Kowalski, who erupts into anger, wrecks the room, and beats his wife, Stella, when he thinks she is turning away from him. Only after he cries his head off does he use his potent sexuality to lure her back to him.

The quintessential vulnerable male is James Dean in Nicholas Ray's *Rebel Without a Cause*. In the film, Jim Stark (Dean) is a loner whom most teenagers could identify with. The opening scenes show him being picked up by the police and questioned at the precinct house by a youth officer, as are two other teenagers, Judy (Natalie Wood) and Plato (Sal Mineo). Jim, who is drunk, giggles and ignores the officer's questions. At the station, the neglected rich kid Plato is claimed by the family maid, and Jim and Judy are picked up by their respective sets of parents. Jim's father is a middle-class wimp who lets his wife boss him around. "If he had the guts to knock Mom cold once," Jim complains, "maybe she'd be happy and stop picking on him. . . . How can a guy grow up in a circus like that?"

Clearly, Jim has already been drawn into the unrelenting war between the sexes. He is frightened by the arbitrariness of conventional sex roles in his family. So his concern is with his father's ability to control and manipulate his mother, by brute force if necessary. What father does best is bring home the bacon,

but this doesn't make him a real man to his son. Seen through the boy's eyes, the father is a flabby, middle-aged jerk who wears an apron and doesn't understand him. This image of his father frightens Jim and he begins to panic.

According to film historian Graham McCann, despite Jim's sensitivity, he has to confront a brutal and deforming masculine culture outside the home. First, there's a knife fight in which Jim proves his masculinity. Next, there is an explosion of homoerotic tensions between Jim and Buzz, leader of a gang. Highly vulnerable to peer pressure, Jim has already learned from his classmates what it means to be a man. Before the chicken race (a contest in which two boys race their cars to the edge of a cliff and the first one to jump out loses) that he has been challenged to, Jim asks his opponent, "Why do we do this?" Buzz responds, "Well, you gotta do something, now don't you?" The two boys drive their cars toward the cliff and have to jump out before their vehicles go over the edge. But Buzz gets his jacket caught on the door handle of his car and is killed.

In this system, film critic Tania Modleski explained, "surplus violence fixes power imbalances and guarantees male mastery."[5] To be a genuine man means to dominate and control and to keep things in order. Because of the disruptive changes and pressures Jim is experiencing, he wants a different model of manhood he can look up to. Since he can't identify with his father, he decides to create his own best father by trying to live up to a self-invented ideal image.

After the accident, the three teenagers—Jim, Judy, and Plato—run away to an abandoned house, where they are later menaced by a rival gang. Jim and Judy become surrogate parents to Plato. In a fight-or-flight scene, Jim strives to take care of his friends, Plato, who is small, weak, and mildly retarded, and Judy, whom he is attracted to. Jim talks Plato, who has stolen a gun for protection, into removing the bullets from the weapon. Later, Plato is shot by the police when he panics on the steps of the planetarium and pulls out his empty revolver. In a pivotal scene, Jim, who feels responsible for Plato's death, covers the boy's body with his own blood-red jacket. Jim's parents witness their son's futile attempts to save the other boy, which gives them a new understanding of him. As the film ends, Jim's father is forced to

reclaim his manhood but far too late to save Plato. Order is restored as the father puts his jacket around Jim's shoulders. "I'll try to be as strong as you want me to be," the father promises.[6] Earlier critics viewed *Rebel Without a Cause* as a tale of teenage rebellion, but, as McCann suggested, the film reaffirms the authority of state, family, and masculinity.[7]

In 1950s terms, part of becoming a man meant engaging in hand-to-hand combat with your henpecked father. According to the film, the protagonist's behavior is shaped by the absence of a strong father. The audience is presented with parents who don't provide authority, structure, or love, and teenagers who are searching for something authentic. Among teenagers who were confronted by rapidly changing times, the traditional messages in these male-oriented films have a false ring because they tried to reconfirm old values in the face of a new and different kind of society.

Female audiences viewed Judy's parents as cold and strict. Natalie Wood becomes a "bad girl" because her father favors her brother and cannot deal with her emerging sexuality, so he distances himself from her when she is most needy by calling her "a dirty tramp." The image of her body, with its budding breasts, is more than he can endure. Her "sexed" body overwhelms him, and he stifles his attraction to his daughter by a hurtful distancing from her. The film follows biblical lore by suggesting that all men are sexually aroused by the sight of breasts. What seems particularly sad about the film is how it presents daughters and fathers. It suggests that young women are prohibited from having relationships with their fathers.

Judy contrasts her parents' way of life with the life she envisions for herself. She identifies with Jim as a kind of male alter ego. Since she can't be equal to him, she becomes his feminine soul support. The situations presented in *Rebel* seem to mirror what was going on for white middle-class youths of the 1950s, and they helped to reinforce the idea that the youths' parents didn't really love them. Many teenagers thought that all adults cared about was money, and money couldn't buy happiness.

Girls, such as the one Wood portrays, often experienced the separation process as a painful loss, not only of the father, but of intimacy with the mother. Moreover, some feminists have sug-

gested that a child's desire to separate from the mother is often fueled by a desire to be different from a woman who is oppressed and lacks power in a patriarchal society.

Undoubtedly, the 1950s ushered in an era of youth rebellion, regardless of how one interprets the film now. Heavily influenced by the deep shadows and oblique camera angles of film noir, films such as *The Wild One, East of Eden, Blackboard Jungle,* and *Rebel Without a Cause* all had white male antiheroes whose alienation, nihilism, and impulses toward violence and rebellion were profoundly antisocial, much like the gangster films of the 1930s. These film images marked an important turning point in America's journey toward transformation for both males and females.

In 1953 Dwight David Eisenhower became president of the United States. People liked Ike, and the majority believed in "Peace and Power with Eisenhower." But Eisenhower inherited all the loose ends of the Truman administration. Moreover, the inherent sexism of the era may have contributed to his decision concerning the famous Rosenberg spy case. In a letter to his son, Eisenhower commented:

> I must say that it goes against the grain to avoid interfering in the case when a woman is to receive capital punishment. Over against this, however, must be placed two facts that have greater significance. The first of these is that in this instance it is the woman who is the strong and recalcitrant character, the man is the weak one. She has obviously been the leader in everything that they did in the spy ring. The second thing is that if there would be any commuting of the women's sentence without the man's, then from here on the Soviets would simply recruit their spies from among women.[8]

Convinced that the Rosenbergs had been fairly convicted, he refused them clemency, despite widespread doubts about their guilt. Eisenhower's attitude seems to have been eminently pragmatic. But in characterizing Ethel as "the leader in everything," he was condemning her for asserting herself, as much as for engaging in a conspiracy to steal and then pass on to the Soviet Union "the secret" of the atomic bomb.

To the American mass media, Rosenberg was not just a working-class housewife and mother, but the stubborn, intransigent

force behind her mild-mannered husband's disloyalty. Because she wasn't passive, most reporters portrayed her as evil Ethel. Her stoic manner, refusal to admit her "guilt," and defiant death in the electric chair only added to this impression.[9]

CREATING THE AMERICAN WOMAN

It was in this mixed climate that Madison Avenue advertising agencies helped to promote a postwar consumer economy. Most promotions were based on the idea that women did most of the buying. Television commercials were geared toward women. Women's magazines were filled with advertisements and articles devoted to telling their readers what to buy and how to use it to make them and their families young, healthy, sexy, secure, and successful. Americans of this generation were better educated, read more, traveled more, bought more, and were more influenced by television fads than at any other time in our history.

In October 1956, *Look* magazine published an article entitled "A New Look at the American Woman." "This marvelous creature," it proclaimed, "looks and acts far more feminine than the 'emancipated' girl of the 1920's or even 1930's." That same year, *Life* devoted a special issue to "The American Woman: Her Achievements and Troubles." But as historian J. Ronald Oakley noted, "In spite of all the progress, . . . American women still lived in a society in which the men controlled the wealth and power, made the rules under which both sexes lived, and stacked them in favor of men."[10] Oakley pointed out that women were treated as an inferior minority group. They were stereotyped and discriminated against on the basis of "alleged differences, thought to be less intelligent and talented, subjected to sexual harassment, paid less than men and exposed to ridicule and even retaliation if they stepped outside their traditional place."[11]

It is not surprising that Hollywood was one of the most prominent teachers of sexism in the 1950s, with films like *Gentlemen Prefer Blondes, High Society, From Here to Eternity, The Country Girl, A Streetcar Named Desire, Picnic,* and *The Seven Year Itch.* The sex bomb of the screen was Marilyn Monroe, who had an hourglass figure and played a variety of "dumb blonde" roles. On screen, Monroe was presented as a sex goddess, but off-screen,

she experienced all the confusion, pain, and suffering of many American women. She had three failed marriages, tried to make the studio give her serious acting roles, had a series of unsuccessful relationships with prominent men, and is alleged to have died from an overdose of sleeping pills while listening to Frank Sinatra records. Later, Gloria Steinem made Monroe a feminist icon by showing how brutally victimized she was by the patriarchal system.[12]

The reality of family life made the house a battleground for many women and children. Brutality and sexual abuse were common. During this era, male violence was creating "shell-shock" in its victims, and a conspiracy of silence kept the incidents of alcoholism, drug abuse, battering, child abuse, incest, rape, and even murder under wraps. It is not surprising that many middle-class white women felt like the characters in the film *The Stepford Wives*. Confined to the kitchen, dining room, family room, and patio, these women were supposed to be content with their lot in life. If they weren't, they could be replaced with robots who baked cookies and followed the program. Husbands, who provided for their wives, couldn't understand what the women were complaining about.

Betty Friedan's study, *The Feminine Mystique*, found that educated women who were removed from cities were also deprived of realizing their potential. Rarely did they have the energy to pursue professional careers, take university courses, or fulfill their creative possibilities in any way. When they complained of feeling listless or told their doctors their lives were pointless, they were told to take Miltown or Valium, buy a new dress, or try a new hairstyle.

By 1960 the proportion of married women who worked outside the home had reached 32 percent, representing 54 percent of all working women. Americans might have believed that women's place was in the home, but statistics indicated otherwise. Women constituted 85 percent of all librarians, 97 percent of all nurses, and 57 percent of all social workers. Yet they made up only 3.5 percent of all lawyers, 19 percent of all college presidents and professors, and 6.8 percent of all physicians. Regardless of color, women were discriminated against in the economic, political, and cultural spheres.[13]

A contributing factor was the view of love and sex that prevailed during the 1950s and 1960s and that still troubles women today. Since the foundations of patriarchy are shaky, conditioning in early childhood is crucial. Being tough, aggressive, and in control keeps the self-esteem of insecure men intact. Men and women become players in the game of sexual politics, in which women are regarded as objects by men who pursue them. Women have learned to compete against each other to attract and secure men. Most American songs, movies, novels, and television shows help to support this concept of love, which is portrayed as finally leading to marriage and happiness.

Grace Kelly, daughter of a Philadelphia millionaire, epitomized the American princess that all nice middle-class white girls were supposed to emulate. Alfred Hitchcock's films, including *Rear Window* and *To Catch a Thief,* made her famous. In the United States, nudity and sex were dirty, and Kelly upheld the puritanical standards of restricted sexual relations, as well as a dress code that most of the girls and young women tried to imitate. For some people, however, she represented old Victorian models of virginity. Those women who were seeking sexual freedom wanted nothing to do with her.

From generation to generation, this systematic discrimination has greatly influenced the way women think about themselves. After World War II and the Korean War, having fought for freedom and democracy abroad, women's attitudes toward male-dominated institutions began to change. By the late 1950s and early 1960s, a number of factors had joined to challenge the established gender patterns under which women had been raised.

First, civil rights and human rights activists launched a concerted attack on white supremacy and the legacy of segregation. Then the 1964 Civil Rights Act established a national policy prohibiting racial segregation and discrimination. Once again, the dramatic struggle for civil rights had unexpected consequences: just as they had done in the previous century, women gradually broke free from the fight for black enfranchisement and renewed the struggle for their own human rights. Feminist activists drew strength from the revitalized movement for women's equality and stressed their right to self-determination. Rejecting decades of political, medical, scientific, and academic opinions that had

little or no sympathy for what women wanted or much solid understanding of female biology, they struck out on their own.

During this period, Friedan and other feminist reformers uncovered structures that kept women in the places men reserved for them. These reformers' "consciousness-raising" discussions led women to see that they frequently did not focus on the same values as men and did not rank them in the same order of importance. Consequently, during the 1960s and 1970s, something remarkable occurred: women who were fortified by a renewed sense of mission began to demand their freedom, much as their foremothers had done. They took on their age-old enemy—the entrenched patriarchy. But like other disenfranchised groups, they had to learn about power—how to get it and how to use it. Spelling out their rights in women's conventions, in self-published broadsides, and in overblown rhetoric, women put the emphasis on themselves.

In theory, the renewal of the feminist revolution began with the need to examine the whole construction of femininity. As women built friendships and listened to each other, instead of competing with each other for men, it became clear that society encouraged them to look and act in certain ways that were not conducive to developing their full potential. Boys and girls followed different rules of etiquette, and sexuality was regulated differently for women than it was for men. Middle-class women and men adopted styles of dress that helped to distinguish them from the working classes, and they created modes of behavior and language that marked them as respectable members of the dominant society. For many, breaking away from the basic values of their upbringing and learning new ways of thinking and living proved difficult, if not impossible.

BODY IMAGE

Most of the institutions that this society has created, including educational institutions, religious institutions, corporations, and legislative bodies, are directly influenced by patriarchy. In addition, no discussion of the "woman question" would be complete without an examination of conventional ideas about women's body image.

"Asking me if I believe in feminism is like asking me if I believe in integration," said Betsy Carter, executive editor of *Harper's Bazaar*.[14] Despite this claim, the so-called sister magazines persist in catering to the beauty industry because they depend on it. They use headlines, such as "Do You Feel Out of Control or Overcontrolled Around Food?" "Are You Unhappy with Your Body and Your Current Weight?" "Do You Go on and off Diets Regularly?" Women who write for, subscribe to, and read these magazines still seem to condone and validate certain ideas about attractiveness.

In a 1995 survey conducted by *Esquire* magazine, women aged eighteen to twenty-three said they would rather die than be overweight. Millions of Americans are prone to eating disorders, and American women are obsessed with dieting. Anorexia nervosa is a disorder in which the preoccupation with dieting and thinness leads to excessive weight loss. In the United States, 1 percent of teenage girls develop anorexia nervosa, and up to 10 percent may die as a result. Bulimia, a related disorder, involves repeated cycles of bingeing and purging through vomiting, taking laxatives, dieting, and engaging in vigorous exercise. Bulimics suffer from intense feelings of guilt or shame; they feel out of control but can't seem to stop themselves. Approximately 5 percent of college women in the United States are bulimic.[15]

Those who are bulimic or anorexic must make a lifelong commitment to change if they are to restore their health because those with these eating disorders (as well as many other women) have been conditioned to believe that their appearance is the source of their self-esteem. The majority of victims who enslave themselves to the latest fashions are women. The pressure of trying to conform to an artificial identity motivates many women and young girls to restrict their food intake, which leads to a feeling of deprivation that sometimes causes them to depend more on food as a source of comfort. There is no denying the analogy that exists between food and sex. In the blues, one finds metaphors that liken foods to the sex act or genitals, as in the following example:

Men, they call me oven, they say I'm red-hot,
Men, they call me oven, they say I'm red-hot,

I can strut my pudding, spread my grease with ease,
'Cause I know my onions, that's why I always please.[16]

Other forms of culture, both high and low, also use food and body symbolism. The art historian Meyer Schapiro equated Cézanne's apples with breasts,[17] and the hedonistic consumption of a lavish meal in the film *Tom Jones* is synonymous with sexual gratification.

Feminists argue that the more conscious women become of their inner feelings, hungers, desires, and dreams, the more they can choose to accept all of who they are. Then women will find ways of being genuinely fulfilled without having to use food (or the absence of food) to fill up the emptiness they experience and ward off the sexual advances they fear. Most experts agree that women need to abandon self-loathing, the inner critic, and learn how to distinguish among emotions, beliefs, and actions.

For these reasons, women's troubled relationships with their bodies are a central focus of feminism. Academic conservatives like Nicholas Davidson ridicule this focus, yet few can disagree that men are the first to make fun of overweight women without understanding the nature of the problem. And wanting to be thin in our society is an obsession that is constantly reinforced by fashion and advertising.

Disturbed by feminism's alleged abandonment of feminine fashions, Davidson and other antifeminists mock the movement because they claim it rejects the bra and shaved legs. But many feminists never burned their bras or gave up on natural elegance. Instead, they closely examined some of the myths of feminine beauty that thrive in a patriarchal society and culture. In scrutinizing the development of women's fashions and looking at how these fashions affect women's views of their bodies and lives, feminists explored the desire for distinctive clothes to demonstrate wealth and status to other people. The duchess of Windsor's remark, "You can never be to thin or too rich," succinctly sums up her susceptibility to the beauty myth and her submissiveness to the dress code of women as ornaments. Society's overvaluation of beauty causes many women to choose attractiveness at all costs to them over being comfortable and wearing clothing designed to protect their bodies.

Middle-class white women's perceptions of their bodies were frequently shaped by artists. Although male fashion historians like Thorstein Veblen reassured women that clothes were "conspicuous consumption," others like Quentin Bell told them, "You have to have the right kind of breasts" to wear the topless fashion.[18] Even so, women created and are still creating "Conspicuous Outrage (a style of dressing that attracts people's attention)." According to Bell, Conspicuous Outrage "is the most sophisticated weapon of the fashionable person." His comment suggests that a class war is being waged on the frontiers of design.

Describing the appearance of Marlene Dietrich in director Josef von Sternberg's films, movie critic Molly Haskell wrote, "She parodies conventional notions of male authority and sexual role-playing without destroying her credibility as a woman."[19] Nonetheless, most fashion critics agree that sex, romance, love, lust, and male power are symbolized by the fly front. When it comes to transgressing boundaries of gender, few women have done it better than Dietrich. Psychological theories based on Freud and his followers inform us that the popularity of Dietrich's insolently erotic and dapperly chic heroines kissing women on the lips reveals a deep-seated fascination with "dyke style." But a number of feminists have argued that perhaps it isn't a fascination with dyke style so much as a delight in the way Dietrich inserts herself into the world through dress, action, and speech.

Madonna's video *Open Your Heart*, in which she plays Dietrich, re-creates the fantastic vision of the dominatrix in a top hat, and shows the entertainer's perfect understanding of the modernist body, which is the carefully wrought product of diet and exercise. The fact that fashion designers like Armani, Krizia, Versace, and Sant'Angelo are savvy to women's frustrated desire for freedom of action in the world has their cash registers ringing.

Clearly, public attitudes have a lot to do with how women think about themselves, as well as with the decisions they make about their bodies. Despite the gains of feminism, women, and more recently men, are constantly bombarded with new ideas for improving their appearance. In the 1970s, 350,000 women underwent silicone breast reconstructive surgery after breast

cancer, and more than a million women got silicone implants to increase the size of their breasts.[20] Reports of leaking, migration, infection, autoimmune disorders, and loss of nerve sensation in the breasts led to an overwhelming body of evidence that proved silicone breast implants were dangerous to women's health. In May 1995, Dow-Corning admitted that its product was the cause of many of these health hazards and declared bankruptcy because of the number of women who applied for compensation.

Tooth bleaching may improve your smile, but it has serious side effects that manufacturers don't tell you about. Most women don't know that chemical peels make the skin more vulnerable to sun damage and can contribute to premature aging, as well as skin cancer. Women can train their voices, shape their forms, color their hair, and mistreat their bodies for just so long before these various abuses begin to catch up with them. Only magazines like *Ms.*, which now exists solely on subscriptions, can consistently afford to ask whether any of these actions are worth the risks.

With the massive changes taking place in society and culture owing to feminism, people are examining their relationships with both the beauty industry and the medical profession. Women, in particular, are torn between wanting to look attractive and sexy to men and wanting to do what is healthy for their bodies. Feminists have taken on the challenge of opposing the abuses of the beauty industry. For example, Canadian filmmaker Katherine Gilday's documentary film, *The Famine Within*, explores anorexia, bulimia, and the fear of fat. It traces how women's denial of their appetites is rooted in Judeo-Christian culture. However, whereas medieval women starved themselves as a gesture of piety, contemporary women do it for other reasons. In the film Linda, a twenty-seven-year-old anorexic, explains, "I'm always going to eat later, and later never comes." Linda starved herself to death.

In her brilliant film, Gilday interweaves interviews and facts to illuminate how women are programmed from childhood to starve themselves (young girls are now dieting as early as the first grade). Women's body images are completely out of whack with what women actually look like. One large survey found that 75 percent of young women thought they were

overweight, even though 45 percent of them were actually underweight.[21]

Although some of the assertions that feminists have made may be problematic, understanding how femininity reinforces the lesser status of girls and women brings one in closer touch with the political character of gender relations that are based on the unequal power of sexual relations. It is this correlation between femininity and discrimination that classical feminists believe reveals the true nature of sexism. This indictment, in one form or another, is repeated by virtually every tradition within feminism. This is why feminism, regardless of how you define it, has become a lightning rod for the causes that will transform our society and culture.

Notes

1. William H. Chafe, *The Unfinished Journey: America Since World War II* (New York: Oxford University Press, 1986).

2. Vito Russo, *The Celluloid Closet: Homosexuality in the Movies* (New York: Harper and Row, 1981), 112–15. My emphasis is somewhat different from Russo's, but his insightful interpretation of the nature of "buddy relationships" sheds a great deal of light on how masculinity is constructed in patriarchal cultures.

3. Quoted in ibid., 114.

4. Quoted in ibid.

5. Tania Modleski, *Feminism Without Women* (New York: Routledge, 1991), 135–63.

6. Quoted in Robert B. Ray, *A Certain Tendency of the Hollywood Cinema, 1930–1980* (Princeton, N.J.: Princeton University Press, 1985), 161–63.

7. Ibid., 151.

8. Quoted in Martha Rosler's contribution to the REAP Show, *Unknown Secrets*, 1988.

9. To art critic Maurice Berger, "Ethel Rosenberg signified a denial of men's authority over women. Her alleged communist affiliations seemed allied with that denial in mutually reinforcing abnormality. In short, Rosenberg's media-established lack of 'femininity' threatened the patriarchy that supported the social order of American capitalism." Quote from "Of Cold Wars & Curators" by Maurice Berger in *How Art Becomes History* (New York: IconEditions/HarperCollins, 1992), 42.

10. J. Ronald Oakley, *God's Country: America in the Fifties* (New York: Dembner Books, 1986), 292.

11. Ibid.

12. Several authors have suggested that Monroe's death was not a suicide, but that she was murdered to protect one of the prominent men she was having an affair with. See, for example, Eunice Murray, *Marilyn: The Last Months* (New York: Pyramid Books, 1975); Sandra Shevey, *The Marilyn Scandal* (London: Sidwick & Jackson, 1987); Robert F. Slatzer, *The Life and Curious Death of Marilyn Monroe* (New York: Pinnacle House, 1994); Gloria Steinem, *Marilyn* (New York: Holt, 1986).

13. Chafe, *The Unfinished Journey*, 124.

14. Quoted in Wendy Kaminer, "Feminism's Identity Crisis," in *The Atlantic* (October 1993): 53.

15. Gilday, *The Famine Within* (a Direct Cinematographer Ltd. release, 1990).

16. See Daphne Duval Harrison, *Black Pearls: Blues Queens of the 1920s* (New Brunswick, N.J.: Rutgers University Press, 1993), 106.

17. Meyer Schapiro, *Paul Cézanne* (New York: Harry N. Abrams, Inc., 1988).

18. Quentin Bell, *On Human Finery* (London: Hogarth Press, 1996), Appendix A, 193.

19. Molly Haskell, *From Reverence to Rape* (Chicago: University of Chicago Press, 1987), 147.

20. Janice G. Raymond, *Women as Wombs: Reproductive Technologies and the Battle over Women's Freedom* (San Francisco: Harper San Francisco, 1993), 115.

21. Ellen Goodman, "What This Poll Proves About Women," *Esquire* (February 1994): 65–67.

7

Second-Wave Feminism

The concerns of feminism in the United States have constantly been readjusted as social values have changed and new cases testing the limits of freedom have emerged. The feminist groups that survived the uproar over the various issues they raised from the 1920s through the 1950s advocated legislation for selective issues. The legacy of feminism produced a generation that brought about the so-called golden age of American feminism during the late 1960s and 1970s. This period, beginning in 1969, is generally referred to historically as the "second wave" of feminism.

By 1971 the connections among the civil rights movement, the women's movement, and the dilemmas of liberals in the United States all coalesced into a rich bubbling stew of feminisms. Included in the stew were sexual politics, race matters, and a resistance to Betty Friedan's party line by lesbians and other women who developed their own ideas about feminism. Ironically, among the Republican women who opposed feminism were such foes of the Equal Rights Amendment (ERA) as Phyllis Schlafly who, although they espoused traditional family values, acted remarkably like what Naomi Wolf called "power feminists" in struggling for their personal political agendas.

During the mid–1960s, the major political parties had not made women's issues a specific part of their platforms. This situation changed in 1972, a year after the National Women's

Political Caucus was founded specifically to bring more women into mainstream politics. At the 1972 national nominating conventions, feminists in both parties succeeded in putting the ERA back into their parties' platforms, but they failed to get proposed planks on abortion adopted.

By 1976 feminists were strong enough in both parties to engage in major battles, but, as political scientist Jo Freeman noted, the two parties had different battles. In the Democratic Party, feminists fought for the "50–50" rule, which would require, from 1980 on, that half of all delegates must be women. But it wasn't until three years later that the party actually voted to adopt this rule.

The Republicans fought over keeping the ERA in the party platform. The struggle was between the Reagan and Ford factions of the party, with Schlafly heading the Stop ERA faction. Since Reagan wanted other issues on the floor, the ERA stayed in the Republican platform until 1980, when it was removed by a full committee vote of 90 to 9. Abortion actually got more support than the ERA.[1]

The kinds of changes taking place in politics were also occurring in other parts of society. During the late 1960s, fear of fashion had been almost a mania. In their books and articles, Friedan and Germaine Greer urged women to free themselves from the tyranny of femininity—from the courtesies of romanticism, the razor, and the horror of hairy legs. They considered the process of making oneself feminine through the discipline required to achieve a particular kind of body to be a form of victimization, because they believed that such socialization regarding femininity helped to maintain and perpetuate the patriarchal gender system referred to in earlier chapters. By the end of the decade, many woman had abandoned the old-fashioned sexual stereotypes that conservative men continued to adore: the dumb blonde, the girl next door, the sex pot, the vamp, and the femme fatale. Feminists taught that a liberated women does not play the game of trying to attract masculine attention while playfully discouraging it.

Great changes were also taking place in the visions of America presented to children. As Marshall McLuhan had so insightfully observed in the 1960s, "the medium is the message." During that

era, telejournalism had transformed the mass communication network. It was a dizzying communications outburst that helped to reinvent our society. The events of the time offered journalists and image makers an unprecedented opportunity to shape public opinion. The techniques they used were not unlike those used by Hollywood in previous decades. Using presidential debates, nightly news programs, and polls and surveys, communications networks manipulated what the public saw, when they saw it, how long it stayed in sight, the linkages that were made, the point of view that was conveyed, how divergent the coverage was, and what was excluded.

The generation of the 1960s was polished and refined by love-ins, hallucinogenic drugs, and the Vietnam War. Poet Diane Ackerman commented, "Cynicism and Idealism often went hand in hand. Inherited truths no longer fit; we felt it was both our privilege and our duty to reshape them."[2]

Answering the question, "How has your writing world changed?" posed by Eleanor Munro in a 1994 *PEN* newsletter, Elizabeth Janeway, who was one of feminism's leading lights, stated:

> The rebirth of feminism has been a happy occasion for me, though I was at a women's college and thus was spared educational put-downs. . . . I was not unprepared for the Second Wave. But to be there at the re-creation of the drive for equality of the sexes certainly broadened the areas that could be addressed seriously. Today I believe that the opening of the world of activity to women will not be reversed.[3]

Those in the second wave of the women's movement were willing to stand up and fight for women's rights at a time when it was not easy to do so. Janeway's comment rang a bell for many women of her generation because they took a stand for women's rights. The changes she referred to could never have been achieved without their dedication and that of generations of women who went before them.

The freedoms most young women and men currently take for granted certainly weren't the norm when I was growing up. Paying attention to women's experiences sheds some light on conditions during the so-called golden age of feminism in the

1970s. It makes one suspect that the split between various generations of feminists has been grossly exaggerated. It is often observed that young people's political beliefs and values differ from those of their elders. The truth is that many young people don't reject feminism, per se; instead, they want to redirect the movement to meet their own needs. Thus, there is a growing disparity among women's definitions of feminism and explanations of how it functions.

A DIVERSITY OF VIEWS

Computers, much like television in a previous era, have transformed and are continuing to transform the way we live and communicate. Surfing the net through a number of online services gives one immediate access to a diverse number of cultures throughout the world. Many libraries and forum discussions provide data on how fellow members are struggling with the major issues of our day. On the basis of my own informal survey of feminism, it seems that most women simply want to be themselves. Many espouse a feminist position but hate what the white male-dominated media has tried to make feminism stand for. The "fluff index"(trivial features, chatter by anchors, celebrities items, and teasers about the news to come after the commercials), as journalist Max Frankel observed, encompasses inconsequential features and misleading analyses. It is the mass media that decide whose voices audiences will hear and how much these figureheads will get to say. Banking on a P. T. Barnam kind of showmanship, television hosts serve up headlines like Camille Paglia's, "We Need a New Kind of Feminism," which may be true, but these programs are remarkably short of any in-depth analyses of what has gone before or what transitions are needed to arrive at this "new" brand of feminism.[4]

What time-tested feminists, including Patricia Ireland, Katha Pollitt, Robin Morgan, Susan Faludi, and Friedan, have to say resonates for many women more than the media-sanctioned words mouthed by Paglia, Katie Roiphe, and Wolf. In fact, one could argue that feminism is merely part of the new society that is emerging out of the collapse of the old patriarchal system. Indeed, many women can still recall their grandmothers telling

them about the first time women could vote. One woman's aunt recollected that she couldn't get a mortgage after her husband died. She was working as a waitress to support her family and had to pay cash for her home because the bank didn't think she was worthy of credit. Such discrimination was commonplace in her lifetime.

Author Margaret Atwood asked a group of female university students what they feared most about men. They listed things like being raped, beaten, or assaulted. She then asked a group of male university students the same question, but about women. The top answer among the male students was that they feared being laughed at by women.[5] Perhaps this answer was common among men because the male ego is so fragile? The truth is that everyone hates being laughed at and belittled, but women have experienced so much of it that they have had to developed a tougher skin to deal with it than have men. Ultimately, the message here is that women fear men's physical brutality even more than the other things I have listed.

Of course, there is no shortage of examples. They are an inventory of all the different forms of feminism that address Sigmund Freud's age-old question, "What do women want?" My brief, informal survey, library and Internet research, and personal experience suggest that some women, at least, want to be allowed to take care of themselves and their loved ones and still follow their dreams. Women want to be appreciated and rewarded in the workplace and in society in the same ways that men are—with equal pay, fair rates of promotion, and equal access to power. All people want to be judged by objective criteria; they want standards that are fair and unbiased. Most of us would agree that what women want isn't so extraordinary; indeed, it's no different from what mature men want.

SORTING OUT THE CONFUSION

Why, then, does the word *feminist* conjure up such negative connotations? First, because there are plural and competing perspectives to be found among women from different ethnicities and social classes on such heated issues as sexual freedom and pornography. Second, because some young, well-educated middle-

class white women have reinforced the idea that feminists widen the rift between the sexes by judging men in ways that are sexist, indulging in "women's talk," and not giving their daughters the room to view things differently. Third, because historically much of the mass media have tended to present feminists as lesbians, unhappy career women, or man-hating masculine members of the National Organization for Women, forcing their ideas on innocent "natural" women with maternal instincts. Finally, feminism gets its bad reputation because many conservative women view it as a "narrowly ideological movement" fighting for "unwinnable" causes that make relations with men "very difficult to find or sustain."[6]

These conflicts are reflected in current male-female debates that are often hostile and downright nasty. Talk radio and television, both liberal and conservative, construct images of feminism that could scare off Attila the Hun or anyone who hasn't got her wits about her. These images, coupled with the threat of the loss of femininity, scare off a lot of freedom-seeking women who might otherwise throw their energies behind feminism.

"Choose any set of criteria you like," Margaret Mead wrote during the 1940s, "and the answer is the same: women—and men—are confused, uncertain and discontented with the present definition of women's place in America."[7]

THE AMERICAN DREAM

Herein lies a cautionary tale not only for feminists but for everyone who is in pursuit of the American dream. At this moment in our social history, nothing seems more difficult for the working class to obtain. Perhaps it is so difficult because the American dream as we know it is a yearning for something that already belongs to the past. In *Families on the Fault Line: America's Working Class Speaks About the Family, the Economy, Race and Ethnicity,*" sociologist Lillian B. Rubin explains that the "American dream— a life filled with goods and comforts bought on credit; goods that in our consumption-driven society are symbols of worth, the emblems of success—has become a nightmare for vast numbers of families."[8] Often unemployed and deeply mired in debt, the working poor have no hope of upward mobility and are losing

the comforts they once had. Change is very hard on people who are working out of outmoded models of dependence.

When tensions of race, class, and gender are brought into such dramatic relief, they highlight issues that have a direct impact on women: adolescent promiscuity, teenage pregnancy, contraception and abortion, date rape, and sexual harassment. Feminists are quick to point out that a major problem with the notion of achieving the American dream has always been that men are in a more powerful position than are women, who are severely restricted in their economic opportunities regardless of class, and thus that the majority of women of all ethnicities and classes are perpetually dependent on men in one way or another. In the United States, the deck has been heavily stacked in favor of white Protestant males ever since the Pilgrims landed. Men of African American, Asian, and Latin American origins and those who are not Protestant still do not have the same career or economic opportunities as do their white Protestant male counterparts. The playing field is not as level as those in power would have us believe. We may all have been created equal, but we don't all get an equal distribution of the available goods, and this unequal distribution of resources is what makes for so much hate in this patriarchal society. However, the computer revolution is changing the rules of the game, so that in the twenty-first century, the playing field will be significantly different; it will offer extraordinary opportunities to those with the imagination to grasp the future possibilities.

In the 1970s, feminism opened the doors for dealing with the body, sexuality, relationships, the marriage contract, the family, and the workplace—the realms of both private and public life. The ideal of equality between men and women that was embraced by our legal system, educational institutions, and businesses has broken new ground, but there is some serious doubt that it has really equalized human relationships or taken advantage of the best our society has to give. During the 1980s, feminists were engaged in reassessing their goals. Wondering whether they could really juggle family and work, women began to fall into agonizing traps of self-blame. They found that despite the feminist revolution, working women were still penalized for not being "good" mothers and that those who didn't hold jobs

outside the home were seen as burdens on their mates. On the basis of what they had learned, some women opted to return to family and home while others tried to emulate Mildred Pierce's transitional career woman by making work a higher priority than family. Many women (and some men) began to ask whether they could really have a marriage in which there was no power hierarchy. For anyone who wants to understand how partnerships work, but, more important, wants to really love another, this is a crucial consideration. Perhaps the most significant question being asked today is, "Is this really what I want?"

The balance of power between men and women, regardless of color, remains inherently uneven. Today, as a result of the political power of the newly enfranchised Religious Right, family values seem to be on everyone's mind. A telephone poll of 1,055 teenagers aged thirteen to seventeen, conducted in 1994 by the *New York Times* and CBS News, found that teenage boys hold more traditional views on the family than do teenage girls. Many of the boys still believe in a 1950s-style marriage in which the wife stays home, rears the children, cleans the house, and does the cooking while the husband is responsible for making money and mowing the lawn. This finding is really surprising, since the mothers of 71 percent of the teenagers who were surveyed were employed outside the home (the proportion for fathers was 80 percent). Most of the girls wanted egalitarian marriages and careers. Many of them said that their mothers had encouraged them to work. One of the girls said, "Every woman should [work], in case you get divorced."[9] But this is only the tip of the iceberg.

What most teenage girls don't know is that being on the mommy track is going to cost them dearly. Quitting a high-profile job to raise children signals corporate America that you are not really a fast-tracker. Most women who try to return to full-time careers after taking a few years off to raise their children are in for a rude awakening. They find that they have to pay their dues all over again just to have the opportunities they once had. They are often treated as beginners by their peers, have to catch up on seniority, and retool their skills, and they lag behind fellow workers in salary, title, and responsibilities despite their past experience.

During the 1980s, Ronald Reagan, who personified the country's deep denial of racism, sexism, drug addiction, and AIDS, dominated American politics. His administration encouraged the public to embrace simplistic conventions and nostalgic attitudes toward women and men, family, and the work ethic. During this decade, feminism as an agent of change was viewed as an evil threat to the safety of the family, heterosexual relations, and job security. These unfounded fears resulted in all kinds of sexism operating at various levels of our society. They also produced conflicting feminist positions. There are feminists who are not pro-choice (for a women's medical right to an abortion) and feminists who don't support affirmative action (job considerations based on a person's gender or race). There are feminists who support the right of women to become surrogate mothers (the woman's right to produce children for others) on the grounds that this is an aspect of women's freedom to choose what she can do with her own body. There are also feminists who oppose "surrogate motherhood" on the grounds that it is a patriarchal exploitation of a woman's body as a baby machine. Each of these groups is convinced that its position is the right one. And each identifies itself (and should be identified) as "feminist" because it is founded on an underlying feminist principle. This is why it is important not to adopt judgmental labels like "Pod feminist."

REPRODUCTIVE RIGHTS

In the past few years, controversies over women's rights have intensified as women's bodies have become economic products: e.g., choice. Abortion is never an easy decision, but women have good reasons for wanting to maintain their legal right to obtain one. A 1992 Abortion Patient Survey Study conducted by Victoria Tepe Nasman, (based on 142 abortion patients and 51 of their partners), from January 3, 1992, to May 3, 1992, found three things:

(1) 68 percent of abortion patients were already parents to an average of two children; 87 percent of abortion patients were unmarried. Existing parental responsibilities in the face of financial hardship played a key role in the decision to resolve an

unwanted pregnancy by abortion. (2) Abortion patients were offended and angered by what they had to confront after making this difficult decision. Over half of the patients surveyed encountered anti-abortion protesters outside the clinic, and more than 80 percent of these patients felt that the protesters' actions constituted an invasion of privacy. (3) Abortion patients and their partners are a motivated voting bloc. More than 2/3 were registered voters, and over 80 percent of these individuals said they will vote this election year for candidates who defend abortion rights.[10]

These findings seem to refute the claims of antiabortion theorists that women who seek abortions are irresponsible, immature, selfish human beings who are merely inconvenienced by pregnancy. They help to dispel the notion that abortion is an easy and thoughtless decision.

"The two groups most supportive of full human rights" for the fetus, cultural historian Garry Willis stated, "are also the two which deny women full access to church office. In the case of Catholic authorities, this second-place role for women is derived from a fundamentalism about tradition—the tradition of the celibate male priest."[11] Among evangelicals, women's roles are determined by passages in the Pauline writings. Both groups claim they are not denying the dignity of women when they uphold the fundamental role of motherhood and the completion of all pregnancies. But despite these claims, both deny women clerical status in their churches and the right to choice. Even so prominent a Catholic as Phyllis Schlafly and a high-profile evangelical like Beverly LaHaye submit to the program that opposes feminism as a challenge to the home, where woman should be enshrined.

Rigid conservatives of many faiths advocate for the rights of fetuses and would-be fathers but challenge the one right that women have historically retained some vestige of: sovereign rights over their own bodies. The Bill of Rights, an integral part of the Constitution, addressed the issue of individual choice to protect citizens from the actions of the federal and state governments. In the original ruling on abortion in the case of *Roe v. Wade*, it was the federal government that protected the individual from coercive state (Texas) law. The Supreme Court ruled that most state laws restricting abortion were in violation of the

personal liberty protected by the due-process clause of the Fourteenth Amendment. Contrary to popular misconceptions, most increases in individual rights in this century have come from the federal government's defense of the individual against state governments. The civil rights movement is the clearest example of this practice.

Roe v. Wade and many other cases have made this point. Catholics who are pro-choice, for instance, argue that church teaching on sexual and reproductive issues is not infallible. Moreover, the Catholic Church has no unified position on when the fetus becomes a person. Catholics for a Free Choice maintain that "abortion can be a moral choice. Women can be trusted to make decisions that support the well-being of their children, families, and society, and that enhance their own integrity and health. So a Catholic who believes abortion is immoral in all or most circumstances can still support its legality."[12]

Pro-choice activist Andrea Dworkin contends that such phrases as "sanctity of human life" are of a religious character and have nothing to do with egg and sperm. But who's to say what an individual has a right to hold sacred. Pro-choicers, as opposed to pro-lifers, maintain that motherhood is not something one consents to merely by having sex. Despite these objections, it is often father essentialism (*his* right to *his* child regardless of the woman's rights) that prevails as a political right in the courts.[13] The issue is about legislating a concept of morality.

Feminists maintain that women can get all the rights in the world, but without the right to elective abortion, women don't own their own bodies. If women can't control what happens to them and the course of their lives can be changed by somebody else who can get them pregnant by accident or by deceit or force, women have about as many rights as slaves. The feminists whom Schlafly and her sisters criticize (NARAL, or the National Abortion Rights Action League) are doing everything they can to protect women's human and civil rights and all people's right to make this difficult decision.

One young African American woman who had to fight her way through a threatening blockade at the Atlanta Feminist Women's Health Center was confronted by a blond white man who yelled that Martin Luther King would "turn over in his

grave" at what she was doing. She stared at him with tears in her eyes and replied: "You're a white boy, and you don't give a damn about me. . . . You even know less about Martin Luther King or being Black. What you have to say to me means nothin', not a damn thing." Leaving him speechless, she entered the center.[14] It is clear that extremists are intent on carrying out a campaign of intimidation and terror aimed at women who are seeking abortions and the health professionals who work at family planning clinics.

Frances Kissling, president of Catholics for a Free Choice, has said repeatedly that one is not allowed to be Catholic and pro-choice. Her group wants to "enable women to make thoughtful decisions." Its members agree that the fetus is a human life, but they maintain that there is a difference between human life and personhood. They say that fetal life deserves respect, especially as pregnancy advances; however, they insist that fetuses aren't people, but pregnant women are. Lamentably, there is no room for dissent, according to the Catholic Church's moral teachings. Kissling won't accept the pedagogical authority of the church, saying, "we must take the risk of engaging in moral discourse. While supporting the decision that each woman makes, we must acknowledge that each decision involves weighing legitimate competing values." According to Kissling, since "the Catholic religion makes the fetus into an icon, a figure of religious veneration . . ." there is no opening for moderation.

In a *New York Newsday* interview, Bishop James McHugh, a diocesan demographer, illustrated the church's stance. McHugh maintained that the world is not overpopulated. The main focus of the 1994 United Nations Conference on Population and Development was to allow women to take a more active role in the community development process, not just in curtailing procreation and reproduction. But this possibility doesn't seem likely when the views of Nafis Sadiq, head of the UN Population Fund, were dismissed by McHugh.

Pope John Paul II joined fundamentalist Muslims in opposing the UN conference. On September 5, 1994, he and his allies met in Cairo to contest the UN agenda because they believed that it would encourage homosexuality, premarital sex, and abortion. By scapegoating gays, people who are sexually active outside

marriage, and people who want to have reproductive choice, the Catholic Church and religious fundamentalists are determined to win control over other people's lives.

In 1994, the *New York Times* noted that six months before the UN's Fourth World Conference on Women was scheduled to open in Beijing, the Chinese government and the Vatican were working together to silence critics by asking the UN to deny credentials to delegations of Tibetans, Taiwanese, and Catholics for a Free Choice, as well as others who disagreed with their politics. The Vatican's observer mission acknowledged that it had challenged the credentials of "certain groups" but declined to explain why.[15] As Kissling commented: "This is the same misuse of the Holy See's status as an observer at the United Nations that they were so roundly criticized for in Cairo—that they would take an internal church dispute between some adherents to Catholicism and the hierarchy and turn it into a U.N. matter."[16]

Feminists throughout the world know that there is a population problem. The pope's credibility has been further eroded among progressives and feminists by the actions of his bishops in conferring mass on Ukrainian collaborators who murdered thousands of Jews during World War II. Time and time again, feminists and broad-minded people who are in the vanguard of meaningful social change have asked disturbing questions that the Catholic Church has not answered, such as "What common ground and shared convictions does the Vatican have with Muslim countries?"

As a rigid right-to-life movement mobilizes to cut off Medicaid funds for abortions in the United States and global "true-believers" pursue their blind faith oblivious of the havoc it wreaks on vulnerable women, the more opposition against them has mounted. In the preface to her banned novel, *Shame*, Taslima Nasrin wrote: "I detest fundamentalism. . . . The mullahs who would murder me will kill everything progressive in Bangladesh if they are allowed to prevail. . . . The disease of religious fundamentalism is not restricted to Bangladesh alone and it must be fought at every turn. . . . I, for one, will not be silenced."[17] Given the fundamentalists' and Vatican's record on women's rights, child abuse, and birth control, it is not surprising that feminists believe that women and children are going to lose at this game.[18]

Nor is this the only instance of fundamentalists interfering in women's affairs.

Muslim fundamentalists have put a price on the head of Bangladesh feminist Nasrin because she dared to say that the Koran should be revised and that Islamic laws should be amended to give more rights to women. Now a fundamentalist group has offered a $5,000 reward for her assassination. Because she dared to challenge the fundamentalists' authority and deeds, she has become the new Salman Rushdie.

Meanwhile politicians, who are easily swayed by these zealots, debate over the amount to spend on what they label "women's concerns." Feminists of all persuasions are telling the world that they will not be hushed or be frightened into not taking a stand on issues that are vital to human rights and the common welfare.

Feminists have fought many hard battles, but nowhere is the collapse of personal and private in American life so evident as on the reproductive frontier. The growing number of arsons, bombings, and murders at family planning and abortion clinics by antiabortion extremists have compelled feminists to speak out and protest when people are killed in the name of God. Feminists insist that hate is not a family or Christian value.

Antiabortion leaders claim to act "in defense of life." But they have actively worked to destroy programs that aid life, including prenatal care and nutrition programs for dependent pregnant women. On September 27, 1994, Newt Gingrich brought three hundred House Republicans and challengers together on the Capitol steps to announce the signing of the Contract with America. Hidden among the promises for term limits, a line-item veto, the balanced-budget amendment, and increased military spending is a section on "personal responsibility" that states that "no funds may be used for abortion services or abortion counseling." In essence, this act would gag physicians and other health care professionals by prohibiting them from giving women vital information regarding their complete range of options for dealing with an unintended pregnancy. This prohibition is a blatant violation of the doctor-patient relationship. Mainstream medical organizations, such as the American Medical Association, the American College of Obstetricians and

Gynecologists, and the American Nurses Association, have opposed this gag rule.[19]

What is needed, insist authors James MacGregor Burns and Stewart Burns in their book *A People's Charter*, is "a larger vision of reproductive rights [that] would encompass not only the negative right to be free from compulsory childbearing, rape, and domestic violence, but the positive entitlement to all the resources necessary to be a mother *and* a self-determining human being—whether one is married or a single parent."[20]

Reproductive rights are crucial and hotly debated. Some people think that exceptions to the prohibition of abortion should be made for women who are pregnant as a result of rape. Others say that if a woman has a right to an abortion if she was impregnated during rape, it means that the real issue is not "fetal rights" as much as whether a women should be forced to accept the consequences of sexual intercourse. Should there be any difference in the way the law "should" protect the "rights" of the embryo or fetus, depending on the stage of gestation and/or whether the embryo is viable?

Conditions such as ectopic pregnancy (implantation outside the uterus), which is considered a severe health risk for the mother, raise issues that have a direct impact on the woman involved, who is shuttled between the state and the legal system. Abortion, indeed, removal of the fallopian tube, is the usual treatment for ectopic pregnancy. Situations such as these are what makes the abortion debate so difficult to resolve. Adding fuel to these fires are debates about the ethics of in-vitro fertilization and the problem of the embryos it generates. To whom do these embryos belong?

In individual households, on television and radio talk shows, in newspapers and magazines, and on the Internet, people are discussing difficult issues, such as "Can you be pro-choice and antiabortion?" Trick questions such as this are commonly asked by antiabortion people and only serve to confuse middle of the roaders. Others are against governmental spending for social programs, which they say have produced marginal, if any, improvement in the quality of life among poor people in the United States, but still insist that unborn life deserves to be protected by the state.

Feminists and their allies maintain that the Christian Right does not have the right to impose their views on everyone else. Their position is that such people may practice what they wish, but they do not have the right to impose their beliefs on others who do not believe as they do. Many who are not Christians believe that requiring women to have babies and then not helping them to care for the children is not compassionate. Controversies over these complex differences of opinion have heightened enormously in recent years because of the actions of the extreme Religious Right and advances in medical technology, especially prenatal treatment. What I have painted is a disturbing picture of a misplaced, uncritical, and highly emotional concern for human life at the direct expense of a more appropriate concern for human suffering. It would be impossible to answer all the complex questions raised by the battle over abortion in one book, let alone one chapter. So I will briefly summarize what is involved.

Before 1973 and *Roe v. Wade*, hundreds of thousands of illegal abortions were performed in the United States every year. Antiabortion laws established a system in which women's bodies and lives were controlled by politicians, the police, and the press when it was politically valuable for them to do so. Millions of women became sterile or died each year from back-alley abortions because they could not exercise any control over their own bodies—their own destinies. Feminism helped to change all that. As Elizabeth Karlin, director of the Women's Medical Center of Madison, Wisconsin, and a physician, explained:

> I don't do abortions because it's a filthy job and somebody has to do it. I do them because it is the most challenging medicine I can think of. I provide women with nurturing, preventive care to counteract a violent religious and political environment. I hope to do it well enough to prevent repeat abortions. Like coronary artery surgery, an abortion is a response to things gone wrong. It is not the underlying disease. Ignoring the disease is bad medicine.[21]

Although violent extremists have marched around her house, plagued her eighty-six-year-old mother with hang-up calls and worse, invaded her office, and threatened her life, Karlin continues to offer the medical care she feels committed to provide.

Some people argue that a person can be against an action and still consider it a justifiable individual choice. They don't believe it's their right to decide when an individual is justified in having an abortion. Given the society in which we live, any woman may one day feel compelled to have an abortion, and many believe that the only person equipped to know when it is the necessary option is the woman whose life will be affected by the decision. Those who support this position think it is shortsighted to believe that making abortion available will increase its incidence. As one man commented, "If you really want to stop abortion, get off women's backs and start taking care of the deep problems in this society. Remember that all animals kill their young when things look hopeless."[22] (Perhaps if this country had a good birth-control policy, and information on contraception was more widely available, then so many women would not have to choose to end their pregnancies—because they wouldn't get pregnant in the first place. But the foes of abortion also condemn birth control, which brings up another issue: Is the purpose of sex only to procreate?)

Most feminists stress a higher obligation. They ask whether birth is in the best interests of the child who will suffer great physical pain or be unable to care for himself or herself. If a child is going to go hungry, suffer neglect and/or abuse, or add to the burdens of an already overburdened family, is it really in his or her best interests to be born? Everyone in these debates keeps asking, "Who is the natural protector of our children?" Should the government or the parents decide what is best for the family?

Feminists have generally treated abortion as part and parcel of the exercise of individual rights and responsibilities. Currently, the abortion crisis centers on the female body as a site of moral, philosophical, and sexual debate. Until recently, the subverting of choice by medical and corporate professionals, to promote technological and contractual reproduction (in-vitro incubation and surrogate production), has been a largely unexamined area.[23] The problem of misogyny becomes evident in public policy and legislation that diminish women's rights by increasingly separating the issue of the fetus from the issue of the female body to safeguard its "personhood."

Cases like the 1987 Baby M case, commonly referred to as the Sorkow decision, which upheld the validity of a surrogate contract and awarded custody of the child to Bill Stern, the natural father, highlight the new problems that biotechnology is creating for the courts. A decision like this one reduces women to "rented wombs." It "privileges the male immediately because it rebiologizes father-right while debiologizing mother-right"[24] It says that a "woman can rent her womb in the state of New Jersey, although not her vagina, and get a check upon turning over the product to its father."[25] The image and reality of woman as a reproductive conduit, someone through whom someone else passes, is chillingly detailed in Margaret Atwood's novel *The Handmaid's Tale*. Echoing Phyllis Chesler, *The Nation*'s Katha Pollitt called it "reproductive prostitution."

Best-selling author Amy Tan dealt with Chinese women's experience in this realm in her 1989 book, *The Joy Luck Club*. Tan wrote the novel in an attempt to understand her mother who came to America from China, but it does far more than that. I saw the film adaptation of the novel, most of which was shot in China, and although some critics called the film a "woman's movie" and a tear-jerker, it struck me as a powerful depiction of four Chinese women's lives: how they survived the brutality of male-dominated prerevolutionary China and how their children were affected by these women's experiences.

The Joy Luck Club is a group of four older Chinese women who meet once a week to play mahjong and exchange family news. One auntie tells the story of her mother who was raped by a rich man, became pregnant, was forced out of her home, became the fourth wife (concubine) of the lord of the house, and lost her son to the second wife who pretended the boy was hers. She was helpless because her master could do as he liked with her, and he treated her like a slave. Finally, the anguished and humiliated mother killed herself.

In prerevolutionary China arrangements of this kind were the rule. In Zhang Yimou's *Raise the Red Lantern*, a similar "marriage" is made. A young and educated girl who wants to explore the world is put on the market by her mother. The young woman thinks she is being married off to a rich old man, but instead discovers that her mother has sold her as a concubine. Her world

consists of the living quarters that she and the three other wives are confined to. The new wife, Songlian, is gradually drawn into the intrigues of the other women of the house. We rarely see the lord and master of the house, but we know when he is visiting one of his caged birds because a red lantern is raised each night outside the quarters of the wife who is honored by a visit from him.

The lord of the manor is self-centered and unfeeling. This is symbolized by the disappearance of Songlian's flute, the only possession her father left her. Her maid, who hates the new "wife" for her superior position, tells the master that his concubine has something of her own, and he orders it burned. He assumes it is a gift from a rival, but never bothers to investigate or ask his new wife about it.

Songlian begins to lose her spirit and her mind because of the cruelty of her ruler, his wives, and servants. Finally, she pretends to be pregnant to get the lord's attention because she knows that if she gives the master a son, he will honor her, and bearing a son is the only way she can obtain any status in the household. Eventually, her ruse is discovered. The furious lord withdraws from her, everyone in the house shuns her, and she eventually goes crazy and dies. This film shows that under the old system, a woman was not entitled to compassion or understanding. Yet anyone can identify with Songlian's longing to produce a male child, since it is the only way she can become a person in this luxurious prison. Both *Raise the Red Lantern* and *The Joy Luck Club* vividly depict crimes of gender—acts related to women's poverty and laws and traditions—that keep women in the place that patriarchy has designated for them.

Notes

1. See Jo Freeman, "Feminism vs. Family Values: Women at the 1992 Democratic and Republican Conventions," in *Off Our Backs* 23 (January 1993): 2–3, 10–17.

2. Diane Ackerman, "Atmospheric Conditions," in *Pen American Center Newsletter* no. 82 (October 1993): 4.

3. Elizabeth Janeway, "The Wave," in *Pen American Center Newsletter* no. 82 (October 1993): 3.

4. See bell hooks, "Camille Paglia," in *Outlaw Culture: Resisting Representations* (New York: Routledge, 1994), 86.

5. Mary Armstrong-Smith [74543,3224], forwarded to the author from "The PR & MKTG Forum, no. 209491," 4 June 1994, 16; and (48:45Sb: What Is Feminism?), CompuServe [73611,2201] online.

6. For a more complete interpretation of the masculinist view, see Nicholas Davidson, *The Failure of Feminism* (Buffalo, N.Y.: Prometheus Books, 1988), 280–85.

7. Quoted in William H. Chafe, *The Unfinished Journey* (New York: Oxford University Press, 1986), 148.

8. Lillian B. Rubin, *Families on the Faultline: America's Working Class Speaks About the Family, the Economy, Race and Ethnicity* (New York: HarperCollins, 1994), 34.

9. Tamar Lewin, "Poll of Teen-Agers: Battle of the Sexes on Roles in Family," in the *New York Times*, 11 July 1994, A1, B7.

10. Victoria Tepe Nasman (vnasman@falcon.aamrl.wpafb.af.mil), "Press Conference on Abortion Patient Survey Study," 3 July 1992, CompuServe online.

11. Gary Willis, *Under God: Religion and American* Politics (New York: Simon and Schuster, 1990), 329.

12. Frances Kissling, "Catholics for a Free Choice", CompuServe journalism forum, 1.

13. Janice G. Raymond, *Women as Wombs: Reproductive Technologies and the Battle over Women's Freedom* (San Francisco: Harper San Francisco, 1993), 31.

14. See James MacGregor Burns and Stewart Burns, *A People's Charter* (New York: Vintage Books, 1993), 358, for a fuller accounting of this incident.

15. Barbara Crossette, "U.N. Talks on Women Under Fire," in the *New York Times,* 17 March 1994, A7.

16. Ibid.

17. As quoted in Associated Press, "Hunted Author Out of Hiding," in *New York Newsday,* 4 August 1994, A4.

18. Vivienne Walt, "Interview with Bishop James McHugh," in *New York Newsday,* 22 August 1994, A21.

19. E-mail "Choice-Net Report," from Women's Wire: Gopher.WELL.Com., a weekly update on reproductive-rights issues distributed through e-mail, Ascend groups alt.activism, talk.abortion, sac.women, and other Internet channels.

20. Burns and Burns, *A People's Charter,* 361.

21. See "Hers," in the *New York Times Magazine,* 19 March 1995, 32.

22. "Sexes Forum," 1995, CompuServe online.

23. Raymond, *Women as Wombs,* xi.

24. Ibid., 34.

25. Katha Pollitt, "Contracts and Apple Pie: The Strange Case of Baby M.," in *Reasonable Creatures: Essays on Women and Feminism* (New York: Knopf, 1994), 63.

8

Repercussions

If the 1960s and early 1970s ushered in the era of the transitional housewife-careerist, then the early 1980s was the time of a dualistic superwoman whose career came first and whose family was of secondary importance. During the 1980s, however, feminist consciousness-raising was attacked by a backlash that attempted to champion a return to home and hearth.

Magazines encouraged women to stop trying to be superwomen and "have it all" because trying to compete in high-powered careers, raise perfect children, create beautiful homes, and support husbands' careers would lead only to burnout. Mass media–created trend stories announced that women who pursued their careers at the expense of home and family suffered from depression, low self-esteem, and infertility as their biological time clocks ran out. Newspapers and magazines featured nightmarish stories about day care and child-molesting nannies.

In 1988, *Good Housekeeping* launched the "New Traditionalist" ad campaign featuring former career women in their Cape Cod homes surrounded by adorable children. Women, the media told the world, are finding their identities by serving home, husband, and children. Behind much of this campaign were the Moral Majority, Heritage Foundation, and fundamentalist ministers who wanted white middle- and upper-class women to leave the labor market and to stay at home where they belonged.

Magazine moralists struck feminism in its most vulnerable spot—its neglect of homemakers and their fear of how feminist-backed legislation might affect them.

During the 1970s, conservative women had defeated the Equal Rights Amendment on a platform that appealed to housewives, arguing that the ERA would undermine the American family, legalize abortion, permit homosexual marriage, and force the military to use women in combat. This trend persisted in Marilyn Quayle's 1992 remark at the Republican convention, "Women don't want to be liberated from their essential nature as stay-at-home wives and mothers." It also recalls a certain enduring nostalgia for the "cult of the true woman." The problem with this view of the world is twofold: first, even college graduates now face diminished job prospects and, second, it takes a two-paycheck couple to better the lot of the average family. In addition, the simple truth is that women generally don't earn as much as men and a dual standard exists in the workplace. Thus, all things considered, it is clear that the whole question of what's "natural" is moot.

In 1990, the median income for full-time working women was $20,586, compared to $29,172 for men. Professional women earned on average $25,982, while professional men took home $47,432.[1] It seems that most working women and men in the United States have little choice about selling their labor, regardless of what Marilyn Quayle assumes to be women's "essential nature as stay-at-home wives and mothers." During this period, Hollywood continued to produce films that mirrored the anxiety that the culture felt (and still feels) about what women want and where they belong. *The Stepford Wives, Diary of a Mad Housewife,* and *A Woman Under the Influence,* as well as films with a more liberating slant, including *Private Benjamin, Up the Sandbox, The Turning Point, An Unmarried Woman,* and *Alice Doesn't Live Here Anymore,* are representative examples. The backlash of the 1980s also produced images that suggested that single women were crazy (such as *Fatal Attraction* and *The Hand That Rocks the Cradle*) and that motherhood and high-powered careers can't mix. A woman on the fast track appeared to be either ruthless, as in *Broadcast News,* or loveless, as in the class-biased film *Working Girl.*

For anyone who doubts the importance of these role conflicts, the results of a simple survey of the women's magazines is revealing. For the white middle-class family woman, putting a woman politician on the cover of *Redbook* or *Good Housekeeping* is the surest way not to sell magazines. The January 1993 issue of *Good Housekeeping*, which carried Hillary Rodham Clinton on the cover, did poorly at the newsstands. More upscale magazines like *Mirabella*, *Harper's Bazaar*, and *Glamour* suggest that feminism has been assimilated into their readers' consciousness. But what brand of "feminism" are they selling their readers?

Feminist theory has provided tools for understanding that gender is both a structural element of society and a way that women experience themselves that is given meaning through various images.[2] In 1985, Steven Spielberg adapted Alice Walker's novel *The Color Purple* into a complex film about a black woman named Celie who grows up in the rural South in the early decades of the twentieth century. Told through a series of letters, flashbacks, and wonderful performances by Whoopi Goldberg, Danny Glover, Margaret Avery, and Oprah Winfrey, this is a gutsy story that reveals the friction between men and women.

We first see Celie as a child running through the fields of purple flowers with her sister. She is pregnant for the second time by her father, who is going to give away her second child just as he did the first one. Later Celie's father marries her off to a contemptible man she calls "Mister." Celie lives in servitude to Mister and his children; he beats her and separates her from her sister, the only person who loves her. The pivotal point in the film is the scene after her husband brings his fancy woman, Shug, home for Celie to take care of. Gradually, the two women bond and form an intense emotional and physical relationship. The blues singer Shug shows Celie that she is beautiful and then Celie begins to love herself and to heal.

The portrait of marriage that Walker created is not what brides' magazines present, although it may be typical of what happens to women who are in abusive relationships, regardless of race, class, or ethnicity. It reveals the pain of a black woman's position in a loveless family and marriage. Celie triumphs, becomes independent, leaves Mister, discovers that her so-called

father wasn't her real father, and finally is reunited with her sister and lost children.

During this period, many middle-class black men objected to Walker's portrayal because it presented them in such an unflattering light. They accused her of creating a sexist stereotype of the black man that encouraged racism. But Walker's critics failed to recognize and validate experiences that many black women and white women identified with. They concentrated on her story, but they saw it through the lens of their own biases. Walker's detractors made themselves the center of debates in the black community about the book and film, rather than the complex human issues she raised.

In an essay entitled "Dear Black Man," Fran Sanders asked, "What of the Black woman? What has become of her?" Like the "difference" feminists, Sanders argued that women are temperamentally different from men. She asked, "How long will black women suffer the indignities and insults that black men direct at them?" and "Who reveres the Black woman?" Her essay contended that black women bear a heavy burden of male frustration and rage through physical abuse, desertions, and rejections of their femininity. Black feminist writers agree that many black men insult black womanhood by whatever means they have at their disposal. Feminists point out that the need to censor Walker's writing and that of other black women authors, such as bell hooks and Audre Lorde, should be a genuine concern for all progressives, regardless of race or gender.

Black women are still treated as second-class citizens in the prestigious NAACP. A class-action suit was filed in federal court by Stephanie Rones, a civil rights lawyer who has been on the organization's legal staff since 1991, and another NAACP employee, Barbara Coggins. The women charged that male staff members were routinely given secretarial help, but the female staff members were not, and that the men were allowed to attend training sessions and were given per diem allowances for their expenses, whereas the women were forced to take time off and pay their own way. Men hold almost all the top-level positions in the organization, although 75 percent of the staff are women.

When Benjamin Chavis became executive director in 1993, things worsened. Edith Hall, who worked for the NAACP for

five years before she quit in December 1994, summed it up splendidly when she said, "I love and respect the NAACP but women have to acknowledge our contribution and our value openly. Our daughters have to learn to be responsible leaders, and they can only learn from our example. We cannot afford to be quiet."[3]

Clearly, as these examples show, feminists are made, not born. It is outrage against sexist injustice that fuels much of the feminist movement and keeps it growing. And reason still dictates that feminism makes sense to millions of women. As has been demonstrated, women are disabled by cultural stereotypes of female attractiveness and of nurturance, as well as by a host of other trends. Women are thought to be warm, tender, compassionate, involved in the welfare of others, and noncompetitive, but they aren't allowed to be loud, aggressive, and competitive.

At the same time, women writers and activists are changing these perceptions. Fannie Flagg's book *Fried Green Tomatoes at the Whistle Stop Café*, which was also adapted for the movies, stirred up controversy because it touched on what appeared to be a lesbian relationship and provided some different female role models. Directed by Jon Avnet, and staring Kathy Bates as an overweight, dowdy, unhappily married white woman whose self-esteem has slipped below the horizon line, this is essentially the story of three relationships—Evelyn Couch's, Ruth Jamison's (and her lover Idgie Threadgood's) and Ninny Threadgood's.

Evelyn is one of those women who feels stuck in the middle of nowhere. As she puts it, "Women's lib came too late for me. . . . I was already married with two children when I found out that I didn't have to get married. I thought you had to. What did I know? And now it's too late to change. . . . I feel like life has just passed me by."[4]

Jessica Tandy plays the feisty storyteller, Ninny, who relates the lives of Idgie Threadgood and Ruth Jamison through a series of flashbacks to Whistle Stop, Alabama, more than half a century ago. Mary Stuart Masterson and Mary-Louise Parker give spectacular performances as Idgie and Ruth. Ruth's first mistake is to marry Frank Bennet, a violent, drunken redneck—she doesn't discover his real nature until they are man and wife. As a consequence of Ruth's actions, her friend Idgie (a nonconformist who wears her hair short, dresses in pants and ties, and is in love with

Ruth) is forced to go her own way brokenhearted. Like Walker's *The Color Purple*, Flagg's *Fried Green Tomatoes* is a wonderful story about how some women respond to their experiences of marriage and create real relationships with each other.

MOTHERHOOD AND REPRODUCTIVE TECHNOLOGIES

The story of motherhood in the United States is getting more complex all the time. Many women have miscarriages, and the agony of infertility has driven people to extremes and caused them to pursue costly medical treatments that didn't exist twenty years ago. Tens of thousands of women in this country want nothing more than to be mothers. And older women who postponed pregnancy until their thirties or forties are now blaming the feminist movement for their plight. "I was misled by the women's movement," wrote one woman who is taking expensive infertility treatments. "The message was: you can have it all. I would have had a better chance back then."[5] But feminism also advocates taking responsibility for one's choices and being mindful of the realities of biological change. What needs to be examined in the context of the patriarchal system, feminists contend, is not the psychological drive to have a career and a baby but, rather, the inability to feel complete without a child or to accept the limits of the female body.

Currently, the fields of reproductive medicine and biogenetics are among the fastest growing and most talked about. Issues related to menopause, genetics, and assisted reproductive technologies have outdistanced our most diligent efforts to keep current. The aging woman and male infertility dominate news coverage. The perils and promise of new technologies of genetic screening and manipulation have enormous implications for the future of our species.

A 1995 episode of the television program *Picket Fences* broached the question of in-vitro fertilization and, in this case, an experiment in which cows act as live incubators for human fetuses—in essence, surrogate mothers. Although this experiment may have benefited the humans who wanted babies, it certainly didn't benefit the cows. More disturbing is the current use of women for the same purposes as the cows were used in

Picket Fences. The program raised a question about our society and our ethics in justifying such practices. Experiments on men and women have already begun, and where they will take us as a species no one really knows.

The *Picket Fences* argument is similar to the case of a pregnant woman who had cancer and whose husband did not want her endangered by removing the fetus to "give it a chance." In this situation, the doctors and the courts decided to operate on the woman to save the fetus; as a result of their unwanted intervention, both the mother and fetus died. The husband's rights were completely ignored, and the state prevailed in this tragedy. The inhumanity of medical ethics in addressing women's rights is something Marilyn French brought to public attention in 1992 in her no-holds-barred book, *The War Against Women.*[6]

Many people are asking where should the line be drawn. What are the ethical and philosophical implications of this new-found power to tamper with DNA? Like religious fundamentalism, asserts Janice Raymond, "medical fundamentalism sets up a determining set of beliefs in the efficacy of its own experiments."[7]

Feminists argue that in the realm of law and social custom, the United States seems to be returning to the nineteenth-century practice of favoring men's legal custody of children and viewing the mother as a kind of human incubator who simply delivers the goods. The father and the product appear to have more rights than the mother. What needs to be examined is why women's human, civil, and economic rights are not as vigorously defended as those of men.

Raymond does not consider childbearing to be a cottage industry. She laments that among certain feminists, an oppositional stance is out of fashion, as are anger, passion, and explicit political activism. She is outraged that academic and professional feminism in the United States today is permeated with sexual and reproductive liberalism, not by sexual and reproductive radicalism. Raymond contends that feminism outside these circles is much more radical and vibrant.[8] In her scathing critique of socialist and libertarian feminism, she called on such women to reexamine their relationship to dominant male theories and to practices that are bound up with the prevailing power system

and its institutions, such as universities, hospitals, and churches.

Moreover, in discussing in-vitro fertilization and other medical miracles, she asserts that many have turned into nightmares for women. Diethylstilbestrol (DES), a synthetic estrogen initially given to women to prevent miscarriage and regulate their periods, is known to have caused cancer and infertility in many of the daughters of women exposed to the drug. Thalidomide, given as a sedative during pregnancy to thousands of women, led to the death and disfigurement of their children. The Dalkon Shield and Depo-Provera were promising contraceptives, but are still under study because of dangerous side effects. As I noted earlier, estrogen is still problematic for women who are undergoing menopause because of its association with an increased risk of cancer. Feminist critics of reproductive technologies contend that there is far too much technological intervention into the functioning of women's bodies.[9]

Many maintain that the patriarchy refuses to acknowledge the need to set limits on technological medical intervention. As a result, Representative Pat Schroeder introduced (H.R. 1161) in Congress a bill that covers many aspects of women's health and reproductive rights. H.R. 1161 promotes "greater equity in the delivery of health care services to American women through expanded research on women's health issues, improved access to health care services, and the development of disease prevention activities responsive to the needs of women." Framed in material terms, the limits are much more than economic cost containment. As Raymond cautioned, we must pay attention to values and the circumstances surrounding how they are applied.

Raymond and other women argue that an adequate feminist politics needs to be developed that can cope with the newly emerging medical technologies. Raymond maintains that moral intelligence and moral passion are the most vital resources an oppressed group has. "Such intelligence and passion form the groundswell of power, since without them the political loses its moorings all too easily." Her call for a regulatory approach is based on a sense of the inevitability of new reproductive technologies that will exploit and abuse women. She urges women to strengthen feminist action and activism at all levels. Adaptation,

she argues, is the key to preventing women from being techno-
logically ravaged.[10]

So despite all that feminists have accomplished, many
women's lives today follow patterns that were established mil-
lennia ago.

THE RELATIONSHIP BETWEEN DIVORCE
AND THE WELFARE SYSTEM

Over half the marriages in this country end in divorce. Studies
have found that after divorce, a woman's disposable income
generally drops while that of her husband rises. Following the
split, a woman often loses her identity and the social networks
that once supported her. In coming to an equitable solution, the
law often does not consider the skimping she did to put her hus-
band through school or the work she put in as a wife and help-
mate to build their resources and ensure his success during the
marriage.

Women who are divorced know how horrifying things can be
when they go to court. Even when a woman is self-reliant and
has a job, she still suffers a gigantic loss in self-esteem and
income. Unfortunately, during the 1970s, when feminists tried to
even the divorce process, men took full advantage of the oppor-
tunity to chuck their responsibilities, leaving many wives and
children in drastic financial straits. Stressing economic goals,
feminists want to reverse the economic consequences of divorce.
It is for this reason that employment, equal pay, the right to abor-
tion, and other issues related to the war on poverty loom so large
on the feminist horizon. Who are we really taking sides against
when we complain about the cost of welfare? Mainly, poverty-
stricken women and children, and older women. Where does this
put the out-of-work wife after a divorce or if her husband has
just walked out? Our society persists in teaching most girls that
the business of being a wife is the career they are really training
for. Everything else is secondary, so they frequently don't take
advantage of the expanding educational and commercial possi-
bilities that feminists of earlier decades opened up for them.[11]

Motherhood after divorce can be a revelation. Life may take
on a completely different meaning, especially for mothers who

are single, poor, undereducated, and abused. Often, the law that they rely on for help and protection treats their former husbands, who are burdened with the responsibility of earning the family income, differently from the way it treats them. For example, the law does a poor job of tracking down child-support dodgers and making them assume financial responsibility for their children.

Women, on the other hand, are generally given no quarter by the courts. If they use day care to go to school or work outside the home, so they can earn a living and support their children, judges may view them as inadequate mothers. The case of Marcia Clark, a prosecuting attorney in the O. J. Simpson trial, is only one, rather singular, instance because, unlike the majority of divorced women, she is not poor and earns more than her ex-husband. When Clark petitioned the court to restore her child care and support payments to their original levels, her ex-husband responded by filing a custody suit.

Clark, through no fault of her own, was caught in the double bind of being a single parent and unexpectedly becoming a high-profile media figure. This latter role required her to take on extra expenses as a prime television presence, including regular hair styling, new shoes, and five new "power" suits. Moreover, her child care expenses spiraled because of her increased public visibility. When she asked for her child support payments to be brought back to the former level of $1,100, instead of the reduced level of $650 that her ex-husband requested and received after he moved to a larger house, he sued for temporary custody of the children. This is often the case when a woman asks for child support payments.

Unfortunately, there seems to be a correlation between mothers trying to obtain or increase child support payments and fathers, who never expressed any sincere interest in caring for their children, filing custody suits. Yet the American legal system persists in awarding guardianship to fathers who take little or no responsibility for bringing up their children. This situation is similar to the cases of the working women in the nineteenth century whose drunken husbands were given custody of their children.

If women's primary role is to be a mother and men's is to be a father, then we need to deconstruct the myth of the father from the reality of fathering in American culture. First, father's are

men, men are people, and people aren't perfect. The myth of the American father is *Father Knows Best*. In this fifties series Jim Anderson (Robert Young) is a family man. He is an attorney, he has all the right answers, and is always there for his wife and children. He is a cultural icon—the perfect father. But the reality of this society is that we don't allow time to parent and co-parent. One middle-class white man I know, an over-fifty father of a baby boy, confided to me that his colleagues at the university made him feel "like an idiot" for being involved with his newborn child. "It's clear that they feel uncomfortable when I take him to work," he said. "Some of my friends have told me that colleagues have called me unprofessional." Co-workers discourage fathers from equal participation in child rearing, and mothers have trouble giving up control because so much of their self-esteem is invested in the role of raising children. Men are supposed to devote themselves to business, so their families will prosper, and they cannot endanger their income by getting involved in bringing up babies or in making decisions like how to discipline their children or what baby-sitters to hire.

Despite everything that prevents a father from participating fully in child rearing, there seems to be an increasing acceptance of men sharing these duties. Yet a 1994 study, reported in the *New York Times*, suggested that men whose wives work earn less and pay a "daddy penalty" in a dual-career family.[12] The sad truth seems to be that executive fathers whose wives are able to stay home earn more, and men generally get ahead faster.

In the 1970s, it became shockingly clear that many men were capable of ending their relationships with their children and providing inadequate economic support for them, regardless of their financial standing. But the truth is American culture does not make it easy for men to be good fathers, or reward them for trying. There are fathers who don't want to take responsibility for their offspring. Feminists blame the father for not being perfect enough—so do conservatives.

Most ultraconservatives assume that teenage boys are "loose cannons." They argue that boys' hormones are running amok and demand that we take a firm hand with them by providing male guidance and a clear structure. They want fathers to take these boys in hand and induct them into mature male society

before they end up on the street, in gangs, hating themselves; hating each other; and, most of all, hating those they view as their oppressors.

The strong father as a panacea for our social ills is mere nostalgia for something that never existed and doesn't exist today. The critique is immature. The reality is that the economics make it impossible to be a good enough father for a great many men, and men aren't brought up to care for babies. Actually, most of our media productions show their incompetence in dealing with babies and assuming a greater role in child care. Few people would disagree that fathers should be responsible for and to their children, but how can working-class men focus on their families when they are undergoing the savage downsizing of the American labor force? As Frances Fox Piven and Richard A. Cloward, winners of the C. Wright Mills Award for their book *Regulating the Poor: The Functions of Public Welfare*, asserted, "The mere giving of relief, while it mutes the more disruptive outbreaks of civil disorder (such as rioting), does little to stem the fragmentation of lower-class life, even while it further undermines the pattern of work by which the lower class is regulated."[13] How to convince unemployed fathers (and I'm not suggesting that it is only unemployed fathers who don't support their children) to fulfill their responsibilities seems to be a major problem, regardless of race, and the ultraconservatives offer no programs or laws that would alleviate it.

If your goal is strictly to reduce what William Bennett called the suffering child "bodycount," the kindest way may well be to eliminate welfare altogether. Charles Murray, of the American Enterprise Institute, estimated that the rate of unwed births would decrease 50 percent overnight if welfare was cut off in one fell swoop.[14]

Such policies would only foster other social ills, however, since a large number of women would be forced to earn their living, either part- or full-time, as prostitutes. Author Fran Saunders considers prostitution "the most outrageous and flagrant form of sexual oppression, in which an individual is forced to sell her body on the basis of both sex and color, rather than use her mind to survive." Feminists argue that prostitution will continue until our society chooses to provide meaningful and productive

employment for the disenfranchised, economically exploited, and physically assaulted.

Until our society holds men and women equally responsible for parenting and supporting their children, mothers will be abused by the judicial system. By what inhuman logic should any mother be forced to give up her child simply because she is poor? If we really care about children, shouldn't we find a humane solution to this problem? Instead, it seems that our system punishes people for being in circumstances that are often beyond their control, as Lillian Rubin's book *Families on the Fault Line* illustrates. What is worse, innocent children get lost in the process. They fall through the cracks of the system and can end up spending their entire childhoods in a series of foster homes, never being adopted.

Under the U.S. Constitution, all who belong to the human species are persons and are guaranteed the protection of their right to life. The sanctity of life, however, does not protect people from the misfortunes of life itself. Our streets are crowded with beggars, many of them women and children, imploring passersby for money, food, and clothing. Often these mothers are forced to use all their time and energy trying to sustain their helpless infants by fighting their way through the welfare system, instead of being able to work.

Patriarchal authority, social scientist Sheila Rowbotham explained, is based on male control over the woman's productive capacity and her person. That is why the question of freedom of choice looms so large on the feminist horizon and in issues related to family values. Women are engaged with questions of what it means to be female in this society and culture. They are concerned with who will control their bodies and to what extent they can do so. Sex, marriage, economics, and divorce are at the heart of our difficulties.

Perhaps the most crucial issue to focus on in these debates is a basic standard of living and the quality of life of the working class. The history of our country shows that American women endured a long struggle to obtain the right to work. But even the victory for just basic civil rights has taken an intense series of national campaigns to achieve. What is striking about the present debates is how they contribute to destroying working mothers.

Today we are onlookers in a new kind of political spectacle based on stereotypes played out in the nation's courtrooms. In attempting to take on this challenge, feminists are confronting an ill-defined set of standards based on gender discrimination that need to be reexamined in detail.

Piven and Cloward and Rubin have argued against the customary American view that the fault is with those in need. The real problem has been that changing world economics, the Internet, anti-inflation strategies, and regulation of labor have all resulted in a shrinking job pool. All recent studies on homeless populations have found an increase in two groups who are on the streets—families and people with full-time jobs.[15] If these group can't afford housing, why not build more acceptable low-cost housing?

Ultraconservatives offer no solution to our real problem, which is that men in power put a different value on various kinds of labor. Menial tasks and services are not as highly valued as are other types of other work. People who engage in these lesser kinds of labor, the majority of whom are female, have little status and almost no determination over their external reality in our society. This situation is discriminatory and explains why feminists believe that poverty has a gender. They contend that if this policy were changed, conditions would be different. The enactment of such a policy change and ensuring that remedies that are meant to correct social injustices were resolutely enforced would mean that, for the first time, men and women, regardless of race, creed, or sexual orientation, would have an equal stake in the process and that they would share and value a common reality and a vision of the common good.

What the feminist critique reveals is how lopsided the power equation really is.[16] Following a feminist social agenda would benefit society at large, while following an ultraconservative program would benefit only the "haves," leaving them, and all of us, to cope with the large criminal underclass their policies would create.

Now that the Contract with America has been published, feminists and concerned others are asking why ultraconservatives, who tout family values, haven't proposed alternative job training plans for unemployed fathers, so they can support their chil-

dren; universal health care; and stiff sentences for deadbeat dads. Is cutting off aid to the most needy in our society the solution to our problems? Feminists and progressives don't think so. They point out that being penniless and sometimes homeless, many poor urban mothers are isolated from mainstream society. Against the backdrop of their daily lives—involving drugs, violence, unemployment, homelessness, and teenage pregnancy—more and more of these women are being encouraged by feminists and others to get involved in their children's schools. Part-time jobs, such as monitoring the lunchroom, supervising the playground, and assisting in the classroom or school office, are bringing hope to the hopeless. These interactions are beneficial to children and the schools and help these women develop personal power through self-realization and a new sense of self-esteem. Because of these activities, many of these previously welfare-dependent mothers are able to move on to get jobs, create businesses, or continue their education with newfound personal growth.

Most feminists maintain that people can change if they are given half a chance to do so. What this country needs are more effective programs and structures with built-in accountability as to how our tax dollars are spent.

Notes

1. Lillian B. Rubin, *Families on the Fault Line: America's Working Class Speaks About the Family, the Economy, Race and Ethnicity* (New York: HarperCollins, 1994), 83.

2. Jill Dolan, *The Feminist Spectator as Critic* (Ann Arbor, Mich.: UMI Research Press, 1988).

3. Sheryl McCarthy, "Women Are Second at NAACP," in *New York Newsday*, 29 March 1995, A4, A26.

4. Fannie Flagg, *Fried Green Tomatoes at the Whistle Stop Café* (New York: McGraw-Hill, 1988), 67.

5. Barbara Stewart, "In Vitro vs. Adoption: Deciding When Enough Is Enough," in the *New York Times*, 8 January 1995, sec. 8.

6. See Marilyn French, *The War Against Women* (New York: Summit, 1992). See also *Issues in Reproductive Technology I: An Anthology*, ed. Helen Bequaert Holmes (New York: Garland, 1992), which presents multiple perspectives on these new technologies from an academic vantage point.

7. Janice G. Raymond, *Women as Wombs: Reproductive Technologies and the Battle over Women's Freedom* (San Francisco: Harper San Francisco, 1993), 93.

8. Ibid., 95.

9. Ibid., 129.

10. Ibid., 201.

11. Nancy Chodorow. "Family Structure and Feminine Personality," in *Woman Culture and Society*, ed. Michelle Zimbalist Rosaldo and Louise Lamphere (Stanford: Stanford University Press, 1974), 43–66; Michelle Fine, "Sexuality, Schooling, and Adolescent Females: The Missing Discourse of Desire," in *Disruptive Voices: The Possibilities of Feminist Research* (Ann Arbor, Mich.: University of Michigan Press), 59.

12. Tamar Lewin, "Men Whose Wives Work Earn Less, Studies Show," in the *New York Times*, 12 October 1994, A1, A21. See also Pepper Schwart, "When Dads Participate, Families Benefit," in the *New York Times*, 18 August 1994, A5.

13. Frances Fox Piven and Richard A. Cloward, *Regulating the Poor: The Function of Public Welfare* (New York: Vintage, 1971), 344.

14. My presentation of the conservative point of view is based on Paul Ciotti, "Feeding Stray Cats and the Single Mom Welfare Plan," in *Daily News*, 29 August 1993, p. 3.

15. Piven and Cloward, *Regulating the Poor,* 345.

16. For further information on the relationship among liquor, domestic violence, incest, and child-protection efforts, see Karen Sanchez-Eppler, "Temperance in the Bed of a Child: Incest and Social Order in Nineteenth Century America," in *American Quarterly* 47 (March 1995): 1–33; Elizabeth Pleck, *Domestic Tyranny: The Making of Social Policy Against Family Violence from Colonial Times to the Present* (New York: Oxford University Press, 1987); Mary Ryan, *The Empire of the Mother: American Writing About Domesticity 1830–1860* (New York: Haworth Press, 1982); Barbara Leslie Epstein, *The Politics of Domesticity: Women, Evangelism and Temperance in Nineteenth Century America,* (Middletown, Conn.: Wesleyan Press, 1981); and James Kincaid, *Child-Loving: The Erotic Child and Victorian Culture* (Ithaca, N.Y.: Cornell University Press, 1982).

9

Goals and Conflicts

Beginning in the 1980s, conservative agitators began to wage a persistent campaign on people's access to diverse forms of culture, including art, music, literature, drama, and conversation. These attacks have taken numerous forms—for example, censoring sexual expression of all kinds, free speech and expression, visual and performance art, and popular music. The Bill of Rights says that "Congress shall make no law respecting an establishment of religion, or prohibiting the free exercise thereof; or abridging the freedom of speech, or of the press; or the right of people peaceably to assemble, and to petition the Government for a redress of grievances."[1] During this period, a stream of liberated women joined the debates, which further confused the public about the aims of the feminist movement in the United States. Classical feminists reacted by labeling these women, such as Camille Paglia, as "Pod feminists" and "postfeminists." Throughout this book, I have characterized these women as part of the third wave of American feminism because of their contributions to the discussion of feminist concerns.

In 1849, when her master died, Harriet Tubman reasoned that there was one of two things she had a right to: liberty or death. "If I could not have one, I would have de oder; for no man should take me alive; I should fight for my liberty as long as my strength lasted."[2] Tubman became a symbol of courageous resis-

tance to slavery, and today is numbered among the chief precursors of the women's liberation movement. The idea that "all men and women are created equal"; [and] that they are endowed . . . with [the same] inalienable rights" has been around since the Declaration of Independence. Yet there is no arguing that there is definitely a double standard applied to men and women in our country.

Here are a few reasons why traditional feminists, such as Gloria Steinem, are so concerned about the discrepancy. Every two seconds a child in the United States is abused, every forty-five seconds a child is the victim of an act of capital sexual battery, one out of every three girls will be sexually assaulted by her eighteenth birthday, and the average length of time an incest survivor is subjected to incestuous assault is seven years. Furthermore, 98 percent of the sexual assaults on children, male and female, are done by persons that the children know and trust, and in 90–100 percent of the reports of child abuse and neglect, the abuse or neglect occurred in the children's homes as opposed to institutional settings.[3] There was an 852 percent increase in reports of the sexual abuse of children between 1976 and 1983, and a 59 percent increase from 1983 to 1984. In addition, over 80 percent of teenage runaways are victims of untreated, unreported sexual abuse, and over 75 percent of teenage prostitutes (male and female) were assaulted as children.[4]

These findings, among other things, may explain a little better what Andrea Dworkin and Catharine MacKinnon think they are fighting against and why they have aligned themselves with the extreme Religious Right to achieve their goals. In light of these facts, the Dworkin-MacKinnon model ordinance on pornography and civil rights proposed for Los Angeles County (see Appendix 1) makes perfect sense as an attempt to extend the feminist debate on exploitation and violence into an effective public domain.[5]

In a nutshell, the MacKinnon-Dworkin definition of pornography is "the sexually explicit subordination of women through pictures and/or words." This is a sweeping definition, as Nadine Strossen argued in her book *Defending Pornography: Free Speech, Sex and the Fight for Women's Rights*, and can have a "devastating impact on human rights." Strossen pointed out that "many peo-

ple use the term *pornography* to stigmatize whatever sexually oriented expression they dislike."[6]

The theme of violence is scattered throughout this book because it is so pervasive in our society and touches us all—newspapers and newscasts are full of it. So why does so much of the media concentrate on Dworkin and Company and make them appear ridiculous? Because the force of their experience, were it legislatable, would give women and children a formidable defense against this epidemic of patriarchal violence. But it would also encourage censorship and curtail the right to free expression.

Anthony Comstock, who founded the New York Society for the Suppression of Vice in the nineteenth century, wanted American sculptor Horatio Greenough's nude figures of "Chanting Cherubs" to wear aprons so as not to offend public decency.[7] Although the pro-censorship movement claims that this sort of legislation will reduce violence, there is no proof that there is a positive correlation between exposure to violence or sexually explicit material and acting out these fantasies in real life.

Furthermore, it's difficult to determine what Americans really think about sex. Indeed, saving souls is fundamental to our Puritan heritage. In the film version of Sinclair Lewis's novel, evangelist Elmer Gantry worked himself into a lather of indignation over the fallen while committing every sin in the book. It may be true that we all sin, as the cases of Jim Bakker, Jimmy Swaggart, and Hugh Grant remind us, but this doesn't seem to stop some of the "fallen" from thinking that they are better than those who engage in sex work for economic survival.

Several feminists have argued that prostitution, or "sex work," is a form of labor. Even so, it is highly paradoxical work, since it demands that the prostitute offer her (or his) body but withhold sexual pleasure. Sex work can be seen as a woman's most humiliating subjugation or as her ultimate freedom from male dominance. Feminists frequently maintain that the "world's oldest profession" exists only because patriarchy exists. The prostitute's social mobility—her ability to transcend class and station—however, threatens the very foundations of bourgeois society.

Undoubtedly, the misogynous social attitudes expressed by many men and women in our society are an attempt to regulate sexual conduct and pleasure. That's why Eve is so hated. In a society that generally prevented women from earning a living by nonsexual means until the late nineteenth century, the trade in human beings was a natural consequence. In France during the nineteenth century, there were around 100,000 courtesans, kept women, and street walkers working—in a population of 2.6 million.

"I love prostitution in and for itself," the French novelist Gustave Flaubert wrote in 1853 to his mistress, Louise Colet. "In the very notion of prostitution there is such a complex convergence of lust and bitterness, such a frenzy of muscle and sound of gold, such a void in human relations, that the very sight of it makes me dizzy! And how much is learned there! And one is so sad! And one dreams so well of love!"[8] But what kind of love was Flaubert talking about?

Flaubert, who seems to have been so broad-minded, was notorious for choosing the ugliest whore in any bordello and having sexual intercourse with her in front of his friends, his hat still on his head, while puffing on a cigar. As Francine du Plessix Gray noted, "For bourgeois misogynists like him female sexuality seems to serve as a disposable conduit for bonds between men. Their homosocial bragging increases ties of male solidarity at the expense of the women they are sexually involved with and supposedly love. Such men feel that women as sexual beings trouble and damage them with their femaleness."[9] In associating the female with loss of their masculinity, they also reflect earlier pagan and biblical attitudes toward women. Unfortunately, Paglia's view of sex appears very like Flaubert's, which is really surprising for someone who calls herself a feminist. Paglia's unbridled attacks on conservatives and protectionist feminists and her identification with gays at the expense of the women she claims to speak for testify to just how much of a court jester she really is.

In fact, many younger women who have become part of the third wave of feminism, discussed in Chapter 2, have examined the protectionist position on sexuality and found it confusing. Some of them are trying to persuade the old feminist guard to

lighten up. They are doing so for three reasons: first, many are upbraiding activist feminists for what they call a simplistic approach to the objectification of women; second, all parties concerned are being criticized for not dealing with the class bias of debates on pornography that take place without the participation of sex workers or working-class street walkers; third, other groups are urging protectionists to take a closer look at eroticism and pornography before dismissing it as smut. These groups, especially artists and writers, plead for a careful examination of the relationship between representation and action, arguing that it is complex. Paglia, to her credit, is in the forefront of this outcry. Many of those who now vilify feminism contend that the majority of the spokespersons are ignoring important variables that affect the debates of such concepts as visual transmission and sexuality.

Certainly, some of these objections are valid and need to be answered. First, people need a reality check—they need to hear from women who are sex workers and can speak their own minds. Several feminist groups support Margo St. James, the founder of the prostitutes' civil rights organization called Call Off Your Old Tired Ethics (COYOTE), who began to respond to concerns about prostitution by organizing a grassroots campaign for the decriminalization of prostitution. Organizations like COYOTE and other professional groups recommend the adoption of sex laws based on those currently in effect in the Netherlands (see, for example, the Amsterdam policy on prostitution in Appendix B). These women and their supporters want the right to control their own bodies and maintain that the government has no right to intervene in their consensual sexual behavior with other adults. To them, *consensual* means rational and unchurched, and it includes exchanging sex for money.

There are serious inconsistencies in the protectionist position on sex that need to be addressed.[10] As a result of these differences, some leaders of the sex workers' movement have come to regard protectionist feminists as prudish, bourgeois, and hypocritical. Sexual liberationists consider the desire for freedom and unlimited sexual gratification to be natural and point out that the purchase of sex goes back to ancient times. The Greek historian Herodotus referred to prostitution in Babylonia, and the temple

harlot had an honorable role and is credited with civilizing the wild man Enkidu, who followed her to the city of civilization.

Second, many younger women who have not done their homework or who have been misled by antifeminists insist that it is time to include men in these discussions on sexism and other issues. They argue that women certainly can't assume, as some separatist feminists do, that all men are rapists, condone pornography, or are influenced by pornography to act on their fantasies. But, in fact, men have been included in feminism from the start. Most mainstream feminists believe that women's liberation is men's liberation and that men must be a part of human liberation. Only the miseducated believe that classical mainstream feminism encourages separatism and female supremacism.

And finally, one must never forget that antipornography and homophobic extremists can use certain provisions against women. Susan Crain Bakos, for example, encountered a problem selling her book *Female Superior Position* because the sex portrayed on the cover was "too graphic."[11] Off the record Bakos was told by her marketing staff that many bookstores had been under attack by antipornography feminists and right-wing fundamentalists for stocking or displaying books that were deemed too sexually graphic. Bakos was surprised because her book takes the position that women are looking for a lot more than a good cuddle between the sheets. It is ribald, raunchy, and bold. The antipornography forces on the Right and the Left are the unhealthy forces in her story. The heroines include former porn stars, a transvestite, and a lesbian editor of a pornography magazine. "My book is not politically correct. Neither am I," Bakos declared.[12]

In her novels, Lee Smith, twice winner of the O. Henry Award, also presents her fair and tender ladies as full-blooded country women. Her novel *Oral History* tells the tale of the women of Hoot Owl Holler, particularly Dory Cantrell, with her amazing liveliness that intoxicates men.[13] Dory gives her "beauty and fresh purity" to men with a sexual freedom and passion that astonishes them. In Smith's novels women expect to see men, to sleep with them, and to explore their own passions freely with them.[14] There is nothing coquettish about Dory. Although this section of the novel is set in fall 1923, in terms of women's sexu-

ality it serves as a model of liberation from the puritanical right-wing and equally problematic left-wing. Smith's women are not politically correct, and readers are richer for it. One can applaud a writer such as Smith for giving people fully fleshed-out images of men and women without the dishonest portrayals demanded by either the conservative Right or the radical feminist antipornography faction.

Pornography and sexual freedom are the great feminist divide. The Feminist Anti-Censorship Taskforce (FACT) was organized for the sole purpose of defeating Dworkin-MacKinnon's proposed feminist antipornography ordinance that would make pornography legally actionable as a violation of women's civil rights. FACT argues that the ordinance creates a strong presumption that women who participate in the creation of sexually explicit material are coerced into it by boyfriends, pimps, and producers of pornography. This is misleading since sexuality is not a one-way street as blues lyrics illustrate. Only the most naive could miss the openly sexual content of Bessie Smith's lyrics, "I need a little sugar in my bowl, I need a little hotdog between my roll."[15]

The Women's Freedom Network takes a similar position on pornography. What is most disturbing to foes of the pro-censorship movement is the effect of legislation of this sort, which results in the prosecution of art and photography students, gay and lesbian writers, and others who are experimenting with sexual expression in their work. Clearly, the moral dilemmas of feminism are many. This misapplication is illustrated by the case of a woman from a prominent Akron, Ohio, family who was acquitted of charges of child endangerment. The state contended that she had taken nude photographs of her eight-year-old daughter and the girl's friend. The woman, who was acquitted, denied taking the photos. Actually, the two girls snapped the pictures themselves.[16]

In the aftermath of ludicrous cases such as these, it becomes increasingly evident that pro-censorship laws are being used to stifle America's creative spirit. Such prominent feminists as Betty Friedan, Nora Ephron, Molly Ivins, Erica Jong, and Katha Pollitt are against the censoring of sexual expression but remain deeply torn on the issue of child pornography.

FEMINISM AND ART

And the controversies keep arising. The most visible sign of them may be the fact that in the 1990s, the dominant culture has become less and less tolerant of free expression across a wide range of issues. This situation is especially evident in disputes over values in discussions of funding for the National Endowment for the Arts.

The question, "What is acceptable artistic expression?" strikes one as a contradiction. Conforming has never been a criterion for modern art. "The defining function of the artist," declared writer Max Eastman, "is to cherish consciousness," and this is precisely what feminist artists and critics of the 1970s tried to do. That's what makes the rise of a feminist pro-censorship movement so ironic. Moreover, feminist art and criticism called into question long-established assumptions about modernism, genius, elitism, originality, and the significance of contradictions.[17] The problem for women artists back then was how to make art that was relevant to their own identity and their experiences as women.

The 1970s and 1980s saw the world of politics intersect with the world of art and culture. Women artists as diverse as Miriam Schapiro, Judy Chicago, Ana Mendieta, Lynda Benglis, Adrian Piper, Faith Ringgold, Martha Rosler, Mary Kelly, Cindy Sherman, and Barbara Kruger all blurred boundaries that separated art from history, philosophy, social theory, and literary criticism. Works like "Connections" (1976), an acrylic and handkerchief painting by Schapiro, with its tongue-in-cheek femininity, depicted a world of women and the contradictions inherent in their daily lives.

Based on quilting, as well as Cubism and collage techniques, Schapiro's way of working (which she terms "femmage") attempted to employ women's traditional arts in a high-art context. This is not unlike rap music's linking of discordant elements, but with a major difference: women's collaboration was a cooperative model that fostered a positive approach to creativity as a community activity celebrating women's lives.

Others, such as Benglis, whose infamous full-color advertisement in *Artforum* magazine showing the nude artist wearing a pair of sunglasses and sporting a gigantic latex dildo, were

inspired by the dada and surrealist movements in art. Benglis's announcement was not a lesbian statement, but an across-the-board feminist challenge to the art establishment. The artist intended it as a parody on role-playing, the pinup, and macho narcissism.

Mendieta's work carried on a dialogue between landscape and the female body. It combined essentialism, activism, and theory. The rape and murder of a fellow student on the Iowa campus in March 1973 inspired Mendieta's first rape creation. "Rape-Murder" (Iowa City, 1973) ushered unsuspecting audiences into an apartment where they discovered Mendieta's bloody, half-naked body. In creating this dramatic work, which she conceived in "reaction against the idea of violence against women," the artist attempted to share the rape victim's reality with the audience, creating a powerful bridge between the personal and the political.

Mendieta's art was a passionate merging of the intellectual and emotional aspects of women's experience. Critic Lucy Lippard pointed out the similarity between the Mexican artist Frida Kahlo's extraordinary work in "My Nurse and I" (1937) and that of Mendieta, which she asserts is "characteristic of a Hispano-American fusion of 'pagan' and Catholic religions."[18] Mendieta's subject is not only a generalized expression of body-earth identity, Lippard claimed, but the use of the artist's own body as a revolutionary metaphor.

Feminist art criticism, as its name implies, is criticism with a cause. During this period, feminist artists disclosed new contexts in which to see and evaluate art. Running counter to the mainstream of male art history and criticism, women, and a few enlightened men, forged a feminist art criticism based on the work of artists who were struggling to redefine themselves within the formal anticontent traditions championed by the critic Clement Greenberg and his followers. Women artists rebelled against participating in an androcentric culture in masculine terms, choosing instead subjects that included birth, motherhood, rape, household imagery, menstruation, autobiography, family, friends, and organic musings on women's experiences. Feminist art critics opened up fresh possibilities for art criticism that were largely ignored by so-called mainstream art critics.[19]

Spurred on by feminism, contemporary artists of both sexes and all artistic persuasions jumped the fence between high art and other art forms, and created postmodern styles that persistently mirrored the changes going on in the society. Sue Coe's grotesque comic-book style, for example, embodied a virulent social critique of the New Bedford gang rape that inspired the film *The Accused*. It was an attack on a decadent working class and the community that sought to protect it.

Painters, such as Elizabeth Murray and Ida Applebroog, depicted women's distrust of modernist aesthetics through their disruptive compositions and manipulation of materials. They rebelled against an art that excluded them from what its supporters viewed as universal. Art applications as paradoxical as the Arcadian realism of Sylvia Sleigh, the parody of identity in Cindy Sherman, the sharp-witted plagiarisms of Sherrie Levine, and the rhetoric of opposition in the works of Adrian Piper and Barbara Kruger coexisted side by side with the amused and antagonistic sculpture of Louise Bourgeois and Kiki Smith's nude, tortured female creature dragging feces across one gallery's floor.

Bourgeois's work spans the development of a politics of feminism and broke the reductive cycle surrounding female identity. A recurring theme in this work is a female figure carrying a house on her shoulders, which represents the female universe in which woman is betrayed by the very system of values that is supposed to protect her. The home becomes a prison from which she cannot escape. Bourgeois's "Femme Maison" (1982–83) parallels and gives form to Friedan's "feminine mystique." Despite this landmark body of work, Bourgeois was not given a retrospective by the Museum of Modern Art until 1982, when she was aged seventy-three.

Historically, women artists of the 1970s and 1980s turned the patriarchal house inside out, exposing its faulty foundation and rotting rafters. By visualizing the subjugation of women in their homes; exposing child abuse, alcoholism, and battering; and making the American public more aware of the dark side of the patriarchal family myth, feminists made domesticity a central theme of their art. Today's feminist artists and critics are working directly out of their understanding of a complex spectrum of

human concerns and have had a decided impact on how dealers, museum personnel, and collectors view visual art.

Another result of the feminist revolution is that young male artists, who often work in tandem with their female partners, have started producing challenging work. This development is illustrated by Carter Kustera, whose installation *Domicide* was shown at the Josh Baker Gallery in New York in February and March 1992. Kustera believes that everything that's misguided in our society comes from the way children are treated in the family. For example two of his dining-room installations dealt with a fascinating deconstruction of images and fictions associated with the American family. A 1930s vintage dining room featured a table with a gun, rope, frying pan, and ice pick embedded in wood under glass, and portrays the family as a dangerous place. A 1950s dining room depicts annihilation by noncommunication; television monitors placed on the table revealed family members' thoughts and inattentiveness to each other. In these works and others, Kustera has gone beyond the superficial veneer to plunge into the darker, more violent regions of family life. In this respect, he echoes James Agee's observation that, "Americans, money, sex, and a readiness to murder are as inseparably interdependent as the Holy Trinity."[20]

According to Schapiro, "generosity and sharing" are the core and basis of women's values. My work, she declared, "is an act of faith." The thousands of stitches that female hands, such as those of black quilter Henrietta Powers, have sewn make us recognize that not all virtues and accomplishments need be epic. Feminist art paved the way for the creation of the AIDS quilt, which is made up of individual pieces commemorating those who have died from the disease. It is yet another example of the collaborative principle at work in a changing society and culture.

A feminist view is also embodied in Sally Mann's unconventional portraits that play with preconceptions of childhood. In collapsing the boundaries between private and public, her spellbinding work forces audiences to deal with their own voyeuristic satisfaction in watching naked children. The majority of her photographs are concerned with family records that explore the psyches of parents and children. Like the photographs of Diane

Arbus, those by Mann force people to deal with attachments they have never dared to explore.

Challenging canonical traditions with their radically critical work, feminist artists aim to undermine the cult of the modern and promote an exploration of multiple relationships between art and sexual politics. Today, women continue to get their cues from advertising, television, movies, and magazines, as Kruger's untitled "I will not become what I mean" ironically points out.

Is this rising wave of politically concerned art a cause for rejoicing? Some feminist art historians and critics don't think so. For them, the problem with Kruger's art and that of other artists championed by male critics of the 1980s, is its emphasis on male theory and male modes of creativity. Once again, masculine styles of expression are elevated to the norm.

For many artists, a picture that stands for something else is no longer adequate to embody the meaning of contemporary life. Women's body art, especially in performance, was perhaps the first phenomenon to demonstrate clearly that modern art had lost its edge. Feminist consciousness helped to shape a new art that referred specifically to the artist's body as a medium. Some women chose to use their aging thighs, pubic hair, and sagging breasts to make their artistic critique of patriarchy. Most who worked in this genre put themselves in the limelight, shifting the focus of attention to the female body: pregnant, aging, beautiful, and grotesque. By showing how femaleness and femininity are treated in our culture, these artists hoped to transform people's misogynist perceptions.

Hannah Wilkie's performances and chewing-gum and kneaded-eraser sculptures challenged stereotypes of women and female sexuality. She called gum "the perfect metaphor for the American woman—chew her up, get what you want out of her, throw her out and pop in a new piece."[21]

Rachel Rosenthal's work illustrates the tension between the individual and society. In her "Pangaean Dreams," she uncovers the remains of a patriarchal civilization that died out because it ignored the necessity of integrating nature with culture. Head shaved, voice ringing with authority, wearing a necklace of carved skulls and chunky stones, she combines narrative, dance,

and fantastic visuals with critically engaging dialogue to address universal concerns: love, hate, survival, and hope.

To date, the most radical formulation of this continuing saga of the personal as political, or at least the one that sparked the most explosive public debates among men and women, was the 1993 performance put on by the Women's Coalition for Change at the University of Maryland's College Park campus. The message these women developed read, "Notice: These Men Are Potential Rapists." The banner headline advertised an antirape performance art piece that was to take place on the evening of April 29, 1993. The following evening, another banner appeared that said, "Any of These Men May Have the Potential to Be Rapists." What enraged people was the 4,500 identifiably male names culled from the directory of students that were exhibited as the local population of potential rapists. The temporal unfolding of the work resulted in an outburst of response from the media, ranging from the university president's press release, published in the *Washington Post* and elsewhere, to the coverage by the conservative press and the Rush Limbaugh talk show.

"All the commotion," art historian Josephine Withers explained, "had been generated by some twelve undergraduate and graduate women."[22] Taking their cue from the New York–based performance group Guerrilla Girls: Conscience of the Art World, the students were motivated by the growing verbal and physical abuse toward women on campus, along with their frustration at the administration's official indifference to their concerns.[23] The performance attempted to open a dialogue about the rape crisis on campus, to emphasize the fact that 84 percent of the women who are raped know their assailants, and to remove the blame for rape from women. Over the next few weeks, many groups used the performance to express their views. Withers, who had helped the women students find resources and had encouraged them to create a performance piece, was harassed by the "Politically Incorrect Coalition against Feminazism" with posters announcing "Josephine Withers May Be a Whore." She even received hate mail from people around the country and from an overseas reader of *Stars and Stripes*. Withers, who has been teaching art history and women's studies at the University of Maryland at College Park for twenty-four years, concluded

that "exposing men's participation in rape culture in such a lit-eralistic fashion gave some men the discomforting experience that women live with most of the time; the men were momen-tarily vulnerable; they were being 'watched.'" [24]

If, as Max Eastman believed, "art cherishes consciousness," then it necessarily exists in ambiguity and is often unpredictable. That is the risk of an experimental art form. It is this movement that Representative Dick Armey and Senator Jesse Helms say America needs to "put limits on." But as many self-respecting Americans know, when a country limits artistic self-expression, it limits itself as a nation.

The democratization of art initiated by feminists in the 1970s has challenged a fresh generation of artists. But the concept of gender partnership that was pioneered by the generations of the 1970s and 1980s is still new to many of them. Coming from sex-ist homes, what will these budding artists create?

On the one hand, trailblazers, such as Schapiro, wonder whether Generation X is going to be as racist as their ancestors and whether they will be more comfortable with aging than its previous generation. On the other hand, many of these young-sters ask such questions as, "Why, when we are now liberated, must we speak of kitchen issues? What is the content of women's work? What is it that makes women's culture different from men's culture?" [25] It is questions like these that all creative peo-ple will have to ponder as the millennium approaches.

For some women artists who have moved into the main-stream, mentioning woman's culture is troubling. It makes them feel ghettoized, embarrassed, and ashamed, as though women are outsiders, naïfs, or—worse—losers. Possible answers to their concerns are suggested by Sherrie Levine's ambitious cultural impoundments that address the production fetishism of our advertising culture. Perhaps Levine's appropriation of such well-known art objects as Marcel Duchamp's bachelors is "the bride's" tongue-in-cheek raid on patriarchal capitalism, with its conceptions of ownership, authorship, and self-sufficient male-ness. Another successful artist, Cindy Sherman, stated, "The male half of society has structured the whole language of how women see and think about themselves. The way women are looked at, objectified, resented." Unquestionably, as the number

of women artists has increased, so has the amount of resentment toward them expressed by some male artists. Women artists may be resented more because they are no longer content to be muses who support men's creativity at the expense of their own talents and development.

CENSORSHIP: TRUTH AND CONSEQUENCES

Sadly, for America's artists, one of the side effects of feminism's gains has been the misuse of those gains by the antipornography and New Right religious movements. Traditionally, political conservatives and religious fundamentalists have been the primary advocates of tight legal restrictions on freedom of human expression, based on their view that such expression may undermine public morality. Now speech and works of art can be accused of being sexually harassing or immoral and can often lead to censorship and/or removal of the offending object. Even classics like Francisco de Goya's painting *The Naked Maja* have been labeled "pornographic" or demeaning to women.

In the past few years, the arts have come under constant attack from both cultural feminists and conservative agitators. These groups have attempted to censor the Robert Mapplethorpe exhibition, missing his Christian message entirely, and withhold funds from the National Endowment for the Arts to censor artistic free expression. Moreover, New Right groups have worked hard to ban books dealing with any form of sexual exploration from high school and college libraries. They have also tried to bar AIDS education and to introduce creationism into the classroom. Dedicated librarians and teachers have been fired for providing books and films on a variety of subjects, ranging from the Barney series to witchcraft, that fundamentalist zealots deem "unreadable" and "unfit for viewing."

And certain feminisms even affront feminists. Janice Raymond, a critic who falls into Dworkin's camp, argued that the liberal critics absolve themselves of responsibility for female victims by saying that women are not casualties of male dominance. They obscure the necessity to create social and political change for those who are victims and disidentify with their own victimization. Raymond insists that one can't recognize the vic-

timization of women without destroying the institutions that promote it. Liberal women, she explains, are agents in a culture of pornography because they sideline the active part of the institutions in promoting and maintaining smut, thereby letting patriarchal producers and consumers off the hook. She complains that women's agency in resisting those institutions is not supported and questions why these feminists locate women's agency primarily within the "culture" of male supremacy.

But as the various incidents of censorship I have referred to throughout this book show, the most effective action a society can take to counter what it deems damaging is to learn to see and interpret these images differently. What people need to do is think critically. To do so effectively, one needs to look at what values are emphasized in contested works and resolve how to handle conflicts regarding them. What the public should be asking is how pornography influences perceptions of other people. One thing that needs to be done is to challenge seriously woman's presumed position as object in the culture of pornography by asking whether anything is changed when a woman assumes the role of active subject. This is a challenge that certain forms of lesbian art and fiction attempt to address.

The real questions that remain are, "What is suitable protectionist legislation?" and "What laws should be passed to give victims of abuse legal recourse and allow them to punish their attackers effectively?" Unfortunately, if the proposed legislation on pornography is passed, postmodern films that present bleak critiques of today's urban society might have a hard time getting their messages to the public.

Blade Runner, Diva, Blue Velvet, and *Desperately Seeking Susan* are examples of such films. David Lynch's *Blue Velvet* is about Jeffrey and Sandy, two middle-class children living in the small and conventional town of Lumberton, U.S.A. It is a black comedy in which people talk like characters in a 1950s sitcom. In this dream-nightmare, these two innocents are gradually drawn into a world of violence and perverted sexuality. Lynch deliberately paints a deceptively simple picture, with a white picket fence and a voyeuristic and sadistic allure. The plot revolves around Dorothy Vallens (Isabella Rossellini), a disturbed nightclub singer, and her sadistic lover, Frank (Dennis Hopper). The film's

ruthless presentation of sexual bondage and female masochism reduces people to the narrowest cultural stereotypes of male and female sexuality under patriarchy. In one scene, Jeffrey hides in a closet and watches Dorothy engage in a terrifying sado-masochistic sexual encounter with Frank, a drug-sniffing psychopath who regresses to infancy and then tries to cut his way back into Mommy's womb with a pair of scissors.

After Frank leaves, Dorothy discovers Jeffrey in the closet, pulls a knife on him, and forces him to submit to her seduction. She wants him to be a "bad boy" and hit her. Lynch's stark, despairing film is deeply disturbing, and it once again raises the troubling issue of women's participation in their own degradation. Rossellini turns in a stellar performance as she is dumped naked on the lawn of a police detective's home, slapped around, humiliated, and stripped naked in front of the camera.

By contrast, Susan Seidelman's *Desperately Seeking Susan* is primarily about women's struggle to create and control their own identity in contemporary society and, in so doing, to shape the sort of relationships they have with men. The film opens with a classified advertisement featuring the three words of the title. A time and place are given where Susan can meet with the person who placed it. Roberta (Rosanna Arquette), a bored housewife, sees the listing and becomes obsessed with finding out who Susan is and why someone is so anxious to find her. So she turns up at the rendezvous, spots Susan (Madonna), and becomes involved in her world, even momentarily collapsing her identity into Susan's.

In this screwball comedy, mistaken identity plays a key role. We first see the punker Susan in a hotel room. Then, the film cuts to a mobster who is killed in the same hotel room and the hit man who comes to look for Susan, who may be a witness. The following scene is in a used-clothing store, where Susan sells the jacket that is her trademark, and Roberta buys it.

Roberta bangs her head and develops temporary amnesia . . . People see her wearing Susan's jacket and follow her. The two women zigzag their way through downtown New York, where underground figures, including Richard Hell, Anne Carlisle, and Rockets Red Glare, add spice to this punk stew. Here, at last, are female rebels with their own causes. In this film the individual

constructs herself as a public icon, and the female body becomes a canvas of shifting urban signs. The "bad" young women in *Desperately Seeking Susan* are struggling to control their social identity and relationships by participating in fluid subcultures and by rejecting silly orthodoxies.

In a series of theatrical gestures, the director uses street-produced bricolage—for example, a battered and painted leather jacket and glitzy earrings, to display the counterculture symbolically. Taken out of the context of bourgeois respectability, a pair of lace gloves becomes part of a female outlaw's outfit. Nothing is off-limits; for instance, the crucifix is torn from its religious framework and combined in ways that give it a new meaning. Seidelman's film explores the underbelly of American urban culture, kicks around feminine modesty and socially acceptable behavior, and transforms the smarmy clichés of *Blue Velvet* into a fanciful critique of sexism.

Although some feminists argue that the sexually explicit subordination of women through pictures or words is pornography, others strongly oppose this view because it sweeps in everything from religious imagery, such as that used in Seidelman's film, to any sexually explicit expression they dislike, including Lynch's depictions of Frank and Dorothy's sado-masochistic relationship. It is indeed ironic that in Canada, Customs officials concluded that two of Andrea Dworkin's books were "pornographic" according to her definition and therefore seized the books at the U.S.–Canadian border.

THE BODY ELECTRIC

Many people use the term *pornography* to stigmatize whatever sexually oriented expression they dislike, according to Nadine Strossen, and to suppress relatively unpopular ideas and groups. In 1993, Attorney General Janet Reno warned television executives that if they did not start seriously censoring violent content in television programming, the federal government would do it for them. That was just the tip of the iceberg. In 1995 Republican and Democratic senators endorsed the "V chip," a device that will allow parents to limit their children's access to violent or sexually explicit television programs. Moreover, these individu-

als also stress the impact that this device will have on advertisers in sponsoring this sort of entertainment. All of these activities culminated in an historic meeting of television executives with the White House in February 1996.

Scapegoating words and pictures, as author Marjorie Heins noted, "whether on TV, in movies, in popular music, comic books, detective novels, high-tone erotic art, or sleazy pornography—is a perennial American pastime." Nevertheless, many social scientists agree that violent art and speech may connect with angered members of the audience and establish a strong association between their own frustrators and the fantasy victim of aggression. In theory, this association should lessen their aggression and provide and outlet for it that is socially acceptable.[26]

Artists, writers, musicians, and television performers continue to challenge traditional values, questioning their applicability to daily living. Art, rock, rap, and sexism represent a synthesis of history, language, and culture. It is evident that since the advent of MTV in 1981, representations of male fantasies of carnal and material desire have begun to look more like pornography. But in spring 1985, in her so-called Virgin Tour, Madonna rocked the music world by showing them what she thought young women wanted to fantasize about. "Madonna is a slut," cried Christopher Connel in *Rolling Stone's* cover story. Madonna's fans, most of whom are teenage girls, didn't care. They liked the way she put guys in their place and strutted her stuff.

What the fans like is that Madonna is in control of her own destiny. This control is exemplified by her 1990 public-service announcement for television—a sixty-second message in which two flag-waving chorus boys in tight shorts and army boots pretend to spank her—illustrating the tag line "And if you don't vote, you're going to get a spankie." The commercial was part of the so-called Rock the Vote campaign by the recording industry to inspire eighteen to twenty-four-year-olds to vote and to oppose obscenity prosecutions directed at record companies. *Forbes* featured Madonna on its cover in 1990 with the headline, "America's Smartest Business Woman?" Madonna was ranked eighth among top earning–entertainers behind Bill Cosby, Michael Jackson, the Rolling Stones, Stephen Spielberg, New Kids on the Block, Oprah Winfrey, and Sylvester Stallone, with

an estimated annual income of $62 million. Paglia and performance artist Karen Finley maintained that "all women should be as Madonna as possible."[27]

Madonna made it an art to shock, tease, and seduce her fans with a constant stream of outrageous acts. Her message wasn't lost on the rappers, who already knew how to "speak the language of the black ghetto" and meld it with a melodic blast of train whistles, screaming police sirens, and the voices of young men and some women, finding their audience in the fast flow of urban culture during the 1980s. By the 1990s, the talk was nasty, and it showed the underside of life in a way that an older, affluent, white and black middle class didn't like. Hiphop style sprang from oral poetry, layered on a beat evolving from jazz, and created a transformative sound. Reggae was subversive and had the power of verbal poetry, so it worked for a broad audience, including many white people who associated it with their own resistance and alienation.[28]

But rap music is more than simply a reflection of the disjointed times we live in. Rap favors modes that fragment things and hints at disorder; rappers break down everything, mixing up details from different periods and cultures. The lyrics are tough, and no subject is taboo. Shooting and killing are inflammatory, but sex and death sell briskly, and that troubles a lot of soul sisters, especially when these violent fantasies are acted out on women. Violence and sexism explain why rap has become a lightning rod for fundamentalists and classical feminists.

Many feminists worry about the speech in albums like *Niggas with Attitude*, which features songs like "Findum, Fuckum & Flee"; "She Swallowed It" (lyric: "If you've got a gang of niggas, the bitch will let you rape her"); "To Kill a Hooker"; and "One Less Bitch," a song about tying a woman to a bed, fucking her, then blowing her away with a forty-five.[29] Sadly, brutal gangster rap has captured the ears of American youths, and recording promoters are amazed and angry when disk jockeys refuse to play these women-hating songs on the air.

In sharp contrast to American rappers, British hiphop groups like Marxman have taken on violence and the degradation of women. Their song "All About Eve" was written to highlight male violence as a misguided internalization of anger that would

be better directed at men in economic power. Currently, marginality and centrality are at the core of dialogues on feminism that have emerged. It is harder and harder to tell who the mainstream society consists of. Indeed, what is dominant in contemporary society is the projection of a universe of multiple differences, all requiring freedom of speech to stimulate meaningful exchange.

LESBIANS

For gays, lesbians, and bisexuals, being "out" in culture is a way of challenging mainstream opinion and representation.[30] This is particularly true for women, who often internalize society's homophobia, which results in unconscious self-censorship; self-denial; or, in extreme cases, self-hatred. The writer Dorothy Allison stated:

> In my lifetime, without question, the most important historical development, the one with the most far reaching impact, was the women's liberation movement, and the lesbian and gay freedom movement that grew out of and paralleled it. In 1973 when I moved to Tallahassee, the fledgling women's movement quite literally saved my life by persuading me that I was not crazy and I did not have to kill myself.[31]

Aside from discovering that it was OK to be a creative woman, Allison also discovered that she was "no longer alone in the world." The woman she encountered at the Women's Center of Florida State University, who was speaking in a lesbian consciousness-raising group Allison had accidentally stumbled upon, gave her the feeling that she belonged, that loving women did not cut her off from everyone else. Today she believes that "we are already living in a new age, that we have been creating it day by day for the past two decades."[32]

By examining lesbian couple's interactions with their original families, the mainstream, and lesbian-gay communities, people are just beginning to understand how women live outside the normative heterosexual pattern that society imposes on them. Lesbians and gays, too, are gaining insight into how they are affected by their social position in a homophobic culture and how they grapple with the particular stresses caused by living as

second-class citizens in this culture. Of course, this is not to say that the gay community is free of the misogynist attitudes that permeate the rest of our society. In fact, in some instances, gay men can be even more virulent than straight men in their hatred of women because they are competing with them for male attention. This is why posing the question, "Is it any better for women in gay and lesbian circles?" is so political.

During the 1970s and 1980s, getting closer to the truth of their own social conditioning meant that feminists had to add the word *homophobia* to their vocabulary. The term describes the irrational fear of any sexual expression between people of the same sex. The hatred of homoerotic feelings in others had sweeping consequences when the mother of modern American feminism, Betty Friedan, exhibited her heterosexual fear of the lesbians in the National Organization for Women by labeling them the "lavender menace." Her fear of what having lesbians in NOW could do to the political agenda split the women's movement, forcing the newly formed organization to confront its own homo-prejudice, just as black women a decade later would force white middle-class feminists to deal with racism. Challenged by some of the strongest and hardest-working women in the movement, the association was obliged to examine its terror of love for members of one's own sex. Only when women who defined themselves as "heterosexual" realized that such a concept was produced by a sexist society did they begin to resolve their difficulties.

Societal pressures are still so powerful that New York City teenagers who belong to Hunter High School's 10 Percent Club (which takes its name from the notion that as much as 10 percent of society may be gay or lesbian) feel it's easier to say "I'm bisexual" because "you can recognize [acknowledge] your feelings but not totally alienate yourself from society." Yet demagogues like Rush Limbaugh falsely claim that gays and lesbians "already have the same rights" as heterosexuals.

Anyone who cares about equal rights has to ask himself or herself honestly if that is truly the case. If it was, gay and lesbian youths would have no reason to hide or to feel that acknowledging who they really are would "alienate" them from society. Given the false assertion that gays and lesbians want "special

rights" and "preferential treatment," one can hardly blame these teenagers for hesitating to make a total commitment to "the life" or for resigning themselves to living in a gay-lesbian ghetto.

The injuries and disadvantages that gays and lesbians sustain because of who they love are without number. However, because of their submission to or dependence on heterosexual society, the concerns of gays and lesbians, like those of women and people of color, have been dismissed or trivialized. Take, for example, Margarethe Cammermeyer, whose story was the subject of a television movie, *Serving in Silence*. Colonel Cammermeyer was discharged from the army because of her sexual orientation. Here was a woman who had served this country honorably for over twenty-three years, won a bronze star, worked in Vietnam, and in every way embodied the best the United States Army could hope for. And what did the army do when she told the truth? It fired her.

Even when gays or lesbians have been tortured and murdered, the perpetrators of these crimes have been let off or given light sentences by the criminal justice system. Walking down any street in the world holding your lover's hand can get you killed if you are lesbian, gay, transsexual, or bisexual. The truth is that gays and lesbians simply do not have the rights and privileges that most Americans take for granted. The rights and privileges that feminists, people of color, and gays and lesbians are asking for are the constitutional rights that white Christian men have always had. If there is a lesson to be learned from Hitler, Bosnia, the Ukraine, and the terrorist bombing in Oklahoma City, it is that to protect our own rights as Americans, we must protect the rights of others.

Certain gay and lesbian eyebrows may elevate over *Lianna*, one of the finest films to depict a lesbian theme, because it was made by John Sayles (a heterosexual man). *Lianna* is a sensitive portrayal of what happens when a married woman in her thirties who has children discovers that she is a lesbian. In the film, one learns that Lianna (played by Linda Griffiths) had fallen in love with her teacher when she was an undergraduate but never acted on her feelings.

Lianna is married to a narcissistic film professor who is the father of their two small children. In scene after scene, he is

shown treating her like one of the children. Dick (Jon Devries) lectures her at the dinner table and cheats on her with his students. He expects her to take care of him and be a kind of mother substitute. In one scene, she is shown packing his suitcase for a convention.

Lianna is a bright, unhappily married woman who decides to change her life by signing up for a night class in child psychology, where she finds herself attracted to the woman professor, Ruth (Jane Hallaren). Ruth is a lesbian, but contrary to popular homophobic myth, it is Lianna who makes the first move. The two women become lovers, and Lianna moves out of her house. The love scenes are poetically portrayed, but they raised a lot of objections among the lesbian community because they were considered too romanticized and heterosexual. Ruth can't take the intensity of their relationship, and she finally confesses that she has had a long-standing relationship with another woman in another city to whom she is returning. Lianna then rents a room off-campus and begins developing a new lifestyle.

In the process, she struggles to maintain a friendship with her old friend Sandy (Jo Henderson), who is married to a coach and can't accept Lianna's new identity. Actually, Sandy's husband is less judgmental of Lianna's lesbianism. At the end of the film, Sandy comes to understand that Lianna's sexual preference has nothing to do with their friendship. Meanwhile, Dick tries to block Lianna's access to her children. One of the most touching things about this film is the way it focuses on how Lianna forges a new relationship with her children, especially her daughter. What distinguishes *Lianna* from films made by lesbians of the period is the fact that Griffiths and Hallaren make the characters so human that they remain people we care about, not just lesbian stereotypes serving some confrontational political purpose.

Playing with the notion of gender identification, however, has made for some provocative films. The shaved head, leather jacket, Doc Marten boots, and trash-mouth attitude formulated by stereotypical and sometimes political "dykes" (lesbians who identify with a male image) of today, as portrayed in Rose Troche's 1994 film *Go Fish*, are a far cry from the images projected by successful lesbians and bisexuals in the beginning of the 1930s and late 1980s.

Between 1930 and today, lesbians have created their own rich-ly diverse patterns of culture and family life. Shot in black-and-white on a modest budget, *Go Fish* centers on finding the right woman for Max, a feisty wanna-be writer incisively played by Guinevere Turner, who co-wrote the script with Troche. Kia, Max's college professor friend, played by T. Wendy McMillan, wants to set her up with Ely, a shy veterinarian's assistant, played by V. S. Brodie. Ely, a 1960s intellectual hippie type, with long hair and shy ways, is involved in a long-distance relation-ship. She is not Max's type. Evy (Migdalia Melendez), Kia's divorced lover, and Daria (Anastasia Sharp), Ely's horny room-mate, also conspire to help. Ely cuts off her hair and puts on an oversized man's shirt to look hip, thus manufacturing a snappy look that will attract Max. The humor and poignancy in the growing relationship that leads to their first date is engagingly filmed. But *Go Fish* raises serious questions about Ely's intrinsic sense of worth.

This is a film that conservative lesbians may have trouble understanding. Many such people cannot afford to understand it because "this understanding," as the gay black writer James Baldwin explained, "would reveal to [them] too much about [themselves], and smash that mirror before which [they have] been frozen for so long."[33] This is a point that Vito Russo under-scored throughout his gay-positive book *The Celluloid Closet*.[34] Breaking the patterns in which they were raised, these two les-bians are learning to develop strong personal identities of their own.

Today the structures of family life and the necessary limits placed on women by the patriarchy are clearly being dismantled by Generation X, with its freer and more open play of desire and pursuit of other differences. Hollywood, quick to notice, has jumped on the bandwagon with a slew of films featuring lesbian relationships and same-sex romance: *Thelma and Louise, Fried Green Tomatoes, Three of Hearts, Claire of the Moon, Even Cowgirls Get the Blues, Boys on the Side,* and the hilarious *The Incredibly True Adventures of Two Girls in Love.* But a question remains: Are films like *Go Fish* and references to forbidden kisses on the television programs *Roseanne* and *L.A. Law* proof that in the gay 1990s everybody's gay-girl crazy? I don't think so. "Women-on-

women," an unnamed Warner Bros. production executive explained, "are far less objectionable than men-on-men. In fact, most guys see it as a turn on." Russo observed that the "fresh-faced Huck Finn appeal of Katharine Hepburn's 'Sylvia Scarlet' (1936) and the magnetic sexual power of Marlene Dietrich in 'Morocco' (1930) and 'Blonde Venus' (1932) put such women in a class by themselves, usually by innuendo. There could be all kinds of women who were considered 'real' women, to be manipulated sexually for maximum fantasy appeal to men."[35]

Some scientists are saying that gays and lesbians are born that way, and many reporters in the media are jumping on the boys', and perhaps the girls', "can't help it" bandwagon. But as Lillian Faderman noted, even if it would be nice to believe the scientists and biological determinists because then they [the bigots] "would finally feel the injustice of their nastiness," gay people can't. Perhaps if such people thought that gays and lesbians were born that way, "they would be ashamed—as they should be." But as Faderman pointed out, "the discovery of the Gay gene wouldn't lessen their prejudice one whit."[36] A racist doesn't care that black people are "born that way" either.

Clearly, recent scientific studies that have found a genetic basis for homosexuality don't help. We can't ignore the change-ability of human beings. Many radical feminists of the 1970s, for example, chose to become lesbians after a lifetime of being het-erosexual. Older women have also become involved with women for the first time, and self-identified lesbians have cho-sen to have relationships with men. Gay people, Faderman asserted, "don't need genetic explanations for our lives any more than straight people do."[37]

GENDER BENDING

Getting rid of outdated assumptions and stereotypes is hard. Filmmaker Maggie Greenwald's *The Ballad of Little Jo* asks a shocking question: "Does a woman have to mutilate herself to be free? This gender-bending film, starring Suzy Amis, Bo Hopkins, and Ian McKellen, is a remarkable story.

Little Jo, an upper-class woman, is disowned because she is seduced, becomes pregnant, and has a son out of wedlock, so she

runs away from home. Traveling alone in the Old West turns out to be dangerous for an attractive young woman, and Jo finds life easier when she masquerades as a man. To do so, she slashes her beautiful face with a razor, straps down her breasts, and puts on grungy male garments. Pretending to be something she is not takes some doing. Learning how to be a man isn't easy. She finally settles in a small mining town, where she is accepted as "Little Jo." Here she learns what being a man really means. This awareness results in some overacting by Suzy Amis as she imitates the crude male behavior that is expected of Jo. Learning masculine logic proves to be the most difficult change she has to make because she must reject everything she has learned about being feminine.

The film asks, "What is a man? What is a woman?" After Jo and her houseman become lovers, she shows him a picture of herself before the transformation and asks him if he likes her better now or as she was. The man responds, "I like you much better as you are. This white girl would never do this with me."

By the time Jo learns how to be a man, she understands what being a woman actually means. She fools most of the people most of time. Finally, she dies, and it's only when the undertaker prepares her for burial that it is discovered that "Little man Jo" is a woman. She has fooled almost everyone.

This is a film for the 1990s. It raises profound questions about role assignments and how they are used to define people—how people are trained to conform to gender stereotypes. Greenwald seems to be saying, "Forget about those standard roles; you don't have to do what people expect of you just because you're a woman or just because you're a man." Rather, she seems to assume, people should take responsibility for what they say and do, for who they really are. The Ballad of Little Jo raises the question, Does femininity have to mean passivity? Most of us would agree that it does not. What women have to ask themselves is, How does this image function for me? How do I see myself in relation to various symbols, and how do I want to be seen?

Hair-raising, gender-bending comedies like The Adventures of Priscilla, Queen of the Desert focus on issues of bodily exposure and containment, disguise and masquerade, parody and excess.[38] Winner of the audience award for the most popular film at the

Cannes Film Festival, *Priscilla*, a kind of road movie in drag, attempts to talk back to role-playing and bigotry. The crucial issue here is the connection between feminine behavior and inferiority. Directed and written by Stephan Elliott, the film is about finding out how difficult it is to walk in someone else's shoes. A perfect example is the character Bernadette, who has a conscience and plenty of soul that audiences can identify with and admire. *Priscilla* breathes new life into protest movies, giving the audience some deep insights into just how complex gender really is.

Unfortunately, because of the polarizations among feminists concerning transsexuals and drag queens, many women feel ambivalent, if not downright hostile, about men portraying women in drag or about transsexuals (as in the film *The Crying Game*) who are more sensitive and sexy than biological women. Heterosexual women, in particular, seem to fear that what these individuals are saying is that it takes a man really to know what a man needs and wants.

On the one hand, right-wing ideologues in the United States have essentially denied any responsibility for coming up with workable solutions to the complex problems they so maliciously attack. Instead, they trot out the tried-and-true homophobic formulas that have destroyed people's lives, even those they love, and continue to do so. On the other hand, the most committed feminists attempt to develop hands-on solutions devoid of political pretense, e.g. flex time, day care, co-parenting. But there are also feminists whose anger stands in the way of a genuine sense of consensus. In a society divided by race, gender, class, ethnicity, and various sexualities, it is essential that people keep posing tough questions and not settle for easy solutions.

By targeting material they don't like, one group is attempting to curtail another group's creativity and access to materials it may find interesting and entertaining. They are very skilled at criticizing, however, and they do not provide workable solutions. Extremists on both sides confuse fiction with fact, imagination with reality. For example, art is fictive. Artists assume that audiences can distinguish between fantasy and reality. Playful images are designed to make people think. Therefore, the withdrawal of public funds for supposedly "offensive" art is a regu-

lation of the interpretive imagination. The interpretation an individual makes is related to their unique psychology. What one person might view as stupid, another might view as an expression of their deepest longing. Any American who values free thinking must protest.

At the core of this argument is the fact that all an individual has to do to avoid these images is turn off the television or radio or not attend art shows or performances that are offensive to him or her. It is indeed ironic that at a time when the federal government is being thoroughly scapegoated, the same people who are calling for its downsizing also expect that the Federal Communications Commission to do their job for them. People who disapprove of a particular exhibition or film are free to choose not to see it or they can see something else. One can also censure what one disapproves of without censoring it. That's what being an adult in a free and democratic society means.

Protecting children is an adult responsibility—and Americans are not taking it seriously enough. Censorship and the repression of sexuality will not wipe out abuse, incest, rape, or a host of other social ills that currently plague us. Instead of concentrating our energies on fantasy, we should be seeking ways to address the real problems we do have.

Notes

1. James MacGregor Burns and Stewart Burns, *A People's Charter: The Pursuit of Rights in America* (New York: Vintage Books, 1993), 58.

2. Ibid., 117.

3. This figure refers only to reported cases.

4. See America Online, "General Facts About Domestic Violence" from Ronet Backman, Ph.D., U.S. Department of Justice, Bureau of Justice Statistics, "Violence Against Women: A National Crime Victimization Survey Report," January 1994. Moreover, according to the information on the CompuServe online, "Domestic Violence Statistics," 43 percent of drug and alcohol abusers and over 80 percent of all prison inmates were assaulted as children. Furthermore, 45 percent of all sexual-abuse activity is nonorgasmic. Therefore, the excuse that perpetrators abuse children because of an overwhelming sexual need is fallacious. In addition, according to CompuServe online, 42 percent of child sexual assaults are committed by adolescent boys, and one-third of all child assaulters begin molesting other children when they are aged ten to thirteen. Also, 43 percent of self-reported child molesters stated that they had told someone they were molesting other children when they started doing so, but nothing was done to help them or stop them at that time. The average child assaulter (pedophile) assaulted children for seven years before being caught. Assaulters who are known to their victims assault an average of 62.4 girls and 30.6 boys before they are caught, whereas the average "stranger" who assaults children abuses approximately 380 children before being caught. Only one out of ten child assaulters is ever caught, and only one out of every ten child assaulters who has been caught is ever brought to trial. (Being brought to trial does not mean that the assaulter is convicted or, if convicted, goes to prison, however.) Over 90 percent of all child molesters were assaulted as children. Women who have been assaulted as children have a greater tendency to marry men who will abuse them and their children. In addition, 97 percent of those who suffer from multiple personality disorders were assaulted as children. Teenagers are victims of violent crime twice as often as adults, and 12 percent of high school students were physically abused during dating situations.

5. CompuServe online legal forum. Similar versions that were adopted in Indianapolis, Indiana, and Bellingham, Washington, were struck down by the federal courts as being unconstitutional. Another variant, adopted in Minneapolis, Minnesota, was vetoed twice by the mayor. All the variants

are substantially the same. This version is found in L. Shiffrin and Choper, *The First Amendment: Cases—Comments—Questions* (West Publishing, 1991).

6. Strossen publication from ACLU American online legal forum 1–27, 1995, "A Conversation with Nadine Strossen, author of *Defending Pornography: Free Speech, Sex and the Fight for Women's Rights*," p. 1.

7. Comstock also prosecuted birth-control pioneer Margaret Sanger. So in the United States, the connection between suppression and vice and the control of women's bodies goes back at least to the late nineteenth century.

8. Francine du Plessix Gray in *Flaubert Correspondence*, vol II, ed. Jean Bruneau, (Paris: Pleiades, 1989). I am grateful to Francine du Plessix Gray for this information and for her insights into the problem of homosocial display in patriarchy. See her review "Splendor and Miseries," in the *New York Review of Books* 39 (July 1992), 340–41.

9. Ibid.

10. Laurie Shrage, *Moral Dilemmas of Feminism: Prostitution, Adultery, and Abortion* (New York: Routledge, 1994).

11. Telephone interview with Susan Crain Bakos, 6 April 1996, regarding *Female Superior Position* (New York: Kensington Books, 1994).

12. *American Society of Journalists and Authors Newsletter*, March 1995, p. 6.

13. Lee Smith, *Oral History* (New York: Ballantine Books, 1983).

14. Ibid., 144. Dory says "Suck me"; then she pushes Richard Burlage's fingers inside her and moves her hips.

15. Quoted in Daphne Duval Harrison, *Black Pearls: Blues Queens of the 1920s* (New Brunswick, N.J.: Rutgers University Press, 1988), 106–107. Other variations on this theme include Alberta Hunter's "Handy Man" and Edith Wilson's "Used to Be Your Man."

16. Doreen Carvajal, "Family Photos or Pornography? A Father's Bitter Legal Odyssey," in the *New York Times*, 30 January 1995, A1. Similar cases have been reported in California, and my ex-student Alice Sims found herself in a protracted legal battle in Washington, D.C., over the nude photographs she took of her children that resulted in the temporary loss of her children to the state.

17. Miriam Schapiro, "A Philosopher's Stone: Radical Changes in Teaching," convocation address presented at the convention of the College Art Association of America, New York, Hilton Hotel, February 1994.

18. Lucy Lippard, *Overlay* (New York: Pantheon Books, 1983), 48.

19. It should be noted that a number of liberal art critics, such as Lawrence Alloway, John Perrault, Peter Frank, and Donald Kuspit, encouraged open debate and invited emerging feminist critics to participate as speakers on panels and to contribute articles to various journals they worked with.

20. Quote from October 1944 review in *Film*, vol. 1 (New York: Grosset and Dunlap, 1969), 119.

21. Quoted in Joanna Frueh, *Hannah Wilike: A Retrospective* (exhibition catalog), ed. Thomas H. Kochheiser (Columbia: University of Missouri Press, 1989), 73.

22. For a full explanation of this extraordinary happening, see Josephine Withers, "The Women's Coalition for Change," in *Art Journal* 53 (Fall 1994): 25–28.

23. The campus newspapers—*Clubside*, an underground hate-filled rag that regularly characterized women as "conniving sluts," "stupid JAP bitches," and "cunt-brained, dick-sucking sorority chicks," and the *Diamondback*, an official campus newspaper that in 1992 had included on its official editorial wish list a "gorgeous, mute, toothless bimbo with bodacious boobs and the I.Q. of a roadkill"—inspired the young women's efforts.

24. Withers, "The Women's Coalition for Change," 28.

25. Schapiro, convention address.

26. Marjorie Heins, "Media Violence and Free Speech," paper presented at the International Conference on Violence and the Media, New York, October 4, 1994. As she pointed out, attempts to find a statistical correlation between television viewing in general and antisocial behavior also yielded mixed results.

27. As quoted in Adam Sexton, "Introduction: Justifying My Love," in *Desperately Seeking Madonna* (New York: Delta, 1993), 10.

28. "African American Forum," CompuServe online. See the music library forum for the full text of this file on hiphop.

29. Ann Jones, *Next Time She'll Be Dead* (Boston: Beacon Press, 1994), 118, note 38.

30. Corey K. Creekmur and Alexander Doty, eds., *Out in Culture: Gay, Lesbian, and Queer Essays on Popular Culture* (Durham, N.C.: Duke University Press, 1995), 1.

31. Dorothy Allison, "Our Son Who Will Be Eight in the Year 2000," in *PEN American Center Newsletter* no. 82 (October 1993), 1.

32. Ibid.

33. James Baldwin, "If Black English Isn't a Language, Then Tell Me, What Is?" in *The Essay*, ed. Michael F. Shugrue (New York: Macmillan, 1981), 54.

34. Vito Russo, *The Celluloid Closet* (New York: Harper & Row, 1981). See the Introduction for more on the "closeted mentalities of gay people themselves."

35. Ibid., 14.

36. Lillian Faderman, "Are We Really Born That Way?" in *New York Newsday* (New York Forum, Gay Perspectives), 21 June 1994, A–30–A-32.

37. Ibid.

38. Mary Russo, "Female Grostesques: Carnival and Theory," in *Feminist Studies/Critical Studies*, ed. Teresa de Lauretis (Bloomington: Indiana University Press, 1986), 213–29.

10

Understanding Feminism's Concerns

The costs of being a woman in a man's world are almost too high to count. "Wife or whore," Marilyn French contended, "women are the most scorned class in America. . . . Women don't get even the respect of fear. What's to fear, after all, in a silly woman always running for her mirror to see who she is."[1] Women in French's stories are constantly asking themselves who they are. Exploring this sense of disorientation and examining the feelings underlying it continues to be a primary task of feminism. Feminism's agenda includes exploring individual authenticity and identity, confronting sexual harassment, rethinking traditional relationships, legislating against abuse and violence, striving for equal pay for equal work, promoting birth control, and fighting for affordable child care. These ongoing social concerns, which have become priorities for more and more women, regardless of age, have defined the women's liberation movement from its inception. Abortion has had, and continues to have, a profound effect on women's lives and deaths. But political parity is dependent on young people taking the time to think critically about who they vote for and what their representatives can, and should, do for them in Washington and at home.

AUTHENTICITY AND IDENTITY

"Our bodies," noted Robin Morgan, "have been taken from us, mined for their natural resources (sex and children), and deliberately mystified."[2] In fact, many feminists believe that women are a colonized people who have been robbed of their culture, history, pride, and roots. In reviewing the patriarchal reward-and-punishment system, they have concluded that the system has forced women to adopt its oppressive standards of values and to identify with masculinity as power. Since women have been educated to think like men, it is difficult for them to sort things out for themselves.

Traditional concepts of "femininity" that are common in many cultures can be hazardous to the economic, social, educational, and sexual development of girls. Indeed, to feminists in the United States, they also have a negative impact on women later in life. French's views on oppression, however, are more passive than those expressed in blues singer Victoria Spivey's "Blood Hound Blues," which tells how an abused woman finally poisoned her man, went to jail, escaped, and was tracked by bloodhounds:

> Well, I poisoned my man, I put it in his drinking cup,
> Well, I poisoned my man, I put it in his drinking cup,
> Well, its easy to go to jail, but lawd, they sent me up.
> I know I've done wrong, but he beat me and blacked my eye,
> I know I've done wrong, but he beat me and blacked my eye,
> But, if the bloodhounds don't get me, in the electric chair I'll die.[3]

In sharp contrast to French, Spivey used the personal experience of one black woman to show that women need not be passive victims of violence. Her image of the vengeful woman who acts against her oppressor stands in stark opposition to French's portrayal of women as helpless.

French's and Spivey's views illustrate two distinctly different states of mind. There are, however, additional reasons for feminism's present crisis. First our society's gender-based power asymmetries make it difficult for most women to imagine a liberated female sexual self. One problem, as Michelle Fine pointed out, is that "sexual acts of violence, including marital rape, acquaintance rape, and sexual harassment, were historically con-

sidered consensual." Added to this problem is the fact that "violent acts of sex, including consensual sadomasochism and the use of violence-portraying pornography, were once considered inherently coercive for women. Female involvement in such sexual practices historically has been dismissed as nonconsensual."[4] Liberty and authority exist, as historian Barbara Tuchman observed, in eternal stress. Indeed, anyone who studies women's blues, prostitution, and lesbian and bisexual literature knows that the idea of women's unwilling participation in such activities denies the violence and complexity of the urban experience and its effects on women of all races and classes under patriarchy.

Second, many people still think that a woman is, first and foremost, a wife and a mother. Indeed, for men, a wife is viewed as a social asset, and many people believe that women cannot live satisfactory lives outside the nuclear family. For the evangelical clergy, the traditional nuclear family, consisting of a heterosexual female who stays at home, a heterosexual male who is the breadwinner, and the married couple's children, is the only possible definition of the family. Jerry Falwell believes that feminism has launched a "satanic attack on the home." The whole idea of "preserving family values in our nation" is premised on the assumption that the traditional nuclear family is the proper moral family. Any other family form is unacceptable to the Religious Right.

Conservatives recognize that in a patriarchal system, the chief institution of control is the family. Clearly, this is the reason for their interest in commanding the family and through it, the state and the nation. Without question, the state represents the father of the institutional regional family. Indeed, a close examination of the relationship between modern democracy and autocracy is crucial to understanding the mission of religious conservative caucuses on the grassroots level of American politics. During the 1980s, the rural fundamentalist ministers and televanglists warned, "There are people who want a different political order, who are not necessarily Marxists. Symbolized by the women's liberation movement, they believe that the future for their political power lies in the restructuring of the traditional family, and particularly in the downgrading of the male or father role in the traditional family."[5]

SEXUAL HARASSMENT

Today this country is in the midst of a societal crisis that involves paralyzing gender issues, racial tensions, religious divisions, and partisan politics. Therefore, it comes as no surprise that many women are reluctant to deal with sexual harassment. A *Newsweek* poll indicated that 21 percent of the women surveyed had been sexually harassed on their jobs and that an additional 42 percent knew someone who had been harassed. Other surveys have found that about half of all American women have experienced sexual harassment at one time or another while in the work force.[6] "Sexual harassment," author Elaine Landau explained, "is actually not about sex—it's about power and abuse. This misuse is especially prevalent in male-dominated industries, where a woman's career can be instantly destroyed if it's even rumored that she's a troublemaker or uncooperative."[7] Women seldom press charges because of what happens to them when they do, as in the case of Anita Hill.

In fall 1991, Anita Hill, a highly respected professor of law, brought charges of sexual harassment against Clarence Thomas, who was a candidate for the Supreme Court. Both were prominent black persons, and the hearings that followed her charges focused the media's attention on the issue of sexual harassment and made it front-page news. The heated debates about gender and race that occurred over this event have since taken on mythic proportions in the minds of the American public.

Even before Hill's charges of sexual misconduct came to light, critics had noted Thomas's "mediocre mind" and disturbing record. Hill's charges of sexual harassment hit a nerve with many different kinds of women and smacked of disloyalty to many black people. Faced with conflicting loyalties to race and gender, Anita Hill confronted a predicament that has tormented black women for more than a century—whether to support the party line or be excommunicated for speaking out in public. She committed the cardinal sin and spoke the unspeakable truth of her experience as a woman first. What was worse, she spoke out in public against a black man.

Protecting their interests, the pro-Thomas faction used classic sexist tactics to disqualify Hill's testimony from being heard

impartially. These hearings became a public spectacle reduced to sound bites by what bell hooks called "the white male-dominated, racist and sexist media."[8] In general, television reporting pitted black men against black women. Predictably, the drama forced women (and men) who believed that Thomas was lying to side with Hill, against black and white chauvinists who closed ranks to support Thomas uncritically. The polarization was viewed by many as representing a serious setback to black political objectives.

Hill was frequently presented in the media as an oversexed black Jezebel, whereas Thomas was depicted as a victim of a lynch mob. This stereotype of black women as whores is pervasive in representations of American culture. Indeed, it was the misplaced anger aimed at her by some senators and the media that transformed Hill into a rejected, revenge-seeking woman whose insane sexuality drove her to make unwarranted charges against an "innocent man." Thomas declared himself blameless, despite the fact that his former Yale classmates told members of the Judiciary Committee of his strong "interest in pornographic films."

Hill was smeared by Reaganite Republicans like Alan Simpson of Wyoming and Strom Thurmond of South Carolina, and even noted author Maya Angelou expressed her support for Thomas in a *New York Times* editorial. Harvard sociologist Orlando Patterson defended Thomas on the grounds that Hill was taking it all too seriously. He commented that it was just a "down-home style of courting."[9] Others suggested that Hill was a loose woman who invited Thomas's overtures, that she was incompetent, and finally that she might be a lesbian.

It is difficult to imagine the personal anguish Hill went through and the taboos she breached to tell her story. Despite Hill's detailed testimony and her obvious disgust, embarrassment, and ambivalence in coming forward to make her allegations, the Judiciary Committee, among others, refused to believe her.

From the vantage point of racial matters, this was a watershed. Black women who had never before considered sexism an issue serious enough to merit any thought began to organize. They realized that Hill's sexist treatment by members of the

Judiciary Committee and by many other men (both black and white) was one of the reasons that more women don't risk filing sexual-harassment complaints.

Every woman who is employed outside the home knows that a boss who pressures his employees for sexual favors is abusing his power because he is in a position to damage or ruin their careers. There is no doubt among professional women that because of the Hill-Thomas debates, charges of sexual harassment in the workplace, junior high and high schools, and colleges are being taken more seriously than they were in the past. And 1994 court decisions have finally set some legal guidelines for sexual harassment. One of the criteria the Supreme Court established is conduct that is perceived as sexual harassment by the "reasonable woman" in the workplace.

On November 2, 1994, ABC's *Turning Point* and *Nightline* used the appearance of yet another book on the Thomas-Hill affair, *Strange Justice: The Selling of Clarence Thomas* by Jane Mayer and Jill Abramson, to hear from three women who had been prepared to give testimony about Thomas's come-ons, reading habits, and behavior. The reasons for this follow-up seem self-evident, but members of the New Right were incensed at the network. They wanted to know what end it served and accused the press of bias. Reporters responded by saying that they were just doing their jobs. ABC aired the program because Hill was credible then, and she appeared more credible based on what subsequent investigations revealed about Thomas. Despite these arguments, antifeminists believed that their point of view was being silenced.

In fact, journalists and the television news persons were just following up on a pathbreaking story and presenting new information to the public. What enraged the New Right was the positive comments on Mayer and Abramson's highly critical report on Thomas. Disagreeing with Mayer and Abramson's view, the New Right denounced the book, demanding that viewers and readers rely on Richard Bernstein's *Dictatorship of Virtue*. Reading like an old-time gospel hour, Bernstein's book was carefully evaluated by astute reviewers, who determined it to be poorly researched and preposterously slanted in Thomas's favor.

Rarely has any woman been as denounced in private and

public as was Hill for objecting to conduct demeaning to women. Ruth Bader Ginsburg, who kept a low-enough profile to be elected to the Supreme Court, effectively addressed the issue of sexual harassment when she noted:

> The critical question is whether members of one sex are exposed to disadvantageous terms or conditions of employment to which members of the other sex are not exposed. . . . It suffices to prove that a reasonable person subjected to the discriminatory conduct would find that the harassment so altered working conditions as to make it more difficult to do the job.

Just "doing the job" seems to be getting harder and harder. Since 1994, women in positions of influence have been taking on some pretty complex and controversial challenges.

Obviously, Hill isn't the only woman to be unfairly attacked by a sexist system because she was forced by circumstances to become a major player in national politics. From the moment that Hillary Rodham Clinton became First Lady, she has been battered by the power brokers in the press and Congress, and the press has made her the embodiment of every negative stereotype popularly associated with American feminists. Hillary-bashing is popular, and given what is known about television ratings, it is difficult not to become cynical about the communications media and its role in putting her down.

Unquestionably, since the 1970s, there have been major changes in attitudes toward women, such as expecting women to receive an equal education, equal job opportunities, and equal pay. But although some journalists have contributed to these new perceptions, A. M. Rosenthal still believes that he needed to reprimand the First Lady in the Op-Ed pages of the *New York Times* because she takes the job of being First Lady seriously.[10] In his criticism of Mrs. Clinton for shouldering the burden of trying to find a solution to the health care crisis, one would think that she is the spokeswoman for costly financial chaos when it comes to taking care of the national well-being. Was Rosenthal correct in saying, "In concept, the First Ladyship is an affront to American democracy"? If Eleanor Roosevelt is any example, I don't think so. Any nation worth its salt isn't afraid of independent-minded people. Rosenthal's antifeminism was strikingly

evident when he collapsed the boundaries between American feminism and his judgments of Mrs. Clinton.

In American politics, women are simultaneously condemned for taking an active role and denounced if they don't exercise their rights, regardless of their ability to raise funds or their experience in government. Furthermore, there are good reasons for their ambivalence about political participation. Who among us can forget that during the election campaign, Mrs. Clinton was reduced to participating in a chocolate-chip-cookie bake-off with Barbara Bush to create the correct domestic impression. And as the president's reelection campaign nears, she is once again being urged to appear more homey. This make-over attempt comes as no surprise in a time when every candidate has an expensive political adviser who shapes his or her public image.

Nowhere does the question of women's place in American politics occur so frequently as in the arena of family protection. Over the years, women politicians from both parties, including Geraldine Ferraro, Paula Hawkins, Nancy Kassebaum, Pat Schroeder, and Barbara Mikulski, have fought for the significant issues that directly affect women's lives. Neoconservatives in Congress and elsewhere hammer away at the links between working mothers and the country's ills using such terms as "mother-dominated families and drug use," "more women working means lower pay for men," and "the frightening growth of the mother-state-child family."

Given the New Right's political agenda, it comes as no surprise that Hillary Clinton has become a lightning rod in the battles about children and health care. "Billary," as she is often derogatorily referred to by Rush Limbaugh and others on the New Right, has become the butt of antifeminist jokes. But when one examines the root of these comments, one finds they are founded on the fear that the political exclusion of women from our country's decision-making process is finally breaking down.

It is all well and good to say that women have equal access to power in the political process, but these examples show that it is hard for women to break into the inner circle of American politics. Geraldine Ferraro couldn't do it when she ran for vice president with Walter Mondale, Hillary Clinton can't do it now, and

Lani Guinier was just another particularly disturbing casualty in the long chain of qualified women who have tried to break into the upper echelons of government.[11]

When President Clinton nominated Guinier to the position of assistant attorney general for civil rights, a political firestorm erupted. Certain influential men accused her of being "antidemocratic" and a "quota queen," and a chorus of voices called for her withdrawal. After he finally read Guinier's writings himself, President Clinton withdrew her nomination instead of fighting for her. If Guinier had been a man, would he have led the fight to have her nominated, as he did in the case of Henry Foster, who was a candidate for surgeon general? Her 1994 book, *The Tyranny of the Majority*, draws some perceptive conclusions about "what it means to be part of America." In it, she discusses how to tell when people are left out and what to do about their exclusion. Guinier's vision of what is "good" for this country differs significantly from that of extremists on both the Right and the Left. With the publication of her book, perhaps, Guinier can now get the fair hearing she was denied during the heated controversy over her nomination.

THE PARADOXES OF TRUE ROMANCE

Millions of romantic novels are sold in the United States, and since 1976 there has been a boom in romantic fiction marketed for women. The Harlequin romance has a basic formula that was perfected by Margaret Mitchell in *Gone with the Wind*: boy meets girl, boy loses girl, boy gets girl, and they get married. Mitchell, however, gave it an ironic twist: boy leaves girl.

Clark Gable once said, "The only thing that kept me a big star has been revivals of *Gone with the Wind*. Every time that picture is re-released a whole new crop of young movie-goers gets interested in me."[12] With recent revivals of Mitchell's Civil War saga, Rhett Butler and Scarlett O'Hara have become the focus of passionate debates centered on domestic violence.

Still proclaimed in the July-August 1995 issue of *Film Comment* as illustrating "The Great American Passion," the grand staircase scene pictures Rhett swinging his wife off her feet into his arms and starting up the stairs:

He hurt her and she cried out, muffled, frightened. . . . She was wild with fear. He was a mad stranger and this was a black darkness she did not know, darker than death. He was like death, carrying her away in arms that hurt. She screamed, stifled against him and he stopped suddenly on the landing, and turning her swiftly in his arms, bent over her and kissed her with a savagery and a completeness that wiped out everything from her mind but the dark into which she was sinking and the lips on hers. He was shaking, as though he stood in a strong wind, and his lips, traveling from her mouth downward to where the wrapper had fallen from her body, fell on her soft flesh. He was muttering things she did not hear, his lips were evoking feelings she never felt before. She was darkness and he was darkness and his lips upon her. She tried to speak and his mouth was over hers again. Suddenly she had a wild thrill such as she had never known; joy, fear, madness, excitement, surrender to arms that were too strong, lips too bruising, fate that moved too fast. For the first time in her life she had met someone, something stronger than she, someone she could neither bully nor break, someone who was bullying and breaking her.[13]

I've quoted the passage extensively because I want to stress its ambiguity and complexity in relation to heterosexuality. In his passionate rage, Rhett humbles Scarlett, hurts her, uses her brutally, and Mitchell has her glory in it. This blurring of the distinctions between coercion and consent has sparked heated arguments among both sexes. But nowhere have these been more fervent than in the university community. The disagreement that has erupted between Christina Hoff Sommers and feminist philosopher Marilyn Friedman is typical of the nasty, sometimes ahistorical, and convoluted arguments among academics that allude to women's real lives and make their way into the popular press.

Sommers asserted that until 1989, she was "an academic feminist in good standing." Then she "ran afoul" of what she called the "feminist establishment." Using an "us and them" approach, Sommers claimed that she said something "politically incorrect" about the famous staircase scene in *Gone with the Wind*.

"Many women continue to enjoy the sight of Rhett Butler carrying Scarlett O'Hara up the stairs in a fate undreamed of in feminist philosophy," she declared in an essay published in the

Chronicle of Higher Education.[14] There is nothing ambivalent about Sommers's challenge or the context she chose for throwing down her gauntlet. She knew full well that feminist ethics demanded a response. Outraged by Sommers's simplistic reminder that some women are entranced by the image of masculine sexual aggression, Marilyn Friedman accused her of trivializing Rhett's "rape" of Scarlett by proclaiming it to be "simply stunning." Although Sommers claimed that she never used the word rape, Friedman interpreted it that way, characterizing Sommers's interpretation as "romanticizing and mystifying" Rhett's aggression because the portrayal of the "rapist" as a handsome man whose domination is pleasurable in bed reinforces the idea that a woman is happy to have her own sexual choices and refusals crushed by such men.

"The major obstacle preventing us from transforming rape culture," according to bell hooks, "is that heterosexual women have not unlearned a heterosexist-based 'eroticism' that constructs desire in such a way that many of us can only respond erotically to male behavior that has already been coded as masculine within the sexist framework."[15] Today, because of feminism, psychological abuse, verbal harassment, intimidation, threats of physical harm, sexual jealousy, and forced sex are viewed by many judges and prosecutors as acts of domestic violence. From this perspective, Friedman's equating a liking for Rhett Butler with favoring Richard Speck makes perfect sense.[16]

Sommers, however, contended that the encounter is ambiguous and can be interpreted as a scene of mutually pleasurable "rough sex." Searching for justification for her point of view, she conducted a survey and reported that most of the women who responded to her argument saw the episode as erotically exciting, emotionally stirring, and profoundly memorable. Few of her respondents viewed it as an act of "rape."[17] They seemed to get a vicarious thrill from Rhett's primitive brutality and his failure to curb his animality.

The question of Rhett Butler's "rape" or "ravishment" of Scarlett O'Hara is open to interpretation. Friedman treated it not as mere fiction, but as a symptom of the kind of thought that privileges brute masculinity at the expense of women's right to have respect and control over their own bodies. From the

moment Rhett appears in the film, he verbally rapes and abuses Scarlett—power is the dominant theme associated with him.

In a later article, Friedman expanded her definition of rape to include "any very intimate sexual contact which is forcibly against the will of the recipient. 'This wider' use of the term includes 'sexual domination.'" Moreover, the scene in contention develops after a drinking bout in which Rhett becomes progressively more threatening and intimidating, which links the use of alcohol to sexual abuse.

Further confusing the issue for film audiences and those who follow this debate is the fact that Gable was a Hollywood type, the quintessential sexy he-man. As an actor, he pushed women around, traded insults with them, and pretended to despise them, while secretly adoring them. By Hollywood standards he was every woman's ideal lover and every man's man. But it was in *Gone with the Wind* that he achieved lasting fame as a fictional character who embodied a titillating, dangerous sense of masculinity. Ironically, Gable didn't want to play Rhett. And Vivien Leigh, the English actress who played Scarlett O'Hara, commented, "I never liked Scarlett. I knew it was a marvelous part, but I never cared for her."[18] Despite their misgivings, both Gable's and Leigh's performances made the film box office magic.

Making sense of the contradictions in Mitchell's story would confuse anyone. In this melodrama, Scarlett's no fool, and she knows that marriage isn't fun for women. She tells Rhett, "All a woman gets out of it is something to eat and a lot of work and having to put up with a man's foolishness—and a baby every year."[19] Still Scarlett can't resist the "sensations she has never known she was capable of feeling" and agrees "almost against her own will" to marry Rhett. And she does admit that it will be nice having a man whom she "doesn't have to lie to." Rhett personifies adventure and is exhilarating. He does what he wants to do and doesn't give a hoot whether she likes it or not, and he laughs at her. Scarlett seems to appreciate that about him, and even if her heart belongs to another, she learns to let go sexually with Rhett.

Scarlett isn't an ideal mother either. When she learns that she is pregnant, her reaction is anything but joyful. She proposes an

abortion, which was pretty radical for a nice southern girl of that time. Rhett explodes and then tells her how he saw a girl die from getting "fixed." By some standards, this is hardly the conduct of an insensitive brute. But from the start, he tells her that the baby is the first person who's ever belonged utterly to me."[20] Scarlett, the female subject, has no right to the child she delivers. The baby is his.

After their child is born, Scarlett informs Rhett that she doesn't want any more children, which means that she doesn't want to have sex anymore, and she confirms this by saying, "I shall lock my door every night!" to which he replies, "Why bother? If I wanted you, no lock would keep me out," which reinforces the violent image of such masculine traits as virility, toughness, and fearlessness.[21]

The controversial scene that Sommers and Friedman are arguing about is a result of Rhett's rage over Scarlett's faithlessness. What both contenders fail to mention is that Rhett is hopelessly in love with Scarlett and is deeply hurt by her infatuation with the poetic and civilized Ashley Wilkes, who is married and can't make up his mind between his wife and Scarlett. Rhett is jealous. Drunk, raging, and desperate to blot out his rival from Scarlett's mind, he forces himself on her. What this scene shows is Rhett's hopeless dependence on Scarlett and his need to command her love. Thus, Mitchell's staircase spectacle is meant to be a passionate love scene in which two willful and intense people test each other's mettle and both achieve momentary sexual bliss through the classical trope of domination and submission. This is, indeed, "rough sex." Today, however, ignorance isn't bliss, and seasoned feminists view the scene as rape.

Still, some people wonder if the famous scene really is a rape as Friedman contends. I think that it is because Rhett abuses Scarlett and dominates her against her will. The fact that he sweeps her off her feet and kisses her passionately en route to the bedroom doesn't change the force of his actions or the verbal abuses he heaps on her. The source of the controversy is her submissiveness. Scarlett gives up the fight quickly and thus colludes in her own oppression with a passion that matches Rhett's intensity. She "glories" in it. It may not be politically correct for Sommers to hold the opinion she does, but given the context of

Mitchell's fictional conceit and women's conditioning at that time, Scarlett's ravishment or rape reveals the paradoxes inherent in American romantic fiction and in women's socialization in a sexist society. Only by applying feminist theory, as Friedman does, can the charge of rape be substantiated.

During the 1970s, feminists tried to amplify pedagogically some of the political problems inherent in narratives of sexual harassment. Today, feminists continue to argue about the tensions and complexities of fantasies of dominance and submission in romance novels, many of which are written for women.

Protectionist feminists are up in arms at self-appointed post-feminists like Sommers for endorsing Rhett Butler as a manly hero. Sommers's ideas are totally at odds with the development of feminist theory and practice. The two sides, as I have demonstrated, view the dramatic grand staircase scene differently. To protectionists, romantic novels and films only reinforce general patterns of female socialization through narratives of dominance and submission.

Unfortunately, feminists who have learned to resist the allure of romantic fiction tend to ignore the erotic fantasy elements that some women perceive in these fantasies of desire and domination, which only serves to weaken their arguments against it. This preference perhaps explains why some younger women authors who haven't fully examined these stories, such as René Denfeld, refer to protectionists as "the new Victorians." Women like Sommers, who make excuses for male abusers, and more libertarian types like Camille Paglia rarely challenge patriarchal violation or deal with the dualisms inherent in such formulations. In fact, they dismiss the concerns of people like Friedman as absurd and view women who want to examine the politics of gender as the "thought police." Yet by engaging in feminist talk about passion, politics, and power, these women are contributing to the new, growing consciousness of predators and victims.

MISOGYNY AND VIOLATION

It's a fact that women are being victimized and dumped on. What accounts for so much woman-hating in our society? Why aren't molestations, rape, domestic violence, and serial killing

considered under the classification of hate crimes against women? Why do some people blame a brutally battered and terrorized woman like Hedda Nussbaum and excuse and feel sorry for a perpetrator like Joel Steinberg? When Hedda made the cover of *Newsweek* on December 12, 1988, it should have been clear from the picture that any decision concerning the welfare of their adopted daughter, six-year-old Lisa, was beyond her.

The most frequently cited case of a crime motivated by misogyny was the massacre by a twenty-two-year-old gunman, Marc Lepine, of fourteen female students at the University of Montreal. On December 6, 1989, Lepine entered a room, told the men to leave, and started shooting at the women, shouting "It's the women I've come for. You're all fucking feminists. I'm against feminism. That's why I'm here."[22] This raises the question of what women's unconscious reactions to such hate crimes are going to be.

Lepine's three-page letter, which was later found on his body, blamed females for everything that had gone wrong in his life—his inability to finish college, keep a job, get into graduate school, and maintain a relationship with a woman. What is most disturbing is that the doors of the classroom had glass panels. When Lepine let the men go and shut the door, they just stood outside. In her account of the incident, Robin Morgan pointed out that "no one ran for help." According to her, "after shooting the first woman he had to reload his [semiautomatic] rifle, no one rushed him, none of the men, including the male teacher."[23]

The seventeenth-century Mexican nun Sor Juana Ines de la Cruz, for instance, eloquently expressed her anger and frustration at men in the following lines from her poem:

Hombres necios, que acusais
a la mujer sin razon
sin ver que sois la ocasion
de lo mismo que culpais.[24]

Foolish men who berate
Woman unjustly,
Not seeing that you create
The very image you denigrate.

Lorena Bobbitt knows she is a victim of a hate crime. Her reactions are a direct response to her sexual victimization. In her mind she is engaged in a sex war. Why is it when women try to defend themselves against these terrorists, their defending themselves is seen as worse than the original crime? In the end, whenever a victimizer makes himself a victim at his victim's expense, e.g. Joel Steinberg, a lie is present. A system that allows this is dealing with a case of terminal denial. It means that the image being created is in conflict with the reality of men's and women's lives.

On the pages of the *New York Times Book Review*, the advertisement for Ann Jones's book on battered women, *Next Time She'll Be Dead*, asked, "Who do people hate more, Hedda Nussbaum or Lorena Bobbitt?" Blaming women and excusing men is popular in this society, and many traditional feminists link hostility toward victims to some dangerous consequences for battered women. These consequences include doctors who treat battered women but fail to ask how they got their injuries; police who refuse to arrest abusive men; violent husbands and boyfriends who ignore court orders of protection against them; attorneys who defend their clients in what Jones called, "the language of love"; and journalists who persist in describing victimized females as castrating or exasperating harridans. Unfortunately, there are more cases of injustice in this country and throughout the world than there are activists or money to finance their actions.

Currently, the greater the degree of victimization a person can claim, the more authority is attached to his or her strength as a representative of the oppressed class. It is this line of thinking that underlies Paglia, Wolf, Roiphe, and Denfeld's critique of "victim" feminism. They argue that one can be a victim of society but not everyone responds by killing or mutilating their tormentor. Indeed, many women, Jews, African Americans, and lesbians and gays respond by empowering themselves in a more positive way despite the obstacles they find themselves faced with. Unquestionably, always seeing women as victims has its problems too. It can lead to a backlash of equivalent violence, and it can teach women not to experience their own thoughts as creators of their lives.

In summer 1991, a number of formidable female characters

appeared in films: Linda Hamilton playing an embattled mother who joins forces with a cyborg in *Terminator 2*; Kathleen Turner, playing a tough, smart private eye who can take it on the chin and dish it out to the bad guys, in *V. I. Warshawski*; and Anne Parillaud, playing a chic, deadly, and skilled assassin in *La Femme Nikita*. Reviewing *Thelma and Louise*, critic Margaret Carlson observed, "Not since *Fatal Attraction* has a movie provoked such table-pounding discussions between men and women. Men attacked the movie as a male-bashing fantasy in which they are portrayed as "leering, overbearing, violent swine who get what they deserve."[25] Women liked the film, as I noted earlier, because it criticized Hollywood movies about bimbos, prostitutes, vipers, and bitches, and glamorized the "misogynists who kill them."[26]

Perhaps the reason so many women cheered in movie theaters when Louise pulled the trigger on a would-be rapist in a parking lot is that they didn't think these women could get a fair hearing in real life. Vigilante justice appeals to these spectators because deep down, they want to have these wrongs righted and the bad guys punished. Many women in the audience have stood up and clapped when Thelma and Louise blow up a phallic gas rig driven by a fist-shaking, leering, macho man who won't apologize to them for his disgusting, sexist behavior. Indeed, in identifying with these acts, women are unloading a mother lode of anger and expressing their desire not to be victims of male indifference and abuse. It is the general failure of the courts to reward and punish justly that accounts for these outbursts. Regardless of its flaws, which still prove Hollywood is a man's world, Thelma and Louise ignited explosive issues of sexual politics that have yet to be productively resolved.

Where does this rage come from? Every year, according to FBI statistics, roughly 3,000 men murder their current or former wives and girlfriends. In this country, a rape occurs every forty-six seconds and a man attacks a woman every twelve seconds, but few believe these figures. Stalkers are and have been a fact in women's lives. More than a century ago, Louisa May Alcott wrote *A Long Fatal Love Chase*, about a young woman who is stalked by a former lover. Rosamond, the eighteen-year-old heroine, is swept off her feet by Philip Tempest, a rich man

nearly twice her age, who takes her away, marries her, sets her up in a villa in Italy, and then is revealed to be a bigamist. Rosamond flees, and Tempest pursues her across Europe. The story opens with the words: "I tell you I cannot bear it. I shall do something desperate if this life is not changed soon. It gets worse and worse, and I often feel as if I'd gladly sell my soul to Satan for a year of freedom." Considered too sensational to be published until now, this story of obsessive love could have been written today.[28]

Does it surprise anyone that after generations of brutal conditioning, women have low self-esteem and often fall victim to exploitation? The actions and events of childhood and youth are the raw material out of which all people make sense of the world. Thus, it is not difficult to see how girls learn to be women in a patriarchy.

The economics of sex are reaffirmed in the family, in the home, and on the street. Being a housewife and mother isn't always a great role, but many women still feel they are stuck with it, and some girls resent having this model imposed on them by their parents. The damage our mothers unwittingly cause in trying to socialize us is a function of the abuse they suffered in our woman-trivializing society. It wasn't until Betty Friedan's book *The Feminine Mystique* that some women of our mother's generation got the message. Thanks to feminism, many of their daughters are able to follow a new path. I sometimes think that, as painful as it has been, our mothers helped us to find our own voices out of the silences they endured and tried to impose on us.

Despite antifeminist tirades, women all over the world protest that they are not defensive, that they are angry and with good reason. Any intelligent analysis of violence and victimhood sees the links. So domestic violence is an issue that is framed in the media and in the political arena as one of male perpetrators and female victims. Since 1974, the rate of assaults against young women (aged twenty to twenty-four) has jumped almost 50 percent, whereas the rate of assaults against young men, with the possible exception of black youths, has decreased. Each year more than 1 million women seek medical assistance for injuries caused by violence. In 1994, the number of women who were

abused by their husbands was greater than the number of women who got married.

Violence in gay and lesbian relationships, which is a rich and untapped vein to mine, is rarely discussed, and violence against men in heterosexual relationships is discussed even less. The men's liberation movement complains that legislation about domestic violence is always oriented toward the female victim. It probably is because 95 percent of all spousal abuse is committed by men.[29]

THE POLITICS OF VIOLENCE

With regard to strategies for mending the broken connections between women and their mates, one pressing question that grew out of the feminist debates of the past three decades was whether the election of women to public office would make a difference.

The answer to that is a resounding yes. For instance, in 1991, Senator Joseph Biden and Representative Pat Schroeder again introduced the Violence Against Women Act, which as of this writing has passed the Senate Judiciary Committee. One section of this bill, called Safe Homes for Women, allocates funds specifically to "women's" shelters.[30]

Violence and Women's Rights

As of 1991, eight states—California, Connecticut, Michigan, Minnesota, New Hampshire, North Carolina, Vermont and West Virginia—had hate-crime laws that include gender-bias crimes.

Between 2 million and 4 million women are victims of spousal battery each year, and about one of every three women who is murdered each year in America is killed by her husband, according to Richard Gelles, director of the Family Violence Research Program at the University of Rhode Island.[31] In 1995 women were able to help pass the $33 billion federal anticrime bill, which allows victims to sue assailants for gender-motivated attacks (a provision that, as of this writing, the Republican-dominated House and Senate are trying to dilute). The provision is an acknowledgment that women, like members of racial and

ethnic minorities, may become victims of crimes simply because they are women. This is a piece of landmark legislation despite conservative attempts to turn it back. "It's actually creating a new civil rights law that women can use to sue their assailants for violating their civil rights," said Leslie Wolfe, of the Center for Women Policy Studies in Washington, D.C. "It shows the extent to which crimes against women . . . are crimes of hatred and misogyny, control and domination, which have as part of their purpose the terrorizing of all women."[32] The bill gives women who have been raped, for example, a remedy. Formerly, when a rapist was prosecuted by the state, the woman was simply a witness with no ability to shape the case. This bill gives women the chance to bring their own suits against their attackers—a crucial option.

But actions like that of Ohio governor Richard F. Celeste, who granted clemency to twenty-five women who were in prison for murdering their husbands, are disturbing to many people. The reason Celeste gave for granting these women clemency was that they suffered from the battered-woman syndrome. Masculinists contend that little concern is shown either for making spousal abuse a capital crime, with the victim as extra-judicial executioner, or for the idea that perhaps some of the men who murder their spouses may be suffering from an analogous battered-man syndrome. What masculinists say they want is a blueprint for social and institutional changes that is well conceived and deals with causes and consequences. That's fine, but what they fail to acknowledge is the vast imbalance of power in incidents of male-bashing compared with incidents of female-battering.

The 1980s taught us that a home may be a man's castle but that it is often a dungeon for women and children. Has men's rage at women's newly won independence contributed to the escalation of violence against women during the 1980s and 1990s? Studies indicate that domestic violence increased markedly in this period and that shelters experienced more than a 100 percent increase in the number of women who were seeking refuge. Reported rapes doubled and sex-related murders rose 160 percent, with at least one-third of these murders committed by husbands or boyfriends.[33] The O. J. Simpson case is only the most sensational to hit the headlines. Simpson, the football hero, was

accused of brutally murdering his ex-wife and an unfortunate male waiter who was returning a pair of eyeglasses to her at home at the time the crime took place. In 1992, a report by the American Medical Association called domestic violence "a public health problem that has reached epidemic proportions."[34] Some 30,000 American women were murdered by men who once claimed to love them, noted author Ann Jones. We live amid an epidemic of violence by men against wives, former wives, lovers, ex-lovers, and other females.

With the advent of a new groups of postmodernist, media-proclaimed feminists, the word *victim* has become a loaded term, which refers to anyone who has suffered harm as a result of being a woman. Americans have a deep uneasiness and even hostility toward victims, regardless of their gender. Journalists and television commentators frequently present victims as pathological doormats who are terminally passive or as obsessives who are out-of-control aggressors and get what they deserve. At the most basic level, the victim issue is not really about the wounded. It is about the value of women in society.

The rights and wrongs of our society are measured in reality by dysfunctional families, battered women, broken bones, and abused children who frequently grow into psychotic adults, such as Lepine, who murdered the female students in Montreal. The injustices persist, and as long as they do feminists will persist in examining how victims are victimized and nonvictims benefit from the patriarchal status quo. Indeed, the problem for most feminists is that the social contract is not being enforced and is not protecting women and children or, for that matter, some men, from criminal behavior. This is why feminists continue their untiring efforts to secure equal participation for women with men in the workplace, courts, and Congress. Until women's grievances are addressed, feminists will keep calling attention to the issues of sexuality, family values, and equal justice under the law. When the broken connections I have been discussing throughout this chapter are mended, there will be no need for feminism.

But if this society is to mend the broken connection between men and women, pitting them against each other is not the way to do it. To unravel the contradictions, dilemmas, and choices

before us involves moving back and forth between representations of gender, with their male-centered frame of reference, and the ethical questions and political consequences a feminist approach suggests. Collaboration and cooperation may enable men and women to examine a multiplicity of positions and look for theories, practices, and methods that will lead to new forms of community and will effectively address the complex problems this country has.

DEFINING RAPE

To illustrate these problems, this section examines how this country deals with the crime of rape, which is central to the theme of violence against women. The courts believe that facts in the lives of both accused and victim are sometimes relevant to understanding whether a crime was committed and, if so, how serious that crime was in terms of violating accepted social behavior as codified by the male legal system. Some attacks are easier to prove than others.

Compounding the problem is the fact that many city hospitals keep rape victims waiting hours while the staff attends to victims of stabbings and gunshots instead of the survivors of rape. This situation has disturbed a lot of people, and in Tulsa, Oklahoma, they are doing something about it. In Tulsa, innovations have changed what is often a shocking and humiliating experience for the victim into a caring and sensitive process. Making the best of the worst, a program called Sexual Assault Nurse Examiners (SANE) ensures that the victim of rape is taken to a quiet section of the hospital, where she is treated with kindness, and an examination is performed by a specially trained nurse. The SANE program collects samples of semen and saliva and any other evidence that may help the prosecutors convict the rapist. At the end of the examination, victims are invited to shower and fresh clothes and underwear are available.[35] This kind of treatment makes it much easier for victims to press charges and for the police to track down vicious rapists.

Most feminists say that regardless of the circumstances, men who don't listen to no become rapists. But when it's one person's word against another's, under patriarchal law the credibility of

both people must be examined and previous behavior is often viewed as relevant. As long as there is room for misunderstanding, the courts have taken such possible mistakes into account.

How judges rule on such evidence in the cases of men and women is problematic. The trial of William Kennedy Smith illustrates the fact that the law treats cases of acquaintance rape differently from cases of stranger rape. For victims, the major difference between the two types of rape is the problem of proof. For the state, it is a matter of whether the lack of consent is an element of the crime of rape, and for the defense the focus is on the defendant's consent to the sex act.

Most people agree that the complaining witness in a stranger-rape case should not be treated like a seductress. But that is not what happened in the Smith case. Smith met his victim in a bar and invited her to a party at the Palm Beach mansion where he was a house guest and where a good deal of drinking was going on. Later that evening, Smith assaulted the woman. Most of the jurors thought that they had to decide whether Smith believed that his advances were wanted, despite the victim's protests.

Many feminists see the situation differently. They believe that other men who have been in situations like Smith's have not assaulted the women they were with. Jurors in the Smith case, however, did not know anything about Smith's history, and the judge did not allow evidence in court to show that Smith had violently assaulted other women in the past. What the jurors did know was the victim's prior sexual history, which was allowed as evidence to discredit her. As a consequence of the legal bias, Smith was not held accountable for his past conduct, nor was the jury privy to it in coming to their decision.

What really confuses people, as the Smith case demonstrates, is "acquaintance rape," or "date rape," in which the issue of "provocation" and the woman's previous behavior may be relevant in determining the truth of the accusation and the extent to which the alleged rapist was aware that he was raping, as opposed to merely having misunderstood the woman's intent (again feminists insist that mature men don't become rapists). Today, a woman victim can be treated like a seductress and temptress who "led the man on" and then lies that she was raped. This situation is ridiculous. But it would be equally

absurd to convict every man who is accused of "rape" simply because the woman says that she didn't intend to have sex with him.

To begin with, it is difficult to try rape cases. One reason is that in our judicial system, the victim has little control over whether and how the crime will be prosecuted. In a criminal suit, the defendant is the alleged perpetrator, the plaintiff is the state, and the victim is only a witness. In reality, the state often will not prosecute a crime unless the victim not only reports it but is prepared to be a witness. Furthermore, rape cases often become the stuff of soap operas. Once in court, the woman's character, sexual history, honesty, and common sense are questioned in the most insulting terms. Men are rarely treated in the same way. It is for all these reasons that more women don't file charges of rape.

Between acquaintances, the sole issue in dispute is often the state of the victim's mind, and both the accused and the jury are in a bind because this culture strongly encourages women to act in misleading ways and to send out knowingly false messages in potentially sexual situations. And, in effect, this culture encourages men to use "force" to overcome the "resistance" that women have been taught to feign. Some cultures even have ritual abductions in which this interpersonal drama is enacted. An acquaintance rape may well present a jury with a situation that is merely an "exaggeration" of the normal "rituals" that men and women are taught to go through. So assuming that juries tend to treat clear-cut cases involving force and/or violence much the same way, regardless of any acquaintance between the accused and the victim, they may demand a slightly higher standard of proof of force for an event that is perceived as heterosexual "normalcy" because it makes it harder for them (or the rest of the community) to cast the accused in the role of "rapist."[36]

Most people agree that the victim should not be blamed for what happened to her, but sadly, judges and juries often do. What happened to the woman in Smith's trial for rape was sexist, but it is standard operating procedure in many communities nationwide. It was bad enough that the woman was physically raped, but then, the justice system violated her again by questioning her previous conduct and giving everyone the impression that she was to blame for what happened to her.

Using Rhett and Scarlett as examples raises an even more troubling question: If a married or otherwise intimate couple engage in sex several times, and the last time is without the woman's consent, is it rape? In the case of a married couple, it's difficult to show that the final instance was not a misunderstanding. To complicate matters, many men claim that acquaintance rapes are "more gently" arrived at. A male acquaintance whom I questioned about the meaning of this term suggested that "more gently" really means gaining one's objective through seduction, deception, and/or less physically violent means. This rationalization for unacceptable conduct is illustrated by the case of an older male teacher in New York City who took advantage of an inexperienced teenage girl who worshiped him as her champion. Even so, feminists contend that such conduct is no less exploitative and argue that the shock of betrayal may be even more violating to the victims. In fact, most women believe that the man should be held liable for any harm, physical or emotional, that can be successfully documented. It doesn't matter whether he intended any harm. In general, there is a principle that when one commits an assault, one assumes the responsibility for any harm, whether or not it could be foreseen. The law calls this principle "strict liability."

The controversial film *The Accused* (1988), directed by Jonathan Kaplan with a screenplay by Tom Topor, was based on the infamous rape that took place in New Bedford, Massachusetts. It considers the responsibility of bystanders in a group rape case. Jodie Foster, who plays Sarah Tobias, and Kelly McGillis, who plays Kathryn Murphy, portray the relationship between two women of different classes: one, an articulate lawyer, and the other, an uneducated, angry alcoholic who can't put her feelings into words.

The film tells the story of Sarah Tobias, a young woman who is not a "good girl" or a "lady." One night, she has a fight with her live-in boyfriend, a drug dealer, and ends up going to a sleazy bar, where she drinks more than is good for her. Feeling loose, she begins to dance and starts to flirt with a man in the bar's backroom. The man, also drunk, starts to dance with her; then he picks her up and lays her down on top of a pinball machine and begins to assault her. Two other men hold the

protesting woman down as he bangs away at her. The other men in the backroom cheer him on, and when he finishes, another man is pushed forward until the assault turns into a gang rape. Finally, Sarah escapes and runs out onto the highway, crying for help.

All this is seen in a flashback, since the film opens with the immediate aftermath of the rape. We see Sarah being processed by the medical and legal systems and meeting professionals who are efficient but distanced from her situation. The assistant district attorney who takes her case is not impressed by some of the things she discovers about Sarah, such as her prior conviction on a drug-possession charge or her being drunk on the night of the crime. To add to the tension, one of the rape suspects is a clean-cut fraternity man, whose parents hire a smart lawyer to get him off. In conference, Murphy agrees to reduce the charges to "aggravated assault." When Sarah finds out, she feels doubly betrayed. She has been brutally and repeatedly raped in front of witnesses. To her, that is a clear-cut case of rape, not "aggravated assault."

The movie argues that even though a young woman acts improperly or recklessly, she still has the right to say no and to be listened to. This is something the articulate middle-class lawyer has problems with. She has lost touch with Sarah as a human being and doesn't identify with her experience. When she finally overcomes her distaste for Sarah as a person, she is able to bring charges against the men in the bar for inciting a rape. In preparing the trial, she receives no support from the chief district attorney, and many of her colleagues think she is crazy to try the case because it is a lost cause.

What this film so vividly and disturbingly demonstrates is that rape victims are often suspects in their own cases. Both men and women think that such individuals must have been somehow to blame. Defense lawyers ask how they were behaving at the time of the crime, how they were dressed, and if they were drinking. They delve into their personal lives to see if it is spotless and proper. If a woman fails to measure up to the unreasonable standard they hold up to her, they imply she is a slut who was just asking for it.[37]

Film critic Roger Ebert got the point of the film when he com-

mented, "I wonder who will find the film more uncomfortable, men or women? Both will recoil from the brutality of the actual assault. But for some men, the movie will reveal a truth that most women already know. It is that verbal sexual harassment, whether crudely in a saloon backroom or subtly in an everyday situation, is a form of violence that leaves no visible marks but can make its victims feel unable to move freely and casually in society. It is a form of imprisonment.[38]

Notes

1. Marilyn French, *The War Against Women* (New York: Summit, 1992), 9.

2. Robin Morgan, *The Word of a Woman: Feminist Dispatches 1968–1992* (New York: W. W. Norton, 1992), 76.

3. See Daphne Duval Harrison, *Black Pearls: Blues Queens of the 1920s* (New Brunswick, N.J.: Rutgers University Press, 1993), 81.

4. Michelle Fine, "Sexuality, Schooling and Adolescent Females: The Missing Discourse of Desire," in *Disruptive Voices: The Possibilities of Feminist Research* (Ann Arbor: University of Michigan Press, 1992), 46–47.

5. Susan Faludi, *Backlash* (New York: Crown, 1991), 232.

6. Ibid.

7. Elaine Landau, *Sexual Harassment* (New York: Walker, 1993), 3.

8. See bell hooks, "Camille Paglia: Black Pagan or White Colonizer?" in *Outlaw Culture: Resisting Representations* (New York: Routledge, 1994), 86.

9. Quoted in Kimberle Crenshaw, "Whose Story Is It Anyway?" in *Race-ing Justice, En-Gendering Power*, ed. Toni Morrison (New York: Pantheon, 1992).

10. A. M. Rosenthal, "On My Mind," in the *New York Times*, 11 March 1994, A13.

11. Rev. Henry Louis Gates, Jr., "At Last: Lani Guinier Will Receive the Public Hearing She Was Denied." *New York Times*.

12. David Shipman, *The Great Movie Stars: The Golden Years* (New York: Bonanza Books, 1978), 215.

13. Margaret Mitchell. *Gone with the Wind*. (New York: Macmillan, 1936), 940.

14. See Tom Kuntz, "Word for Word/A Scholarly Debate," in the *New York Times*, 19 February 1995.

15. bell hooks, "Seduced by Violence No More," in *Resisting Representations* (New York: Routledge, 1994), 111.

16. Richard Speck was a madman who brutally mutilated, raped, and murdered eight student nurses in Chicago on July 14, 1966. Corazon Auraro, a twenty-three-year-old Filipino exchange nurse escaped by rolling under a bank of bunk beds and lay there petrified through the night during which she heard the screams of her sister victims. See Jack Altman and Marvin Ziporynn, M.D., *Speck* (Delavan, Wis.: Hallberg Publishing Co., 1984) in which they try to get sympathy for the devil by examing his unhappy life.

17. Kuntz, "Word for Word/A Scholarly Debate."

18. Shipman, *The Great Movie Stars*, 337.

19. Mitchell, *Gone with the Wind*, 833.

20. Ibid., 891.

21. Ibid., 896.

22. Robin Morgan, "A Massacre in Montreal," in *The Word of a Woman: Feminist Dispatches 1968–1992* (New York: W. W. Norton, 1992), 199–205.

23. Ibid., 204.

24. Sor Juana Ines de la Cruz, *Poesia, teatro y prosa*, ed. Antonio Castro Leal (7th ed., Mexico City: Editorial Porrua, 1976), 34–37.

25. Margaret Carlson, "Is This What Feminism Is All About?," in *Time*, 24 June 1991, 57.

26. Ibid.

27. Ann Jones, *Next Time She'll Be Dead* (Boston: Beacon Press, 1994), Department of Justice figures.

28. Lawrence Van Gelder, "A Tale for the 90's from Louisa May Alcott," in the *New York Times*, 20 December 1994, sec. L-C 17.

29. Department of Justice figures.

30. Roni Rabin, "Sex-Bias Violence Lawsuit," in *New York Newsday*, 4 August 1994, 4A.

31. Ibid., A50.

32. Jones, 201.

33. Jones, *Next Time She'll Be Dead*, 201.

34. Ibid., 202.

35. Anna Quindlen, "After the Rape," in the *New York Times*, 19 October 1994, A23.

36. Ran, "Sexes Forum," 1993, CompuServe online.

37. Roger Ebert, "Ebert Forum," CompuServe online.

38. Ibid.

11

Conclusions

As I have discussed throughout this book, despite all the talk about "political correctness," there is no one feminism and there is no politically correct feminism. There are only feminisms.

Nonetheless, a question remains: Why do so many American women regard feminism as the real F-word? Perhaps they do because many of the movement's most visible figures—Camille Paglia, Andrea Dworkin, and Catharine MacKinnon—have articulated opinions that are too extreme and inaccessible or that just don't make sense to most of us. Moreover, the mass media have definitely been instrumental in promoting the fallacious idea that there is an extreme split among generations. Even Paglia, the queen of the media, blames the communication network for playing up the "wrong" spokeswomen. There is nothing new in this slanted positioning of spokespersons.

In his book *The Seduction of the Spirit*, Harvey Cox made a distinction between story and signal that is important to understand:

> Stories reflect those forms of human association which blend emotion, value and history into a binding fabric. Signals, on the other hand, make possible large-scale and complex types of human association where such binding would not be possible. Stories amplify. . . . Signals specify. . . . Traffic lights are signals. They transmit one unequivocal message and discourage all but one response.[1]

Although written in 1973, Cox's book targets the problem some people are experiencing regarding the true meaning of feminism. They are so busy with signals that they seem to have lost sight of the story.

Many women in their twenties, who have grown up in a multicultural society, refuse to accept the classical feminist idea that sisterhood is global. Rather, their experiences have made them more aware of diversity among women. By rejecting classical feminism, as some of these younger women do, they avoid dealing with its true complexity. Some third-wave women have trouble with the word *feminism* because of what it means to them. One twenty-year-old single white woman who lives in New York City wrote:

> I myself have trouble with the word feminism. For me it has always had connotation of anger and militancy rather than of peaceful and constructive unity. . . . It seems that this is a word of the 1960's and 1970's that has unfortunately been polluted. I think it should mean "aware and sympathetic to women's issues," but in my mind it carries much more baggage than can be defined.[2]

In sharp contrast, a happily married fifty-year-old wife and mother from California commented:

> I think women of all ages have trouble with the word "feminism" because it is defined for them by white males in positions of authority. . . . The connotations that feminists are strident, aggressive, dissatisfied, non-feminine women who want to deny safe, loving, secure homes to truly feminine women are advanced and embellished upon endlessly in the white male dominated world. It is a fine scare tactic and works beautifully until a woman is in her late 30's or early 40's and begins to learn how totally expendable she is. By that time it is too late.

Herein lies a crucial difference between women who entered the liberation movement in the 1970s, when Betty Friedan and other women began to speak for themselves on questions affecting women, and those who are just now becoming acquainted with feminism.

The former are a group of women who still remember when their grandmothers didn't have the vote, when they had little hope of improving their situations outside marriage, and how

difficult it was to pass a host of laws equalizing opportunities for women. They know their own bitter struggle and the widespread opposition they encountered in trying to play a larger role in the world. During the new feminist wave of the 1970s, major campaigns were fought to gain greater freedom of action for women, to satisfy their basic needs for equal opportunity and advancement, and to achieve economic and social justice.

By the 1980s, because of their actions, a new wave of debates gushed forth. In the backlash of the 1980s, the forces representing entrenched tradition, liberalizing evolution, and open revolt confronted one another with increasing hostility. Despite diplomas, union cards, and a dazzling array of accomplishments, most women in their forties and fifties simply did not gain equal opportunities, their careers did not advance in the ways that their male peers did, and they did not win promotions that would have brought them high wages, status, and the power to participate in policy changes. Their ambitions were frustrated and their hopes dashed.

During the 1990s, when the single twenty-something woman joined the work force, she did not confront the same problems that the fifty-year-old woman encountered when she entered the business world. Her prospects and possibilities were vastly enriched by the fundamental changes in women's roles and expectations brought about by her grandmother's and mother's feminism. Currently, new elites and political leaders are emerging who are dedicated to political, economic, and social changes. However, the third-wave feminists appear to be looking in many different directions for models and inspiration to try to reshape feminism for today.

Compounding the problem these two "groups" of women have in understanding each other is that authority figures in the news media and ultraconservatives from the New Right have worked hard to promote the false idea that feminists are man haters and lesbians. "Unfortunately," as British editor Jemma Kennedy maintained, "feminism is still associated to some extent with the 'dykes in dungarees' image."[3] "The connotations that feminists are strident, aggressive, dissatisfied, nonfeminine women who want to deny safe, loving, secure homes to truly feminine women," in the words of the fifty-year-old woman

quoted earlier, are advanced and endlessly elaborated by right-wing diehards like Rush Limbaugh and Patrick J. Buchanan.

At the Republican National Convention on August 17, 1992, Buchanan made a harsh speech. In it, he ridiculed then presidential candidate Bill Clinton for telling voters, "Elect me, and you get 2 for the price of 1." Buchanan asked voters, "And what does Hillary believe?" Then he bellowed:

> Well Hillary believes that twelve-year-olds should have a right to sue their parents, and she has compared marriage as an institution to slavery—and life on an Indian reservation. Well, speak for yourself, Hillary. Friends, this is radical feminism. The agenda Clinton and Clinton would impose on America—abortion on demand, a litmus test for the Supreme Court, homosexual rights, discrimination against religious schools, women in combat—that's change, all right. But it is not the kind of change America wants. It is not the kind of change America needs. And it is not the kind of change we can tolerate in a nation that we still call God's country.[4]

This speech is now just history. In studying it, one is prompted to ask, "Why is Hillary Clinton speaking her mind any different from Buchanan speaking his?" A great number of Americans, in fact, want some of the changes Buchanan and the New Right movement wish to forbid them from having.

Hosts of talk-radio shows like Limbaugh have helped to create a myth of sexual behavior for middle-class white "Christian" Americans and a new morality that undermines all women's independence and right to sexual pleasure. A "true woman" who subscribes to this romantic myth of purity abstains from sex until she is securely married and then spends the rest of her life coupled with one man, producing children, and taking care of her husband and family. Although this arrangement is fine for those who choose to live this way, for others, it is simply unrealistic and unhealthy. This has been the dominant religious ideal since the 1850s. But religious institutions limit sexual expression to reproductive purposes and perpetuate the idea that sex outside marriage is a sin. In this system, passivity, dependence, and the desire to have and raise children are the formula for female contentment whether it works or not.

Feminists in the 1920s, such as writer Louise Bryant, wanted serious alternative structures of relationships between the sexes

that did away with the conventionality of bourgeois marriage. The writer and free-thinker John Reed, who was Bryant's lover, supported her desire to be both sexy and independent. Among this set, female eroticism was seen as an end in itself and pivotal to fulfillment in other areas of life.

No one can deny that there are contradictions within feminism and that there are traditions of female thought, women's culture, and female consciousness that are not feminist. Nobody is completely happy with the words that feminists use to deal with "women's issues." But maybe they are not because these issues aren't just women's issues: they are part of the mainstream social issues facing the country as a whole.

Feminist theory often suffers from a lack of precision. Everything in current research is constantly in the process of being updated. That's what makes feminist studies so exciting and challenging and why it is difficult to find any two feminists who agree on anything.

Who's to blame for the disturbing confusion over what feminism is and what women really want? "Puritanical feminist prudes," proclaims Paglia. But what does Paglia mean by "prudes"? "Politically correct feminists," asserts Katie Roiphe. But what does she mean by "politically correct," and who are these people? "Gender feminists," insists Christina Hoff Sommers. But what is a "gender feminist," and on what grounds is Sommers attacking her? Lack of self-esteem and "external structures that undermine our worth as women in order to assert their own authority" are one cause of the problem, maintains Gloria Steinem. Is she right? Do women lack self-esteem in our society? If this is true, then what are these external structures and how do they undermine our worth? What can we do to fix them?

"Perhaps we are all to blame," noted therapist Phyllis Chesler, "for spawning a generation that knows the problem but has no intention of doing anything but profiting from it." Should we accept Chesler's interpretation? It is a pretty harsh assessment to swallow. Is the entire younger generation so uncaring and materialistic? I don't think so, and movie director Kathryn Bigelow's comment in a *New York Times* interview is revealing of what many younger women seem to believe: "I know that power is never given, only seized, and you have to decide to seize it and

do it."[5] No one can deny that there is a lot of blaming going on today. Many people complain about violence in movies and on television, yet few of us seem prepared to do the required concentrated reading that is necessary to form reasonable opinions on the complex problems currently facing us. Instead, we settle for network television's slick packaging of local and national news. Forty-five percent of Americans now get their news from network television, according to an ABC poll.[6] No wonder so many people are unhappy with the word *feminism* and/or how the media has portrayed it.[7]

In view of how the media has regulated our ideas regarding women's liberation, it comes as no surprise that some liberal, socialist, and radical feminist leaders—activists and entrepreneurs of the 1970s, who built their campaigns and careers on classical models that seemed to criticize all men—are in deep conflict with the younger postfeminist generation.

Up to two-thirds of American women will not call themselves feminists even though they believe in women's equality.[8] Although younger women have undeniably gained from the sacrifices made by older women, many of them do not seem to understand the inequities that outraged their elders. They may not do so because relationships between men and women have undergone considerable change since the 1970s.

Since the 1980s, the two-paycheck family has been the standard. Women no longer go to work merely to earn "pin money," and they probably never did. Unquestionably, the sanctity of motherhood and the sacredness of the home have been transformed by economic necessity, and many ultraconservatives find this situation unacceptable. So the grounds for inferring that feminists of the 1990s are different from feminists of the past are valid. Many of the 1990s women live in cities, rather than suburbs, and have created new family models. Yet the suburban ideal abounds on television and in films. Television programs, such as *The Wonder Years* (1988–93), a sitcom that portrayed the white-bread homogeneity of a boy's suburban schooldays in the 1960s, affectionately recall earlier eras. Nostalgic film parodies like *Edward Scissorhands* (1990), the recounting of a cruel fairy tale of suburban ostracism, still lovingly reimagine the quaint conformity and rigid gender roles of tract-house life.

But is this distinction between household mothers and commuting fathers relevant to the question of how women ought to be treated? Common experience and research seem to indicate that younger women of a certain class and education have definite initial advantages in life because of the gains feminism has made. Although many younger women admit that feminism has benefited them, they don't subscribe to it. And many of them are more conservative.

Also, despite the rapid upward movement in their careers, many women seem to believe that being labeled a feminist will interfere with their relationships with men and have an adverse effect on their careers. Many still believe that marriage is everything. They often forget that marriage is an institution, a legal contract, and discover how binding and unfair it can be only when they divorce. Because the true nature of sexism isn't clear to many younger women and because these women don't want to oppose the traditional male-female roles, they perceive earlier feminists as the problem. Although they may see the disadvantages of raising children and maintaining the home, it rarely occurs to them that it is not mainly their responsibility. Everywhere in the world men place this burden on women.

In addition, many people in our society now appear to think that "victims" and feminists who demand justice for them are not worth bothering with. Even worse, some of these "new" women construct elaborate defenses and arguments to support their contentions. But they really have a larger purpose. These people oppose most ideas and programs that protect working-class women because they are incompatible with the free-enterprise system that postfeminists and their men support. The entanglement of classical feminism with racism and class prejudice is inevitable because of its social agenda. But this still leaves the new feminists having to deal with the real evidence of most men's need to dominate.

Reacting to their own fears of possible victimization, contemporary women of the 1990s prepare themselves for action in a variety of ways. Some train themselves in martial arts, stage "take back the night" marches, and pressure universities to install blue safety lights in dangerous areas. Others get guns, push safer sex, and relentlessly ask themselves if dancing buck

naked on a stage for money is much different from dancing as fast as they can in the executive suites of corporate America or on Capitol Hill.

In sum, given the success of feminism, it is not surprising that younger women are demanding a better lot for themselves and a say in the decision-making process. Naomi Wolf, for instance, advocates a kind of no-holds-barred laissez-faire postfeminist capitalism. This stance makes her seem bigoted, self-serving, and harsh to older women like Chesler, whose own struggles gave new opportunities to able and ambitious entrepreneurs like Wolf. In attempting to command respect for women's rights, some conservative and radical feminists and postfeminists are making dangerous alliances.

Looking back, one can see that what most feminists of the 1970s wanted was a massive restructuring of society and culture. Women's right to self-determination, like the democratic principle, was central to this stage of the feminist revolution, and this drive mirrored the actions of feminists of the nineteenth century. Despite their differences, Friedan and Steinem still advocate a liberal democratic model that protects the underdog from both the rugged and ruthless postfeminist and the patriarchal commerce system. "We don't want to have a piece of the pie," Steinem explained, "we want to make a whole new pie."

Clearly, there is a deep cleavage between some feminists of the 1970s and many postfeminists of the 1990s. The rules of the game have changed, but one thing they all agree on is the need to participate in the decision-making process that keeps women from economic self-sufficiency, a political voice, and control of their own bodies. The question of why some younger women deny the suffering of older women marks a distinction between their comprehension of the problem and that of their elders, as well as the issue of daughters' need to break away from their mothers— symbolic and otherwise. It is hard for a younger generation to identify with mature women because many of them don't think sexism is affecting them. In fact, many of them view displacing their elders as profitable to them.

What we are dealing with here is "supply-side economics," which David Stockman characterized as "feeding time at the trough." During the postwar period, opponents of women's lib-

eration argued that if women went out into the work force, there would be fewer jobs for men, which would have an adverse effect on the family because there would be no one to cook, clean, and mind the children. Following this logic, ultraconservative men stress that woman's place is in the home. This adage makes perfect sense to them, since they believe that woman's psychic life is permanently shaped by her biological status. Most of their criticism of feminism is uninformed, and they don't eagerly accept Friedan's observation that "men are fellow victims" of an exploitative value system. Even if Friedan's observation is true, such men simply don't picture themselves that way.

Inspired by the masculine economic model, many younger women view older women who have been severely wounded and who are fighting hard not to be injured again as a lesser species, and they have no compassion for them. They see them as a threat to the growth of a new generation. This view gives postfeminists and antifeminists a sort of moral justification, much like that of their male peers, for ignoring suffering when it occurs. Their lack of compassion leads one to wonder how many of these female masculinists, "feeding at the trough," know anything about the way such wealth is produced and at what human cost? How many close their eyes to the process because it would not be to their benefit to risk doing anything about it—or perhaps because deep down they believe they have no power to change anything? It is not until they themselves become victims of this value system that they gain any insight into or empathy for the problems other women face.

The more important question remains: What is men's place in the feminist revolution? Why would any man in his right mind support women's rights? In the nineteenth century, many men voted against giving women the vote because to vote that way appeared to some to be in their own self-interest. Just as the question of a person's indisputable ownership of his or her body was a fundamental and God-given right that sparked the abolitionists, so the question of a woman's indisputable ownership of her body is at the heart of the current controversy over feminism.

Unlike Hannah's husband, Elkanah, in Cynthia Ozick's story, "Hannah and Elkanah: Torah as the Matrix for Feminism," many men don't understand the classical feminist conception of

woman's "personhood" that is rooted in Jewish religious ideas. Elkanah, Ozick explained, lives in the same patriarchal society as his wife, yet he says to the childless Hannah, "*lameh tivki?* (Why weepest thou?) And why eatest thou not? And why is thy heart grieved? Am I not better to thee than ten sons?" In this unconventional response, Elkanah is telling his wife that she has intrinsic value. That with or without sons, who were the most valuable persons to have in their society, Hannah has value in herself.[9]

Following this line of reasoning, Elkanah refuses to go on creating a "hell on earth" by continuing to be an instrument of women's oppression. Fortunately for the feminist cause, numerous men who are true humanitarians and visionaries continue to battle alongside women for equality and a new social order, rather than scapegoat feminism. To the majority of feminists, this distinction separates the real men from "the boys," who need to be aggressive in perpetuating old stereotypes. It is men who are able to love women and to identify with them as people, as Friedan maintains, who will help us break through sex discrimination and create the new social institutions that will someday liberate us all.

In thinking about how to accomplish this goal, what comes to mind is the marked contrast between two classic films, Charlie Chaplin's *Limelight,* which I alluded to in an earlier chapter and which was awarded the National Board of Review of Motion Picture's prize as one of the ten best films of 1952, and *The Red Shoes,* which was the top grossing film of 1948.[10]

In the opening scenes of *Limelight,* comedian Calvero (Charlie Chaplin), an elderly drunk who is down on his luck, stumbles through the doorway of his dilapidated rooming house, smells gas, and rushes to break down the door of the apartment it is coming from to rescue a young ballerina, Terry (played by Claire Bloom), who is living there. Despite his inebriated condition, Calvero then fetches a doctor, offers Terry a home in his apartment, nurses her back to health, and finally helps to cure her psychosomatic inability to walk. The two artists form a mutually loving and supportive relationship. Because of Calvaro's compassion, Terry is able to realize her talent and become the true artist she really is. And after countless rejections, Terry's love enables Calvero to recover his comic gifts and make a tri-

umphant return to the stage. In the process, Calvero struggles with his own selfishness and refuses to stand in the way of what he sees as Terry's happiness with a young composer who loves her. Both Calvero and Terry are unselfish on behalf of each other. Each sacrifices for love, and in the best interests of the other. In the final scene, Calvero dies contentedly, watching Terry dance in the limelight as his own life fades into darkness.

The Red Shoes, on the other hand, is a tale of a ballerina, Victoria Page (Moira Shearer), who is torn between a struggling composer, Julian Craster (Marius Goring) and a dictatorial impresario, Boris Lermontov (Anton Walbrook). Both men say they love Victoria, yet throughout the film they display utter selfishness in their struggle for the affections of the talented and sensitive young dancer. Each man wants her for his own purposes. Julian needs a wife to be there for him so he can create his music and see himself reflected larger than he really is through Victoria's eyes. He doesn't seem to care about her love of dance, which equals his passion for music, and it doesn't matter to him that the dance is her life, and without it she doesn't feel complete.

Lermontov, on the other hand, is a ballet impresario who sees Victoria only as the embodiment of his own creativity. To him, she is not a flesh-and-blood human being with emotions of her own, but a vehicle through which he expresses himself. He manipulates her need to dance and mercilessly exploits her as he does the rest of his troop. The two men clash time and time again as each tries to exploit Victoria and make her adapt to his purpose and his vision of who she should be. Victoria's function for both men is symbolic; for Julian, she is a muse, sexual partner, and caregiver, and for the Diaghilev-like Lermontov, she is the physical presence of the dance itself—its aesthetic form, to be shaped by his taste and worshiped like a marble statue that becomes animated on stage.

Thus, the Victoria figure functions as the essence of the romantic ballerina, with her aerial, virginal grace and vague spiritual yearnings. She embodies the feminine, and she is an exceptionally beautiful woman whose shapely limbs exude a veiled eroticism, both on- and offstage. Throughout the film, her protector Lermontov materializes behind the scenes, promoting her, dis-

pensing funds, and destroying any relationship that Julian and Victoria try to build because their liaison threatens his exclusive ownership of her. But despite the character's clichéd stereotype, Moira Shearer plays this young woman as a stunning refutation of the woman as muse-victim.

As the film unfolds, Victoria is shown to be far more complex and fragile than either man realizes, and although she is torn to shreds in their contest with each other, neither man realizes the ultimate cost of their battle to her. In the closing scenes of the film, Victoria disrupts her own oppression by committing suicide, thus interrupting this progressive narrative of ownership and destabilizing the patriarchal commerce that is destroying her. Similar to the concluding scenes of *Thelma and Louise*, the only way out that is left in this restricted sexist narrative framework is death. *The Red Shoes* is not a woman's story but, rather, the enacting of an ancient ritual in which two patriarchal men naturally consume the woman they are supposed to love and sacrifice her to their ambitions.

What Chaplin's film suggests is the capacity to switch roles and change the mood of the stereotypic sexist narrative. His audacity comes not only from placing a man in a nurturing role, but from then denying that character his usual function as an emasculated heterosexual—a "sissy." We gradually come to understand the whole messy meaning of gender itself as a continuous flow in which the professed masculine and feminine are constantly in play with each other. In Chaplin's films, gender is in constant flux, and *Limelight*, unlike *The Red Shoes*, puts both masculinity and femininity into critical relief. More important, it envisions a rejection of the patriarchal power structure itself, obliterating narratives of subjugation and domination based on gender.

The sexism of our society stems from many factors. Classical feminists argue that women have been enslaved by necessity. They maintain that the key structures of production, reproduction, and socialization of children through the institutions of marriage and household labor are held in contempt by patriarchy. To prove their case, classical feminists cite the fact that women are not compensated for their labors in the way that men are. What women's rights advocates battle for is an equal share

in the political process—a change in women's status and general legislative circumstances. This is one of the central goals of feminism.

As I mentioned at the beginning of this book, Linda Gordon suggested that "feminism is a critique of male supremacy formed and offered in light of a will to change it, which in turn assumes a conviction that it is changeable."[11] It is a philosophy based on the fact that American women live in a male-dominated culture and society. What many women's rights advocates have failed to ask themselves is whether the power brokers in our society want to be more humane and progressive. Do they want to eliminate the problem or merely distort and suppress it and hope it will go away? How society deals with the effects of violence on women's bodies, minds, and spirits reflects the mood of the country and those who run it.

Feminism, despite what ultraconservatives would like us to believe, is far from dead. In fact, the resurgence of feminism confronts us with one of the most fundamental critical choices of our lives—the act of consciously choosing to change how we live, love, and interact with each other. Unfortunately, the mass media aren't treating the women's movement as seriously as it deserves to be. Feminism has become a scapegoat for changes in the economy and society, to wit the fact that the middle class in general is losing ground in terms of material betterment and quality of life for families. Because of this scapegoating, many people think that feminism is the problem.

On the basis of the evidence, I submit that leadership in the feminist movement is constantly changing, so the matter of needing a "new" movement is false and René Denfeld's notion of "The Final Wave" is premature. Denfeld and her sisters are already shaping the future and the dramatic changes that will continue to energize the drive for women's rights.

In 1992, for instance, women had a decided impact on the elections, electing three new female senators and retaining one female incumbent, which brought the total number of female senators to a record six. Only twenty-one women (fourteen Democrats and seven Republicans) have served in the U.S. Senate, which may explain why women's progress has been so slow. Carol Moseley-Braun was the first African American

women to be elected to the Senate. In the same year, twenty-four new women were elected to the House of Representatives and twenty-three incumbents were reelected, bringing the total to twenty-eight in the 102nd Congress and to a record forty-seven in the 103rd Congress. This situation is encouraging, but more needs to be done, and the rise of the New Right movement has spawned extremists who threaten the hard-won freedoms that feminism has gained for society over the last quarter of a century.

Much of the noise surrounding debates about feminism is like radio static: it's hard to hear the music unless you tune out the noise. You can't make judgments about feminism on the basis of whether it fits some dogma. Right from the start, you have to face the complexities of discovering what the feminist critique of society is really all about. The present state and probable future of the women's movement is difficult to determine. Like all truths, it is multifaceted. The problems and questions I have raised throughout this book represent the views of feminists who fought earlier battles to open doors for other women and/or who are on the front lines of debates regarding women's liberation and of those who oppose them. What stands in women's way today are the false images we have all grown up with. Indeed, narcissistic indifference to all but one's own reflection characterizes many of the 1990s debates on the humanism of classical feminism.

THE APPROACHING MILLENNIUM

In 1991 Pulitzer Prize–winning journalist Susan Faludi summed up the state of feminism succinctly at the end of her book *Backlash*. She wrote, "The backlash decade [of the 1980s] produced one long, painful, and unremitting campaign to thwart women's progress."[12] She attributed this backlash to male policy-makers who were threatened by "polls indicating huge and rising majorities of women demanding economic equality, reproductive freedom, real participation in the political process, as well as a real governmental investment in social services and a real commitment to peace."[13]

In the decade of the 1990s, the malaise and fears of decline usually associated with the end of a century are clearly in evi-

dence as American life seems to be undergoing a radical change. We are living in a time characterized by an appetite for frantic rhythms, instability, clutter, and a refusal to distinguish between Mickey Mouse and Michelangelo. This postmodern era was described as neobaroque by Italian writer Omar Calabrese.[14] According to Calabrese, people are living in an apocalyptic culture that focuses on themes of decadence and death—a cultural phenomenon that is visible throughout the Western world. These fantasies of destruction reveal some of the ways we express our latent anxieties regarding the approaching millennium.

Calabrese added a further insight to our understanding of what is at stake. In our ardent desire to reconstitute our social world, it is not surprising that psychoanalysis continues to play an important part in the endeavor. Indeed, it is one of the most contested and productive areas of debate within feminism today. By examining Freud's phallocentrism and his theory of the castration complex and Jacques Lacan's theory of the phallus, feminists have offered reflections on theories of male supremacy and have used such privilege to expose the fallaciousness of this kind of thinking.[15] Feminism's reinterpretation of these men's theories has revealed the arbitrary nature of both male and female sexual identity. Women have constantly transcended the barriers of definition to which they have been, and still are, confined.

In the course of its history, feminism has brought its powerful and frequently angry voice to bear on the role of women in society. Indeed, a central goal of the movement has been the reform of patriarchy. Hillary Rodham Clinton said in Beijing, "Human rights are women's rights. And women's rights are human rights." Gloria Steinem has insisted on this point in most of her books. But in striving for women's just rights, feminists have encountered some setbacks along the way. In a time of decay and discouragement among progressive forces, when middle-class Americans are losing their American dream, feminism offers fresh strategies to galvanize a new generation of intellectuals and activists who can effectively confront the compelling issues of our times and come up with creative solutions for the future of our society and culture. They will have to discover persuasive means of negotiating to preserve humankind's sense of community beyond the waves of hate and violence that currently assault us.

Most feminists believe that the tattered quilt of our society is not beyond repair. But they know it will take truly dedicated individuals to forge a collective vision of the new society that will replace the one that we have known. This new world will require a change of consciousness—one that sees the transformation of people within an ever shifting landscape. To contribute to this transfiguration meaningfully, we will need to develop an ethos of cooperation from all sectors of society.[16]

There's nothing wrong with feminism's vision . . . a society founded upon ethics, kindness, and mutual respect. If this be utopianism, let it be. Those who criticize this as utopian must be coming from a philosophical position that stresses the notion that human beings are by nature uncooperative, unjust, and inhumane. It is my contention that what humanizes us is our ability to become conscious of our failings and to work to correct them. This is the essence of progress. Working from within the context of mutually agreed upon ethical values I hope that we will be able to negotiate the difficult tasks of balancing technology with respect for the individual. Undoubtedly one of the circumstances that people will have to face as they move toward this new society is what part the mass media will play in determining our way of thinking. What we will need more than ever is a calm voice of reason in a noisy time—a firm voice that acknowledges the harsh realities of life, yet insists on what compassion and caring for each other have to teach us about love. Feminism cannot change the past, but it can help to change the future, making ours a more humane world in keeping with what more and more women really want.

I am comforted by the ethical teaching of Rabbi Tarfon from the *Sayings of the Fathers*:

> *You are not obligated to complete the work,*
> *but neither are you free to abandon it.*

> *Do not be daunted*
> *by the enormity of the world's grief.*
> *Do justly, now.*
> *Love mercy, now,*
> *Walk humbly, now.* [17]

Notes

1. Harvey Cox, *The Seduction of the Spirit: The Use and Misuse of People's Religion* (New York: Simon & Schuster, 1973), 10–11.

2. Letter to the author in answer to an informal survey of women conducted from June 1994 to June 1995.

3. Letter to the author, 26 July 1994.

4. Buchanan's speech at Republican Convention, 1992; CompuServe.

5. "Kathryn Bigelow Pushes the Potentiality Envelope," in the *New York Times*, 23 October 1995, sec. 2, pp. 13, 20.

6. Robert Entman, *Democracy Without Citizens: Media and the Decay of American Politics* (New York: Oxford University Press, 1989), 68.

7. People are unhappy with puff-paste journalism. Even so, the recent attacks by ultraconservatives on the Public Broadcasting System, one of the few formats left that attempts to stimulate critical thinking and the imagination, only serves to prove how destructive to the humanities the politics of hate can be.

8. Wendy Kaminer, "Feminism's Identity Crisis," in *Atlantic Monthly* (October 1993): 51–68.

9. Cynthia Ozick, "Hannah and Elkanah: Torah as the Matrix for Feminism," in *Out of the Garden: Women Writers on the Bible,* ed. Christian Buchmann and Celina Spiegel (New York: Fawcett Columbine, 1994), 91.

10. Michael Powell and Emeric Pressburger directed the film.

11. See Linda Gordon, "What's New in Women's History," in *Feminist Studies/Critical Studies* (Bloomington: Indiana University Press, 1986), 29.

12. Susan Faludi, *Backlash* (New York: Crown, 1991), 454.

13. Ibid., 459.

14. Omar Calabrese, *Neo-Baroque: A Sign of the Times* (Princeton, N.J.: Princeton University Press, 1992).

15. For a balanced and sane view on Freud, women, and feminism, see Samuel Slipp, *The Freudian Mystique* (New York: New York University Press, 1993). In my opinion, Steinem, Naomi Weisstein, and Phyllis Chesler were particularly reductive in developing their criticisms of Freud and ignored the context in which he developed his views on female development. In rejecting Freud, they ignored how he helped women and supported the development of their careers in psychoanalysis and thus missed an opportunity

to consider modernism and its impact on psychoanalytical theory in the United States. Much of what they criticize—shock treatments and so on— were elaborated on in the United States. What is needed is a serious discussion of Freud in the context of feminism and its critique that considers Freud's own life and relationship to his mother and other women. This is precisely the gap that Slipp's book attempted to fill.

16. Stephen R. Covey, *Seven Habits of Highly Effective People* (New York: Simon & Schuster, 1989). In November 1995, I attended a seminar led by Covey, Tom Peters, and Denis Waitley and moderated by Linda Ellerbee that focused on these issues. Peters's "W.O.W" factor was an inspiration and set feminism within the context of the ability to thrive on chaos, embrace risk, and celebrate diversity.

17. Rabbi Rami M. Shapiro, *Wisdom of the Jewish Sages: A Modern Reading of Prike Avot* (New York: Bell Tower, 1993), 41.

Appendix A

SECTION 1. STATEMENT OF POLICY

Pornography is sex discrimination. It exists in the County of Los Angeles, posing a substantial threat to the health, safety, welfare, and equality of citizens in the community. Existing state and federal laws are inadequate to solve these problems in the County of Los Angeles.

SECTION 2. FINDINGS

Pornography is the systematic practice of exploitation and subordination based on sex which differentially harms women. The harm of pornography includes dehumanization, sexual exploitation, forced sex, forced prostitution, physical injury, and social and sexual terrorism and inferiority as presented as entertainment. The bigotry and contempt pornography promotes, with the acts of aggression it fosters, diminish opportunities for equality of rights in employment, education, property, public accommodations and public services; create public and private harassment, persecution and denigration; promote injury and degradation such as rape, battery, child sexual abuse, and prostitution and inhibit just enforcement of laws against these acts; contribute significantly to restricting women in particular from full exercise of citizenship and participation in public life, including in neighborhoods; damage relations between the sexes; and undermine women's equal exercise of rights to speech and action

guaranteed to all citizens under the Constitutions and laws of the United States, the State of California and the County of Los Angeles.

SECTION 3. DEFINITIONS

1: Pornography is the graphic sexually explicit subordination of women through pictures and/or words that also includes one or more of the following: (i) women are presented dehumanized as sexual objects, things or commodities; or (ii) women are presented as sexual objects who enjoy pain or humiliation; or (iii) women are presented as sexual objects who experience sexual pleasure in being raped; or (iv) women are presented as sexual objects tied up or cut up or mutilated or bruised or physically hurt; or (v) women are presented in postures of sexual submission, servility, or display; or (vi) women's body parts—including but not limited to vaginas, breasts, or buttocks—are exhibited such that women are reduced to those part; or (vii) women are presented as whores by nature; or (viii) women are presented as being penetrated by objects or animals; or (ix) women are presented in scenarios of degradation, injury, torture, shown as filthy or inferior, bleeding, bruised or hurt in a context that makes these conditions sexual.

2: The use of men, children, or transsexuals in the place of women in (1) above is also pornography for the purposes of this law.

SECTION 4. UNLAWFUL PRACTICES

1: Coercion into pornography: it shall be sex discrimination to coerce, intimidate, or fraudulently induce (hereafter, "coerce") any person, including transsexuals, into performing for pornography, which injury may date from any appearance or sale of any product(s) of such performance(s). The maker(s), seller(s), exhibitor(s) and/or distributor(s) of said pornography may be sued, including for an injunction to eliminate the products of the performance(s) from the public view.

Proof of one or more of the following facts or conditions shall not, without more, negate a finding of coercion:

1. that the person is a woman; or
2. that the person is or has been a prostitute; or
3. that the person has attained the age of majority; or
4. that the person is connected by blood or marriage to anyone involved in or related to the making of the pornography; or
5. that the person has previously had, or been thought to have had, sexual relations with anyone, including anyone involved in or related to the making of the pornography at issue; or
6. that the person has previously posed for sexually explicit pictures with or for anyone, including anyone involved in or related to the making of the pornography at issue; or
7. that anyone else, including a spouse or other relative, has given permission on the person's behalf; or
8. that the person actually consented to a use of the performance that is changed into pornography; or
9. that the person knew that the purpose of the acts or events in question was to make pornography; or
10. that the person showed no resistance or appeared to cooperate actively in the photographic sessions or in the events that produced the pornography; or
11. that the person signed a contract, or made statements affirming a willingness to cooperate in the production of pornography; or
12. that no physical force, threats, or weapons were used in the making of the pornography; or
13. that the person was paid or otherwise compensated.

2: Trafficking in pornography: it shall be sex discrimination to produce, sell, exhibit, or distribute pornography, including through private clubs.

1. City, state, and federally funded public libraries or private and public university and college libraries in which pornography is available for study, including on open shelves but excluding special display presentations, shall not be construed to be trafficking in pornography.

2. Isolated passages or isolated parts shall not be actionable under this section.

3. Any woman has a claim hereunder as a woman acting against the subordination of women. Any man, child, or transsexual who alleges injury by pornography in the way women are injured by it also has a claim.

3: Forcing pornography on a person: it shall be sex discrimination to force pornography on a person, including a child or transsexual, in any place of employment, education, home, or public place. Only the perpetrator of the force and/or institution responsible for the force may be sued.

4: Assault or physical attack due to pornography: it shall be sex discrimination to assault, physically attack, or injure any person, including child or transsexual, in a way that is directly caused by specific pornography. The perpetrator of the assault or attack may be sued. The maker(s), distributor(s), seller(s), and/or exhibitor(s) may also be sued, including for an injunction against the specific pornography's further exhibition, distribution, or sale.

SECTION 5. DEFENSES

1: It shall not be a defense that the defendant in an action under this law did not know or intend that the materials were pornography or sex discrimination.

2: No damages or compensation for losses shall be recoverable under Sec. 4(2) or other than against the perpetrator of the assault or attack in Sec. 4(4) unless the defendant knew or had reason to know that the materials were pornography.

3: In actions under Sec. 4(2) or other than against the perpetrator of the assault or attack in Sec. 4(4), no damages or compensation for losses shall be recoverable against maker(s) for pornography made, against distributor(s) for pornography distributed, against seller(s) for pornography sold, or against exhibitor(s) for pornography exhibited, prior to the effective date of this law.

SECTION 6. ENFORCEMENT

A. Civil Action: Any person, or their [sic] estate, aggrieved by violations of this law may enforce its provisions by means of a civil action. No criminal penalties shall attach for any violation of the provisions of this law. Relief for violations of this law, except as expressly restricted or precluded herein, may include compensatory and punitive damages and reasonable attorney's fees, costs, and disbursements.

B. Injunction: Any person who violates this law may be enjoined except that:

1. In actions under Sec. 4(2), and other than against the perpetrator of the attack or assault under Sec. 4(4), no temporary or permanent injunction shall issue prior to a final judicial determination that the challenged activities constitute a violation of this law.

2. No temporary or permanent injunction shall extend beyond such material(s) that, having been described with reasonable specificity by the injunction, have been determined to be validly proscribed under this law.

SECTION 7. SEVERABILITY

Should any part(s) of this law be found legally invalid, the remaining part(s) remain valid. A judicial declaration that any part(s) of this law cannot be applied validly in a particular manner or to a particular case or category of cases shall not affect the validity of that part(s) as otherwise applied, unless such other application would clearly frustrate the intent of the Board of Supervisors in adopting this law.

SECTION 8. LIMITATION OF ACTION

Actions under this law must be filed within one year of the alleged discriminatory acts.

Appendix B

1. INTRODUCTION

Prostitution is the world's oldest profession. Throughout the ages, men and women have sold their favours and it is something there is no way to stop, even if we wanted to. In the Netherlands, like anywhere else, metropolises have traditionally been the site of prostitution. The Red Light District in Amsterdam is known all across the globe. Although Dutch legislation does formally view running a "prostitution enterprise" as a punishable act, a tolerant and pragmatic policy has always been implemented. The Dutch might not have a positive attitude to prostitution, but it is accepted as part of the reality. Municipalities need the kind of rules that help them keep a check on prostitution's unwanted side effects. Paradoxically enough, the fact that it is formally a punishable offence has often been a handicap, since no rules can be enforced to regulate something that is forbidden by law. This situation is soon to change. In the foreseeable future, the law is going to be amended. Municipalities will have the option of either maintaining the brothel prohibition or drawing up rules to keep this social reality under control. Just exactly how Amsterdam is planning to put its policy on prostitution into effect is what this brochure is going to explain.

2. THE PRESENT SITUATION

In the Netherlands, being a prostitute is not punishable. What is formally prohibited on the grounds of section 250b of the Dutch

Penal Code is running a prostitution enterprise, such as a window brothel, a closed house, or a sex club. In practice, however, authorities turn a blind eye and businesses of this kind flourish throughout the Netherlands. The present-day policy in Amsterdam is focused on preventing the number of window brothels from expanding. As long as they do not disturb the peace, the ones that are already in existence are tolerated. Another rule is that it is forbidden for minors to work as prostitutes. And to minimize the spread of venereal diseases, every effort is made to encourage prostitutes to have regular medical check-ups. In addition, there are general municipal regulations as regards fire safety, noise, and hygiene.

3. THE NEW AMENDMENT

In the near future, Section 250b of the Dutch Penal Code is to be amended in such a way as to make the brothel prohibition considerably more lenient. In essence, each municipality will be free to formulate its own policy. Amsterdam has opted for a system of licenses. Once a license has been granted for a prostitution enterprise, the person in charge will no longer be punishable by law. The brothel prohibition will however continue to be enforced in the event of coercion, in other words the person running the brothel is punishable if he or she forces anyone to work as a prostitute. The amendment of the brothel prohibition has to do with an amendment of the section of trafficking in human beings. The amendments are expected to go into effect in 1994.

4. SYSTEM OF LICENSES

One thing that is certain is that in the foreseeable future, the absolute brothel prohibition is to be repealed and that as long as prostitution is voluntary, the management will no longer be punishable by law. This will enable the municipality to draw up its own rules to prevent undue expansion, unpleasant situations, or disturbances to the peace and to keep the situation from getting out of control. Amsterdam has planned a license system which is to go into effect as soon as the amendment has been passed in

Parliament. To prevent any misunderstandings: the license system will solely pertain to prostitution enterprises such as window brothels, closed houses, and sex clubs, and not to individual prostitutes such as streetwalkers. The aims of the Amsterdam license system are:

- to protect the prostitute and improve his or her position;
- to minimize or prevent disturbances to the peace.

If a neighbourhood is to function well, it is obviously of crucial importance that there are no regular disturbances to the peace. For even if city authorities do view prostitution as a social reality that has to be accepted, the fact remains that some people still disapprove of it or are bothered by it in their daily lives. Legalizing prostitution is not going to change this. This is why every effort should be made to avoid conflicts with neighbourhood residents. A license will be issued to a specific individual and is non-transferable. If someone else takes over the enterprise, a request will have to be submitted for a new license. The person who runs a prostitution enterprise will be held responsible for what takes place there and for seeing to it that the rules are adhered to. These rules will pertain to various points including: where the place is located; the layout and furnishings of the place of business; how the place of business is managed.

The Location

The main purpose of the rules about where these places of business are located will be to protect the residential and social climate and prevent prostitution from acting as a nuisance or disturbing the peace. The distinction will be drawn between window brothels and closed houses or sex clubs. Since window brothels are so conspicuous, they will only be allowed in districts of Amsterdam where window prostitution has traditionally existed. The number of window brothels is not to increase there. This means no new window brothel can be set up unless some other one has been closed down. Elsewhere in the city, window brothels will be prohibited. There are also restrictions on soliciting and advertising.

Businesses will be free to present themselves to passersby as

window prostitution enterprises, but within acceptable confines. And of course they can not act as a nuisance by being too noisy. As regards window brothels, there will be a "no . . . unless" situation. For other prostitution enterprises such as closed houses and sex clubs, there will be a "yes . . . provided that" situation. In principle, they will be permitted . . . provided that they meet with a number of requirements. Closed houses and sex clubs are solely permissible if they are in keeping with zoning plans for the district and other arrangements in the city planning framework. They cannot be established in premises classified as residential, only in premises classified as commercial. Another requirement will be that they are not severely detrimental to the residential and social climate in the area. The city can refuse to issue a license if there is already a concentration of hotels, restaurants, pubs, and prostitution enterprises at "sensitive" spots, for example near a church, synagogue, mosque, or school. In deciding whether or not to issue a license, the city will evaluate the extent to which an enterprise might act as a nuisance or disturb the peace. The rules on sex clubs and closed houses differ from those on window brothels in that they are not permitted to be conspicuous. They can only make themselves recognizable to their customers by way of an illuminated house number or a nameplate that does not attract too much attention. And they too cannot act as a nuisance, for example by making too much noise.

Layout and Furnishings

In order to improve the working conditions of prostitutes, the license system is to stipulate certain requirements, for instance pertaining to fire safety and hygiene. In principle these requirements will apply to window brothels as well as closed houses or sex clubs. The size of the enterprise will be taken into consideration. These requirements might pertain for example to the size of the rooms, the washing accommodations in the rooms, the ventilation, adequate sanitary facilities, and clean sheets, towels and so forth.

Management

In order to qualify for a license for a prostitution enterprise, the management will have to meet certain requirements. Public

health care regulations will have to be complied with and steps will be taken to curb undesirable and criminal activities. This will enable the city to implement a policy focused on the protection of prostitutes and the improvement of their situation, which is the major point of departure for the entire license system. The person who runs the enterprise will have to meet with these requirements. He or she will have to promote safe sex techniques and the use of condoms. Moreover, in principle a prostitute is to have the freedom to refuse a customer. The management will be held responsible for whatever undesirable activities take place in the enterprise, for example the employment of minors or victims of trafficking. These people are in a vulnerable position and can easily fall prey to coercion, abuse or exploitation. As in any other business, it will be the responsibility of the management to see to it that no criminal activities are engaged in, such as dealing in hard drugs, fencing, illegal gambling, discrimination, and so forth. If these punishable activities are engaged in the Mayor can have the premises closed down.

IN CLOSING

Sex Entertainment and Merchandise

There is a special license system for pornographic movies, live show theatres, peep shows, and sex shops. A license can be refused if starting or continuing an enterprise for sex entertainment or merchandise is contrary to the zoning plan or to other decrees in the city planning framework or if the residential and social climate is in serious danger of being detrimentally affected.

Street Prostitution

The license system explicitly does not pertain to street prostitution. On most of the streets and roads in Amsterdam, soliciting for purposes of prostitution is prohibited, although there are streets where it is tolerated to a certain extent. Due to the nuisance that is often caused, certainly if prostitutes are addicted to hard drugs, this "ban on streetwalking" will continue to be enforced. The ban covers the prostitute as well as whatever other person might be involved (an intermediary, protector, or pimp,

for example, a heroin addict who needs these earnings). In essence, street prostitution is mainly a drug-related problem. Many of the streetwalkers are addicted to hard drugs and there is a good chance they are HIV-positive. Amsterdam does not have a special zone where these prostitutes are tolerated. This has been a deliberate policy decision. Tolerating them in a special zone would be contradictory to the municipal deterrent policy on hard drugs.

Published by the City of Amsterdam Press, Information and Public Relations Department. Copyright 1992.

Selected List of Works Consulted

Ackerman, Diane. "Atmospheric Conditions," in *Pen Newsletter* no. 82 (Spring 1994): 4.

Allison, Dorothy. "Our Son Who Will Be Eight in the Year 2000," in *Pen Newsletter* no. 82 (October 1993): 1, 3.

Angier, Natalie. "Biologists Hot on Track of Gene for Femaleness," in the *New York Times*, 30 August 1994, C1, C5.

Appignanesi, Lisa. *Femininity and the Creative Imagination: A Study of Henry James, Robert Musil and Marcel Proust*. London: Vision Press, 1973.

Arendt, Hannah. *The Human Condition*. Chicago: University of Chicago Press, 1958.

Ashe, Geoffrey. *The Virgin: Mary's Cult and the Emergence of the Goddess*. New York: Arkana, 1988.

Atlas, James. "The Counter Counterculture," in the *New York Times Magazine*, 12 February 1995, sec. 6., 32–65.

Barney, Natalie Clifford. *The One Who Is Legion*. London: Eric Partridge, 1930. Facsimile reprint: Orono: University of Maine, National Poetry Foundation, 1987.

Barr, Winifred Rothenberg. *From Market-Places to a Market Economy: The Transformation of Rural Massachusetts, 1750–1850*. Chicago: University of Chicago Press, 1994.

Beale, Frances. "Double Jeopardy: To Be Black and Female," in *The Black Woman*, Toni Cade, ed., 90–100. New York: Mentor Books, 1970.

Beauvoir, Simone de. *The Second Sex*. New York: Knopf, 1953.

Bem, Sandra Lipsitz. *The Lenses of Gender: Transforming the Debate on Sexual Inequality*. New Haven, Conn.: Yale University Press, 1994.

Benedek, Laslo. *The Wild One*. 1954. Film. Rebellion of a good bad boy and innocent girl.

David L. Bender, ed. *American Values: Opposing Points of View*. Opposing View Points Series. San Diego, Calif.: Greenhaven Press, 1989.

Benstock, Shari. *Women of the Left Bank: Paris 1900–1940*. Austin: University of Texas Press, 1986.

Bradwick, Judith M., and Elizabeth Douvan. "Ambivalence: The Socialization of Women," in *Women in Sexist Society: Studies in Power and Powerlessness,* Vivian Gornick and Barbara K. Moran, eds., 224–41. New York: Basic Books, 1971.

Breeskin, Adelyn D. *Romaine Brooks.* Washington, D.C.: National Museum of American Art–Smithsonian Institution, 1986.

Brooks, Romaine nee Goddard. "No Pleasant Memories." Unpublished type-script biography, National Collection of Fine Arts, Washington D.C., Archives of American Art, n.d.

Bronde, Norma and Mary D. Garrard, eds. *The Power of Feminist Art: The American Movement of the 1970s: History and Impact.* New York: Abrams, 1994. 6–318.

Brown, Lyn Mikel, and Carol Gilligan. *Meeting at the Crossroads.* New York: Ballantine Books, 1992.

Brownmiller, Susan. *Femininity.* New York: Linden Press, 1984.

Bufwack, Mary A., and Robert K. Oermann. *Finding Her Voice: The Saga of Women in Country Music.* New York: Crown, 1993.

Butler, Judith. *Gender Trouble: Feminism and the Subversion of Identity.* New York: Routledge, 1990.

Cade-Bambara, Toni. "On the Issue of Roles," in *The Black Woman: An Anthology.* Toni Cade, ed., 101–10. New York: Mentor Books, 1970.

Carabillo, Toni, Meuli Judith, and June Bundy Csida. *Feminist Chronicles 1953–1993.* Los Angeles: Women's Graphics, 1993.

Carrington, Karin Lofthus. "The Alchemy of Women Loving Women," in *Psychological Perspectives* 23, no. 6 (1991): 65–80.

Carroll, E. Jean. "The Future of American Womanhood," in *Esquire* (February 1994): 58–64.

Caskey, Noelle. "Interpreting Anorexia Nervosa," in *The Female Body in Western Culture,* Susan Rubin Suleiman, ed., 175–92. Cambridge, Mass.: Harvard University Press, 1986.

Chafe, William H. *The Unfinished Journey: America Since World War II.* New York: Oxford University Press, 1986.

Chauncey, George, Jr. "From Sexual Inversion to Homosexuality: Medicine and the Changing Conceptualization of Female Deviance," in *Salmagundi* 58 (Fall 1982): 114–45.

Chesler, Phyllis. "A Wolf in Feminist Clothing," in *On the Issues* 3, no. 2 (Spring 1994): 8–9, 52, 53, 54.

Clark, Christopher. *The Roots of Rural Capitalism: Western Massachusetts, 1780–1860.* New York: Cornell University Press, 1994.

Clift, Elayne. "Every Child a Wanted Child: A Conversation with Surgeon General Dr. Joycelyn Elders," in *On the Issues* 3, no. 2 (Spring 1994): 26.

Connor, Steven. *Postmodern Culture: An Introduction to Theories of the Contemporary.* Cambridge: Basil Blackwell, 1990.

Cook, Pam. "Duplicity in Mildred Pierce," in *Women in Film Noir,* E. Ann Kaplan, ed., 68–82. London: British Film Institute, 1994.

Cott, Nancy F. *The Grounding of American Feminism*. New Haven, Conn: Yale University Press, 1987.

Daly, Mary. *Beyond God the Father: Toward a Philosophy of Women's Liberation*. Boston: Beacon Press, 1973.

———. *Gyn/Ecology*. Boston: Beacon Press, 1978.

Debord, Guy. *Society of the Spectacle*. Detroit: Black and Red, 1983.

Delacoste, Frederique, and Priscilla Alexander. *Sex Work: Writings by Women in the Sex Industry*. Pittsburgh: Cleis Press, 1987.

Denfeld, René. *The New Victorians: A Young Woman's Challenge to the Old Feminist Order*. New York: Warner Books, 1995.

Diamond, Irene, and Gloria Feman Orenstein. *Reweaving the World: The Emergence of Ecofeminism*. San Francisco: Sierra Club Books, 1990.

Driscoll, Dawn-Marie, and Carol R. Goldberg. *Members of the Club*. New York: Free Press, 1993.

Dugger, Celia W. "Researchers Find a Diverse Face on the Poverty in New York City," in *New York Times*, 30 August 1994, A1.

Dworkin, Andrea. *Pornography: Men Possessing Women*. New York: G. P. Putnam's Sons, 1979.

Dworkin, Andrea, and Catharine A. MacKinnon. *Pornography and Civil Rights: A New Day for Women's Equality*. Minneapolis: Organizing Against Pornography, 1988.

Eagle, Carol J., and Carol Colman. *All That She Can Be*. New York: Simon & Schuster, 1993.

Echols, Alice. "The New Feminism of Yin and Yang," in *Desire: The Politics of Sexuality*, Ann Snitow et al., ed., 64–66. London: Virago, 1984.

Elliot, Bridget, and Jo-Ann Wallace. "Fleur Du Mal or Second Hand Roses?: Natalie Barney, Romaine Brooks, and the 'Originality of the Avant-Garde,'" in *Feminist Review* 40 (Spring 1992): 6–30.

Faludi, Susan. *Backlash*. New York: Crown, 1991.

Feinstein, Howard. "The Transsexuals' Stamp of Approval," in *Out* (September 1994): 46.

Flaubert, Gustave. *Correspondence*. Paris: Pleiades, 1989.

Flexner, Eleanor. *Century of Struggle: The Women's Rights Movement in the United States*. New York: Atheneum, 1970.

French, Marilyn. *The Women's Room*. New York: Summit Books, 1977.

———. *The War Against Women*. New York: Summit, 1992.

Friedan, Betty. *The Feminine Mystique*. New York: Dell, 1963.

———. *It Changed My Life: Writings on the Women's Movement*. New York: Random House, 1976.

Friedenberg, Daniel M. *Life, Liberty, and the Pursuit of Land: The Plunder of Early America*. New York: Prometheus, 1994.

Friend, Tad. "The Rise of 'Do Me' Feminism," in *Esquire* (February 1994): 21–56.

Gallagher, John. "Attack of the 50-Foot Lesbian," in *The Advocate* (March 1994): 40–46.

Gardner, Paul. *Louise Bourgeois*. New York: Universe, 1994.

Garon, Paul, and Beth Garon. *Woman with Guitar: Memphis Minnie's Blues*. New York: Da Capo, 1992.

Gilligan, Carol. *In a Different Voice: Psychological Theory and Women's Development*. Cambridge, Mass.: Harvard University Press, 1982.

Gilmore, David D. *Manhood in the Making: Cultural Concepts of Masculinity*. New Haven, Conn.: Yale University Press, 1990.

Gimenez, Martha E. "What Next: Some Reflections on the Politics of Identity in the U.S.," in *Heresies* 27, no. 3, Latina issue: 38–42.

Gitlin, Todd. *The Sixties: Years of Hope, Days of Rage*. New York: Bantam, 1987.

Glickman, Rose L. *Daughters of Feminists*. New York: St. Martin's Press, 1993.

Goodman, Ellen. "What This Poll Proves About Women (and About Men)," in *Esquire* (February 1994): 65–67.

Gray, Francine du Plessix. "Splendor and Miseries" [reviews of four books on prostitution in France]. *New York Review of Books*, 1992, 31–35.

Griffin, Susan. *Pornography and Silence: Culture's Revenge Against Nature*. New York: Harper and Row, 1981.

Guerrilla Girls. "Guerrilla Girls Probe *The New York Times*," in *Hot Flashes* 1, New York: Guerrilla Girls, 1993.

Gutierrez, Marina. "Nine Voices Hearing from the Next Generation," in *Heresies* 27, no. 3, Latina issue: 29–35.

Hammond, Harmony. "A Space of Infinite and Pleasurable Possibilities: Lesbian Self-Representation in Visual Art," in *New Feminist Criticisms: Art, Identity, Action*, Joanna Frueh, Cassandra Langer, and Arlene Raven, eds., 97–131. New York: HarperCollins, 1994.

Harrison, Daphne Duval. *Black Pearls: Blues Queens of the 1920s*. New Brunswick, N.J.: Rutgers University Press, 1993.

Harvey, Sylvia. "Woman's Place: The Absent Family of Film Noir," in *Women in Film Noir*, E. Ann Kaplan, ed., 22–34. London: British Film Institute, 1994.

Haste, Helen. *The Sexual Metaphor*. Cambridge, Mass.: Harvard University Press, 1994.

Heath, Stephen. "Male Feminism," in *Men in Feminism*, Alice Jardine and Paul Smith, eds., 1–32. New York: Routledge, 1989.

Heilbrun, Carolyn G. *Towards a Recognition of Androgyny*. New York: W. W. Norton, 1973.

Henretta, James A. *The Origins of American Capitalism: Selected Essays*. Boston: Northeastern University Press, 1994.

Herman, Edward S., and Noam Chomsky. *Manufacturing Consent: The Political Economy of the Mass Media*. New York: Pantheon, 1988.

Higashi, Sumiko. *Virgins, Vamps, and Flappers: The American Silent Movie Heroine*. St. Albans: Eden Press, 1978.

Hillman, James. *The Myth of Analysis*. New York: Harper and Row, 1972.

hooks, bell. "The Ice Opinion: Who Gives a Fuck?," in *Artforum* 32, no. 10 (Summer 1994): 7–8.

Hughes, Robert. *Culture of Complaint: The Fraying of America*. New York: Oxford University Press, 1993.

Illich, Ivan. *Gender*. New York: Pantheon Books, 1982.

Irigaray, Luce. *Speculum of the Other Woman*, Gillian C. Gill, trans., Ithaca, N.Y.: Cornell University Press, 1989.

James Cain novel adaptation. *Mildred Pierce*. Joan Crawford. 1945. Film.

Janeway, Elizabeth. "The Wave," in *Pen Newsletter* 82, no. 3 (October 1993): 82.

Johnson, Jill. *Lesbian Nation*. New York: Simon & Schuster, 1973.

Jones, Ann. *Next Time She'll Be Dead: Battering and How to Stop It*. Boston: Beacon Press, 1994.

Jones, Lisa. *Bullet Proof Diva: Tales of Race, Sex and Hair*. New York: Doubleday, 1994.

Kaminer, Wendy. "Feminism's Identity Crisis," in *Atlantic Monthly*, (October 1993): 51–68.

Kisselgoff, Anna. "Why, 'The Red Shoes' Is Still a Hit—on Film," in the *New York Times*, 9 January 1994, 6H.

Kramarae, Charis, and Paula A. Treichler. *A Feminist Dictionary*. Boston: Pandora Press, 1985.

Kulikoff, Allan. *The Agrarian Origins of American Capitalism*. Richmond: University Press of Virginia, 1994.

Landau, Elaine. *Sexual Harassment*. New York: Walker, 1993.

Lauretis, Teresa de. *Technologies of Gender*. Bloomington: Indiana University Press, 1987.

Lauter, Paul. "Feminism, Multiculturalism and the Canonical Tradition," in *Transformations* 5, no. 2 (Fall 1994): 1–15.

LeGuin, Ursula K. *The Wind's Twelve Quarters*. New York: Harper and Row, 1975.

Leo, John. "Watching 'As the Jury Turns,'" in *U.S. News and World Report* (14 February 1994): 17.

Lesser, R. C. "The Psychoanalytic Construction of the Female Homosexual." Paper presented at the spring meeting of Division 39, American Psychological Association, New York City, 1993.

Lesser, Wendy. *His Other Half*. Cambridge, Mass.: Harvard University Press, 1991.

Limbaugh, Rush. *See, I Told You So*. New York: Pocket Books, 1993.

Lipking, Lawrence. "When You're in Love," in *New Republic* (28 February 1994): 38–42.

Lippard, Lucy. *Mixed Blessings: New Art in a Multicultural America*. New York: Pantheon Books, 1990.

Lorber, Judith. *Paradoxes of Gender*. New Haven, Conn.: Yale University Press, 1994.

MacKinnon, Catharine A. *Feminism Unmodified: Discourses on Life and Law.* Cambridge, Mass.: Harvard University Press, 1987.

———. *Only Words.* Cambridge, Mass.: Harvard University Press, 1994.

Marshall, Penny. *A League of Their Own.* Film.

McCann, Graham. *Rebel Males: Clift, Brando, and Dean.* New Brunswick, N.J.: Rutgers University Press, 1993.

Mead, Walter. "Domestic Saints in the Next Revolution," in *Worth* (April 1994): 41–45.

Michael Powell and Emeric Pressburger. *The Red Shoes.* Film. Moira Shearer, Anton Walbrook, Leonide Massine, and Ludmilla Tcherina. 1948. Inspired by Hans Christian Andersen's tale.

Millett, Kate. *Sexual Politics.* New York: Avon, 1971.

Minkowitz, Donna. "Undercover with the Religious Right," in *Out* (February– March 1994): 56–61.

Minnelli, Vincente. Produced by Pandro S. Berman. Screenplay Robert Anderson based on his play. *Tea and Sympathy.* 1956. Film.

Morrison, Toni, ed. *Race-ing Justice, En-Gendering Power.* New York: Pantheon Books, 1992.

Morrow, Lance. "Are Men Really That Bad?" in *Time* (14 February 1994): 53–59.

Naifeh, Steven, and Gregory White Smith. *Jackson Pollock: An American Saga.* New York: Clarkson N. Potter, 1990.

Newton, Ester. "The Mythic Mannish Lesbian: Radclyffe Hall and The New Woman," in *Hidden from History: Reclaiming the Gay and Lesbian Past,* Martin B. Duberman, Martha Vicinus, and George Chauncey, Jr. eds. New York: New American Library, 1990.

O'Connor, Noreen, and Joanna Ryan. "'Truth' and 'Reality': Joyce McDougall and Gender Identity," in *Free Associations* 4, part 3, no. 31 (1994): 338–68.

Ogden, Gina. "Women Who Love Sex," in *On the Issues* 3, no. 2 (Spring 1994): 44–45.

Ortner, Sherry. "Is Female to Male as Nature Is to Culture?" *Women, Culture and Society,* Michelle Zimbalist Rosaldo and Louise Lamphere, eds. Stanford, Calif.: Stanford University Press, 1974.

Otto, Whitney. *Now You See Her.* New York: Villard Books, 1994.

Paglia, Camille. *Sexual Personae.* New Haven, Conn.: Yale University Press, 1990.

Peiss, Christina Simmons, et al., eds. *Passion and Power: Sexuality in History.* Philadelphia: Temple University Press, 1989.

Pelka, Fred. "Sick? It's Your Own Damn Fault!'" in *On the Issues* 3, no. 2 (Spring 1994): 34–37.

Pfister, Bonnie. "Swept Awake: Negotiating Passion on Campus," in *On the Issues* 3, no. 2 (Spring 1994): 13–16.

Phelan, Shane. *Identity Politics: Lesbian Feminism and the Limits of Community.* Philadelphia: Temple University Press, 1989.

Phillips, John A. *Eve: The History of an Idea*. San Francisco: Harper & Row, 1984.

Piven, Frances Fox, and Richard A. Cloward. *Regulating the Poor: The Functions of Public Welfare*. New York: Vintage Books, 1971.

Pollitt, Katha. *Reasonable Creatures: Essays on Women and Feminism*. New York: Knopf, 1994.

Quick, Lawrence J. *The Great Romantic Films*. Secaucus, N.J.: Citadel Press, 1974.

Quindlen, Anna. *Thinking Out Loud*. New York: Random House, 1993.

———. "The Little Woman," [Op-Ed] in the *New York Times*, 9 March 1994, A-20.

———. "Victim and Valkyrie," [Op-Ed] in the *New York Times*, 16 March 1994, A21.

Rabin, Roni. "Sex-Bias Violence Lawsuit?" in *New York Newsday*, 4 August 1994, A4, A50.

Rapping, Elayne. "Crowd on the Couch," in *On the Issues* 3, no. 2 (Spring 1994): 10–11.

Raven, Arlene, Cassandra Langer, and Joanna Freuh, eds. *Feminist Art Criticism: An Anthology*. Ann Arbor, Mich.: UMI Research Press, 1988.

Ray, Robert B. *A Certain Tendency of the Hollywood Cinema, 1930–1980*. Princeton, N.J.: Princeton University Press, 1985.

Raymond, Janice G. *Women as Wombs: Reproductive Technologies and the Battle over Women's Freedom*. San Francisco: Harper San Francisco, 1993.

Rich, Frank. "What Now My Love," [Op-Ed] in the *New York Times*, 6 March 1994, E6.

Roberts, Michele. *The Wild Girl*. London: Methuen, 1984.

Roiphe, Katie. *The Morning After: Sex, Fear, and Feminism on Campus*. Boston: Little, Brown, 1993.

Rolley, Katrina. "Cutting a Dash: The Dress of Radclyffe Hall and Una Troubridge," in *Feminist Review* 35 (1990): 54–66.

Rosaldo, Michelle Zimbalist, and Louise Lamphere. *Women, Culture and Society*. Stanford, Calif.: Stanford University Press, 1974.

Rose, Barbara. *Autocritique: Essays on Art and Anti-Art 1963–1987*. New York: Weidenfeld and Nicolson, 1988.

Rosen, Marjorie. *Popcorn Venus: Women, Movies and the American Dream*. New York: Avon, 1974.

Rosenberg, David, and Harold Bloom. *The Book of J*. New York: Grove and Weidenfeld, 1990.

Rosenthal, A. M. "The First Ladyship," [Op-Ed] in the *New York Times*, 11 March 1994, A31.

Ross, Loretta J. "A Simple Human Right: The History of Black Women and Abortion," in *On the Issues* 3, no. 2 (Spring 1994): 22–25.

Sandroff, Ronni. "Beware of Phallic Drift," in *On the Issues* 3, no. 2 (Spring 1994): 2.

Savitch, Jessica. *Anchorwoman*. New York: G. P. Putnam's Sons, 1982.

Scharlatt, Marsie. "Boundary Breaker (and Accomplice)" [Letter]. *New York Times*, 6 March 1994,6H.

Scott, Ridley. *Thelma and Louise*. 1991. Film.

Secrest, Meryle. *Between Me and Life: A Biography of Romaine Brooks*. Garden City, N.Y.: Doubleday, 1974.

Sedgwick, Eve Kosofsky. *Between Men: English Literature and Male Homosocial Desire*. New York: Columbia University Press, 1985.

———. *Epistemology of the Closet*. Berkeley: University of California Press, 1990.

Segal, Lynne. *Is the Future Female? Troubled Thoughts on Contemporary Feminism*. London: Virago, 1987.

Sexton, Adam, ed. *Desperately Seeking Madonna*. New York: Delta, 1993.

Sherman, Daniel, J., and Irit Rogoff. *Museum Culture: Histories, Discourses, Spectacles*. Minneapolis: University of Minnesota Press, 1994.

Shewey, Don. "The Saint, the Slut, the Sensation . . . Madonna," in *The Advocate* (7 May 1991): 42–51.

Shipman, David. *The Great Movie Stars: The Golden Years*. New York: Bonanza Books, 1978.

Shnayerson, Michael. "Barbra Streisand—The Way She Is," in *Vanity Fair* (November 1994): 150–59, 190–94.

Silverman, Debora. *Art Nouveau in Fin de Siècle France*. Berkeley: University of California Press, 1989.

Sischy, Ingrid. "Photography: White and Black," in *The New Yorker*, (13 November 1989): 124–46.

Skittone, Susan Lisa. "Ninjutsu," in *On the Issues* 3, no. 2 (Spring 1994): 38–43.

Smith-Rosenberg, Carroll. "The New Woman as Androgyne: Social Disorder and Gender Crisis, 1870–1936," in *Disorderly Conduct*. New York: Oxford University Press, 1985.

———. "Discourses of Sexuality and Subjectivity: The New Woman 1870–1936," in *Hidden from History: Reclaiming the Gay and Lesbian Past*, Martin B. Duberman, Martha Vicinus, and George, Chauncey, Jr., eds., 264–80. New York: New American Library, 1990.

Sommers, Christina Hoff. *Who Stole Feminism? How Women Have Betrayed Women*. New York: Simon & Schuster, 1994.

Spence, Jo, and Patricia Holland. *Family Snaps: The Meaning of Domestic Photography*. North Pomfret, Vt.: Trafalgar Square, 1992.

Stanley, Robert Henry. *Mediavisions: The Art and Industry of Mass Communication*. New York: Praeger, 1987.

Stannard, Una. "The Mask of Beauty," in *Women in a Sexist Society*, Vivian Gornick and Barbara K. Moran, eds., 187–206. New York: Basic Books, 1971.

Stein, Arlene. "Sisters and Queers: The Decentering of Lesbian Feminism," in *Socialist Review* 22, no. 1 (January–March 1992), 118–19.

Steinem, Gloria. *Outrageous Acts and Everyday Rebellions*. New York: Holt, Rinehart and Winston, 1983.

————. *Revolution from Within*. Boston: Little, Brown, 1993.

————. *Moving Beyond Words*. New York: Simon & Schuster, 1994.

Stimpson, Catharine R. "The Somagrams of Gertrude Stein," in *The Female Body in Western Culture*, Susan Rubin Suleiman, ed., 30–43. Cambridge, Mass.: Harvard University Press, 1986.

Stoltenberg, John. *The End of Manhood: A Book for Men of Conscience*. New York: Dutton, 1994.

Stone, Merlin. *When God Was a Woman*. New York: Dial Press, 1976.

Suleiman, Susan Rubin. *Subversive Intent: Gender, Politics and the Avant Garde*. Cambridge, Mass.: Harvard University Press, 1990.

Sweetman, David. *Mary Renault: A Biography*. New York: Harcourt, Brace, 1993.

Troche, Rose, director; written by Troche and Guinevere Turner. *Go Fish*. 1994. Film.

Tucker, Marcia, et al. *Bad Girls*. [Exhibition catalog, Part 1: January 14–February 27 and Part 2: March 5–April 10.] New York: New Museum of Contemporary Art, 1994.

Tuttle, Lisa. *Encyclopedia of Feminism*. London: Longman, 1986.

Warner, Marina. *Alone of All Her Sex: The Myth and the Cult of the Virgin Mary*. New York: Vintage Books, 1983.

Weinberg, Jonathan. *Art, Homosexuality and Modernism*. New Haven, Conn.: Yale University Press, 1993.

Wellman, William. *The Public Enemy*. 1931. Film.

Wenzel, Lynn. "Crying Rape," in *New Directions for Women* 22, no. 3 (March 1993): 3.

Wiley, Mason, and Damien Bona. *Inside Oscar: The Unofficial History of the Academy Awards*. New York: Ballantine Books, 1986.

Willis, Garry. *Under God: Religion and American Politics*. New York: Simon & Schuster, 1990.

Winerip, Michael. "In School," in the *New York Times*, 23 February 1994, B7.

Wolf, Naomi. *The Beauty Myth: How Images of Beauty Are Used Against Women*. New York: William Morrow, 1991.

Wolfe, Alan. "The Gender Question," in *New Republic* (6 June 1994): 27–34.

Wright, Robert. *The Moral Animal*. New York: Pantheon, 1994.

Index